# W A L L B A N G I N '

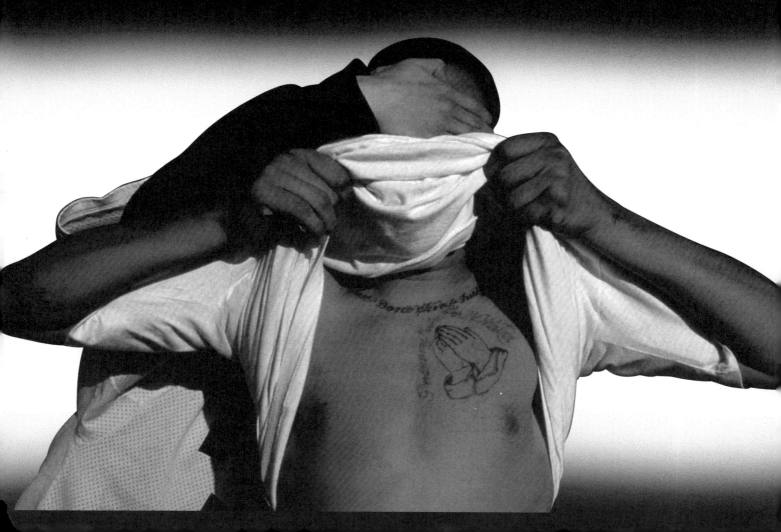

S U S A N  A .  P H I L L I P S

# wallbangin'

## GRAFFITI AND GANGS IN L.A.

THE
UNIVERSITY
OF
CHICAGO
PRESS

CHICAGO
AND
LONDON

SUSAN A. PHILLIPS currently teaches in the Department of
Anthropology at the University of California, Los Angeles.

The University of Chicago Press, Chicago 60637
The University of Chicago Press, Ltd., London
© 1999 by The University of Chicago
All rights reserved. Published 1999
Printed in the United States of America

08 07 06 05 04 03 02 01 00 99          1 2 3 4 5
ISBN: 0-226-66771-5  (cloth)
ISBN: 0-226-66772-3  (paper)

Library of Congress Cataloging-in-Publication Data

Phillips, Susan A., 1969–
Wallbangin' : graffiti and gangs in L.A. / Susan A. Phillips.
        p.        cm.
Includes bibliographical references and index.
ISBN 0-226-66771-5 (cloth : alk. paper). — ISBN 0-226-66772-3 (pbk. : alk. paper)
1. Graffiti—California—Los Angeles. 2. Gangs—California—Los Angeles. 3. Mexican
American youth—California—Los Angeles—Social life and customs. 4. Afro-American
youth—California—Los Angeles—Social life and customs. I. Title.
GT3913.13.C2P55 1999
364.1′06′60979494—dc21                                         98-31899
                                                                   CIP

♾ The paper used in this publication meets the minimum require-
ments of the American National Standard for Information Sciences—
Permanence of Paper for Printed Library Materials, ANSI
Z39.48–1992.

For Erik

# CONTENTS

ILLUSTRATIONS

# ACKNOWLEDGMENTS

Conversations with two archaeologists first made me realize that graffiti was something I could study as an anthropologist. Graffiti wasn't necessarily an intuitive anthropological topic, but it was an intuitive archaeological one. Mike Glassow at the University of California, Santa Barbara, and Timothy Earle, then at the University of California, Los Angeles, pointed me solidly in the direction of graffiti and I never looked back. That initial encouragement cemented the course of my work, and I am grateful to them both.

I wrote much of this book (as my dissertation) while a doctoral fellow in the UCLA department of anthropology from 1997 to 1998. My many thanks to the university for this generous support and for the departmental grants I received that made my studies possible. At UCLA I had the benefit of a wonderful committee. Leo Estrada was always a willing and ready reader who made himself available at a moment's notice. His commitment to Los Angeles has informed my own perceptions of the possibilities and rewards of work here. Diego Vigil, even before I knew him personally, profoundly affected my approach through his research and writing; his work with gangs was my model as I began my own project. When I finally did have the benefit of his tutelage in person, I was grateful for his critiques and for always treating me as a colleague in the strange field of gang studies. I owe a great intellectual debt to Anna Simons, whose balance of theory with the practical viability of anthropological research continues to be an inspiration to me. She has been an accessible mentor and an honest critic. My committee chair, Allen Johnson, has also greatly impacted my approach to this topic. I thank him for his attempts to teach me to think clearly, to follow a train of thought, and to zero in on a problem. His own ability to do this and his careful consideration of this text through its various stages helped to shape it into the work you see before you.

Tim Earle has always been the moral anchor for this project. Since its inception, he has encouraged me to emphasize my strengths: to research and write in images, material objects, and photographs. I will feel as though I have succeeded if I come close to any of his expectations for me. If I do, it will be in some part because he pushed me to set my sights just a little higher. I must also thank Alessandro Duranti, Doug Hollan, Louise Krasniewicz, Paul Kroskrity, and Kyeyoung Park for their guidance during my years as a graduate student. Brian Feuer, an archaeologist and my undergraduate professor at Cal State Dominguez Hills, also supported my early efforts in the graffiti field. Together, these people have shaped who I am as a scholar.

Special thanks go to my friends Conerly Casey, Rowanne Henry-Jugan, Lisa Lucero, Liesl Miller, and Kirsten Olson for providing a network of trust and companionship. I am also indebted to Louise Tallen and Erik Christiansen for taking me out on their Sea Tow boat to see the graffiti of sailors from around the world in the L.A. Harbor.

In addition, the following individuals were instrumental in seeing this manuscript to fruition: Rudi Colloredo-Mansfeld's critical feedback at early stages of this work was enormously helpful in shaping its outcome. John Steinberg generously shared his knowledge of map making and worked long hours with me to produce the maps that appear in this book. Rosie Ashamalla provided constant comparative materials, her passion for the topic, and her friendship. Rhoda Janzen taught me not to be afraid of experimenting with language and has greatly inspired all my written efforts. Carey Fosse, Dave Spiro, and Wally Zane are the only three other people I know who get as excited about graffiti as I do. All of these people deserve special recognition for their help in getting this manuscript into shape, and for keeping my spirits in shape as well. I will not forget their generosity.

I wrote a large portion of this book while a fellow at the Getty Research Institute from 1996 to 1997. At the Getty, I would first like to thank Michael Roth and Roger Friedland for their initial criticisms of my presentation of gangs as political groups. Everyone at the Getty impacted my project in some way. I would like to point them out individually: Brenda Bright, Robert Carringer, Dana Cuff, Robert Dawidoff, Bill Deverell, Thomas Dumm, Phil Ethington, Doug Flamming, Robbert Flick, Ramón García, Kanishka Goonewardena, Thomas Hines, David James, Jérôme Monet, Becky Nicolaides, Bill Mohr, Carolyn See, R.J. Smith, and Harold Zellman. I must also thank the Getty Research Institute's staff, particularly Sabine Schlosser, Charles Salas, and JoEllen Williamson, for the gra-

cious support and friendship during my residence. It was a year in which I grew immensely and learned more about Los Angeles than I thought possible.

I greatly appreciate the thoughtful criticism of A. David Napier, whose detailed feedback encouraged me to expand my treatment of many portions of this manuscript. His courageous approach to his own writing as well as to the discipline in general has indeed been inspiring.

Ben Lomas and Gershon Weltman have generously made available their early collection of graffiti photographs from a project they started together in 1965. Ben Lomas in particular has been a strong ally in support of this project, and many of his pictures appear in the text. I owe Evelyn de Wolfe Nadel, currently curator of the Leonard Nadel Photo Archives, similar thanks. She has generously allowed me to use some of Leonard Nadel's outstanding photographic work in this book. Both Lomas's and Nadel's photographs enhance the ethnographic accounts with a depth that never could have been realized without their early insight. My debt to them is greater than I can say, and I hope I do their work justice in the pages that follow. In addition, I also thank Sally and Jerry Romotsky for their inspiring efforts in the graffiti field, and for sharing with me a handful of their experiences on the street.

Formally, I wish to thank *Lowrider* magazine, Larry Gordon of the Los Angeles County Housing Authority, the MIT Press, Wieland Kirk, Ralph F. López-Urbina, and Teen Angel of *Teen Angel's* magazine for permission to use several images.

I conducted fieldwork from 1995 to 1996 while volunteering at the California Black Women's Health Project. My thanks go first to Frances Jemmott and Elois Joseph for introducing me to South Central Los Angeles and for welcoming me to "the Well." I would also like to thank Michelle McMillan, for her companionship and her questions, as well as Mary Walton and Holly Mitchell. I am also greatly indebted to Leon Gullet, who provided me with support and introductions as I was first beginning my work among Bloods and Crips.

This book has benefited from information I learned from several neighborhoods in particular. Among Chicano gangs, I particularly point out members of Santa Monica 17th Street and the Santa Monica Little Locos, with whom I worked when I was just beginning this project in 1991 and 1992. In particular, I would like to thank two individuals: the man I call "Bear" for being a good friend and a willing respondent, and Diablo of Santa Monica 17th Street for checking and correcting portions of the Chicano gang chapter. More

recently, the outstanding artists of the 29th Street neighborhood and of the 36th Street neighborhood in South Central Los Angeles provided me with invaluable material regarding the stylistic and social elements present in their graffiti.

For my study among Bloods and Crips, I must first thank members of the Pueblo Bishops and the people in the Pueblo del Rio Housing Projects. Although I cannot name specific individuals here, I would like to thank one particular family in the Pueblos (you know who you are), as well as everyone over at the pool hall for making me feel welcome. On Central Avenue, I thank members of the Blood Stone Villains as well as the many people who would "look out" for me while I was on the street. Members of the Mad Swan Bloods, the Foe Duce, Foe Tray Gangster Crips, and the Five Duce Hoover Gangster Criminals also gave me information about the culture of African American gangs that enriched my knowledge of the Eastside geography. These gang members and their families, as well as the people I constantly encountered on the street, are the ones who made my research possible. I hope the spirit of this work lives up to their expectations for it.

Alejandro Alonso, currently at the University of Southern California, knows more about gangs than anyone I have ever met. I thank him for our graffiti trips and discussions, and for the wealth of information at his fingertips regarding the Bloods and Crips of Los Angeles. He has been a good "check" for the work that I present.

David Brent, of the University of Chicago Press, has been one of the active forces behind this book. I owe him not only many thanks for being the wonderful editor that he is, and for accepting my work early on, but for becoming a good and understanding friend in the process. At the Press, I also thank Jennifer Moorhouse for her careful copyediting and suggestions, Mike Brehm for his wonderful book design, and Matt Howard for facilitating the photographic aspect of the manuscript. Additional thanks go to the anonymous reader who reviewed the original manuscript, and to whom I am grateful for comprehensive and helpful feedback.

My family is another story. I am lucky to have understanding relatives who never tried to stand in the way of the work I do, but instead helped me all along the way. Both my aunt and uncle, Silvia and Vincent Milosevich, read and commented on early versions of the text, and I am indebted to them for their time and feedback, as well as that of my stepfather, Bob Klang—it pays to have English professors in the family. My sister Jennifer has been with me through thick and thin; her excitement with regard to this project has always made me feel like the risks are worth it in the end. Celinda and Ralph Jungheim, my

parents-in-law, provided dinners, countless suggestions (thanks Ralph!), and constant moral support to a weary fieldworker on her way back home. I am grateful for my "second family" here in Los Angeles and thank Celinda in particular for first introducing me to Fran Jemmott and the Black Women's Health Project. I must also thank my two grandmothers, Elvira Granieri and Doris Shepard, for their inspiring lives and words.

My father, Peter Phillips, taught me early on to see pictures in nothing—to look for the details in everyday things, something I have taken to heart in my study and photography of graffiti. He also provided me several mini-grants from the "Phillips foundation," as well as his own excitement in seeing this project come to fruition. Great rewards indeed.

I owe countless personal and intellectual debts to my mother, Maria A. Phillips. I grew up in a house full of books about art, listening to her and following in her footsteps almost without realizing it. It was my mother who taught me to never let fear limit me, a lesson that I am sure she never meant for me to take quite so seriously. There is no way to gauge her influence on who I am as a scholar or individual, but I hope that the successes in this work will be some small measure of both.

I dedicate this book to my husband, Erik Blank. Since the day he first taught me the difference between tagging and gang graffiti, he has given me the support and understanding that have made this project possible. Without him, I could not have embarked on many of the journeys I took on my own—nor on those we took together. I look forward to many more to come.

# THE STORY OF GRAFFITI

We too wonder, O Wall, that you've borne your burden so bravely
Under the weight of the words scribbled all over your face.

Pompeii graffiti

**gra•fi•to** \gre-'fe-(,)to\ *n., pl.* -ti \(,)te\ [It., a scribbling; *graffio*, a scratch], an inscription or drawing scratched on pillars, buildings, etc., as in ancient Rome

*Webster's New World Dictionary*

**graffiti** (g) *n. pl.* crude drawings or inscriptions on a wall, fence, etc. 1851, ancient drawings or writings scratched on walls, as those of Pompeii and Rome; borrowing of Italian *graffiti*, plural of *graffito* a scribbling, from *graffio* a scratch or scribble, from *graffiare* to scribble, ultimately from Greek *gráphein* draw, write; see CARVE. The transferred meaning, applied to recently made crude drawings or scribblings, is first recorded in English in 1877.

*Barnhart Dictionary of Etymology*

Hebrew: *graffiti; ktvot kir* (writings on the wall)
Greek: *graphitis*
Italian: s. *graffito;* pl. *graffiti; scritte* (writings) or *scritte sui muri* (writings on the walls)
Spanish: *grafiti* or *graffiti*
French: s. *graffite, graffito;* pl. *graffites, graffiti*
Romanian: *grafiti*
German: *Graffito, Kratzmalerei* (scratched picture)
Dutch: *graffiti; (muur) inscripties als leuzen* ([wall] inscriptions in wood); *schuttingwoorden* (fence word, dirty word)
Swedish: *graffitin*

Finnish: *graffiti*
Portugese: *grafite*
Croatian: s. *grafit;* pl. *grafiti*
Japanese: *rakugaki* (writing or drawing where it is not allowed; words that fall from the person to the ground)
Chinese (Mandarin): *tu(2)ya(1)* (scribblings made without purpose)
Korean: *nak sou* (to make dirty)
Arabic: *shaw(kh)batah,* (to scribble)
Armenian: *aradavorel; aghavaghel* (to make dirty)
Hindi: *divaar pay likhai* (writing on the wall)
Bengali: *hijibiji aanka* (absurd or useless pictures)
Mongolian: *sewar* (to write on the wall)
Maori: *tuhituhi anuanu* (disgusting writing; doodling)

## NOTE

I primarily adhere to the colloquial usage of graffiti to represent both the singular and the plural.

## EXTRACTS

In the same hour came forth the fingers of a man's hand, and wrote over against the candlestick upon the plaister of the wall of the king's palace: and the king saw the part of the hand that wrote. Then the king's countenance was changed, and his thoughts troubled him, so that the joints of his loins were loosed, and his knees smote one against another. The king cried aloud to bring in the astrologers, the Chaldeans, and the soothsayers. And the king spake, and said to the wise men of Babylon, Whosoever shall read this writing, and shew me the interpretation thereof, shall be clothed with scarlet, and have a chain of gold about his neck, and shall be the third ruler of the kingdom. . . .

Then Daniel answered and said before the king, Let thy gifts be to thyself, and give thy rewards to another; yet I will read the writing unto the king, and make known to him the interpretation. . . .

Then was the part of the hand sent from him; and this writing was written. And this is the writing that was written, MENE, MENE, TEKEL, UPHARSIN. This is the interpretation of the thing: MENE; God hath numbered thy kingdom, and finished it. TEKEL; Thou are weighed in the balances, and art found wanting. PERES; Thy kingdom is divided, and given to the Medes and Persians. Then commanded Belshazzar, and they clothed Daniel with scarlet, and put a chain of gold about his neck, and made a proclamation concerning him, that he should be the third ruler in the kingdom. In that night was Belshazzar the king of the Chaldeans slain. And Darius the Median took the kingdom . . .

<div align="right">Dan. 5:5–7, 17, 24–31 (King James Version)</div>

The walls of the church were crumbling and were not the right place for epigraphs in charcoal. But the three wide stairways which led to the main door were smooth and polished. "Wonderful!" said Don Paolo. It was as if generations of Christians had polished these steps every day for centuries in the expectation of Don Paolo and his piece of charcoal. Don Paolo wrote in fine printed letters: "Long live Liberty!" "Long live Peace!" When he finished, he went off and looked at his handiwork from two or three points. He was satisfied.

<div align="right">Ignazio Silone, *Bread and Wine*</div>

Fabio had already painted out MUSSOLINI IS ALWAYS RIGHT and was halfway through the eight DUCE's.

"Four more to go, eh?"

"Yes. Whoever did it, overdid it," Fabio said.

"I did it," Bombolini said.

Fabio was silent. It embarrassed him to think of a man risking his life to climb a tower and write DUCE DUCE DUCE all over the side of it.

<div align="right">Robert Crichton, *The Secret of Santa Vittoria*</div>

Presently the hide-and-seek frolicking, and Tom and Becky engaged in it with zeal until the exertion began to grow a trifle wearisome; then they wandered down a sinuous avenue, holding their candles aloft and rading the tangled webwork of names, dates, post-office addresses, and mottoes with which the rocky walls had been frescoed (in candle smoke). Still drifting along and talking, they scarcely noticed that they were now in a part of the cave whose walls were not frescoed. They smoked their own names and moved on.

Mark Twain, *Tom Sawyer*

There was heaps of old greasy cards scattered around over the floor, and old whisky bottles, and a couple of masks made out of black cloth; and over the walls was the ignorantest kind of words and pictures, made with charcoal.

Mark Twain, *Huckleberry Finn*

Making them pens was a distressid-tough job, and so was the saw; and Jim allowed the inscription was going to be the toughest of all. That's the one which the prisoner has to scrabble on the wall. But we had to have it; Tom said we'd *got* to: there warn't no case of a state prisoner not scrabbling his inscription to leave behind. . . .

Ibid.

Napoleon sent for pots of black and white paint and led the way down to the five-barred gate that gave on to the main road. Then Snowball (for it was Snowball who was best at writing) took a brush between the two knuckles of his trotter, painted out MANOR FARM from the top bar of the gate and in its place painted ANIMAL FARM. This was to be the name of the farm from now onwards.

George Orwell, *Animal Farm*

Benjamin felt a nose nuzzling at his shoulder. He looked round. It was Clover. Her old eyes looked dimmer than ever. Without saying anything, she tugged gently at his mane and led him round to the end of the big barn, where the Seven Commandments were written. For a minute or two they stood gazing at the tarred wall with its white lettering.

"My sight is failing," she said finally. "Even when I was young I could not have read what was written there. But it appears to me that that wall looks different. Are the Seven Commandments the same as they used to be, Benjamin?"

For once Benjamin consented to break his rule, and he read out to her what was written on the wall. There was nothing there now except a single Commandment. It ran:

All Animals Are Equal

But Some Animals Are More Equal Than Others

<div align="right">Ibid.</div>

He felt his triumph grow into admiration as he traced the name RICKY DE LA CRUZ across both lobes of the heart, made out a plus mark, and spelled out the EVA that was wedged into the heart's point. For the guy must have spent days of stolen spoon labor carving that five-inch heart into the bare institute wall, and he had to be full of guts and love to do it, because he knew he was going to have to suffer for it. Yet he had so much guts he carved it in the most conspicuous spot in the cell, where it could be seen by everyone who looked through the glass slot, and *so that* it would be seen by anyone and everyone.

Aaron wished he had a spoon, too, to prove that *he* had the guts to love, to prove that neither the man nor the cell nor dead time could kill either his guts or his love, to prove what the thick useless paint and the year that had passed had proved for Ricky De La Cruz, to prove that he, like Ricky De La Cruz, was greater than the cell!

<div align="right">Floyd Salas, <em>Tattoo the Wicked Cross</em></div>

The walls of the Mettray yard have fallen about me; those of the prison have sprung up, walls on which I read, here and there, words of love carved by convicts and phrases written by Bulkaen, the more singular of appeals, which I recognize by the abrupt pencil strokes, as if each word were a matter of solemn decision.

<div align="right">Jean Genet, <em>Miracle of the Rose</em></div>

He set down her basket and the tin pot and, stirring the paint with the brush that was in it, began painting large square letters, on the middle board of the three composing the stile, placing a comma after each word, as if to give pause while that word was driven well home to the reader's heart:

Thy, Damnation, Slumbereth, Not.

2 Pet. ii. 3.

Against the peaceful landscape, the pale, decaying tints of the copses, the blue air of the horizon, and the lichened stile-boards, these staring vermillion words shone forth. They seemed to shout themselves out and make the atmosphere ring. Some people might have cried, "Alas, poor Theology!" at the hideous defacement—the last, grotesque phase of a creed which had served mankind well in its time. But the words entered Tess with accusatory horror. It was as if this man had known her recent history; yet he was a total stranger.

Thomas Hardy, *Tess of the D'urbervilles*

Alba went up to them and pointed to the mural on the other side of the street. It was stained red and contained a single word printed in enormous letters: Djakarta.

"What does that mean, compañero?" she asked one of them.

"I don't know," he replied.

And none of them knew why the opposition had painted that Asiatic word on the walls; they had never heard about the piles of corpses in the streets of that distant city. Alba climbed on her bicycle and pedaled home.

Isabel Allende, *The House of the Spirits*

I went from window to window and printed in huge soap-letters all my newly acquired four-letter words. I had written on nearly all the windows in the neighborhood when a woman stopped me and drove me home. That night the woman visited my mother and informed her of what I had done, taking her from window to window and pointing out my inspirational scribblings. My mother was horrified. She demanded that I tell her where I had learned the words and she refused to believe me when I told her that I had learned them at school.

Richard Wright, *Black Boy*

Filled with a sense of euphoric kinship with his unseen brothers, the unknown hands who had left their marks, O'Rooley scrabbled in his pocket and, passing by the page he'd torn from the back of *L'Histoire de la Langue d'Oc,* fetched out his pen.

He looked round for a spare stretch of wall.

Brigid Brophy, *In Transit*

The walls speak. To the careful eye, every surface reveals signs, most often scratched in with a pin or, in dark corners, in thin pencil lines. . . . The eternity of love is expressed in writing; the permanence of animal lust and all the suffering it brings in these circumstances cries out in these drawings. . . .

These walls: That is reality. And those one-hundred-and-sixty little lines on the dark corner of the floor under a sentence etched in by an unknown hand:

*"Only seven months more and I'll kill her."*

Victor Serge, *Men in Prison*

Now Benja is standing by my bunk bed. The guard has tied his hands to the end of my bed. I remember his untied hands setting free all those leaflets on the streets of Bahía Blanca, his easy laughter and childish face, his deeply furrowed brow when we discussed politics. We called him Benja because, like the Benjamin of the Biblical story, he was the youngest of the group. We never got to know each other very well, a few meetings . . . I think the two of us once wrote together on a wall: "Down with the military killers. We shall overcome!"

Alicia Partnoy, *The Little School*

Oedipa headed for the ladies room. She looked idly around for the symbol she'd seen the other night in The Scope, but all the walls, surprisingly, were blank. She could not say why, exactly, but felt threatened by this absence of even the marginal try at communication latrines are known for.

Thomas Pynchon, *The Crying of Lot 49*

The air was hot and quiet. She stood still in the middle of the front room for a while, and then she suddenly thought of something. She fished in her pocket and brought out two stubs of chalk—one green and the other red.

Mick drew the big block letters very slowly. At the top she wrote EDISON, and under that she drew the names of DICK TRACY and MUSSOLINI. Then in each corner with the largest letters of all, made with green and outlined in red, she wrote her initials—M.K. When that was done she crossed over to the opposite wall and wrote a very bad word—PUSSY, and beneath that she put her initials, too.

Carson McCullers, *The Heart Is a Lonely Hunter*

But by this time the cable of the *San Dominick* had been cut; and the fag-end, in lashing out, whipped away the canvas shroud about the beak, suddenly revealing, as the bleached hull swung round toward the open ocean, death for the figurehead, in a human skeleton; chalky comment on the chalked words below, "*Follow your leader.*"

Herman Melville, *Benito Cereno*

The figures of fiends in aspects of menace, with skeleton forms, and other more really fearful images, overspread and disfigured the walls. . . .

Demon eyes, of a wild and ghastly vivacity, glared upon me in a thousand directions, where none had been visible before, and gleamed with the lurid lustre of a fire that I could not force my imagination to regard as unreal.

Edgar Allan Poe, "The Pit and the Pendulum"

Bending over, I caught sight of Nissim; myopic Nissim with the thick lenses, who was forever breaking his glasses and having to get a new pair made. He had never learned to fire a rifle, and we hadn't bothered to call him. He left the cellar, however, tagging along behind me until we reached the deserted base. Nothing was left of it but a couple of old stoves, a few ramshackle bungalows and an outhouse. Many things were scrawled on the walls of the outhouse: "Out of bounds!" "Officers only!" "For children!" "Auxiliary corps for women only!" Over these was written in Hebrew: "Men." "Ladies." "Company D." "Yoska is an ass." "Down with German rearmament!" "General John, go home!" "For shame!" "On with Spanish rearmament!"

I stood beneath the sign which said "Out of bounds," but I was definietly within bounds. Bounded by death and by destiny.

Yehuda Amihai, "Battle for the Hill"

We impute it therefore solely to the disease in his own eye and heart, that the minister, looking upward to the zenith, beheld there the appearance of an immense letter—the letter "A"—marked out in lines of dull red light. Not but the meteor may have shown itself at that point, burning duskily through a veil of cloud; but with no such shape as his guilty imagination gave it; or, at least, with so little definitiveness that another's guilt might have seen another symbol in it.

Nathaniel Hawthorne, *The Scarlet Letter*

By my retentive memory of the hieroglyphics upon one Sperm Whale in particular, I was much struck with a place representing the old Indian characters chiselled on the famous hieroglyphic palisades on the banks of the Upper Mississippi. Like those mystic rocks, too, the mystic-marked whale remains undecipherable.

Herman Melville, *Moby Dick*

"I like naughty rhymes, when they don't try to be pompous. I like the kind bad boys write on fences. My uncle had a rare collection of such rhymes in his head that he'd picked off fences and out-buildings. I wish I'd taken them down; I might become a poet of note!"

Willa Cather, *My Mortal Enemy*

They were: a sentry box at which a soldier was standing with a rifle, two or three cab-stands and, lastly, long fences with the usual kind of inscriptions and drawings scrawled on them in chalk and charcoal. There was nothing else in this desolate or, as it is usually described among us, picturesque square.

Nikolai Gogol, *Dead Souls*

She had gone past the bakery shop again the next afternoon. The windows had been smashed, the front door had apparently been broken in, because it was boarded up. There were messages chalked on the sidewalk in front of the store. They all said the same thing: "White man, don't come back."

Ann Lane Petry, *The Street*

Her finger moved over the glass, around and around. The circles showed up plainly on the dusty surface. The woman's statement was correct, she thought. What possible good has it done to teach people like me to write?

Ibid.

Next door Roy and Rene had chalked up over their door "Shangri-la"; across the way, three infantrymen had printed cheerfully: "Abandon hope all ye who enter here"; through the grill which separated our cell block from the British, I could see five Englishmen who sat on the floor and, in close harmony, assured the world that "There's No-o Place Like Home. . . ."

Russel Braddon, *The Naked Island*

But while I was sitting down, I saw something that drove me crazy. Somebody'd written "Fuck you" on the wall. It drove me damn near crazy. I thought how Phoebe and all the other little kids would see it, and how they'd wonder what the hell it meant, and how they'd all *think* about it and maybe even *worry* about it for a couple of days. I kept wanting to kill whoever'd written it. . . .

I went down by a different staircase, and I saw another "Fuck you" on the wall. I tried to rub it off with my hand again, but this one was *scratched* on, with a knife or something. It wouldn't come off. It's hopeless, anyway. If you had a million years to do it in, you couldn't rub out even *half* the "Fuck you" signs in the world. It's impossible.

J. D. Salinger, *The Catcher in the Rye*

Above her head the old porch pillar was carved with initials and monikers: GJG, Mingo, Lola, Chavo, Pina, Juanito. A generation of lost kids had defaced even the little they had, as they might deface and abuse anyone who tried to help them in ways too unselfish for them to understand.

Wallace Stegner, "Pop Goes the Alley Cat"

The Moving Finger writes; and having writ,
Moves on; nor all your Piety nor wit
Shall lure it back to cancel half a Line,
Nor all your Tears wash out a Word of it.

*Rubaiyat of Omar Khayyám*

# INTRODUCTION

It is February 1995. The front page of the *Los Angeles Times* reports that a fourteen-year-old Pakistani boy has been sentenced to hang for writing blasphemous graffiti inside the mosque of a small Punjabi farming village. The article explains how antiblasphemous laws against such activities, which seem to outsiders to be unduly harsh, are actually meant to minimize tensions between Muslims and Christians. While the Pakistani government had never executed someone for breaking these laws, the six people most recently accused were all murdered by mobs.

Justice had exacted its revenge and promised to do so again to the boy for his alleged crime—no matter how weak the case against him. Police reportedly never disclosed the contents of the chalked graffiti, and they had erased it immediately after finding it. Others testified that the boy, only twelve when the crime allegedly took place, was illiterate and hence could not have written any message on the wall of the mosque, blasphemous or otherwise. Nevertheless, the boy receives the death sentence.

Weeks earlier the *Los Angeles Times* reported another graffiti-related story—this time closer to home. In Sun Valley, near North Hollywood, eighteen-year-old tagger Cesar Rene Arce was killed and his friend David Hillo wounded in a confrontation over graffiti. William Masters, a white man, was walking through his neighborhood shortly after midnight when he noticed the two Latinos tagging a freeway overpass. As Masters began to jot down the license plate number of their car, the taggers noticed him and demanded that Masters give them the paper with the number on it. He refused. Then the account begins to get fuzzy. They approached him, and one of the taggers reportedly threatened him with a screwdriver (a tool whose primary purpose, it turns out, is to enable taggers to climb and tag street signs). Masters, who had no permit to carry the nine-millimeter hand-

gun concealed in his fanny pack, brandished his weapon and opened fire as the two were apparently turning to leave the scene. He killed one and wounded the other and reportedly told the survivor that "this all happened because you were tagging."

Although Masters did help to administer CPR on the man he had just shot, he later displayed no remorse for his actions. He basked in the overnight "hero" status bestowed by citizens frustrated with graffiti in their neighborhoods. He even went so far as to censure Arce's mother on national television for her failure to raise her son to be anything but a tagger. Several times he referred to the two young men as "Mexican skinheads." Praised as his action was in an instantaneous popular groundswell of antigraffiti sentiment, it took people a few days to realize who it was they were supporting—a vigilante who might actually be making the situation worse. Still, they could understand what he had done. Maybe killing the tagger was going too far, the public said, but we need to do something about this graffiti thing. It's a blight on our neighborhoods.

A follow-up story in the *Los Angeles Times* reported that, according to law enforcement experts, sociologists, and community activists, "Like racial slurs, urban graffiti provoke deep psychic turmoil that can push usually placid people to verbal excess and even violence" (5 February 1995, B1). Though the collective knowledge surrounding how graffiti works at a "deep psychic" level is in fact nil, the *Times* was reporting the fact that we live in a society fed up with things like graffiti. Concerns with property values, urban blight, a lack of control over our environments—all these things frustrate and complicate our lives.

But a "usually placid" person William Masters was not. Of the three participants, he was the only one who had employed racial slurs. Of the three, it was only Masters himself who had a previous criminal record for carrying swords on a Texas street, a crime he now repeated by illegally concealing a weapon. And the coroner determined that Arce had been shot in the back (Hillo was hit in the buttocks). But none of these circumstances persuaded the D.A. that there was enough evidence to try Masters. As Masters himself boasted, "Where are you going to find twelve people willing to convict me?" Nor did Masters give the judge who tried his misdemeanor case for possession of a concealed weapon any assurance that he would stop carrying guns—he vociferously defended his own version of our second amendment rights. Masters remained untried for murder and attempted murder and even for manslaughter. He was never sentenced to prison time; the only punishment he received was community service for the gun possession misdemeanor—which, ironically, forced him to perform graffiti clean-up.

Now just imagine if it had been the other way around. If Masters had only threatened the two youths with the gun, they would have had reasonable cause to fear for their lives (they did in fact demonstrate such a fear by turning to leave). What if one of them had managed to stab Masters with his screwdriver, perhaps fatally? The outcome is the same: one person is dead. While Masters—a white male fighting for a "just" cause—atoned for his crime merely with graffiti cleanup, chances are both Latinos would have been tried and sentenced to twenty-five years to life in prison. In California, a single stab wound is more than enough to convict two people of first-degree murder. It happens all the time, particularly if the people charged are affiliated with something like a gang or crew.[1] In fact, so vociferous was the public outcry *against* the Latino taggers in this case that some even suggested the remaining tagger be charged with murder himself. The taggers were the criminals after all—they had been writing on the wall. Masters was an "observant neighbor," finally someone willing to take a stand against this pervasive symbol of neighborhood decline.

Not all of us deal with our frustration as violently as William Masters did that night. It is the nature of prejudice to be much more insidious. It creeps into our daily activities through language, through gestures we learn as children, and it infuses our media in ways that reinforce what is considered just and good and right and what is considered reprehensible. Our prejudices—the habit of seeing things from our own points of view—teach us not to question the difference between that boy in Pakistan hanging at the end of a rope or killed by a fanatical mob and that young man dead on the streets of Sun Valley at the hands of a neighbor who is applauded for his actions by other citizens.

It was the public reaction to that killing that first prompted me to write a proposal for this book on the graffiti of Los Angeles. I felt disturbed that many L.A. citizens considered the loss of a human life to be an appropriate punishment for the crime of graffiti. Graffiti has the ability to push normal people over the edge, the newspapers were saying. It reportedly causes people more fear than some types of violent crimes. But I also had faith in my fellow Angelenos. I was sure that there were twelve people capable of trying William Masters on the facts of the case and not on their emotions.

Is graffiti a life-and-death issue? On the surface it doesn't seem to be. But looking more deeply into it, we see the fear it provokes; we see that rush that spurs kids to endanger their own lives on freeways to write it or to risk retribution in punitive political or religious circumstances. We see how gang members instigate conflict by crossing out enemy names and initials. With the Masters case as a guide, we also see that in certain circum-

stances graffiti may spur the public to regard the deaths of the people who write it as less important than the crime they commit. In all of these senses, graffiti *is* a life-and-death issue. At least that is what our society has made it out to be.

These examples offer a powerful context for this book. If the public is indeed so frustrated with graffiti that it unwittingly sides with someone like William Masters, then my task is simple. I can indeed make a difference in helping to fight such prejudice. By providing information about graffiti in Los Angeles—who writes it and why, and what it means—I can hope to create a buffer of understanding surrounding graffiti, to resolve some of the unnecessary frustration that it evokes, and to make people think about it before they react to it.

People who read this book doubtless have fears of one kind or another regarding both graffiti and gangs. But chances are some of these fears are uninformed, misplaced, or too easily confused with racial prejudices that we all carry. This does not mean that we have to be victims to our prejudices. Rather, I suggest that we need to confront them full force and fight them tooth and nail without compromising our rights as citizens. It is a little more difficult, after all, to resolve our problems when our solutions only make them worse.

One day I was driving near the Pueblo del Rio housing projects in South Central Los Angeles. I was talking with my friend Michelle, just chitchat, a little absentminded. I had stopped late to turn right at the corner and in the process almost cut off a pedestrian in the sidewalk: a young black man crossing the street in front of me. Our conversation in midstream, I barely noticed as I automatically reached over to lock my door. But he noticed; he was looking right at me. As I backed up to let him pass, I saw the anger in his face as he turned toward me and slammed his fist down on the hood of my car. Michelle looked curiously at me: "What was his problem?" Flushed with embarrassment, I told her that I had nearly run him down, then had insulted him by reaching over to lock my door—the cardinal sin for a white person in a black neighborhood. I had not been afraid of the young man. But his very presence, the blackness of his face, the bagginess of his clothes, triggered a reaction in me. He reminded me that there are things that need to be feared in life, that I needed to protect myself from them—from him. So I locked my door. As I engaged in this action without even thinking, I had affirmed two stereotypes. One targeted him, the black male, as synonymous with danger. The other was of myself, of the white community: the thoughtless white person who took in the stereotype hook, line, and sinker.

Fear is a mixture of ignorance and knowledge. Though I knew my reaction to him had

been mistaken, the young man purposefully reminded me by slamming his fist down on the car that he might indeed be someone to fear. This was his neighborhood, not mine. For the rest of the day, I kept thinking I was the worst reminder of what is wrong with our society today. Here I was, driving through a neighborhood I had visited dozens of times, where my closest friends were gang members, prostitutes, and crack addicts, where I was doing work that I had done for the past six years in similar neighborhoods. During fieldwork, I gave trust and relied on trust everywhere I went, and I loathed people who, like myself that day, could in a single gesture undo the meaning of relationships I had worked hard to build. If society so effectively fosters prejudice in us even when we fight against it, that is a sickness indeed.

Theodor Adorno has said that it is part of morality *not* to feel at home in one's home—we all have a moral obligation to de-familiarize the familiar and thus fight the forces of oppression.[2] In many senses, the familiar is culture: it's what we know about ourselves and others; it's what makes us comfortable, what we take for granted, what we may not even be aware of. To pick it apart—to make it unfamiliar—means we have to confront why we think the way we do, what really drives our actions, who we include in our beliefs and symbols, and which people we exclude as a result of them. Whenever we frame our own views as natural or normal while condemning those of others, we need to question ourselves about the disparity and ask why their views might be different. We need to make ourselves feel uncomfortable. However difficult, this task is essential if we are to educate ourselves about the lives of others.

Through the years, anthropologists have specialized in one thing: rendering the unfamiliar more familiar (Marcus and Fisher 1986). They have provided translations between cultures, brought knowledge from distant locales, pointed to similarities and differences, or searched for elusive pan-humanity. Whatever the specific goals of research, it is based on the simple premise that ours is not the only state. There are many ways of living, of being wealthy, poor, moral, or beautiful. In the process of making these things understandable, anthropologists also urge us to question how our society got to be the way it is and to wonder what it must be like to subscribe to a very different belief system.

Anthropologists who work in the places in which they live, however, sometimes expose things that people don't want to see, things they don't want to know about themselves or others. It is difficult for people to imagine that members of their own society may not share their experience of that society. Sometimes hearing the stories of people I work

with and watching them live their lives is so compelling I forget that the rest of the world doesn't necessarily get it: how debilitating the daily grind of poverty is, how oppressive it feels to be circumscribed by enemies, or how demeaning it is to be blamed for circumstances beyond individual control—what it's like to have to break the law just to survive. "How's a rich person gonna tell a poor person how to live?" a woman asked me one day, tears in her eyes. We have developed into a society where the same laws rule what have grown to be entirely different worlds.

In my own work, I was able to bridge these worlds more or less successfully through my focus on graffiti. I developed a strategy: I would give people photographs of their graffiti and establish my links through those photographs—through my images that captured the images they created of their gangs. The things they were making were objects already. That meant I didn't have to dehumanize my subjects to find out about their culture. Once they saw my interest, they were often more than willing to show me their creative expressions of their culture—throughout the neighborhood and on their bodies as well. Because graffiti are generally short-lived, and gang members put a lot of effort into their design, they are often happy to have lasting photographs of their creations. In this way, I was able to nurture a connection through the documentation of gang writing that provided me a fair measure of diplomatic immunity in the street.

I cannot underestimate the importance of this. Graffiti allowed me to meet with my informants on neutral ground. We shared a common interest in art and words. We were interested in objects and in style, in how symbols worked and were created, and in history. We were also interested in the reasons for gangs—and how their lives could be so different from mine. Focusing on graffiti allowed me to go beyond either a personal or local perspective; it allowed me to extend my reach as a researcher; and it also allowed me to bypass the problem of looking at gangs solely in terms of the crimes they commit. In a broader sense, it legitimized my endeavor by helping me to address questions people have about gangs and graffiti in the cities where they live.

Many urban ethnographers have been harshly criticized for glamorizing, understanding, sympathizing with, or crucifying those who have committed crimes. In the popular media, gangs in particular have been almost completely defined by their illicit aspects, in terms of both violence and economics. They kill not only each other but innocent bystanders. They deal drugs that harm their communities, drugs that in and of themselves encourage crime and violent behavior. But it was neither the violence nor the drugs that

brought me to the field of gang studies in Los Angeles. It was the writing—that was the thing that drew me. And this writing was the only way that I could study L.A. gangs honestly and with any degree of success.

I have never expected to be excluded from the critiques that other urban ethnographers have faced. Whenever I present this material, I anticipate severe criticism of one kind or another. I expect that people who hate graffiti will hate me for presenting this information as I do. Although I have encountered my fair share of criticism, it seems that people already know why this work is important. People are interested in looking at gangs through graffiti, not only because they see it every day on the walls around them, but because it is a topic with which, to a degree, we are already somewhat familiar.

Anthropologists have traditionally focused on analyzing things that human societies have in common. Kinship, marriage, families: every society in the world shares these things. Part of my reason for including the extended list of extracts in the beginning of this book is to indicate that there also seems to be something about graffiti that remains constant across the globe and through time. It is part of humankind's collective consciousness, if indeed we can be said to have such a thing. In gang graffiti, we see flashes of Kilroy, intimations of love and hate, the expression of fundamental beliefs. Like looking at kinship, focusing on graffiti allows me to create a neutral arena of interest using material that is in and of itself far from neutral. Because graffiti is not neutral (it is in fact hypercharged with sentiment), it also forces interaction, however unwanted, between gang members and the larger society.

In this book I attempt to grasp two gang systems. In many ways I seem to focus on abstractions—not on people but things, on ideas and nebulous ideologies instead of concrete realities and individuals. But graffiti is an abstraction in writing, fibrous and hard; it is apart from the people at the same time as it is the people. It is the activity and product that people use to make culture. In his essay "The Author as Producer," Walter Benjamin (1979) encouraged scholars to view works of art and literature as active parts of social reality. He said we must not just ask what a work represents but what role that work plays in social production.

When gang members discuss their cultures, they talk about a practice called "representing." Benjaminian in their approach, gang members describe representing as the activities that keep their group going. Representing doesn't just reflect, it creates. Different kinds of gang activities become roughly analogous through representing: people and

graffiti become neighborhood landmarks, tattooing adorns the body as do clothes, hand signing becomes spray paint on a wall. At different levels, toward different audiences, these diverse activities stand for the same thing. The gang is nothing more than the ways that gang members represent it through diverse practices.

Before starting with the topic at hand, I need to explain how I have organized this book and why I have made certain decisions regarding the presentation of this material. I have divided this book into six chapters. The first two chapters introduce broader issues concerning graffiti and gangs. In chapter 1, "Graffiti for Beginners," I review general ideas regarding graffiti and attempt to link together diverse manifestations of graffiti. Graffiti is a topic with the power to bring us around the world and through time, while never losing that elusive primordial element that binds it into a coherent phenomenon. Because actually defining this topic is at some level futile, I have instead attempted to represent some of its breadth—to give readers a good sense of it, rather than listing a series of characteristics it must have to qualify. After reviewing some of the pertinent literature, I focus on the culture, language, art, and politics of graffiti that are especially important to my project on gangs.

In the second chapter, "Understanding Gangs," I build from the work of others to offer a cross-cultural, political approach to the topic of gangs in Los Angeles. Here, I seek neither to understate nor overstate my position. I simply wish to point out that gangs are similar to other groups around the world, and I explore some reasons why we might so easily compare groups in vastly different contexts. Although there are many potential approaches to the topic of gangs, analyzing them through their graffiti leads in a precisely political direction. An ethnography of gangs through graffiti does not directly lead to the state of the drug trade, nor does it offer information about why individuals join gangs: It leads us into the vast realm of gang politics. By this, I do not mean politics in terms of governmental policy. I mean politics in its broader sense. I am writing about gang politics primarily in terms of how gang members construct cultural systems and how intergang relationships work within and across those systems.

I need to make this exceptionally clear at the outset: Any time we talk about the construction of groups, their shifting relationships of warfare or alliance, or the representation of those relationships, we're talking about political concerns. This is what I mean in this book by "political," and it is what I mean when I discuss "gang politics." Sometimes gang politics does encompass elements of the larger society's politics. I indicate, for example,

how both African American and Chicano gangs periodically express nationalist senti-ments. But mostly, following representations in graffiti, gang politics focuses on position-ing a gang within a larger gang system through positive statements of self and expres-sions of broader affiliations—as well as through representations of enmity and alliance. Depending on one's perspective, this introductory chapter on gangs might be the most important in the book. It provides a framework that I hope will be useful for understand-ing the nature of gang membership today by explaining how gangs are connected. Though I refer to scholarly debates and literature, I have tried to make the material as ac-cessible as possible without sacrificing my theoretical argument.

Chapters 3 and 4 are ethnographies of Chicano and African American gangs, prima-rily as seen through their graffiti. The basis for my work rests with translating specific codes and graffiti practices. But in doing so I also demonstrate how people use those practices to construct their own sense of self, group, and other. Sketching the concerns of gang cul-ture, I include my own experiences in learning, as well as the voices and images of those whose lives are at stake in this process. Gang members are far more lucid than I in de-scribing the difficulties that confront them; in many ways they are harsher judges of both themselves and the society we share. Although the two chapters treat two different gang cultures, I have tried to make them roughly analogous by focusing on what seem to be important, and distinctive, issues among these gang systems.

Because I began my fieldwork with Chicano gangs, chapter 3 introduces the reader to gang life much in the same way I learned about it myself. I begin by discussing the con-cept of "gang as family" and how that relates to issues of neighborhood security. I also focus on how gang members use graffiti and other means to construct neighborhood landscapes. Finally, I begin an analysis of the Chicano gang boundary system, a geo-graphically based system of divisions within the state of California, the Southwest, and even parts of Mexico. This takes the reader back and forth from prison to the streets—a journey with which most gang members are intimately familiar. This journey brings up several topics, including racial ideology, a radical split between North and South, and a broader thread of nationalism that underlies gang sentiment. Further, a strong concept of "style" has also had considerable impact on Chicano gangs and their graffiti through time. Thus I emphasize the Chicano gang focus on style and how it intersects with broader concepts of culture, race, and history.

Chapter 4, "African American Gang Graffiti," is in some ways more concise than chap-

ter 3. When I began my research among African American gangs, I already had experienced the shock of the new—gang culture and I were, by that time, old friends. I had also reconciled many of the ethnographic dilemmas that I encountered in my first work among Chicano gangs. Most of the chapter focuses on how gang members represent political relationships between Bloods and Crips in graffiti. I discuss the structure of these gang relationships, particularly how enemies are represented at varying levels through speech and writing, and how gang alliances work (particularly between Bloods). In addition, I take time to examine two special topics. First is the mystical role of numbers within African American gangs. I examine its centrality to this gang culture through a variety of practices, focusing on how connections through numbers help construct alliances and common historical sentiment. Second is the graffiti from the 1992 Los Angeles Uprising and the latent thread of black nationalism that motivates this culture at core levels. Both chapters on gangs benefit immensely from archival materials made available by Ben Lomas and Gershon Weltman, who studied graffiti in 1965, and by Leonard Nadel, who documented L.A. graffiti in 1974.

Chapter 5 offers a brief review of hip-hop graffiti, a type of graffiti prevalent around Los Angeles (and the world) that is often mistaken as gang related. This chapter primarily draws comparisons between the two genres and explores some differences in the groups that produce them. It is not as "ethnographic" as the chapters on Chicano and African American gang graffiti—there are no lengthy quotes from interviews, for example. But for my purposes, these aren't necessary. Many are more expert than I on the phenomenon of hip-hop graffiti in Los Angeles. I do have some insights into this culture, however, particularly as it relates to gangs. In the process of sharing these I hope to point to the richness of this now-global culture, to which this chapter only briefly alludes.

In chapter 6, the conclusion, I discuss cross-ethnic gang relationships and examine how the notion of cultural "hybridity" relates to gangs and graffiti. The ethnographic examples all demonstrate how people have built lives through creative solutions in a society where, for whatever reason, they have little integration within the dominant system. The system has given up on them; in turn, they have given up on the system. In harsh urban environments, they have created ways of life that meet their needs at a much more immediate (and even visceral) level. Gang members do not construct themselves as hybrids, but rather as racially and culturally "pure." They do this in part by concretizing their wishes and goals and divisions in writing as well as other arenas. In Los Angeles, gangs are constructed along

racial lines and in relation to white society (and its racially motivated actions). In gang membership, then, we begin to see the power of racial politics on the L.A. streets; this politics of race poses broader questions of group construction throughout the text.

In broaching these topics, two moral questions automatically present themselves for consideration. First, do gangs have their own system of morality? I address this question in the ethnographic sections, viewing gang culture from within to demonstrate that gang members have strong views about right and wrong, and that these views guide their behavior on a daily basis; I also examine how pride and respect are the moral goals of gangs and the ultimate fiber that binds them together. Second, are my attempts to understand gangs and my discussions of graffiti as if it were a legitimate endeavor somehow immoral? I realize that because I have made a concerted effort to see things from the insider's point of view, I might seem to be arguing for the legitimacy of gangs and graffiti in society today.

So far, little information has been available to aid the process of understanding what either gangs or graffiti represent. Instead of attempting to convince people to like graffiti, however, I only hope to teach people that learning to read graffiti is a process of empowerment. Developing a simple literacy in this subject can do much to assuage the fear of those who cannot understand what is written on the walls around them. With gangs, my aim is to replace black-and-white reductionist views of gang members with ones that allow for color, contrast, and contradiction. In this process of humanizing what has popularly become the savage enemy, I hope to combat some of the fear and resultant hatred that surround these topics and enable people to see gangs and graffiti in new light.

Combating fear may seem counterintuitive when dealing with the violence and destruction of gang behavior. These are things we should be afraid of, certainly. But fear is itself a major part of what causes the gang problem. It is one of the most active forces that fragments our society along racial, class, and ethnic lines, shutting doors that should remain open and forcing people to turn on themselves in what little the larger society leaves behind. These are precisely the forces that create gangs today. Because, like Adorno, I believe we all have a moral obligation to confront our fears, in this book I have tried to provide some of the tools with which we can do so for these increasingly relevant issues. If there is a moral question at stake in the presentation of this material, it concerns the inequity and racism that produce gangs in the first place. In this way, I consider that I am really fighting gangs by working to understand them. This is my moral goal and the reason I have written this book. I can only hope that my readers will keep this same goal in mind.

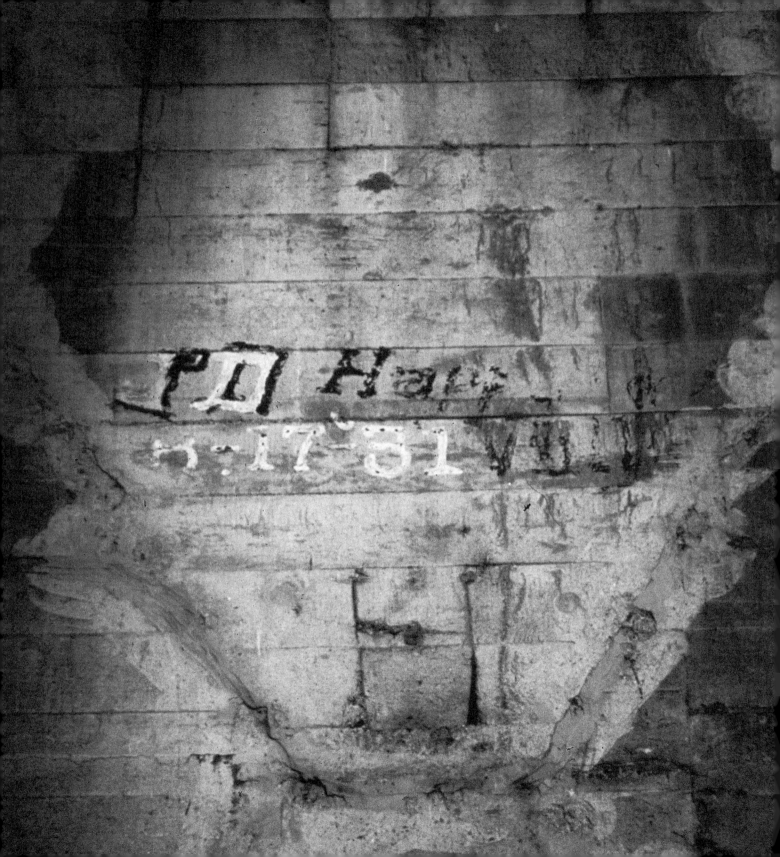

Graffiti is at once familiar and unfamiliar territory. It is so widespread that we all have some experience with it: some of us might remember carving our names into school desks as children or writing with crayons on the walls of our rooms. It's not usually difficult to decipher the name of a favorite band on the wall along with the year of the next graduating class and the requisite proclamations of love. Neither are the graffiti of political protest or the vulgar humor of a bathroom wall usually beyond our interpretive reach. Likable or not, these are graffiti most of us can understand.

The graffiti that constitute the majority of this book are different. They seem exclusive and unreadable, and they scare people. So do their writers: gang members; hip-hop kids that everyone believes are gang members. Of all, the medium that should be available to everyone—which some have even posited to be the least common denominator of human communication—graffiti today present the contradiction of being simultaneously public and private, both familiar and unfamiliar.

In 1990, I began to search for graffiti everywhere I went. I sometimes found it in the most unlikely spots: as tar drippings on the asphalt of a California highway (Caltrans workers clearly the culprits); as a name carved into a wooden railing at St. Peter's Basilica in Rome (an 1881 tourist); as characters etched into the wet concrete foundations of a World War II Japanese internment camp (inmates of the Manzanar Relocation Center near Lone Pine, California). Once I developed an eye for locating it, everywhere I found puzzles with historical clues and hints to be uncovered, pondered, and deciphered. These puzzles gave

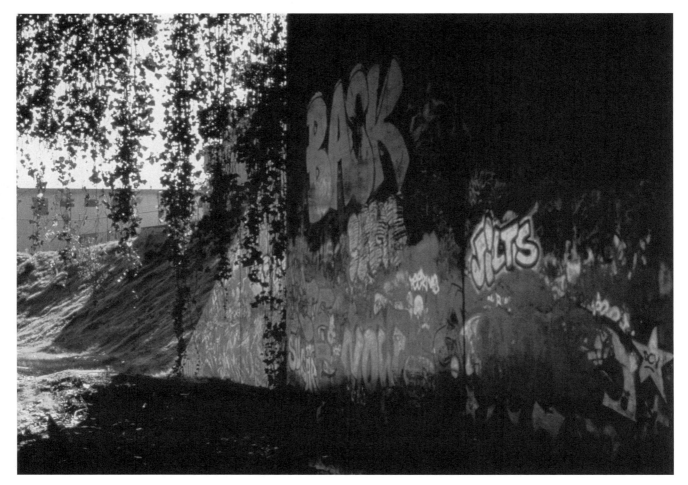

Fig. 1.1. Hip-hop graffiti at the Motor Yard (January 1993)

me a new way to relate to my city; they came to affect my view of "the town I live in," as the gang members say it.

Most people in this town, of course, do not share my sense of graffiti wonderment. For them, as occasionally for myself, graffiti represents a thorn in the side of civil society, a symbol, in fact, of its very uncivilized aspect. Many residents of Los Angeles today may even have a better chance of comprehending graffiti from a distant Russian city ("Great Fuck to Everyone!"[1]) than they have of reading much of the graffiti on their own city walls ("wsH30s," for example). Interpretive gaps abound in graffiti—they not only separate us from one another but, in our search for commonalities, they link us to places we might

not expect. Graffiti bring up all manner of questions about the state of our world and the changes within it, not the least of which continues to be, What compels us to write it?

I have included at the outset of this book references to the graffiti of old, from literature (extracts) and multiple languages (etymology), to see whether they might offer us any insights. As a body, they bring up several salient points. The words that mean "graffiti" in different languages, for example, can generally be classed in two ways. Judgment-free terms for graffiti include both those words that mean "writing on the wall" (Hebrew, Italian, Hindi, Mongolian), as well as that vast array of languages that use some form of the Italian "graffito," which we also use in English. Whatever connotations they may have in their native cultures, the words do not carry judgments in the labels themselves. "Writing on the wall" is just what it says it is, free from any indication as to its value. On the other hand, words in Maori, Korean, Chinese, Bengali, and Armenian present a stark contrast, having abandoned all pretext of impartiality. They do, however, point to aspects of graffiti that we also might recognize to be consistent with its nature: that graffiti are dirty, disgusting pollutants that carry a risk of impurity; that they are immature scribblings made without meaning or purpose; that they are thoughtless and childlike.

Most everything that one would like to say in an introduction to the topic of graffiti seems largely to have been said already in the etymology and quoted passages that open this book. For example, languages of the world use both noun and verb words for graffiti. Most Western languages use the noun form. Westerners view graffiti as a product, as something that already exists. Other languages (Korean, Armenian, Mongolian) employ the verb form, instead perceiving graffiti as the action of its production. These noun-verb/product-action elements in graffiti are something many authors have spent time trying to unpack (see most notably Spitz 1991, discussed later in this chapter).

Still other languages (German, Dutch, Russian) define graffiti as at one with their place or medium. They can be "fence language" or "inscriptions in wood." Such designations (often synonymous with "dirty words") link graffiti's place, medium, and sometimes even content together. This heightened tie to place led Allen Walker Read ([1935] 1977) to describe graffiti as *autochthonous,* "formed or originating in the place where found" (*Webster's Collegiate Dictionary,* 10th ed.). Autocthonous is almost like graffiti creating itself, from the Greek "springing up from the earth," making graffiti simultaneously of time and place. In correspondence to the author dated September 1996, Brenda Robb

Jenike explains that the Japanese term for graffiti, *rakugaki,* means something similar—words that fall from the individual outward, or words that everyone can understand.

In our not-so-distant past it was not the spraycan that dealt us the graffiti of the world; nor was it necessarily paint and brush. Considering the cumbersome nature of paint cans with separate brushes, it is easy to see why the successful graffiti writer has always favored convenience of material. Therefore a piece of chalk or charcoal in hand, or the more time-consuming pocketknife, were historically the media of choice. To some degree, these cheap, easy methods continue to be old standbys, in part because they combine the medium and applicator in a single unit. Before the spraycan (introduced to Los Angeles in 1948), it is even thought that kids used shoeshine bottles with their characteristic rectangular sponge nozzles to press early gang graffiti onto a variety of surfaces (Romotsky and Romotsky 1976). Both chalk and charcoal carry this same power—the ability to cover spaces of variable textures, whether rough-hewn stone or stucco, smooth concrete or marble, or slats of wooden fencing. Further, the ability to hide the medium of production—a can of spray paint shoved into the pocket of some oversized pants, or a nub of chalk plucked from some tighter-fitting jeans—implies a covert (as well as potentially anonymous) aspect to graffiti production.

The opening sample of literary extracts—despite their Western, if not wholly English-speaking, bias—can offer a general sense of who it is that writes graffiti and what their concerns might be. Travelers and tourists; children and adolescents (especially boys); all manner of prisoners, revolutionaries and activists; folks in the bathroom—all are known for the production of graffiti. Their messages range from base obscenities to indicators of pent-up aggression, from heartfelt political sentiments to declarations of frustrated romance, to simple communion with fellow humans.

In these, we also see that people sometimes find meaning in the commonplace patterns of accident—as with Hawthorne's asteroid-interpreting priest, or Melville's whaler looking to the scarred body of leviathan for Egyptian-like hieroglyphics. People like to find patterns and secret messages, even in nature. Conversely, they sometimes deny meaning in other messages. Looking to the Bible, perhaps the most famous interpretation of graffiti dictates that marks appearing on walls are most wisely associated with impending doom—we can all learn from Belshazzar's mistake. Because they are wrapped in the unfamiliar, graffiti may still be interpreted as a sign we are nearing a possible "end of civilization," or the "herald of some apocalypse less and less far away" (Mailer 1974).

A basic concern in studying graffiti of any kind continues to be the problem of figuring out what it means. Not all of us are Daniels with a natural gift for graffiti interpretation. But with some basic tools, perhaps we can learn to recognize a few biases inherent in our own views of graffiti. Anthropologist Arjun Appadurai (1986), for example, has pointed out that as any object moves through realms of production, distribution, and consumption it can be subject to radically different interpretations along the way. He alludes to the trouble that results when people attempt to interpret things with little or no knowledge of the contexts surrounding their creation. More often than not, people begin to construct what Appadurai calls "mythologies"—native explanations based on preconceptions and previous experience within a culture.

Because little accurate information has been available about the production of most graffiti today, people have tended to frame their interpretations of all graffiti within more familiar contexts: as hooliganism, vandalism, and malicious mischief; as lashing out at society; as antisocial; as alienation; as marking territory; and so on. In Los Angeles, for example, people continue to confuse hip-hop tagging with gang graffiti because of the prevalence of gang writing on the city walls through the years. Gang graffiti has been in Los Angeles longer than most of its residents. In another example, Mailer, (1974) indicates that New Yorkers encountering early versions of hip-hop graffiti on subways expected to see New York's (and America's) other native tradition of graffiti: obscenities on the bathroom wall. That was the context in which they knew graffiti best and that colored their experience of the new subway decor. At any given time, people's characterizations of graffiti vary according to their experience of it.

Graffiti appear in a number of contexts and in a variety of forms. Because of the variability of wall writing in general, it behooves us to examine one contextual aspect of graffiti that links its diverse manifestations into a single phenomenon: its context is always illicit. Thus, the ultimate defining aspect of graffiti is its illegality.

Some consider Paleolithic rock art to be the first obvious example of graffiti—animals, hunting scenes, fertility symbols, representations of day-to-day environments and the mystical realms of religious experience. Today we can make neither heads nor tails of the actual meaning of most rock art. But we can look at its placement, see some recognizable figures, note the complex iconography and repeated symbols, and hazard educated guesses about what "might" have been. People like to link rock art and modern graffiti; in fact, many a graffiti writer has expressed a kinship with these marks in more tangible

form. After all, rock art is public imagery written on rocks, those natural equivalents to walls. Venturing down Little Big Sheep Canyon (in China Lake, California) with my thoughts one day, I tried to imagine it was a city alley. Walls rushing up alongside me, gang markings all over the place (see figure 1.2). But it wasn't that simple. The repetition wasn't there, and the thought of gang shamans was equally absent from this other view.

If a mark, like a tribal mark, or rock art, or a spray-painted sign in front of a store, is made with permission and the blessings of society—if it is legal—then it is not graffiti. I make this statement both cautiously and sensitively. Even within graffiti circles legal activity may surround many kinds of graffiti production. For example, hip-hop graffiti writers often do their work legally for stores and art galleries. Even gang members sometimes do legal signage around town. Further, if it is viewed from within the groups that produce it, writing graffiti is a perfectly acceptable thing to do. Several gang members, for example, have made the comment to me that their graffiti are the equivalent of rock art and a perfectly legitimate endeavor within gang culture. As one young man asked me, "Why isn't it okay for us to do it if that's what those guys were all about?" referring to his Native American counterparts. I wasn't sure what to tell him. But with most graffiti writing, the people who produce it do so within the framework of a larger system that deems their activities unacceptable.

When viewing graffiti from a global perspective, the question of legality separates many "would be" graffiti from the genuine article. Tribal markers in the Middle East, for example, which are startlingly similar to modern gang graffiti, have been cited in Western books as graffiti (Field 1952). Comparing the contexts of their production can help us understand how gang members are using their graffiti today. Ownership marks on Aramaic coins have also been titled "graffiti" and have been used to study shifts in language use (Torrey 1937). Content markers on the bottoms of Greek vases designated as "graffiti" have provided wells of information for those who would merit them an untapped source of data (Bowman and Woolf 1994).

Today, many legal murals (often part of graffiti abatement programs) end up servicing communities in the same way graffiti do through similar media (Sanchez-Tranquilino 1995). These media may display exactly the same manner of symbols at the core of cultural and political identity. But even though these media are similar to graffiti, and can offer the same types of information, only that which is illegal within the confines of the larger society may be considered graffiti. Its illicit nature also frees us from falling into the

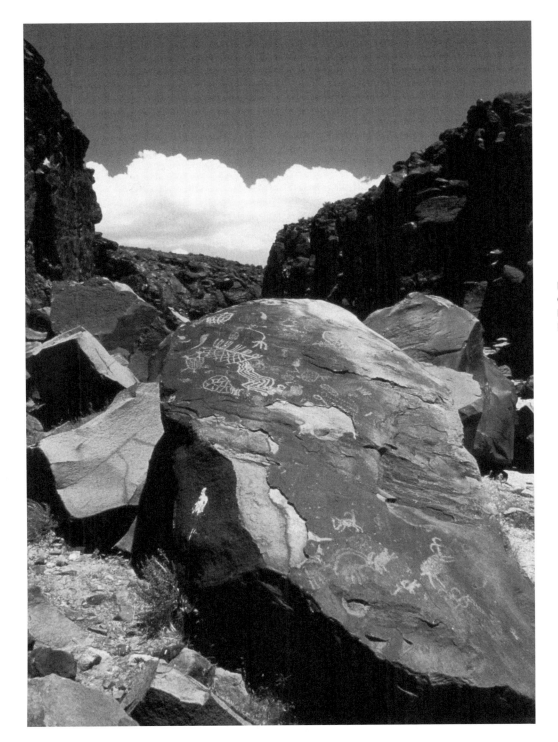

Fig. 1.2. Little Big Sheep Canyon, China Lake Military Base, China Lake, Calif. (June 1997)

pit dug by many graffiti researchers who manage to lump everything from skywriting to bumper stickers to tattoos into a category called "graffiti." This significant problem with graffiti research is one reason why it is important to review the nature of the medium at the outset. From this viewpoint, rock art is not graffiti. Rock art was perfectly legitimate in its day. Graffiti is not.

Even though graffiti resembles many forms of legal inscription and legitimate art through the ages, today it is inextricably linked with illegality. And this aspect of it I embrace. This book is no defense of graffiti writing. I never argue for legalized walls or declare that graffiti is a good thing or that it's not vandalism. It is vandalism, no matter how ordered or beautiful. In fact, it is precisely in its illicit aspect that graffiti presents its most useful facet for social analysis. It creates intersections where legitimate and illegitimate meet and enables cultural groups to give themselves solidity and definition. Because it is so easily produced, graffiti is often adopted by those without power, to negotiate relationships with both the society from which they are disempowered and others within their own groups. If graffiti is a window into a culture, as has often been stated, then it is the same window that people use to look in on themselves as they actively construct the guidelines and concerns of their lives.

## WALLBANGIN'

Once, my sister Jennifer cleverly tried to frame me as the writer of a particular piece of graffiti she wrote on the roof of our dollhouse. She took a black marker and wrote, "Boys go to Jupiter to get more stupider, Girls go to Mars to get more candy bars." She drew a nice picture of a spaceship and then—and here is the clever part—she wrote, "Love Susie. Susie did do it." My sister, besides being so clever, has always been an excellent artist. Everybody knew I couldn't have drawn that spaceship to save my life, so they easily concluded who had really exhibited her artistic prowess on the roof that day. My mom always said she liked that graffiti on the wood shingles of our dollhouse, though for years I retained somewhat mixed feelings about it—just too close a call for me personally, I guess.

The point, besides relating the charming details of my childhood, is that graffiti are not always what they seem. As people attempt to negotiate relations of power through their production, personal or group agendas may influence messages in a variety of ways. As in the case of my sister, this is sometimes manifested in willfully misleading information

within the content of the graffiti itself. We've all heard the expression that the walls never lie—but this is not always so. For example, John Bushnell (1990) notes that during the Soviet regime, the KGB would sometimes write graffiti intended to give the illusion of popular sentiment against dissidents. Political parties in South America sometimes pay people to go around spraying a pretended spontaneous support for their candidates (Chaffee 1989). And popular hearsay alleges that even the LAPD sometimes crosses out gang graffiti in order to try to incite warfare between rivals. How successful these attempts at subterfuge are remains the question under consideration.

"Wallbangin'" is a gang term that means, roughly, "gangbangin' on a wall." This can be through straightforward writing or through crossing out the writing of others; either activity enforces relationships of power between gangs. Gang members in Los Angeles generally recognize this as a generic term for the activity of wall writing. However, "wallbangin'" can also be used as an insult. It can indicate that a person or gang has no real gangster activity beyond the empty gestures of writing on the walls, making them into mere "wallbangers." I asked a group of gangsters one time about a photograph I had taken that I didn't understand, saying "Who are the so-and-so Hoodstas?" They shook their heads, and one indicated "Aw, they're nothing but a bunch of wallbangers." This insult indicated that the Hoodstas in question didn't have the stuff to back up their posturing; the extent of their gangster curriculum vitae was limited to symbolic activity alone. Their actions were not enough to survive the gang world—indeed, they were not even enough to buy them a legitimate place within it. However, although the Hoodstas may have been only wallbangers, I could also doubt the sincerity of my respondent's statement. Gang members make a habit of ritually denigrating their rivals to make them seem as little a threat as possible. Wallbangers or no? Posers? Wannabes? Toys? I never did find out the status of the particular group in question.

Any type of cultural or artistic production forces change on an environment. Most of the time, people abide by well-established rules for culture-producing activities. They do it through consuming certain products in certain ways or by creating symbols of their identity within the scope of what is legal for the entire society. In general, people who write graffiti produce culture in a different manner. No matter what it says, the manner in which graffiti is produced defines the writer's position as an outsider and alienates that person from the rest of society. Inherent in graffiti, then, is a "politics of criminality" (Ferrell 1996), which forever separates graffiti writers from the mainstream.

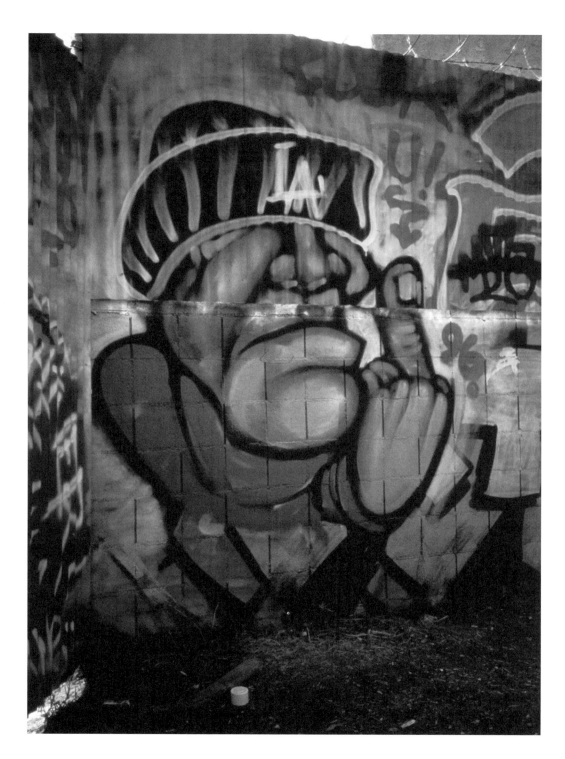

Fig. 1.3. Flippin' the bird at the Motor Yard (1995)

Criminal aspects of graffiti free the writers from constraints that laws would place on their creations. Writers force change on an environment, but without recourse or permission. Their marks are like advertising for groups and individuals who may themselves be outside the law already. Graffiti writers usurp public and private property for their own purposes. The graffitists have not been paid, nor do they pay for the space they use for the privilege. Viewed from the larger society's perspective, graffiti is always just wallbangin': it is cultural production through destruction.

Because of these destructive tendencies, graffiti says "fuck you" to society, even if it doesn't exactly say "fuck you"—though many graffiti, of course, do. In fact, Abel and Buckley (1977) indicate that a majority of the world's graffiti does involve the use of the word "fuck." As Holden Caufield muses in *The Catcher in the Rye:* "If you had a million years to do it in, you couldn't rub out even *half* the 'Fuck you' signs in the world. It's impossible" (Salinger 1951, 202). Whether or not it says so in so many words, the fuck you message is implicit in the use of graffiti as communication. The medium itself implies alienation, discontentment, marginality, repression, resentment, rebellion: no matter what it says, graffiti always implies a "fuck you." Though addressing the larger society in this contemptuous manner may be a secondary or even tertiary element of the graffiti writer's agenda, this element always lurks in the background of every graffito on every wall.

In his exploration of the "marginalized" aspects of graffiti, Armando Silva (1987) indicates that graffiti transform permissible writing into the impermissible. A message may be moral, legal, or social, but it is incompatible with societal norms due to its form. What is acceptable in a newspaper ad becomes illicit when it resides in graffiti, even if the messages are identical. In using graffiti, Silva indicates, writers marginalize activities that could potentially be legitimate. Further, the fact that the chosen medium is marginal and illegal often correlates to the types of people who produce graffiti—people who are themselves marginalized, even if only through the manner they choose to express themselves.

The antisocial nature of graffiti makes its analysis an inherently social endeavor. Graffiti is all about people. It's about relationships, and individuals, and motives. As a researcher, you need to get hold of a social situation on the ground in order to understand the story presented on the walls. On the other hand, once general patterns are established, graffiti becomes a great way for researchers to cover more ground than they could

otherwise, or to gauge the social state of affairs at times and in places where it might be dangerous to conduct fieldwork.

This was a beginning point in David Ley and Roman Cybriwsky's landmark 1974 article on the geographical aspects of Philadelphia gang graffiti:

> Graffiti might be regarded, perhaps, as a rather whimsical element in the sum total of cultural baggage of interest to the social scientist, yet in inner-city Philadelphia they provide accurate indicators of local attitudes and social process in areas where more direct measurement is difficult. (491)

All forms of difficulties arise when attempting field research, especially among quasi-legal populations. Learning to read graffiti is one way to bypass the difficulty of always having to talk to people to get a basic idea of what is going on and who the players are. Rooted as they are in time and place, the walls give you their own unique view. For example, compiling data on graffiti allowed me to generate a detailed gang map of the neighborhood where I did fieldwork from 1995 to 1997. I created the map in figure 2.1 by compiling data on gang graffiti. I would either drive down different streets and map gang graffiti that appeared at corners and along thoroughfares; or, for some of the denser gang areas (such as in the northwest corner of the map), I would locate the core area of a particular neighborhood, then search for the boundaries of that neighborhood (indicated by graffiti being crossed out). Combining these two methods gave me the ability to develop a map of the roughly eleven square miles of the Central Vernon neighborhood. When I went to the Newton division police station to check my results, I was surprised to find that their gang map differed from mine by only two gangs. The rest of the names and positions of the gangs were identical, convincing me of the accuracy of both maps. The police indicated that they compile their maps using criminal statistics. When a person gets arrested, they ask for that individual's gang affiliation and where he or she lives; through these data, they have been able to compile area gang maps and also to note any new activity and changes. I was able to reach the same conclusions by simply reading what was written around me.

The success I had at reading the gang landscape on the walls is common to many studies of graffiti, which together demonstrate the efficacy of graffiti as a research tool. This has been the strength of looking at graffiti through the ages. It has also been its greatest

weakness. One must always beware of taking the walls at face value, for, like the many wallbangers of the world (not to mention my sister), they sometimes have their own agendas. It is as fruitful to explore these hidden messages as well as the literal graffiti writings themselves. In wallbangin' we find a powerful tension between intention and action, between structure and agency, and particularly between people and their products.

In his classic essay in *Golden Boy as Anthony Cool,* Herbert Kohl demonstrates how looking at graffiti is sort of like looking through that rear window from which James Stewart's character spied upon his neighbors: "The more I attended to that particular wall, the more I felt like a voyeur, peering into the lives of strangers" (Kohl 1972, 9). He overcomes this problem quickly, developing relationships with graffiti-writing kids in the neighborhood where he worked, and noting that "It went beyond their inscriptions on walls, though it started there" (17).

Kohl's politico-humanist approach links graffiti to naming, language use, and larger social process, while Ley and Cybriwsky relate graffiti to issues of neighborhood control, security, the racial construction of cities and how gangs use different kinds of graffiti to different ends. Ley and Cybriwsky deserve credit as the first (and perhaps last) to approach graffiti in a hardheaded social science kind of a way, analyzing the uses of Philadelphia graffiti spatially. They urge that "The scholar must be sensitive to the nuances of such native guides as inner-city graffiti. If he is unable to interpret the visible, then the invisible meaning of place will be beyond his grasp" (1974, 505).

Graffiti is the visible and the obvious. Regardless, it is easily overlooked. Kohl's devotion to graffiti and his sincere effort to understand those who produce it is a lesson anyone who wishes to study graffiti must take to heart: "I have tried to follow things as far as possible and then return to the walls again and again. . . . I have tried to look at the walls in the cities I inhabit as if I were a stranger who wanted to find out about the culture from the way in which the natives decorate their environment" (40).

That is what I have tried to do here—to link the people with their products, talking to writers, and, like Kohl, going back to the walls again and again. Graffiti has always been a faithful and reliable informant. When no one else would talk to me, the walls always would. But the surprising misinformation I encountered, and the wondrous frustration I felt walking down that canyon full of petroglyphs, convinced me that without people and context, graffiti are no more than the meanings our imaginations give them.

## CAGING THE GRAFFITI BEAST

Through the ages, literature on graffiti has been quite like graffiti writing itself—widely scattered, diverse in its orientations. There is no graffiti "field." It is a subject that people approach for their own reasons and with all the biases of the disciplines from which they come. Nothing is necessarily wrong with this. But the disjointed nature of the literature makes graffiti a difficult topic to research effectively from the start. Perhaps this makes the literature a true representation of its subject.

As a beginning graduate student, I entered the library hoping to find an abundance of graffiti-related books and articles. There were many. But as I started reading, I felt as though none of them related to what I was studying on the streets of Los Angeles. All the books on Americana and bathroom wall graffiti, though often amusing, seemed relevant only to that particular genre at the particular time the book was written. It didn't seem like the authors said anything about graffiti that could help me understand what I was studying. But still, how could I say there was "no good literature on graffiti" when I was citing all these works by different authors? (My thesis committee was a bit curious on this point as well.) Why was this literature so easy to dismiss?

I came to realize that the graffiti literature was in fact like a famous L.A. joke my grandfather liked to tell. He used to say that the best way to look at Los Angeles was as a "bunch of suburbs in search of a city." These were a bunch of books and articles, but where was their city? Somewhere in the department of psychology maybe? Or maybe over in folklore? It certainly didn't seem to be anywhere near anthropology. And all these writings seemed to be leading down their own little alleyway toward nowhere in particular. Other than some momentum in the 1960s and 1970s, there was little sense of building—works building on other works to create, if you will, graffiti "schools" with some sense of unified direction.

Those who have taken the time to study graffiti all agree that it is an important and insight-gaining line of work. In broaching the topic, they delve into concerns with the nature of graffiti—how to characterize it, what makes it distinct as a form of communication. Of equal interest has been how to characterize the writers and their motivations for engaging in such expressive acts. In considering these questions, authors have given record to voices that might otherwise have remained unheard; they universally lament the inadequacy of a scholarship that has consistently overlooked this rich source of data. As Tanzer

notes, "scholars do admit that whereas the writers, historians, and record keepers of various eras have provided panoramic stylization of a civilization, it is the graffiti that attest to the continuity of the common man, and the continued commonness of many of his problems" (1939, 34).

### The Psychological School

Within the common frame of the human psyche emerged the Freudian element in graffiti literature, what I am calling "the psychological school." The legacy started with Allen Walker Read in the 1920s, was followed by Alan Dundes and Harvey "Ben" Lomas and Gershon Weltman in the 1960s, who were in turn followed by Robert Reisner, Abel and Buckley, Gadpaille, and others who wrote about graffiti from the point of view of 1970s psychology.

Allen Walker Read and Alan Dundes were folklorists and anthropologists. They were heavily into the popular graffiti of their day, and each coined a lasting term for the graffiti he studied. Allen Walker Read used "folk epigraphy" mostly to refer to folk writings of travelers he collected during a road trip across the United States in 1928. Read's major point in *Classic American Graffiti* ([1935] 1977) is that graffiti represent written versions of things that usually survive only in oral speech. He focuses on the use of taboo words, mainly obscenities, whose usage would not otherwise be recorded in common dictionaries. This already indicates a marginalized aspect to the graffiti he documented, if not their actual producers.

Alan Dundes was an avid follower of what he termed "latrinalia," a more scientific term for what we generally call bathroom wall graffiti. Dundes was unique in his argument that anthropologists must begin their studies at home before exploring the far-flung corners of the globe, where research might be driven by simple exoticism; latrinalia proved his way to begin the "hard core ethnography!" (1966, 93). Besides creating compendia of their topics, both Read and Dundes were concerned with theorizing taboo and dirt in relation to them, and Dundes remarks on convincing insider evidence for a Freudian analysis of graffiti. Presenting the idea of "graffiti as smearing impulse," he writes in its defense that "While Freudian explanations are not popular in anthropological and folkloristic circles, the fact that the folk confirm the Freudian explanation [in their graffiti] must be taken into account and explained by anti-Freudians. The independent congruence of analytic and folk or native theories does, it seems to me, present a rea-

sonably convincing argument" (101). This brings up a larger point that some types of graffiti are better suited for some types of analysis, because their makers embody such a wide variety of elements of human experience in the messages. Dundes is right that we should look first to the graffiti themselves and the theories contained therein as native guides for interpretation.

The work of Read and Dundes offered a jumping-off point for the psychological school that followed in their wake. Lomas, Gadpaille, Reisner, Abel and Buckley, and a handful of others used their interpretations and even some of their examples to bolster their own arguments. This psychological literature is run through with speculative attempts at psychoanalytic explanations—deflowering virgin walls, anal fixations, the aforementioned smearing impulses and taboos, repressed egos, daunting urban environments, trains disappearing into tunnels. Dundes coyly defends against certain criticism at the end of his own article: "I would ask only that they offer an alternative theory" (104).

Despite the prevalence of graffiti work in the scholarly realm, it was really Robert Reisner (1971) who gained popular recognition for the study of graffiti in the early seventies. He extended his reach from the bathroom walls of America to those of the world over, past and present, writing in a lucid, journalistic style. Ultimately he fell into the trap of wanting graffiti legitimization and classifying some graffiti as better than others:

> . . . there is a great deal of writing on walls which should not be there, and cannot be called graffiti in the pure sense of the word. These inscriptions are, ordinarily, one-line gags or jokes of low-level stuff of dubious origin. . . .
>
> After you have seen a great deal of graffiti, you almost instinctively know which are genuine and which are phonies and, therefore, mere defacings of a good surface. The true graffito has style, a surrealistic, imaginative quality, a spontaneity you can feel even though the topic itself may now be stale. (21–22)

The true graffito, he seems to indicate, retains a timelessness linked to the excitement of never knowing how long it will last. Reisner's proclamations about the genuine article were probably more similar to opinions of good and bad work within graffiti circles of the time—not necessarily part of a scholarly definition of it.

My favorite lesson from the psychological school literature comes from an article by Ben Lomas:

It is my view that the meaning of wall writing cannot be gleaned solely from the messages themselves, for like dreams, jokes, and slips of the tongue, graffiti do not easily betray their meaning. Indeed, we would be lost in our attempt to understand them if we relied too heavily on their content. We can no more understand graffiti by separating them from the walls on which they appear than we can fully understand dreams by neglecting their obvious connection with sleep or comprehend jokes by ignoring the laughter they produce in the listener. It is this relation of the writer to the wall that holds the key to our investigation. (1973, 88)

Lomas's was an early argument for a physical, if metaphorical, context. He indicated somewhat playfully that the walls themselves, their shape and position, have as much to do with creating a social context for graffiti as the human psyche. Walls are the symbols that spring up to divide us; he considers writing upon them as a way of taking possession of them. In these terms, "wallbangin'" uses the walls that separate our worlds as canvases for personal and group expression.

The diverse authors of the psychological school deserve credit for looking to graffiti as a source of data upon which to elaborate broader psychological issues. They also deserve credit for documenting material that would otherwise have been lost. With some notable exceptions, however, most graffiti research has failed to make broad links to the people who write graffiti and has thus remained entirely medium-centered. This is partially because of graffiti's anonymous nature. Attempting to move beyond this dilemma, some have attempted general definitions of graffiti or applied theoretical notions that rely on research with the actual people who write graffiti.

## The Silva School of Ephemerality

Armando Silva is one of the few authors who has ever tried to define graffiti globally. His work is not as well known in the United States because he writes in Spanish, but his 1987 *Punto de vista ciudadano* (From the city's point of view) is one of the best general books on graffiti ever written. In it, he makes a serious attempt to distinguish graffiti from other media. He identifies seven distinct, and critical, elements that graffiti comprises: marginality, anonymity, spontaneity, elements of the setting (space, design, and color), speed, precariousness (the use of cheap, easy to obtain materials), and finally *fugacidad,* the fleet-

ing nature of the marks—ephemerality. His most useful characteristics are the first and the last: marginalization (reviewed earlier) and ephemerality, which might embody most of the other elements.

Toward the end of his definition, Silva discusses graffiti's ephemeral nature:

> Because of their ephemeral duration, these marks offer no guarantee of permanency and can disappear or be modified or transformed immediately after they are made. In this way, while "speed" is connected to creation, "fleetingness" [*fugacidad*] expresses the temporal duration of the original text.
>
> It is important to clarify, once and for all, that ephemerality is the only quality that, in principle, operates outside the system of graffiti, so that it accompanies independence from the production of the text. . . . (1987, 33; my translation)

According to Silva, ephemerality is not only a physical characteristic of graffiti, but it makes the act of writing more important than the product. This is because ephemerality is a feature separate from the marks themselves or their production. It operates "outside the system of graffiti," because it is forced upon it from the outside through defacement by others, erasure, and so on. Ephemerality lends an inherent instability to the graffiti form. It is also one of the things that makes graffiti seem almost as if they appear by magic. People rarely hang around next to their work to see who's reading it, to protect it from damage, or to give tips on interpretation. As words leave their authors' control, the productions alone must face the forces that can either eradicate, tolerate, misinterpret, or not even notice their creations.

The concept of ephemerality also suggests related issues. Graffiti writing is about the ability to represent oneself to one's pleasure—on a grand or small scale, quickly or slowly, cheaply or costly. Whatever the specific goals, one accomplishes said task without either paying (except perhaps for supplies) or being paid for the privilege.

Usually the only people able to represent themselves on a grand scale are those who command the resources to do so legally for prescribed amounts of time. A billboard, for example, is a paid advertisement that—like graffiti—is displayed for the public. It is in a hard to reach location, and special people must be hired to design, produce, and finally place the billboard where it will command the most attention. People pay greatly for these services, and for their money buy the ability to represent themselves legally for a designated period of time in a designated spot.

Graffiti writers, on the other hand, put up their own advertisements only for the cost of the paint they use and the risk they take. They represent self and group on a comparable scale to their legitimate counterparts—but because of their illegality, no limits constrain their representations. Besides the risk of getting caught, the only price graffiti writers pay for this stolen freedom is precisely Silva's notion: ephemerality. Graffiti are, like their makers, here one minute, gone the next. Some may be up for years. Graffiti writers never know how long their works will last nor, indeed, whether their marks will even live to see the light of day. Thus hand in hand with ephemerality is illegality: the one imposes itself on the other to make *fugacidad* a defining aspect of this communicative form.

I grew up in a suburban L.A. neighborhood where one piece of graffiti would continually reappear. Right next to my elementary school were the looming capital letters in black spray paint that read something like "Motivation is the key to success." I fear the noble sentiment carried in those words may have been entirely lost on the K–5 constituency of the school—in my preliterate mind, for example, I continually mistook that large "M" word to mean something about a mountain (we were on a hill after all). Though my memory of the precise phrase is a bit fuzzy, what I do remember clearly about that message was its tenacity. It would get painted over, then would show up again in the same location, in the same handwriting. Exactly the same message, over and over again, year after year. It never gave up.

Many authors who write about graffiti have pointed to its ephemeral nature. They have indicated that ephemerality is not only an important feature of graffiti itself, but one that is equally applicable to the actions of graffiti writers. Thus it is easy for me to say "it" never gave up, because the existence of the message apart from its writer makes the graffiti seem like it's doing its own work. The writers are conspicuously absent from the scene. As Jeff Ferrell indicates in his title essay to *Crimes of Style*, "graffiti writing is also notable for the sudden and mysterious manner in which it appears. If graffiti writing escapes the uninspired seriousness of conventional politics, it escapes the scheduled tyranny of deadlines and datebooks as well" (1996, 173). In this way does the unscheduled, unconventional, and generally clandestine nature of graffiti impose its own form of temporal tyrrany—ephemerality—on both the products and their makers. A graffito scratched into the concrete sidewalk over which I walk in Santa Monica staunchly declares "I was here but I disappeared" (see also Lipsitz 1993 for another incidence of the same quote).

Art historian Ellen Handler Spitz has also noted this seemingly contradictory nature of graffiti: "Simultaneously proclaiming presence and absence, it declares provocatively to beholders that it is there but soon won't be there, and that its adolescent artist was there but isn't there any longer" (1992, 40). Spitz indicates that street writing is like adolescence, something that is growing and changing. It is active and unfinished, as her words on the subject testify: "Created by artists to whose very existence we give the name *adolescent*—that is to say, evolving, changing, developing—the subway car graffiti, in its coming into being, is charged with intensity and evanescent excitement" (1992, 34; Spitz's italics). She argues that "Graffiti shifts our focus from the object as beheld in its "finished" state to the process by which it comes into being—as well as that by which it is received. *Graffiti turns art into a verb*" (37, Spitz's italics). In Spitz's sense, ephemerality is linked with adolescence and with action in graffiti. Its active process of creation and reception mirrors breaks between production and consumption, and between author and audience. These Marxian writings create interactions through word and object instead of through individual and individual. Ephemerality is itself the graffiti writers' daring to take space and use it in ways to which they have no legal right, and in ways that ultimately relinquish control over the messages they create.

Ephemerality is an important reminder of how deeply rooted graffiti are in the historical contexts in which they appear. Whether they last or not, graffiti are valuable historical tools. Mrs. Violet Pritchard knew this as well as anyone. Pritchard (1967) analyzed English medieval graffiti to demonstrate shifting patterns of language use and religious values through time. She determined that most of the medieval marks were the work of crusaders. Reading her work, I tried to imagine a crusader resting in a church, carving out the symbols and language of that world on a wall. Pritchard was one of those who believed that graffiti was important and useful to the scholar and historian, and that it should be paid more attention.

Ancient graffiti attenders also include Helen Tanzer (1939) and Jack Lindsay (1960), both of whom studied the graffiti of Pompeii. Others note the tourist graffiti of Greeks in the temples of Egypt (Garstang, Newberry, and Milne 1989), or the graffiti at the pre-Columbian Maya site of Tikal (Trik and Kampen 1983). It seems ironic that, when they have survived, marks that constitute this ephemeral art form offer a uniquely strong method for retrieving voices not generally included in the historical record.

The concept of ephemerality points not just to the circumstances that surround a graf-

tito's production but to the broader context of its "being and becoming" in the first place. As Kohl (1972) determines:

> Graffiti are not a particularly durable form of expression. Names are crossed out or replaced by other names, layers of graffiti develop and often it is hard to make out what was once boldly proclaimed on a wall. Life on the street itself is not durable. There are too many enemies, too many pressures. Gangs and clubs break up; people in the ghetto are often forced to move from one neighborhood to another. . . . The marks left by youths are themselves as transient as their authors' lives. (Kohl 1972, 147)

Documenters of such transient forms must always be prepared to search and record just as fast as the writings appear on the walls around them. Only this constant chase allows us to capture not only the marks themselves but the lives they represent—which, it turns out, are equally prone to the whitewashing of the dominant system.

Ferrell describes the rush tied to the spontaneity of graffiti production: "The adrenaline rush of graffiti writing—the moment of illicit pleasure that emerges from the intersection of creativity and illegality—signifies a resistance to authority, a resistance experienced as much in the pit of the stomach as in the head. . . . the pleasures of graffiti writing result not only from its illegality, but from the collective creativity of the writers . . ." (1996, 172–73). As they seek the rush they feel when they produce it, Ferrell argues, graffiti writers constitute the core of their opposition to established political structures, an opposition that lies in the active realm of graffiti's production. Writers are unafraid of graffiti's ephemeral nature—it's the doing it that counts.

Silva's notion of ephemerality is not only a defining characteristic of graffiti, but also of the people who write it as well as of the social situations that produce it. Coupled with this is Spitz's idea of adolescence: growth, change, crises of identity, uncertainty, restlessness, lack of balance, often poverty. These qualities dominate the places where graffiti play their most vital roles.

## THE L.A. GRAFFITI INFRASTRUCTURE

L.A. is the perfect city in which to conduct graffiti research. We have more gangs here than anywhere in the world, some of which have developed their graffiti into art forms and

complex systems of communication. Nongang circles of hip-hop graffiti are flourishing. Tags, throw-ups, hit-ups, placas, strikes, and pieces abound on the walls of the city, often dubbed the "graffiti capital of the world." Despite the prevalence of data, I felt terribly alone in my endeavor when I began to study graffiti in 1990. Books on gangs mentioned graffiti only in passing, as if it mattered little. The only work on L.A. graffiti was published during the 1970s, when Chicano gang graffiti experienced a heyday of sorts. For example, Sally and Jerry Romotsky wrote a book called *Los Angeles Barrio Calligraphy* in 1976, along with a handful of articles on the subject. Another book, a beautiful photographic essay called *Street Writers* by Gusmano Cesaretti (1975), detailed interpretations of Chicano gang graffiti from the same era by Chaz Bojórquez, a gang-oriented street kid who later became a well-known Los Angeles artist. In the 1990s, when the city housed more graffiti than ever, not a whit of information was published about it in non–law enforcement circles. The graffiti of other cities also seemed to be wholly ignored, except for that of the New York subways, in celebration of a full-fledged hip-hop tradition (I review this other school of graffiti research in chapter 5, which is devoted to hip-hop). Thus, I felt isolated with this topic, without literature to reference, without guidelines for questioning or approach.

Only much later did I realize I was in entirely distinguished company. Los Angeles graffiti had attracted the attention of a number of people who pursued the topic for variable amounts of time. Sometimes they published their findings, sometimes they did not. If they, like the Romotskys, did publish, it usually only represented a portion of their research. Other times their work remained completely invisible. For example, famous L.A. photojournalist Leonard Nadel, who got his start working for the housing authority in the 1950s, had photographed Chicano and African American gang graffiti around the city in 1974.[2] Although the photographs were never published, his widow, Evelyn de Wolfe Nadel, showed me the collection and I am fortunate to include many of the photographs here. She explained how Leonard would always go out into the street by himself, talking to people and developing a relationship with them before he took their pictures. He was never afraid, she said, and generally had good experiences wherever he went. (He was once held up at gunpoint for his cameras, and his ladder was stolen on another occasion, but, Nadel reasoned, "I take what I want, let them have what they want.") Known for the inclusion of the human element in his photographs, with graffiti he felt it was important to take pictures of the marks just as they were, usually without people, as he did in the City Terrace composition in figure 1.4. He wanted the creations themselves to be the central feature of the photographs.

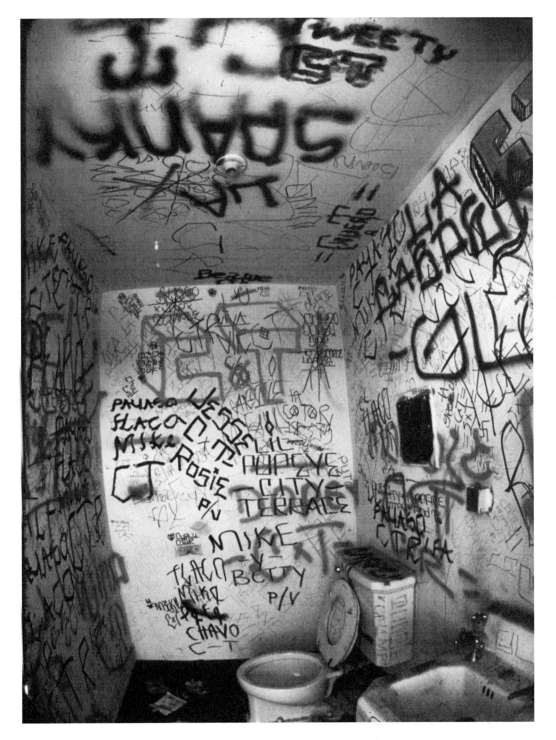

Fig. 1.4. Chicano gang graffiti in a bathroom in City Terrace, an East L.A. neighborhood (1974). "CT" stands for City Terrace, the name of the gang; to the right is a work by Geraghty Lomas ("GL"). The small "p/v" in some of the compositions means por vida, or "for life," no longer common in Chicano gang graffiti. Photograph by Leonard Nadel, courtesy of the Leonard Nadel Photo Archives.

Later, I managed to track down Ben Lomas—of the psychological school—who had analyzed the graffiti of Los Angeles with his friend Gershon Weltman in 1965 and the early 1970s. In Lomas's article about the psychological aspects of graffiti, he mentioned how he and Weltman used to wander around Los Angeles with notepad, camera, and film, transcribing or shooting pictures of the graffiti that they observed. In 1966, Lomas and Weltman presented a paper at the American Psychiatric Association annual meeting that offered their views on the subject from a psychoanalytic perspective. Their first attempts at copublishing this article were roundly rejected by the *American Journal of Psychiatry* due to the presence of profanity; it was not until seven years later that Ben was actually able to publish it. After the initial conference, though, such a furor of popular interest surrounded this work that Lomas described feeling completely overwhelmed. The New York City Port Authority invited him to comment on their graffiti problems. People wrote him letters from all over the world, sharing the graffiti of their place and time. In talking to him, I realized the hunger for information about graffiti that often shows its appetite but which is rarely fed by scholarly endeavor. I had the good fortune to meet and interview Ben in person, and he shared valuable insights regarding work in the old days:

> We thought that graffiti could be used by scholars to get the lay of the land, to see what the people were up to, and that it would be useful data to add to other data. We thought how much fun it would be to kind of reconstruct our society . . . if you could be the anthropologist who came down from Mars or out of the clouds and said, "We're looking at these things and trying to figure out what these people are all about," kind of like what they did with Pompeii. They would see we had quite a sense of humor.

I met Ben's graffiti partner, Gershon Weltman, still in Los Angeles. He had grown up in the Temple neighborhood near downtown Los Angeles in the era of the pachuco, back when the gang life was "all about clothes and hair," he said. He still remembered the name of the guy at his high school who had the best ducktail and described how he and his brother used to feign pachuco accents when they wanted to irritate their parents. He said there was a time when the only graffiti on L.A. walls was that of hobos, who would mark out in chalk or charcoal homes that might provide them a little work, people who would give them money or breakfast. We talked for a while, and when he picked up the phone to call Sally and Jerry Romotsky, authors of the long-admired *Barrio Calligraphy*, I

was surprised that she knew his voice even without identification. The Romotskys had found out about Lomas and Weltman's original paper at the 1966 APA annual meeting and had contacted them because of their common interest in graffiti. They had remained friends ever since, even though none of them continues to work on this topic. When I expressed my amazement at the lasting connection between them, Gershon looked at me and said, "It's the L.A. graffiti infrastructure."

I think people who have studied graffiti have always presumed they were alone, fighting one- or two-person battles against ignorance, tapping into a resource seldom seen as important. This was certainly true for Lomas and Weltman, Leonard Nadel, and the Romotskys, all members of the original L.A. graffiti infrastructure. Somehow, as I found them, I also found a certain comfort in our common pursuit of this line of work. Sharing their stories and field experiences, as well as their photographs, often gave me more insight into the city than I could have hoped from the published sources that were available.

For example, talking to (and reading about) Chicano artist Chaz Bojórquez has added considerable depth to my understanding of L.A. graffiti. Growing up in the Avenues neighborhood cemented in him an early interest in the style of gang writing. He has his own memories of early Chicano graffiti—how, in the days before the spraycan, pachucos used to write their names in tar with sticks, or burn messages into the sides of the tunnels with smoke from their Zippo lighters. His knowledge of the tradition is unparalleled; and his work has bridged gang, hip-hop, gallery, and commercial traditions. Chaz was the center of Cesaretti's photographic essay at a time when he was busy formulating the graffiti style that would eventually earn him a permanent position in the L.A. art world (Cesaretti 1975). He continues to be an advocate for the positive and creative values embodied in the practice of graffiti writing. If graffiti in Los Angeles can be summed up by the life and work of a single individual, Chaz is that individual—he has single-handedly constituted the backbone of the L.A. graffiti infrastructure for many years.

Today, many more people have joined the L.A. graffiti infrastructure. Sojin Kim, of the folklore department at UCLA, recently published her dissertation and a book on graffiti, murals, and the sense of place in Los Angeles (Kim 1997, Kim and Quezada 1995). Marcos Sanchez-Tranquilino, also a former UCLA student, studied Los Angeles graffiti from an art history perspective particularly as it related to muralism in the 1970s (Sanchez-Tranquilino 1991, 1995). Alejandro Alonso, a graduate student in geography at USC, has mapped out gang territories of South Central Los Angeles and explored the history of L.A.

gangs. Specifically interested in gang migration, he has documented graffiti not just in Los Angeles but in other cities around the United States. Others in the hip-hop realm and in the Chicano community have charted changes in graffiti writing for years with unflagging, active interest. L.A. gang members are also a notable part of this infrastructure today. They are sometimes the most avid documenters of their own work, creating compendia of photographs of themselves and their graffiti in photo albums (see also Buford 1993 for an example of group self-documentation). Teen Angel, Chicano artist and founder of *Teen Angel's Magazine* (established in 1981), must now hold the largest collection of gang drawings and photographs ever compiled, as Chicano gang members send him their work for publication and distribution. His magazine is an important document of gang artistic and social development throughout the state of California and beyond.

Noting stylistic shifts, changes in content, and integration with other forms of art and communication would be impossible without the continued documentation of this material. I am fortunate to be able to include some of the outstanding photographic material of Lomas and Weltman and Leonard Nadel in this book, thus providing a historical context that would not have been possible without their generosity and insight. Historical documentation and its corresponding stories and connections offer one of the most powerful forms of comparison. Because of their remarkable stability, graffiti testify to the conservative nature of L.A. gang members, who are usually classified as society's unstable fringe.

None of us has seen graffiti in all its forms. No matter how many books we read or people we talk to about graffiti, a majority of these marks have been lost already. Most remain undocumented, never to join any theoretical thrust toward a general definition of the phenomenon. Thus, we are ever confined in the clutches of our local experience. In the words I am writing, I sometimes feel Los Angeles—its special oppressiveness and the particular brand of frustration it generates, which I have witnessed on its streets. Los Angeles, the sprawling metropolis, has wormed its way into this text and promises to insinuate itself into any writings that feign objectivity. Then again, at other times when I wish the power of the city to be most strong, I instead feel it receding into the background. I will not force the city into this text, nor will I drive it out. But if the reader also feels Los Angeles here, so much the better. As my predecessors acknowledged in their own work, I realize that, besides the documentation I provide, it may be particularly in my subjectivity that I have something lasting to offer.

## GRAFFITI AS ART AND LANGUAGE

The diversity of graffiti research and approaches indicates its depth as a topic for study. I take certain comfort in the definitional problems that graffiti has incurred—they signify to me that the subject is indeed an important one. Like "culture," "ideology," or "community," "graffiti" is one of those words whose exact definition will always (and pleasantly) be just beyond our reach.

As a medium of communication, graffiti lies somewhere between art and language. Words become signifiers, solutions, and slogans; that is, they cease to be individual words but become symbols and images, which communicate at a variety of levels. These word images are laden with the visual modifiers of style, color, placement, and form. As much as the content of the writings, these modifiers may radically change the meaning, presentation, and effectiveness of any message.

Certain circumstances may influence the primacy of linguistic or artistic elements of graffiti. For example, with hip-hop, the content of graffiti is subsumed by its own artistic elaboration—one can hardly read the names of hip-hop writers for all the arrows, colors, and cryptic styles. Similarly, although content is important in Chicano gang graffiti, gigantic and cleanly rendered images of the gang name communicate power and prestige that enhances a gang's reputation. Among African American Bloods and Crips, writers instead engage in intriguing wordplays by manipulating the content of graffiti rather than being overly preoccupied by its style. Writers of political graffiti have always needed to prioritize a clear, straightforward presentation because of the didactic nature of many of their messages. In all these cases, graffiti writers combine elements of language and art to create variable impacts in a variety of circumstances.

Even within graffiti genres, people may manipulate the shape and position of their messages depending on their needs. Sociologist Lyman Chaffee makes this point in an article in which he distinguishes between traditions of political graffiti and wall painting in Buenos Aires. He writes that graffiti are most often spontaneous efforts with aerosol cans on an unprepared surface, while murals are created carefully with paint and brush on prepared backgrounds. Most intriguing is his analysis that, during authoritarian regimes, there is usually an increase in the percentage of graffiti—easily produced, instantaneous, covert—due to heightened surveillance and punishment. During periods of democracy, on the other hand, writers prefer the more elaborate and time-consuming wall painting because of "its larger

size, its creative application, its refinement, and its visual domination" (1989, 39). Chaffee notes that "Political messages are therefore communicated through the medium most appropriate for groups in relation to the political structure of the system and the forces in control" (39–40). The technicalities of such distinctions are telling and sometimes difficult to formulate. But political variables in the Argentinian case help us to understand what is important about those messages from the writers' points of view—the common denominator of a visual mode of communication for political concerns.

Popularly, murals are considered more "legitimate" than graffiti, regardless of their legality. For one thing, they bear more direct similarity to pictorial art traditions in general. For another, particularly in Los Angeles, mural productions may be part of city-endorsed neighborhood pride and graffiti abatement programs. Marcos Sanchez-Tranquilino (1995) notes that in the context of Los Angeles barrios, graffiti are viewed as vandalism and murals as art, though his work bridges the divisions between the two, emphasizing instead how they can both be used to achieve common goals.

Low literacy rates preclude the use of the written word as a main communicative method, be it in advertising, promoting religious ideology, or furthering political struggles. For example, pictures of "the Whale and the Crossbones" on inn signs in England informed nonliterate travelers that they had arrived at their destinations, just as stained glass windows in churches taught medieval people stories from the Bible. Throughout South Central Los Angeles, storefronts advertise their wares with drawings of large bottles of bleach, slabs of meat, cows or chickens, and cold beer (see figure 1.5). Muralism is not so different from this—drawings of political ideology and community identity, playing off one another through multiple layers of symbolism.

Sometimes it helps to define something (like graffiti) by considering what it's not (like a mural). The difference between graffiti and murals helps to explain the nature of graffiti as a particular mode of visual communication when we recognize that muralism is fundamentally image based, rooted in those nonliterate pictorial traditions.

Graffiti is fundamentally word based. It has its roots in literacy. It implies the presence of a written language. As a medium that combines language and art, graffiti is indeed an art of the word. Its etymology relates to writing: "graph" refers to pencil and writing media and is based on the Greek *graphein,* meaning "to write." Even the Italian *graffio,* "hook," has particular metaphorical implications apart from the scratchings to which it relates directly: the hook upon which an identity is hung; upon which a movement rests. All these

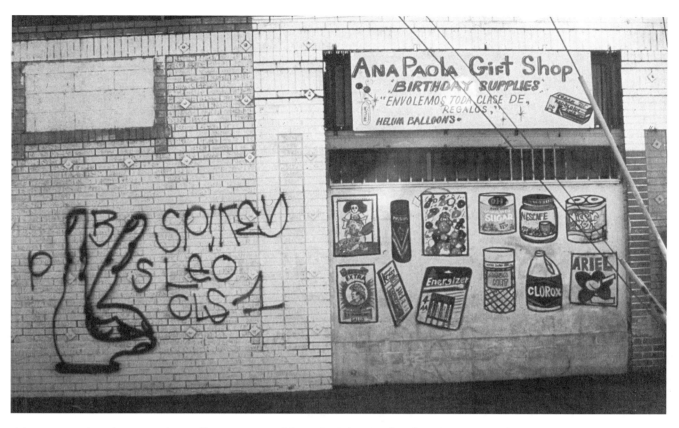

things are related to words, to literacy, to writing. As John Bushnell points out in his *Moscow Graffiti:* "I was much slower than I ought to have been to realize that the graffiti functioned as a language—not just as a generic sign system, but as a real language . . . " (1990, xi).

This is easy to understand when we see the graffiti slogans of communist struggle: "¡Cuba sí, Yanqui no!" We can imagine people at a demonstration yelling these words or picture such slogans in leaflets strewn across city streets. This type of graffiti is closely correlated to words as they exist both in speech and in formalized writing. Similarly, through graffiti, scholars of the ancient world have studied shifts in language use to chart the educational levels of writers. Greek soldiers in Egypt are known to have been basically literate because of the marks they left behind. The so-called graffiti on the bottoms of vases or on coins and signatures in churches and on walls have been used to examine shifts in language—like Pritchard's studies (1967) of medieval crusaders.

Fig. 1.5. A corner store at Central Avenue and 43rd Street (1996). Advertisements for wares like Duracell batteries, Aqua Net Hairspray, and Clorox Bleach decorate the storefront; adjacent is graffiti from the Playboys Chicano ("PBS") gang. The composition includes the Playboy Bunny hand sign and the names of its creators, "Spikey" and "Leo," to the side.

In graffiti are not only the intricacies of language development but all the implications of social and political change through the ages. Marks on today's L.A. walls show the development of alternative written systems that exist outside of well-established realms of traditional literacy. For example, Herbert Kohl described the nontraditional literacy of one of his main informants: "Yet none of this knowledge did him any good in school. Many of the words he could read were even prohibited in the classroom. I only managed to discover his reading vocabulary by talking with him about his life on the streets . . ." (1972, 17).

Literate aspects of graffiti are more difficult to pin down when one attempts to interpret a jumble of letters and numbers and pictures on a wall. Indeed, "ES43GC" means little to the everyday passerby. Even deciphered, the proclamation "East Side Foe Tray Gangster Crips" hardly seems to relate to common sentences or speech patterns as we know them. Some writings in fact seem to have no correlates in speech at all (crossing out enemies is one example).

In *The Legacies of Literacy*, Harvey Graff reasons that literacy "is above all a *technology or set of techniques for communications and for decoding and reproducing written or printed materials.* Writing *alone* is not an 'agent of change'; its impact is determined by the manner in which human agency exploits it in a specific setting" (1987, 4; Graff's italics). As a technology, Graff argues that literacy is an "acquired skill." Graffiti as art and language similarly represents its own form of living literacy; it shifts and changes with its makers and settings. One must become literate in the symbols of its culture in order to read graffiti. One must read beyond the names to see what tagging and graffiti art are all about. One must learn the language of communism to follow wall-written references to communist struggles worldwide. As a system of writing, people learn to read and write graffiti in much the same way that they learn to read and write standard language. Once they have acquired rudimentary skills, they may exploit the powers of this medium to change circumstances, to represent positions, and to negotiate relationships.

Currently significant in the United States is how alternative literacies become more marked as populations grow intertwined but construct self-imposed boundaries—especially now that rates of traditional literacy are shaky at best. While graffiti around the world are increasingly written in the language of America, specialized forms of writing on the wall within the United States have begun to affect traditional written languages as well. On the decorated envelopes gang members send from jail and in the letters they write,

the shape and detail of words mirror gang graffiti on the wall. Punctuation in wall-written gang languages—decorative dots, dashes, and quote marks that separate words on walls—sometimes become the only punctuation present in their sentences. Further, since the advent of hip-hop, teachers in art classes rarely can get kids to work on elaborating anything but their names in their artwork. As Norman Mailer (1974) says, it is the *name* that is the faith of graffiti. What has happened to the name at different places and at different times is the history of graffiti.

Does graffiti function as "a real language," as Bushnell indicates? It does and it doesn't. Like writing, some types of graffiti correlate more closely to spoken words than other types. Also like writing, sometimes graffiti involve letters based on traditional alphabets, but they may also involve symbols or pictures. Graffiti writers combine both words and images, which are sometimes analogous to speech and sometimes analogous only to what they stand for—then again, sometimes only to themselves.

Inscriptions on rocks and on walls have long been made by humankind. They represent a need not only to live within our environments, but to place ourselves very indelibly into them. Rock art itself is arguably the root of written language around the world—this has been shown to be true in both the Middle East and China. Out of pictures come alphabets; out of alphabets come written systems. In writing, the power of the image becomes harnessed in shorthand, tamed for our use. It defines terms whose meanings are elusive; they are themselves imaginary.

For gangs, writing has become important because it has allowed gang members to rigidify their systems, to concretize symbolic and territorial boundaries, and to maintain connections over distances without actual contact. Far from imaginary concerns, these. For gang members living in hostile environments, it is as Jack Goody suggests, that "writing represents not only a method of communication at a distance, but a means of distancing oneself from communication" (1986, 50). In Goody's terms, gang expression represents gang members' separation from one another and from the society at large, both physically and metaphorically. As a boundary-maintaining device and a form of intracultural connection, graffiti is an important tool through which gang members materialize their concerns. They achieve this in writing by breaking down their system and locating themselves very specifically within it, as if to say, "This is where I belong among many like myself." In the process, they separate themselves from the need to be present to communicate those concerns. Only through this written form is it possible for entities like

Bloods and Crips to blanket themselves across the nation while maintaining the classification and social order characteristic of their system.

Graffiti works because it presents these things visually. The messages themselves may come from language, but the artistic elements are what enable graffiti to communicate that language effectively. Much time and energy is lost arguing about whether graffiti is art. Such arguments only detract from other types of issues that might be useful to explore on a more practical level. Arguments about graffiti as art usually degenerate into protracted lectures on illegality. If something is illegal, then it cannot be art. So the Michelangelo question inevitably comes up. If Michelangelo were to have painted the ceiling of the Sistine Chapel on your garage without your permission, would it be art? Illegality and art are separate issues. Ultimately, such debates give people an excuse not to understand what graffiti is and why or how people are using it.

I have always considered gang graffiti and hip-hop graffiti to be forms of art. It was, in fact, my own study of art history (specifically early Christian art and the art of the Northwest Coast) that drew me to the graffiti of Los Angeles gangs in the first place. There is, however, little reason to focus on that issue. People who study art have enough trouble defining just what they mean by that term, just as anthropologists often have a hard time defining culture. But if we look at them closely, graffiti writers who take their work seriously behave very much like artists. They specialize, they practice, they plan, they go through some kind of "creative process," they are recognized for their work. As Ferrell offers, "Graffiti writing is not an abstraction driven by the concept of Style, or the force of Aesthetics; it is collective activity constructed out of the practical aesthetics of its writers" (1996, 168). Graffiti is a written system that embodies the aesthetic values of its makers. (See also Mailer's [1974] discussion of graffiti as art.)

Art has been the term used to describe things very much like graffiti in the literature of art history. In Oceania, for example, are the so-called dendroglyphs produced by the people of the Maori culture. These designs carved into living trees resemble the famous facial "moko" tattoos of the Maori. In Oceania as a whole, social concerns were expressed artistically in wood, in fabric, and on the body (Thomas 1995, 73). Similarly, as the Cherokee were forced into the forests of Alabama and Georgia in the late nineteenth century, they marked their "trail of tears" with designs in the wood of forest trees. These were sometimes used to indicate where people had buried valuables, and sometimes for reasons that elude us (Thames 1995). Some of the designs have since stretched and changed,

becoming distorted with the passage of time. But they were originally communicating something; something that was important to their culture and their people.

It is perhaps not surprising that the only scholars interested in marks like those of the Maori or Cherokee are artists and art historians. This is because the primary work they performed was a visual work, which played off already established artistic traditions within the cultures that produced them. Similarly, graffiti writing is an active process whose artistic elements are always tied to individuals, neighborhoods, political movements, and larger ethnic concerns. As a medium of communication, graffiti is neither language nor art: it is always both. Cleverly, it lies somewhere between them.

## THE CULTURE OF GRAFFITI

Technological innovations like television, automobiles, and computers have changed the ways in which we relate to one another. Shifts in our world structure have fundamentally altered the way we view ourselves and others around us. Instead of bringing us into a "one-world" type of global melting pot (as many have envisioned to be our inevitable future), we have instead Balkanized, fragmenting further the closer we become. These events have radically changed the way that anthropologists must approach the study of culture.

Traditionally, anthropologists would go "to the field"—to locations distant and unknown, where exotic peoples and places awaited discovery by Western eyes. Groups were bounded by subsistence, isolation, and history, making them more easily distinguishable from one another. With most groups now integrated into the global processes of capitalism, anthropologists can no longer rely on subsistence-based and isolationist notions of culture. How do we define culture in a globally linked world, where Westernized consumerism is spreading like wildfire through our sagebrush mountainsides? One way is to look at the mechanisms people use to distinguish themselves from one another.

All individuals manipulate material goods to balance, distinguish, and unify multiple layers of identity. Our relationships to spatial and material things allow different communities of people to develop within the same spaces. People create the ways in which they use things, and their use in turn defines their culture. Historian Benedict Anderson (1983) has argued that people rarely know all the other people in their community. Their connections are "imagined" and vicarious, he says—they come from people's interactions

with the things around them, like mass media, newspapers, television, and so on. Material indicators of membership in ethnic, religious, or national groups like those that Anderson describes are some of our most powerful methods of sharing culture.

Through behavior, speech, and material creation, humans make their cultures into vibrant, vital entities. These are the realms through which people engage in forms of social "practice": how they act out their lives and their culture. Material productions like graffiti, therefore, become vehicles through which people define themselves and others.

Most symbolic media of communication, like speech or dress, exist in conjunction with a human element; their users are what give them life. But adding material to speech or behavior can extend their efficiency (Goody 1977; Miller 1987). The concrete nature of material objects allows them to take on a life of their own: they can exist beyond the scope of their makers and influence the world in unanticipated ways. Material objects are thus able to link people together without those people being present or ever even having to meet.

Sociologist Anthony Giddens (1979) recognized that the actions of humans may have both intentional and unintentional consequences. Material agents like graffiti suggest a similar dilemma. People create things to act for them in certain ways (just as a street sign, for example, tells you the name of a street). But because people lose control of the objects they create and can rarely control the perceptions of others, creations may have additional unintended consequences (for example, when a monument designed to represent the greatness of an empire becomes instead the symbol of its oppressiveness).

Graffiti allows people to create identity, share cultural values, redefine spaces, and manufacture inclusive or exclusive relationships. But because of its illegal aspect, graffiti both creates and reflects alienation. Oftentimes, this is secondary to the graffiti writer's primary objective, which is communication to his or her own group. James Scott (1985, 1990) has written extensively about forms of resistance, ways of indirectly confronting the dominating class. Graffiti can also act like what Scott calls a "transcript" (hidden or open), which, with a little prodding in the right areas, can reveal the power relations at its base.

Graffiti has traditionally been viewed as the product of people who have little representation within traditional mass media. To look back on graffiti is to hear voices that otherwise would have remained silent. People in a number of different segments of the population use graffiti as a communicative alternative—but they sometimes use it in markedly different ways. Thus, the examination of graffiti requires its division into a few major genres.

*Popular Graffiti*

First is the ever-present "popular graffiti"—the everyday stuff, the witty commentary, Read's "folk epigraphy," Dundes's "latrinalia," the phallic symbols, the jokes, the "for a good time call X's," the "eat me's" and "fuck you's," the love proclamations, and the "so-and-so's were here." This type of graffiti is generally written in the national language so that everyone can understand it and, if they want to, participate in its humor or respond in kind.

My uncle Vincent has a couple of favorites from this graffiti genre. One appeared in the men's bathroom of the English department at California State University, Chico. It read "No grils allowed." Perhaps predictably for an English department, someone had scratched out "grils" and written "girls" in its place. Later someone came back and wrote "How 'bout us grils?" This was a funny one. I later found an almost exact duplicate of this graffito in Bill Alder's compilation *Graffiti* (1967), so it—call and response—must have traveled. (My uncle was disappointed when I told him that recently.) My uncle's other favorite, in a bar bathroom in the outskirts of Chico, involved one man's ranting about the horrible things that people do (e.g., killing and victimizing one another), his outrage at the lack of humanity in our current society, and so on and so on. At the end, driving his point home, he writes "Are we not men?" Due to the inherently dialogic nature of graffiti like these, the story of course does not end there. Someone came back to write what also would have been my natural response: "We are Devo."

The oldest piece of existing graffiti I have yet found in Los Angeles appears in figure 1.6. "J.D." has written his initials in black and white paint, with what appears to be a now-faded "Happy Valley" off to the side. The date reads "8-17-'31"—seven years before the Army Corps of Engineers began their gigantic project to pave the L.A. River after a flood (according to Melanie Winters in a telephone conversation with the author in May 1998). I sometimes try to imagine what it must have been like, walking on the river when its only pavement was grass, rocks, and mud. The bridges there have become repositories for years' worth of identity, a kind of graffiti underbelly of L.A. history. The graffiti in figure 1.6, from the concrete wall of a bridge of the L.A. River, is placed above what would be a normal reach for a person. (Just below it is a six-foot line of hip-hop graffiti pieces from recent years, this, the tiny crown of them all.) Erosion and exposure to sun and rain have made this piece difficult to read, but J.D.'s extra effort paid off: the image survived. Likely,

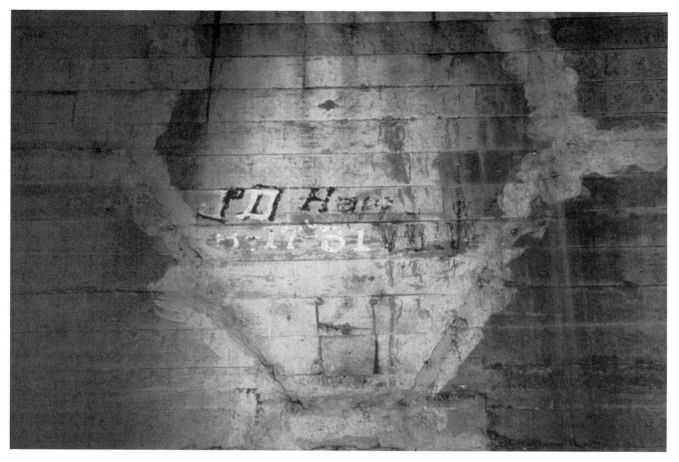

Fig. 1.6. "J.D. from
Happy Valley, 8-17-31"

J.D. found himself walking on the banks of the river, perhaps soaking his feet to get to
this divide, and, standing on a crate, box, or some other such contrivance, left his mark
for the edification of future generations.

The question about J.D. is how to interpret him. If indeed he is from Happy Valley, what
do his initials next to that name signify? Which Happy Valley is he from? Is this an early
piece of gang graffiti? The Happy Valley neighborhood was a major player among the
pachuco gangs of the 1940s. Or was Happy Valley a reference to the poor white neigh-
borhood adjacent the river at that time, as Carolyn See suggested in a telephone conver-
sation with the author in 1998? Or might J.D. have been a traveler from one of the many
towns called Happy Valley that pepper California and the United States? Then again, J.D.
may have been speaking metaphorically—John Steinbeck once wrote of a place called

Happy Valley. In this case, what we have left are his initials and the date—the things that speak a language everyone can understand.

Names on rocks, in rivers, on walls, in bathrooms: these kinds of graffiti are just about everywhere if you look hard enough. Someone like J.D. might have been familiar to Allen Walker Read, with his 1927 exploration of the "folklore of the common man." This folklore is but one element of a much broader genre of graffiti directed toward anyone and everyone. Although one could certainly further classify this category, for my purposes its "popularness" speaks for itself.

## Community-Based Graffiti

I contrast popular graffiti to what I am terming "community-based" graffiti, or graffiti that are produced by and for communities of individuals with shared interests. Although one could argue that all graffiti is community based, I persist in a by-now ancient theoretical distinction between "community" (more village-like, face-to-face) and "society" (of the anonymous modern era). Popular graffiti is society's graffiti, that which is normally called "the graffiti of the common man." Markings are usually anonymous but readily understandable to most; their makers do not direct the messages toward a discrete audience. Gang graffiti, conversely, is based in a community of gangs whose members already understand its meaning and who may even be able to identify one another as individuals.

In the popular model, graffiti may indeed be anonymous. But in our handy community-based model, graffiti may seem anonymous but in fact be exactly the opposite. Community-based graffiti is full of names and identification; it may be coded to hide its meaning from outsiders—but not from community members or from anyone with an eye toward graffiti analysis. It is easy to find out who wrote them. Discovering this information is part of finding out the scope and membership of particular groups.

For example, some of the first community-based graffiti in Los Angeles was that of hobos. I described above how Gershon Weltman, who grew up in the Temple neighborhood near downtown, told me how there used to be little chalk scratchings on the walls, on a mailbox, or a front step. Hobos made these markings, which Reisner (1971) reviews, to classify who was a friendly person, who would give out a free meal or money, what parts of town to stay away from, where the police were, and so on. Hobos across the country shared this common language in writing; it connected them together (a mass media of the hobo, if you will) and helped them survive in the harsh world of the depression era.

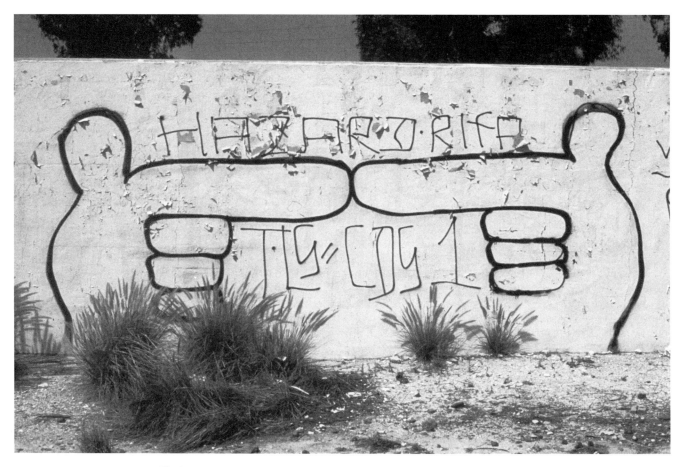

Fig. 1.7. Ramona Gardens housing projects, 1995. The "H" is a Chicano gang hand sign for the Big Hazard neighborhood.

Their messages were internally relevant to a circle of hobos who could already interpret their meanings.[3] In another example, for years sailors from around the world have been writing graffiti consisting largely of their own names and those of their ships in ports across the globe, in whatever language they happen to speak (and write). Today, most of these sailors work in the international container shipping industry; they write their names mostly with paint and brush, in whatever color they happen to be painting their ships at that moment.[4] On a similarly aqueous note, surfers in Los Angeles, and I presume elsewhere, have written graffiti through the years both to demarcate their beach territory as well as their female companions (see Zane 1997).

Although there are many types of community-based graffiti, I review the three most common ones that I know of today: gang graffiti, political graffiti, and hip-hop graffiti.

GANG GRAFFITI    Gang graffiti is a genre of graffiti growing increasingly relevant as the percentage of cities that host these unwanted but tenacious groups rises. Gang graffiti has long been a favorite with me. Initials, numbers, aesthetic and symbolic codes, more or less rigid, layered meanings lurking within disjointed segments. There should be—perhaps, by the very nature of its content and style, there is—a warning label applied to gang graffiti: Not for popular consumption! Gang members only! It is directed toward a group of people who already understand what it means.

Gang graffiti, like the example in figure 1.7, are probably readily understandable to any L.A.-based Chicano or black gang member, as well as potentially to most taggers and others (like me or the police) whose daily lives require a reading knowledge of such marks. Gang graffiti are as diverse as the gangs who write them and, as will become increasingly clear in the chapters that follow, gangs certainly are not lacking in diversity. Generally, gang graffiti is not directed toward you, the larger society; you, the citizen. It is not "claiming" your garage door as actually belonging to the gang. The garage door is rather a place where the gang represents itself within a heightened sense of neighborhood. To study gang graffiti well, one must delve into an assortment of concerns of gang life—its politics, economics, social systems, ethnic relations, and so on, which I attempt to do in the chapters that follow.

POLITICAL GRAFFITI    Political graffiti have always been some of the strongest forms of graffiti in the world. While their writers use internal symbolism, there is also a historical and didactic quality to the marks. Many represent the voice of the politically discontented, either individually or those who have formed themselves into groups. Inasmuch as political graffiti represents concerns with special relevance to these individuals or groups, at its base are the state politics in which everyone participates—for or against. Fundamentally, political graffiti and the groups that produce it are oriented toward the state. Currently, we have little overtly political graffiti in the United States, but it has appeared during particularly charged historical moments in U.S. history. The righteous indignation of the 1960s saw its share of political graffiti, and there is no lack of political graffiti in the days and weeks following in the wake of urban riots.

Today, the percentage of political graffiti in the United States is in no way borne aloft by the city of Los Angeles, with its reputation as one of the most politically apathetic cities

Fig. 1.8. UCLA student union building. "Off the Pigs" means kill the police; "Free Bobby" refers to Black Panther Bobby Seale. Photograph by Ben Lomas.

in the country. Let me take this opportunity to explore a little of our city's relationship to political graffiti. Currently, one of the only consistent forms of graffiti in Los Angeles (or in the United States, for that matter) that I would consider overtly political is white supremacist graffiti, whose "niggers go home," anti-Jew messages are indicative of the ultraconservative shift of our white population in general. Other times university campuses, including my own beloved UCLA, become filled with chalked protestations. But these have always seemed to me somewhat mild compared to the strength of the rest of the graffiti in 1990s Los Angeles. This didn't seem to be the case in the 1960s, however, or in 1970, when UCLA students took over the student union to strike, shown in figure 1.8 with a plea to free Black Panther Bobby Seale.

Sometimes on the L.A. streets you can see graffiti in Spanish relating to struggles in Mexico or Latin America. There has been a lot of recent support for the Zapatistas, for example. Again, these are written in a national language that speaks to a group of people who are already politicized and aware of the references contained within the messages. Just as gang members have transported gang graffiti to Mexico and Latin America with

continual movement between those places, so these political messages find themselves on our city's walls, giving our graffiti history an international depth.

In 1993, when there were rumors of Shining Path Maoist infiltration into the Bloods and Crips of Los Angeles, I began to look for signs. In Watts, across the street from the Jordon Downs housing project, I found some graffiti by the National Revolutionary Youth Brigade, referring to Shining Path leader "Gonzalo" and a number (a date?) "1603" that meant nothing to me as an outsider. Across the street, in clear gang writing, there was also a graffito that said, "If the cops go free, it's on," in reference to the civil trial of the Rodney King beating. As I began to cross over to take a picture of it, a man on a bicycle headed straight for me, oozing his hatred of my white self, like he would run me down. He swerved at the last minute and circled around again to repeat the performance. But he decided to give me a break. He just shook his head and pedaled away. I turned around and left.

Never for a moment did I believe that our gangs were under the influence of Maoist leftists. That reminded me too much of a previous generation of zoot-suiters in the 1940s accused of having links with fifth column Sinarquistas, the hallmark of Los Angeles's Hearstian yellow journalism. However, Los Angeles's reputation as a politically apathetic city was fast losing credibility with me. What did this mean exactly?

Markedly political graffiti are rare in Los Angeles. This fact, in contrast to my own experiences on the L.A. streets, made me realize that the form that politics take in Los Angeles may be masked. Incipient political ideologies seem to manifest themselves whenever the opportunity arises—whether it be when an outsider starts nosing around or when widely publicized events touch at the raw nerves made sensitive by oppression. This may partly be a function of Los Angeles's segregated geographies. When do people have the opportunity to interact with their real enemies anyway?

Though Los Angeles currently lacks widespread traditions of overt political graffiti, all community-based graffiti are political if viewed from the inside. They are manipulations of group and individual relationships, representations of internally focused ideologies, power plays that negotiate position and define identity. It is this broader view of politics that I take in this book and emphasize in the ethnographic examples presented in later chapters.

HIP-HOP GRAFFITI Right now, hip-hop graffiti (also called "graffiti art," "New York–style graffiti," or "subway art") is taking over the world faster and more effectively

than any revolution ever could. Tagging, throw ups, and pieces are the elements of the hip-hop graffiti tradition that emerged out of New York subways in the 1970s. As art historian Maria A. Phillips has stated in a telephone conversation with the author, "It wouldn't surprise me at all if historically these marks are what characterize the end of this century more than any other art form" (March 1996).

Toward the end of the century, hip-hop graffiti is as increasingly global as it is local. From New York it has spread across the United States, from urban centers to small towns. It has spread through both Eastern and Western Europe, Mexico to a degree, and into Canada. Hip-hop is becoming ever more popular in Japan and I assume will eventually make its way throughout Asia, the Middle East, Africa, and Latin and South America—if it isn't there already.

This global phenomenon is moving and expanding rapidly, yet it is easily recognizable in form, content, and style. Names are written in a variety of specialized ways. Though the style (and thus the identification) of this type of writing is rigid, people in different places interpret hip-hop graffiti in unique ways and use it toward different ends. Regardless, hip-hop graffiti practitioners now constitute what they call a "global culture," linked through magazines, travel, the Internet, and, most of all, their common art form. Because an entire chapter of this book offers an examination of this type of graffiti for the city of Los Angeles, I will now take the opportunity to expand upon a few local interpretations of hip-hop with which I am familiar.

For many people today, hip-hop is the "real" graffiti, just as Reisner's witticisms were his "real" graffiti. The word *graffiti* is famous for its Italian origins. But today in Italy, only hip-hop graffiti are actually called *graffiti*. All other graffiti, political and otherwise, are simply *scritte* or *scritte sui muri* (writings, or writings on the walls). In an E-mail to a graffiti artist in Zagreb, Croatia, I asked whether there were any other kinds of graffiti around. He replied, "no, not graffiti, just words, but without pictures." For him, hip-hop is the "real" graffiti—it implies the added element of art.

In New York, where the whole thing began, and in some places in Los Angeles, some people are trying to get away from the "graffiti" label to describe what they do—as aerosol art, spraycan art, and so on. This often accompanies an attempt to gain legitimacy in art galleries or legalize spaces for graffiti art production. Because graffiti is not a profession, and it is generally illegal, losing the "graffiti" part of the terminology makes sense

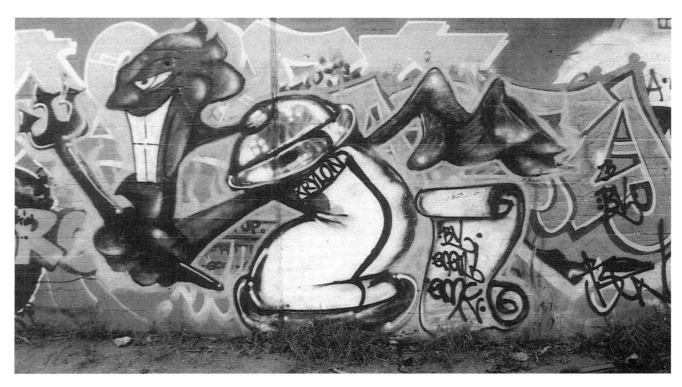

Fig. 1.9. Krylon devil at
the Belmont Tunnel
(October 1996)

at this level, however ironic it may be that an exactly opposite trend is happening in other parts of the world.

In Italy and all over Europe, hip-hop graffiti are inextricably linked with left-wing politics, most specifically through systems of "social centers" that, as I understand it, exist in many Western European cities. These centers are mostly illegally squatted spaces that people occupy for artistic production of various types. In Italy, where I have seen them, many of these centers are like that bouquet of flowers Oldenburg used to describe New York subways, startling masses of hip-hop color that light up drab European streets. Some artists in the centers may be more political than others; some places have their own exhibitions, make their own comic books, and post international communist posters on the walls.

But hip-hop graffiti is not an overtly political art form. In fact, its emergence is beginning to replace many local graffiti traditions that have involved overt politics. Louise Gautier has studied the shift from overtly political graffiti to hip-hop graffiti in the city of Mon-

treal. She attributes this shift to a "giving up on the system" (telephone conversation with the author, February 1996). Though these graffiti are made by left-wing groups in many parts of the world and their makers consider them highly political, they seem apolitical to outsiders. The protest is in medium only, not in message. Only time will tell whether the growth of hip-hop will strengthen or weaken grassroots political activity in the future.

We can look to the United States to note similar shifts, where the emergence of gang graffiti and hip-hop have almost completely replaced the traditions of popular graffiti so evident in the work of Dundes, Reisner, Read, and Lomas. Looking at older graffiti books, or on walls in smaller towns, I often marvel at how much our world has changed.

The categories of gang, political, and hip-hop graffiti are the broadest genres that I assign; to divide them further would take away the commonalties they share. But the question remains: Why do people write different kinds of graffiti at different times?

## THE POLITICS OF GRAFFITI

Timothy Cresswell has detailed a model in which he notes that in some locations, graffiti are considered to be "in place"; in others, they are considered "out of place." He argues that people in the United States consider that "graffiti might be more appropriate 'else-where' in a setting associated with violence and terrorism" (1992, 335). Because of American perceptions of freedom and democracy, graffiti instead represent disorder and are hopelessly out of place in this country: "In one context, graffiti is seen as a symptom of the end of civilization, of anarchy and decaying moral values and in another it is a sign of a free spirit closing the curtain on the stifling bureaucracy of communist authoritarianism" (336). He argues that the way we view graffiti is fundamentally linked with our images of the places we live, our cities and countries, both practically and ideologically. There is perhaps no better example of the political service of graffiti than the famous writing from the West German side of the Berlin Wall (see figure 1.10).

As Cresswell indicates, images that people have of their own place in society influence the types of groups that they form and, thus, the graffiti that they write. For example, during the 1992 L.A. Uprising, it occurred to me that though most political graffiti are commonly associated with political oppression, revolutions, and dictatorships gone bad, they might be more properly understood as exactly the opposite. It may in fact be the poten-

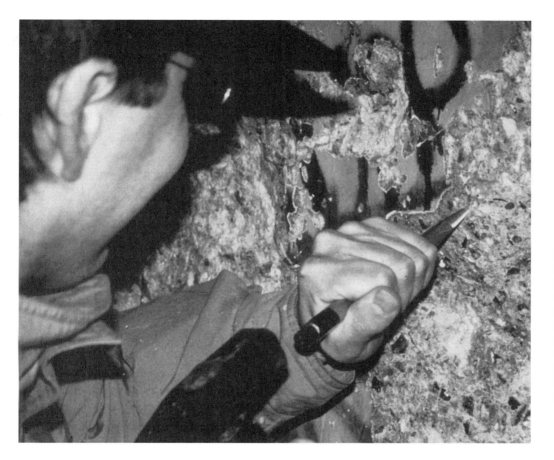

Fig. 1.10. West German side of the Berlin Wall (1989). A West German man helps demolish the wall, just as the graffiti on the free West German side had done symbolically for years. Photograph by Wieland Kirk, courtesy of Rosemarie Ashamalla.

tial for political change that generates the recurrence of politically motivated messages—that people write graffiti in order to create or utilize windows of change.

Places with a lot of political change, like Italy or Latin America, tend to have higher percentages of political graffiti. During elections—during those windows of change—rates of politically motivated messages begin to rise. This has also been the case in the United States, when, during the years of 1960s activism, political graffiti began to come to the forefront. Ferrell (1993) indicates that a revolution without the creativity embodied in graffiti may not be worth attending:

> [G]raffiti writing confirms that resistance without creativity—resistance as a sort of analytic, intellectualized machinery of opposition—may not be worth the trouble.

> Without the spark of playful creativity, resistance becomes another drudgery, re-
> producing in its seriousness the structures of authority it seeks to undermine. The
> imaginative play of graffiti writing and other anarchist enterprises defines their ex-
> istence outside the usual boundaries of intellectual and emotional control. (173)

The creativity embedded in graffiti makes it a successful tool for political subversion, but
its illegality sometimes excludes people from the legitimate participation they seek.

The model in figure 1.11 illustrates that the presence or absence of overtly political graf-
fiti in any given arena can generally indicate the perceived potential for political change at
a popular level. In this way, graffiti can be used roughly to gauge people's integration into
the dominant system and their relationship to traditional political issues. Internally focused
groups like gangs form when people perceive little opportunity for participation in the
larger political system—when they are alienated from the rest of society. They write graf-
fiti with specialized codes and languages that are difficult for outsiders to read. On the other
hand, more nationalistic or other political groups, whose ideological focus is on the larger
state, develop when people are positioning themselves in relation to state politics (whether
to join or overthrow matters not). This happens when people believe they can make a dif-
ference and effect change of some kind. They make use of the national language and al-
ready familiar referents: the government, politicians, political party acronyms, and so on.
The messages people write help them establish the type of group to which they belong;
thus, their graffiti can help us to determine rudimentary group concerns.

Figure 1.11 demonstrates my argument that closed groups develop because the larger
system is armored against their meaningful participation within it. Conversely, open or na-
tionalist groups develop when individuals can influence state politics. Eric Wolf (1957) ar-
gued that exploited peoples form "closed corporate communities" in societies where
there are severe class divisions, something I compare to gang formation in chapter 2. Fig-
ure 1.11 demonstrates that in closed groups, what becomes most important is a group's
political positioning in relation to other segments within the same community. They are
internally focused and are vying for prestige and resources among those with whom they
compete. Among open, or nationalist, communities, the group is vying in essence for a
"state": their position in relation to that entity is what is most important.[5]

Like any dichotomy, these two categories are perhaps more properly viewed as points
on a continuum rather than polar opposites. Boundaries between them may be overlap-

ping, shifting, or under debate. Both types of groups in this case are inherently opposed to the state; their use of "negative" aesthetics through the graffiti medium maintains a boundary that excludes them from legitimate participation within the system.

Graffiti recursively make and are made by their makers. As Scott has stated, the "practice of subordination produces, in time, its own legitimacy . . ." (1990, 10). In other words, what people believe they can do becomes what people actually can do. Conversely, what people do shapes what they believe they can do. Because of the nature of the graffiti medium, however, writers can represent changes in concerns or politics almost immediately. At least economically speaking, they have little invested in previous constructions.

How and when people break out of existing roles of graffiti production is a rich line of questioning, one that is most powerfully explored through historical and cross-cultural study. For example, a summer research trip to Italy working among left- and right-wing political groups helped me to understand the nature of group affiliation in an environment historically rooted in overt political practice. I was in Milan at a time during which left-wing "autonomists" demonstrated against government forces, ultimately culminating in a street riot against city police. The autonomists' use of graffiti as a history- and identity-making tool made me reappraise the necessity for overtly political groups to foster internal solidarity through recognizable symbolic imagery. It further made me reevaluate the importance of larger state forces to internally focused groups like the gangs of Los Angeles.

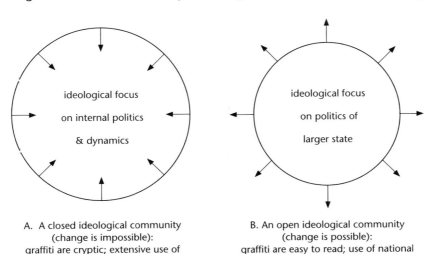

Fig. 1.11. The political shape of graffiti.

A.  A closed ideological community
(change is impossible):
graffiti are cryptic; extensive use of
specialized codes and symbols
(e.g., gangs, hip-hop graffiti)

B. An open ideological community
(change is possible):
graffiti are easy to read; use of national
language with some codes
(e.g., nationalist groups, neo-Nazis)

My main idea is simple: if graffiti are "illegible," they are not focused on larger state politics and consider political change ineffective or impossible; if they are "legible," then the groups that make them are focused on the state and thus overtly political. However, sometimes graffiti are markedly political, but are nevertheless encoded so that not everyone can read them. The famous French "M.A.V." for *Mort aux Vaches* (Death to Cops) is one example of a political message hidden in initials that only people already socialized to the message can understand. Depending on the circumstances, those already socialized can include only a few people or, as in the French case, many thousands of them.

My grandmother often tells me about another graffiti of this type written in Italy during the 1880s—not that she herself remembers back that far. This was the time of the *Carbonari*, when Italy was struggling for independence from Austrian colonizers. This was also the time of the composer Giuseppe Verdi, whose works carried masked political messages of independence; his *Va Pensiero* is still considered almost the national anthem of Italy. The Italians wanted their independence. But the Austrians were strong, and the *Carbonari* were forced to act covertly. They formed a kind of secret society called the "Coalminers" and would write on the walls "VERDI." The Austrians of course thought "oh those children of the Renaissance, loving all that was art and music" were simply displaying their undying admiration for old Giuseppe. But this was not really the case. What the Austrians didn't know was that VERDI was actually an acronym. The initials, V.E.R.D.I., stood for "Vittorio Emanuele Re D' Italia" (Vittorio Emanuele, King of Italy). So it was actually a plea for a new king and kingdom that the *Carbonari* were scrawling over the walls, not simply their love for fine opera (though surely it was that too). Later the covert revolution became overt, the Italians won their independence, and Vittorio Emanuele became first king of the new nation of Italy amid much celebration. The covert graffiti, though highly political, fostered internal solidarity among a select group when it would have been dangerous to publicize the movement more openly.

Issues of hidden versus overt and open versus closed assume broader relevance as they represent how people with limited access to power and resources create affiliations to meet their needs within stratified social systems. By looking at the type of graffiti people create, researchers can begin to gauge the types of political groupings that are relevant to people's daily lives. This makes graffiti a good starting place for research questions, especially ones that ask about intricacies of group relationships in the layered cities of today.

Graffiti is something everybody has an opinion about. In exploring it here as a general

topic, I have tried to point to some useful interpretations of graffiti, particularly through which we might learn about the culture and politics of those around us. Sometimes it seems like the symbols exist only in people's minds, floating until they are caught and brought to earth through media as powerful as themselves. In this way, graffiti are like gifts: information wrapped up in special ways; only the people who write them know the secrets and meanings within.

Through graffiti, people who would otherwise never come into contact are forced into interaction—even if it is only the walls that speak. This is a powerful statement in a city as segregated as Los Angeles. It is no accident that things like graffiti and gangs thrive here—Los Angeles, the place where anything is possible, where there is room to grow, where there is space to alienate populations, to shove away problems, to avoid dealing with others. Los Angeles's graffiti is in some ways its just deserts. The graffiti of Los Angeles is the graffiti of groups that Los Angeles has created—through its history, its segregation, its illusion of complacency and of contentment. These are our native sons. They are what make Los Angeles a monument to itself and the graffiti capital in a world of illicit words.

Los Angeles is a city of diverse populations with as many histories to go along with them. In presenting multiple histories and multiple voices—particularly illicit ones—one must necessarily represent conflicting agendas that ultimately pit people against one another. Rather than fighting against it, I have sought to embrace this conflict. It is at the heart of what graffiti is and will ever be. Nothing I say in this book can diminish it. You can hear it now. It's that mournful cry of the homeowner in distress, calling, ever woeful—"But it's on my property . . . !"

We've all heard these voices and these concerns, and, if not, it's easy to imagine them. Here I instead seek to explore the motivations of those we don't understand so well by looking at graffiti within the scope of entirely different systems of concerns, from the perspective of the people who make it. Learning about graffiti gives us new knowledge about our own lives and the lives of those around us. This knowledge is scattered around L.A. freeways, peppered through the city's barrios and ghettos. It is a knowledge that has grown deeper within me as I have learned to appreciate the place of graffiti writing around Los Angeles and the lives of the people who make it. That is what this book is about: it is an experiment in seeing where graffiti can take us. Hopefully, this process will transform people into active consumers of graffiti instead of its passive, misinformed victims.

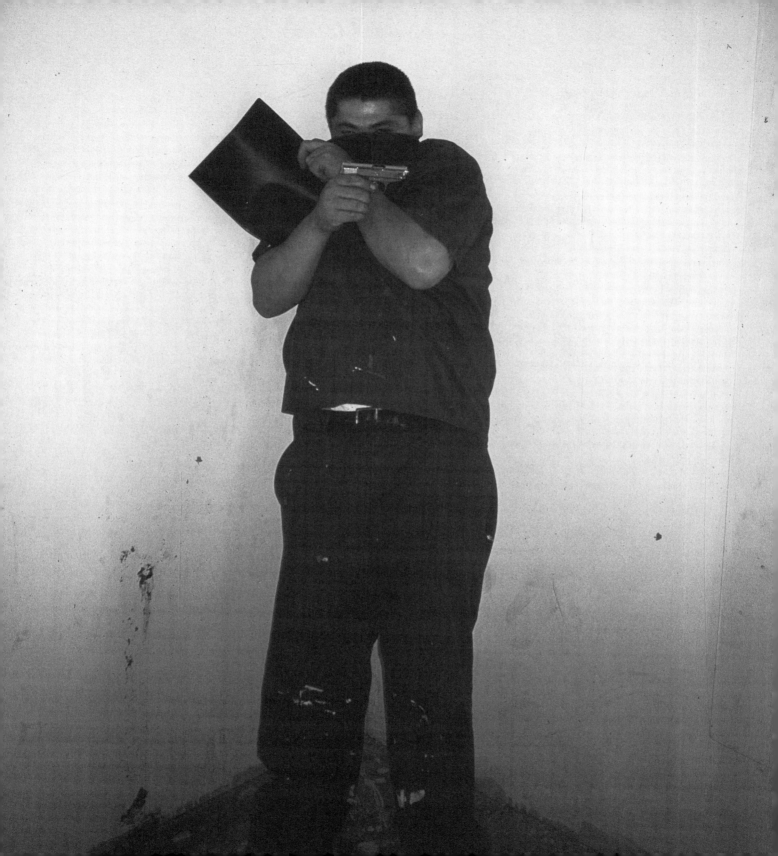

Gangs loom in the minds of many as some of the most frightening entities within our modern cities, dangerous by-products of declining American industry and the breakdown of traditional family structures. They have become the target of national and local legislation while attracting the formidable attentions of a mainstream media that distorts and exaggerates their natures. Their overrepresentation (and misrepresentation) in these arenas plays off the fear gangs generate through widespread criminal activity and seemingly random violence. Popular fascination with gangs equally stems from the fact that they are so poorly understood. No one seems to be able to explain where gangs come from or their fierce spread through society. Almost out of necessity, they have been likened to some frightful organism—a cancer feeding off the body of society, spreading like a fungus to destroy itself and everything it touches. The portrayal of gangs has thus become subject to the self-serving theories of policy makers, academics, and community members alike.

Despite the magnitude of popular concern regarding this phenomenon, the mainstream impact of academic work regarding gangs has been negligible. This is in part due to a paucity of ground-level, ethnographic research. Indeed, so scanty is this literature that journalistic accounts, like Léon Bing's *Do or Die* (1991), become references for academics as well as law enforcement officials and the lay public. There are classic gang ethnographies in academia, such as Thrasher's *The Gang* (1927), Beatrice Griffith's *American Me* (1948), William Whyte's *Street Corner Society* (1943), Lincoln Keiser's *The Vice Lords* (1969), and David Dawley's (1992) *Nation of Lords.* More recently, James Diego Vigil's *Barrio Gangs* (1988a), Joan Moore's *Homeboys* (1978), and John Hagedorn's *People and Folks* (1988) are

63

indispensable references. (See Cummings and Monti 1993; Huff 1990 for excellent reviews of the current gang literature.)

Work on Los Angeles's Asian gangs has also come to the forefront that emphasizes the development of these gangs among new refugee populations or in concert with traditional Asian brotherhoods or triads—Cambodian, Thai, Chinese (Chin 1990), Vietnamese (see Mishan and Rothenberg 1994; Vigil and Yun 1990), Hmong, and Filipino (Alsaybar 1999). In addition are a host of Pacific Islander groups, most notably Samoans and Tongans, who have created their own blends of existing gang cultures in Los Angeles. Of the Asian gangs, the Filipino tradition is the oldest in Los Angeles, and its history and style parallel the evolution of Chicano gangs—from migrant workers and pachucos to cholos and modern-day gang members. Alsaybar (1999) has extensively researched Filipino gangs, concentrating on their seemingly anachronistic position among the middle-class, their integration with other forms of youth culture, and society's role in creating the notions of deviance that surround them.

Despite their insight and breadth, none of these scholastic works has packed the same mainstream punch as the body of investigative journalism that also surrounds this topic. Bing's 1991 *Do or Die*, on L.A. Crips, was the first of several particularly impressive popular accounts published: it was followed by Bob Sipchen's *Baby Insane and the Buddha* (1993), about a Crip and a cop working together; Celeste Fremon's *Father Greg and the Homeboys* (1995), about Father Boyle and his work helping East L.A. gang kids; and the recent *Eight-Ball Chicks* (1997) by Gini Sikes, about girl gang members in three cities. Other popular references include fiction, like Yxta Maya Murray's recent *Locas* (1997), or gang autobiographies, such as Sanyika Shakur's *Monster* (1993) and Luis Rodriguez's *Always Running* (1993). Even movies like *The Warriors, Colors, Boyz in the Hood, Mi Vida Loca,* and *American Me* serve as references about gangs for the world at large.

These works together give the sense that every representation of gangs must be considered a source for study. This somewhat unique ability to cross the boundaries of fiction and nonfiction, the popular and the academic, allows gang researchers to tap into the powers of each of these genres. However, when not carefully contextualized, conjecture, speculation, intensely personal experience, and woeful misinformation (such as that presented in the movie *Colors*) has the power to considerably skew the public's perception of gangs.

Though sources may include the concerns of those at stake, neglecting to place this

rich content into an academic framework for understanding the behaviors can lead to trouble. Those who study gangs seriously often find themselves ritually debunking popular stereotypes before they can begin with their "real" topic (see, for example, Klein 1995; Moore 1993; Huff 1990; Cummings and Monti 1993). Ironically, such stereotypes may themselves feed off poorly analyzed, statistics-based academic literature. Ultimately, it seems as though the gang literature (or at least its deficiencies) is itself somewhat to blame for misconceptions pervading this topic in the popular arena.

For example, academic literature has failed to address mainstream concerns with gang violence; pervasive is the notion that gang members have no regard for human lives, including their own. So far, no academic studies have come up with a remotely adequate explanation for why gang violence takes the form that it does. Ruth Horowitz (1983) has pointed out that gangs fight primarily over questions of prestige and respect, something Jankowski (1991) follows up and that I also stress in my work; Joan Moore (1978) has examined the relationship of drug use to levels of violence. But no one has attempted to explain the shape of gang violence and why it characteristically turns inward. None of these analyses of violence has helped people, academics included, understand why levels of violence rise and fall, and indeed why gang members are fighting others like themselves.

Left to their own devices, journalists and others working closely with gangs have conjured up images of "symbolic suicide" in "hopeless communities" to account for the internalized warfare of today's gangs. Young men with no future go into battle hoping they won't come out alive. When they point a gun at someone who looks and talks and dresses exactly like them, gang members are, in effect, killing themselves (see, for example, Rodriguez 1992; Bing 1992; Yablonsky 1997).

In this chapter, I address this and other folk notions surrounding gang behavior. I argue that gangs are exactly the opposite of a suicide machine. Though I don't deny their life-threatening components, gang membership works most powerfully, though perhaps counterintuitively, as a form of empowerment and protection, a net that people have woven to keep themselves from falling any lower (see also Vigil 1988a). I also examine the infrastructural environment in which gangs thrive, and then present a cross-cultural, political perspective to explain why gangs make war and how they relate to the larger society—as well as the issues of ideology, sociality, and culture that inform their construction.

## GANGS IN THEIR NATURAL HABITAT

Frederic M. Thrasher is famous for saying that the 1,033 gangs he studied in the 1920s emerged from Chicago's interstices: "The characteristic habitat of Chicago's numerous gangs is that broad twilight zone of railroads and factories, of deteriorating neighborhoods and shifting populations, which borders the city's central business district on the north, on the west, and on the south. The gangs dwell among the shadows of the slum" (1927, 3). This has been true for the gangs of Los Angeles, which have also sprung up among shadows of slum and industry, in a legacy of capitalist manufacturing and inequality. In the 1990s, however, even the slum has changed its shape—factories are abandoned to stand or fall like eerie giants; buildings are left burned or cleared as lots for used-car sales. Major distribution warehouses have been transformed into palette collection or recycling centers that use only a portion of the available space. Interior and exterior interstices of the city have grown and compacted with shifts in demography and industrialization. Gangs now stand in the shadows of places that lie uncomfortably between success and failure, where new entrepreneurship is not quite viable enough.

Deindustrialization is often used as a sweeping explanation of the dire conditions of inner cities in the 1990s. Jobs in the large-scale factories of South Central Los Angeles from the 1940s to the 1970s, for example, have been replaced by nonunionized, lower-paying positions in hundreds of smaller companies. The L.A. garment district has flourished, making the city seem healthier than previously supposed. But the people who work within it are often female illegal immigrants. Smaller businesses of today have more to lose by hiring the wrong person, giving way to informalized racism and illegal hiring practices, as well as more control over a wage system that remains underregulated.

Both because of industrial changes and a strong history of exclusionary racism in Los Angeles, the 1990 census revealed that more than 50 percent of black and Latino males in South Central Los Angeles[1] are currently unemployed or not in the job market. Poverty rates have actually risen since 1965, when Watts exploded with its own problems of police brutality. Oliver, Johnson, and Farrell (1993), analyzing pre-1992 Los Angeles, have indicated that while Latinos suffer from underemployment, blacks suffer from severe unemployment: "Whereas joblessness is the central problem for black males in South Central Los Angeles, concentration in low-paying, bad jobs in competitive sector industries is the

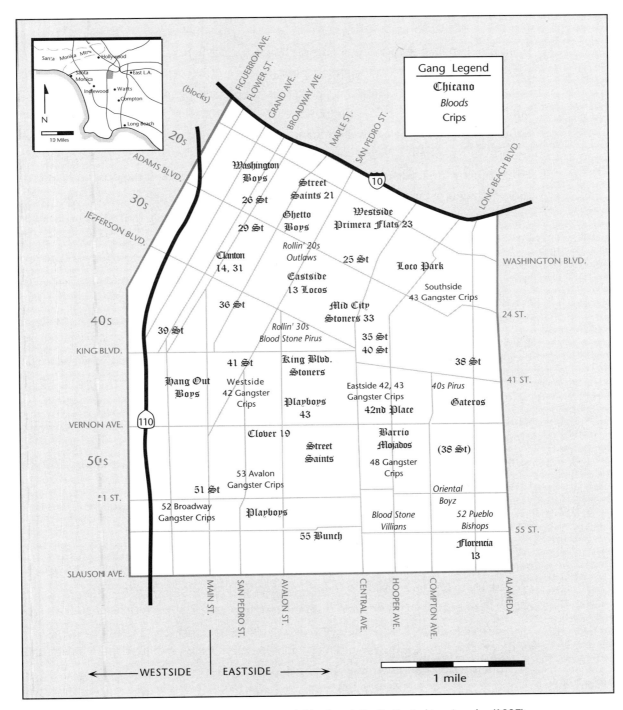

Fig. 2.1. Distribution of gangs in the Central Vernon neighborhood, South Central Los Angeles (1997)

main problem for the Latino residents of the area. . . . Whereas one group is the working poor (Latinos), the other is the jobless poor (blacks)" (123–24).

As a result of these conditions, more than 50 percent of children and 47 percent of families in general live below the poverty line ($14,000 per year per family of four) in South Central Los Angeles. Because gang membership begins in childhood, heightened poverty rates among minors, combined with the lack of general opportunity they see around them, are crucial factors that perpetuate gang systems and the economic opportunities they provide (see also Belcher 1993 for further demographic data on this area)

A recent UCLA study suggests that unemployment is the single most prevalent factor that perpetuates gang membership—more so than family makeup, race, class, or education. "Of all the factors contributing to gangs and their epidemic of violence in Los Angeles, none is more significant than the staggering rates of unemployment in their communities . . ." (*Los Angeles Times*, 28 October 1997, B1). Employment at the community level mirrors the way kids perceive their own futures—as the *potential* for opportunity in the world around them. This means that if community rates of unemployment are high, society can't solve the problem with a Band-Aid by offering a kid a minimum wage job at McDonald's. Low income and high unemployment in children's environments shape their view of their circumstances and future. It is little surprise that they turn to well-established gang networks, which currently provide the most stable economic opportunities available for minority youth in some areas of Los Angeles. The only way to address these problems is to approach them through pragmatic shifts in neighborhood infrastructure—as the UCLA study suggested, "to cut away at the conditions that give rise to gangs."

Unemployment is just one example of the combined conditions of race, politics, economy, education, and justice—as well as the pressures of gang systems themselves—that has constituted broad ecology of gangs in 1990s Los Angeles. Whether involved in gangs or not, many youths now lack educational and practical skill training that might prepare them for the limited job market. Once they turn to gang membership, adoption of that system cuts them off even further from the meager opportunities that exist. Developing gang networks to help alleviate problems prevents people from forming networks of other kinds, which might help them learn important skills to compete with others. Today, fellow gang members may help one another get jobs even within legitimate circles of work, as well as within the illegitimate circles in which they have traditionally

operated. Gang connections have thus become some of the strongest economic networks in Los Angeles today.

The United States is in the process of building the largest juvenile and adult prison system in the world. It currently jails more of its own people than most countries, rivaled only by such governments as China and Stalinist Russia. In a particularly punitive war on drugs, California has increased its prison population tenfold since the 1960s. California now houses one of the largest prison populations in the entire world. Of those incarcerated, blacks, Latinos, and whites hover around one-third each, while blacks, for example, only constitute make up 6.8 percent of the entire California population (Latinos constitute about 25 percent). For many of the urban poor, jail time is becoming a way of life—one that now leaves little room for rehabilitation. Heightened punitive circumstances, including California's "three strikes" law, now keep people in prison and in gangs longer. By the year 2000, the prison population will have increased by 60 percent, with the majority of convictions for drug-related and nonviolent crimes. (The top two convictions are for possession of a controlled substance and possession of a controlled substance for sale; the third is robbery.)

Elliot Currie has analyzed the trends and surprisingly contradictory impacts of America's heightened focus on punishment in his book *Crime and Punishment in America* (1998). He identifies several myths regarding our current systems of punishment—including the widespread belief that putting people in jail for longer periods is a solution to crime. He also indicates the racial divisiveness of the increase in the prison population:

> More than anything else, it is the war on drugs that has caused this dramatic increase: between 1985 and 1995, the number of black state prison inmates sentenced for drug offenses rose by more than 700 percent. Less discussed, but even more startling, is the enormous increase in the number of Hispanic prisoners, which has more than quintupled since 1980 alone. (13–14)

These statistics are telling—and Currie powerfully elaborates that while the United States (and California in particular) has created the most comprehensive system of incarceration "that anyone, anywhere, has ever seen" (27), we remain the most violent industrial society on earth. Something is not working about our current system of incarceration. I argue that in fact it is strengthening the power of gangs on the streets, as well as cementing

more elaborate economic and social links between street and prison gang populations (see also Moore 1978). In short, prisons have been instrumental in the development and continued success of gang networks all over America.

Prison forces people into hostile, racially based situations where they must turn to one another for protection. This process only cements the relationship of street gangs to higher-level prison groups, which are based on existing street gang networks. As the legal interpretation of the age of an adult continues to get younger (to thirteen and fourteen today—Governor Pete Wilson would have them be the newest residents awaiting execution on death row), the ramifications of early criminal behavior need to be addressed in a manner that focuses on transition and rehabilitation. It is too difficult to separate issues of justice from those of class, race, and economy in today's California. Prisons are California's new aerospace—the single fastest growing industry in the state. It is too easy for people without resources to lose their children into the life-sucking vacuum of this system. Whether or not we believe the inmates deserve their incarceration, we must deal with the fact that this system is both self-perpetuating and gang-perpetuating—it is not solving the problems of crime in our society, but is rather taking some very serious steps toward creating more of them.

Anthropologist Renato Rosaldo has recently questioned how the United States can "in the name of less government, drastically reduce social programs and state regulation of capitalism at the same time that they (paradoxically) increase the repressive state apparatus through increases in militarization, police forces, border patrols, and prison populations" (1995, xii). This has become particularly manifest by society's war on drugs and the demonization and scapegoating of the people who deal them to make a living. Today, one of the only places people from the inner cities learn job skills may actually be in prison. When they finally get out, however, the felonies on their records or knowledge of their ex-con status may discourage employers from hiring them. Because of the increasing numbers of people who have been in prison and the barriers in transitioning out of them, established gang networks continue to provide the social and economic instrumentation for people to live meaningful lives before, during, and after serving jail time. In this sense, as a ghetto or barrio is cut off by blanketing economic and social conditions, gangs isolate themselves even further. Gang members themselves begin to produce and reproduce the interstices in which they live—and a new form of culture to thrive within them.

Philippe Bourgois's landmark work with crack dealers in East Harlem, which I return to

later, also focuses on issues of poverty and the unwillingness of society to deal with broader structural forces that ultimately perpetuate the illegal economy:

> In contemporary Spanish Harlem one of the consequences of the "culture of terror" dynamic is to silence the peaceful majority of the population who reside in the neighborhood. They isolate themselves from the community and grow to hate those who participate in street culture—sometimes internalizing racist stereotypes in the process. A profound ideological dynamic mandates distrust of one's neighbors. Conversely, mainstream society unconsciously uses the images of a culture of terror to dehumanize the victims and perpetrators and to justify its unwillingness to confront segregation, economic marginalization, and public sector breakdown. (1996, 34)

Bourgois adeptly weighs broad social forces against the alienating activities that participants in street culture themselves create. He unfolds a complex and often contradictory way of life, demonstrating the many players in the creation of a street culture underclass that seems to act as both human and demon.

Like Bourgois's crack dealers, gang members—because of their links with the dominant system—can neither be considered solely victims of circumstance nor as existing entirely on their own terms. Though L.A. gang members are often well integrated into their local neighborhood environments (unlike Bourgois's crack dealers), they also act as if their existence were entirely separate from the rest of society. Thus, I have instinctively followed their lead toward an analysis that looks at the mechanisms they use to create such boundedness. Examining the shape and nature of those bounded social constructions in the face of a clearly fragmented larger social system enables me to see gangs in the manner they are best explicated: as mature cultures that exist relative to the apparatus of the state, but which retain distinct social and political identities.

An older Chicano gang member, or *veterano*, once explained to me his views on gangs by placing them into the framework of the larger social system:

> Being from the neighborhood, it's all about power—feeling power. It might be a false sense of it. It's a little bit of power and it's something that's gonna keep people alive. And keeping them from blowing their brains out because they just feel helpless. So in that sense, we live in this capitalistic society that capitalism promotes

and encourages and supports greed. And once that happens, the power structure comes out of it. In this country, money talks, bullshit walks. You ain't got money you ain't got no power. So what happens when you have a bunch of people who aren't main . . . aren't from the norm? You get these kids that strive to feel wanted and needed and important, but at the same . . . Let me give you an example. When I was young, thirteen, fourteen years old and dressed in baggy pants, hair net, and short hair, and looking kinda scary even today. Walking down the street, I mean, we'd be walking three or four deep. And just having people cross the street to avoid us or grab on to their purses is a sense of power. That made us think, "yeah," I mean, "we're the shit," you know what I mean? They're going to avoid us. Or, holding someone at gunpoint and watching someone lose all the color in their faces. And they won't be able to give you their purse cause they're too scared to move. So then you just, you rip it from them. You know, that's power. You know, it's not the need to have money. It's that feeling of "I can control you." And like anything in this country, it's the same way. It's the same games they play in the street are the same games they play in these big time offices. That's what it boils down to: power. To address that, people had to become creative.

I interviewed this man—a gang member from Santa Monica—at a time when he was working hard for his homies to move beyond what he knew was destroying them. He explained the gang system to me, an outsider, in a way that I would understand it: through the lens of my own system, the system we both ultimately shared—he as gang member and I as everyday citizen.[2] Like many gang members I have interviewed, he became the lens through which I saw the motivations of the gang world.

His ability to take on this role reflects his own understanding of the processes by which gangs are created. Gangs are socially constructed entities. Their existence is inextricably linked to the larger society's politics, its skewed relations of power, the limited access to its economic resources, and the systematic persecution and exclusion of certain populations from participation within it. It represents perhaps a form of what Turner (1969) controversially referred to as "antistructure": the antithesis of the larger system, its polar opposite and the thing that ultimately reinforces the place of each. As Klein has noted, "Gangs are no accident; our society inadvertently produces them, and they will not decline as a social problem until we confront our relationship to them" (1995, 3). Recog-

nizing society's role in producing them, we can never get away with describing gangs as entirely bounded and isolated from the rest of society. They are part and parcel of it. Thus, we are left to reconcile the contradiction of living in a society that acts both as producer and would-be destroyer of such native systems as gangs.

In the passage I quoted, the Chicano gang member seeks parallels between legitimate and nonlegitimate efforts to gain and exercise power. Publicly sanctioned government agencies use power plays; so do gangs. The United States invades Panama or Iraq just as a gang makes war on its neighbors. Through these and other examples, this man attempted to explain to me why gangs exist and how their behaviors make sense. He recognized that the feelings of power and control that gang members achieved through nonlegitimate means would probably be discredited by the standards of the larger society—hence, his labeling of them as "false."

"Why" questions always lurk at the bottom of any discussion on gangs. Researching graffiti, however, I found myself confronted with a rather different set of concerns: those things gang members did on a daily basis that constructed their identities—in short, not why but *how* they existed. These questions, unlike those ultimate "why" ones, forced me to look at gangs according to how they constituted themselves as bounded systems, with a largely self-imposed alienation from the rest of society.

Scholars such as Wallerstein (1974) and Wolf (1982) have pointed to undeniable links between societies in the context of a world system. Others have described the fragmentary nature of the postmodern condition, where such concepts as "totality," or even "culture," seem outdated and perhaps irrelevant in multilayered, decentered environments like Los Angeles (Jameson 1991; Davis 1990). Though gangs thrive in the fragmented, ahistoric, placeless urban worlds of late capitalist consumer culture—our new interstices—gang members on the street constitute bounded and historic entities, tied by blood and war to the neighborhoods they inhabit. Their exclusion from a structured environment of economy and identity has given rise to the expression of some basic social forms that seem to have little to do with that larger system. They have made themselves into something more akin to Wolf's original concept of a "closed corporate community" (1957; 1986).

Eric Wolf first described the closed corporate community in 1957, in an article in which he compares two societies in Mesoamerica and in Java. He describes seemingly conservative peasant communities that exist within a larger political and social system, noting the cultural, religious, and economic practices they use to "close" themselves off from

the rest of the system. Wolf recognizes that these communities are entirely bound to the larger society, "children of the conquest," as he terms them, and the products of systems with severe economic disparities. He describes how their conservative nature serves as a survival mechanism in the face of such disparities—without addressing them directly. Ultimately he begins to outline contradictions entailed in the continued production of a conservative facade in a society where maintaining the status quo marks and stabilizes the very class and power divisions that produce inequities in the first place.

Although his theory is intrinsically tied to the agricultural life of peasant farmers, Wolf's concept of a "closed" community offers a useful way to analyze gangs. Moore (1978) and Jankowski (1991), for example, have both noted how gangs mark themselves off, acting as if they existed entirely on their own. Gangs form their own "islands in the street," as Jankowski labels them, like little oases in the midst of the desert the larger system leaves behind. In this self-imposed isolation, they live without overt political posturing, only confronting the state indirectly through activities that constitute a positive affirmation of their daily life.

To a degree, gang culture mirrors middle-class concerns and even values. But we also see that on a daily basis gang members behave in markedly different ways, driven by sets of concerns that forever confound our efforts to understand them. Gang members know they are "messing up" and continually define themselves as "evil"—they are well aware of their skewed relationship to society's moral order. Being in a gang is most typically associated with engaging in violent forms of rivalry or involvement in an illegal economy. These things require more explanation than simply saying, "It's like you going to work every day" or "It's like the United States invading Panama." Although those analogies indicate parallel values from one world to another, at a certain point they break down. Instead we need to determine the daily concerns of gang members and how and why they are different from the rest of society. We need to understand why people belong to gangs and how their activities make sense given the context of their America. This is where the real analysis begins.

## MULTIPLE MARGINALITY AND STREET SOCIALIZATION

How the larger system breaks down for gang members is a primary question that can be explored at various life stages. Both Vigil (1988a; 1988b) and Moore (1978; 1991) have provided excellent contextual materials that explicate the development and histo-

ries of Chicano gangs in the L.A. area and their relationship to schools, to work, and to Mexican culture.

Examining relationships of gang growth to school and economic environments often indicates severe marginalization of populations within a broader scheme of racial, social, educational, and economic relationships. Vigil's (1988a; 1988b) psychosocial analysis of gangs points to a "multiple marginality" in which migratory and minority communities wind up with substandard environmental, educational, and economic circumstances—such complexes of factors, he argues, ultimately foster gang development.

Vigil's concept of "street socialization"(1988a; 1988b) indicates that children growing up in lower-income areas may be radically influenced by values and mores tied to the streets themselves—streets that both create and reflect social and economic disparities with the larger system. He indicates that kids left on their own within the context of a hostile social world begin to socialize themselves and one another into values that stress backing up friends—one of the core elements of their later gang life. While they may begin by engaging in regular childhood camaraderie, sometimes their activities tend toward antisocial types of behavior:

> In large part, the gang subculture has arisen as a response to this conflict situation. . . . In short, rather than feeling neglected and remaining culturally and institutionally marginal, the gang members develop their own subcultural style to participate in public life, albeit a street one. . . . [T]his lifestyle is another example of the potential human ingenuity in syncretically creating something new from multiple and sometimes diverse and contradictory sources. (Vigil 1988a, 64)

This ability to merge levels of oppositional identity allows gangs to incorporate a wide variety of participants in diverse levels of affiliation. Gang kids come in all shapes and sizes; their experiences and views vary, as do the gangs to which they belong.

One Chicano gang member described his school experience, for example, the following way:

> If you go to school here . . . You can't go to school here. You go to school, instead of worrying about learning something, you gotta learn how to protect yourself, how to basically survive every day. You can't sit there and concentrate on, oh, you know, what's two plus two. When then again . . . you know, like Timothy out in

the Valley or somewhere, they got that extra teacher telling them, "You know what? If you don't know how to do it, this is how you do it." We go to school, we don't know how to do it, you know, "don't worry." You're just going to get passed onto the next grade. You reach a certain level in school, you're so fucked up in the head, you just don't give a fuck. So what's the next result? You just leave school alone. And what comes after that? Everything else.

As in other realms of existence, failure in school may be linked to everyday concerns for survival—having to learn to fight and protect oneself combined with the perception of getting passed on and passed over by teachers and administrators discourages many from exhausting their efforts in school. Ultimately, concerns of a markedly different nature than those presented in the classroom may affect a child's participation. Another gang member explains how difficult school can be when a student is constantly surrounded by enemies:

Here, we try to go to school, we have enemies everywhere. We can't even . . . we're walking down the hall and we'll get jumped. And then we get kicked out of school. And it gets to a point where, you know, no school wants you. So how are you going to get an education? People would say, "It's your fault, you got so many enemies." But it's not like that. I mean, you grow up in the hood. You know, you're a part of it. It's a part of you. You don't gotta get enemies, but it's just a part of the lifestyle. It's L.A. It's wherever you live. You grow up with your homeboys. There's love between your neighborhood. So eventually things accumulate. You know if I was born in a clean-cut neighborhood, I'm not saying I wouldn't have no problems, but my opportunities to become or do something would have been much better.

Gangs are so localized geographically that people from rival neighborhoods often find themselves thrown into schools that cross over gang boundaries. I've heard stories from African American gang members about going to "red" and "blue" schools (Bloods and Crips take red and blue as their respective colors). Crenshaw High School is a Crips school (called "Cripshaw" for this reason); Dorsey High and Jefferson High are Bloods schools. Some school entrances are designated as belonging to certain gangs—only people with specific affiliations are "allowed" through such doorways. Kids are indeed surrounded by their enemies in these places, a problem that is compounded as gangs become more numerous. These are just some of the consequences that street-socialized children face.

Despite the disparity of concerns between middle-class kids and gang members in places like schools as well as other arenas, gangs subscribe to a surprising amount of white, middle-class ideology. Most gang members that I have talked to believe they should be able to work hard and derive meaning and personal identity from their work—the typical stuff of the American dream. This belief lends them at least some sense of control over a seemingly cut-of-control existence. As do many, one twenty-seven-year-old Chicano gang member articulated his sense of personal responsibility for his situation in life:

> You get to a point where you lived a fucked life, you know. I wish I could live the good life, you know. I wish I could. But it's my fault see. I could, if I would have really pushed myself to it. But I never pushed myself, so now I gotta live this terrible life, it's called a evil life for us. It's evil. We kick doors open and we start blasting, you know. It's not a fairy tale, but it's the life we went through.

This belief in personal responsibility spurs many gang members to conclude that "it's my fault," "I could have done better," or that "society's not responsible." They construct themselves as "evil" in relation to society's "good." But at the same time they harbor intense feelings of anger toward the larger system for the environmental and social slights that confront them on a daily basis. Another man described his feelings:

> But again, on top, the government will sit there and say, "Well you know what, you got all these thugs and this and that, they don't want to do nothing for themselves." Well how can you? When all you know is negative activity since the day you stepped out your door? If all you learn is how to duck when a car passes by? When all you know is if they shoot your homeboy, you gotta retaliate? So how are you supposed to sit there and think different, when everything around you *is* that? If that's the mentality you were taught? I mean, no matter how clean-cut you're dressed. People recognize faces. You can't move on. You can't move on. It's your surroundings, that's what it is.

These two frames of thought—personal responsibility and resentment against societal systems—are only able to coexist within a fundamental disarticulation of the gang world from the world of the larger society. Being socialized by those living the street life, gang-involved children become acutely aware of the dual worlds that they must negotiate—where often the powers of one outweigh the impact of the other. Although they share

societal values such as personal responsibility, loyalty, and hard work, most gang members find it impossible to apply these qualities within traditional economic and scholastic realms. As one man told me, "It's like butting up your head against a brick wall of racism," when a deficient education, felony records, and a general lack of opportunity only allow them access to minimum wage jobs like "flipping burgers at McDonald's." Thus, gang members find other arenas in which to use the same values.

There are no easy answers to gangs—nor are there many easy questions. Vigil notes this with regard to his multiple marginality framework, which considers the confluence of diverse forces that influence gang youth:

> [C]omplex societies require complex frameworks of analysis. A multidimensional analysis identifies the crucial weaves within the broader fabric of the gang subculture. Indeed, it can show us how gang members experience multiple crises and confusion over living, working, associational, developmental, and identity situations and considerations. (1988a, 173)

Rather than directly confronting the larger society through overt political action or making seemingly futile efforts to navigate mainstream waters, gang members instead use their skills toward the manufacture of a close-knit group that enhances their daily survival through community and economy—and cultivates such meaningful relationships that gang members are willing to risk their very lives to protect them.

## NESTED POLITICAL CONCERNS

Though they seem apolitical in their relationship to the larger society, gangs are an inherently political phenomenon. Gangs are political in the face of their internal relationships to one another, among the local networks that most immediately influence their everyday lives. Thus, negotiations of power within local groups, including conducting warfare within these circles, take precedence over negotiating a position in relation to the larger society (or espousing an overtly political stance). This is what ultimately explains those internalized patterns of fighting—it is how warfare with people who look and dress and talk exactly like you makes sense. I demonstrate in both ethnographic chapters (3 and 4) how both California-based Chicano gangs and Los Angeles's Bloods and Crips constitute systems of "segmentary opposition," something that has been recognized as non-

state-level politics since the 1930s and earlier.[3] Segmentary opposition is a nested form of political affiliation—a structuring of identity that starts with the individual and extends progressively broader, like a series of concentric circles. In this context, the two gang systems I discuss in this book (and others, I would argue) are primarily political for the following reasons: First, what makes a gang member a gang member is his or her affiliation to a gang. Today, almost all individual gangs in Los Angeles are part of larger systems of gangs within which they negotiate feud and alliance, status and prestige. Thus, their primary affiliation is a political one, and those nested levels of identity are a type of political affiliation. Also, within the context of this political affiliation, certain activities (as well as the system itself) can be construed as political. This differs from the way we usually think of politics in Western society—as activity that relates only to the larger nation and state. But for the rest of this section and in the following ethnographies, I demonstrate what can be gained from viewing gangs through a political lens.

The importance of highlighting a political perspective lies first in that, though much good academic work has been done on gangs, no one has yet been able to explain in a comprehensive way how gangs fit together either within cities or across them. Thrasher's *The Gang* (1927)—hallmark Chicago school urban sociology—comes closest to creating a broad and practical perspective that details intergang relationships. Despite the passage of time, many of his conclusions can be used to analyze our more complex gangs of today. However, because of the demise of the Chicago school and perhaps of structuralism in general, broader viewpoints of intergang relationships have been completely dropped by subsequent generations of gang researchers.

Part of this is because of the top-down nature of most gang research, as Hagedorn (1988) in particular has pointed out. Because much of the literature relies on data gleaned from police reports or incarcerated individuals, Hagedorn argues, how gangs existed on the ground was for a time an object of nostalgia among researchers for a less violent era of gang studies. Vigil and Moore begin to address these challenges, as does Hagedorn himself with the Milwaukee gangs he studies. Rooted as these efforts are within traditions of urban sociology that focus on deviance, however, the operations of individual gangs as parts of broader social and cultural systems has remained unexamined.

Hagedorn (1988) and Moore (1978; 1991), for example, stop their discussion of gang "structure" at the clique (an age-based division within single gangs)—if anything, they go out of their way to play down links between Milwaukee gangs and Chicago gangs.

Though he studied among People and Folks, a gang system originally from Chicago, Hagedorn never indicates how the Milwaukee gangs relate to the system of People and Folks that now spans all over the East, the South, and, to a limited degree, the Northwest of the United States. He states that "while relationships exist between the satellite and metropolitan gangs, they vary and appear to be more cultural rather than structural" (1988, 77). Examining the nature of those "cultural" connections between gangs is, I argue, the crucial (and missing) step in understanding the operations of broader gang structures today.

Individual gangs are unique entities with unique histories and constituencies, as both Moore and Hagedorn stress. But they also constitute the threads of larger gang fabrics that are beginning to blanket our nation. This does not mean that gangs are hierarchical in their interconnectedness. From what we know of most gangs, they seem in fact to be very much the opposite. Moore's and Hagedorn's hesitancy to explore issues of intergang connections over broader areas comes in part from their wish to emphasize that gangs do not represent a new kind of criminal conspiracy, like a Mafia.[4] The connections they find between gangs in different cities are not economic ones. Feeding pervasive notions of organized criminal networks with seeming proof, they fear, will only increase mainstream paranoia surrounding gangs, something their work explicitly fights against.

This is where anthropological theory that examines the nature of politics cross-culturally makes its strongest entrance. The concept of segmentary opposition I use to analyze Los Angeles gangs provides the theoretical tools to reconcile them as more than singular, unconnected individual entities. But it does so in a way that does not depend upon economics or nation-based notions of hierarchy and overarching leadership.

The L.A. gang systems (Chicano gangs and Bloods and Crips) have no overarching president or leader to connect them. Though Moore and Jankowski both determine that L.A. gangs loathe a leader of any kind, individual gangs may have "presidents" or informal leaders with influence—older guys that get more respect; younger guys that are particularly active—the "shot callers," as police call them. But this leadership is limited and depends on the willingness of others to follow. L.A. gangs also have mechanisms to regulate the power of these leaders, such as holding meetings in which they discuss gang matters in ways that stress egalitarianism and equal voice. Gangs in other cities, such as the Latin Kings or Gangster Disciples, are more hierarchical in their internal organization than L.A. gangs—they have rigid leadership, specified roles, and movement up steps of

the gang life. Klein (1995) describes these types of gangs as "vertical," as opposed to Los Angeles's "horizontal" ones. Despite internal hierarchies and the production of powerful leaders within these gangs, it remains unclear whether hierarchy is an appropriate description for their relationships with other gangs—that is, whether individual leaders emerge who retain control over a conglomeration of gangs (say, all gangs from the east side of a town).

It may be the presence of a strong Mafia model in both New York and Chicago that has fomented the growth of more hierarchical gangs within those cities. Early L.A. gang populations were not involved with higher-powered, Mafia-like entities at the street level—the Mafia presence in Los Angeles has been much more limited. It is only since the arrival of Asian gangs (which themselves sometimes have ties to Chinese triads and the like) that Chicano and black street gangs have begun to commit higher-level crimes like extortion and payment protection—even backing candidates for local elections. Despite their growing popularity, these types of economic and political activities vary tremendously among individual gangs of all ethnicities.

A lot of good work has been done on gangs, and it is improving as people are increasing street-level research surrounding this topic. People can study how gang members interact in school environments (Vigil 1988a; Heath and McLaughlin 1993), their relationship to civil rights in the United States (Jackson and Rudman 1993), how gang members grow out of larger ethnic communities and deindustrialized environments (Vigil 1983, 1988 a & b; Hagedorn 1988), the different kinds of gangs in the United States (see articles in Huff 1990; Alsaybar 1999), how gangs are moving into the suburbs (Korem 1994; Klein 1995), the nature of female participation in gangs (Campbell 1991; Harris 1988), and various issues of public policy (Cummings and Monti 1993; Miller 1990). But we will never understand gangs until we understand the broader political frameworks that comprise gang systems and in which gangs position themselves. Age-graded cliques and local neighborhoods are where the analysis of gang identity just begins.

## GANGS IN A CROSS-CULTURAL CONTEXT

Even though they have their own politics of inter- and intragang relationships, L.A. gangs have no formal government. They regulate their activities and connect their groups without any overarching connections—no overarching leaders, no bureaucracies, limited for-

mal bodies of law (some gangs do have constitutions), no top-down system of representation. Looking cross-culturally, it turns out that the structure of L.A. gangs is nothing new; their system of internalized warfare is relatively common round the globe.

In their *African Political Systems* (1940), Meyer Fortes and E. E. Evans-Prichard ask what constitutes political structure in the absence of a formal government. This question leads them to describe the segmentary lineage system, which is kin based and delineates geographical and social segments, giving territory or family relationships particular kinds of political symbology and meaning. Evans-Prichard describes this system as "characteristically defined by the relativity and opposition of its segments" (1940, 296). According to their model, each segment (in the gang case, each Blood and Crip set, or each Chicano gang) is equal, but opposed to other segments in the system. Relational and usually oppositional connections between them make up the politics of the society.

Black and Chicano gangs of Los Angeles share this system of segmentary opposition. They are classical acephalous[5] systems, similar to the Bedouin in the Middle East, the Yanomami of Venezuela and Brazil, the Maasai of Kenya, and the Nuer of Southern Sudan. Lacking central authority, such groups are basically egalitarian with reliance on a few local leaders. Their politics are characterized by incessant internal infighting, the aforementioned segmentary opposition (they will fight one another when they don't have a greater enemy against which to unify), marking similarity and difference through material production, and many times designating status through conspicuous consumption (showing off whatever wealth they may have). With individual groups numbering from about 100 to 300 (though sometimes into the thousands), they often comprise strongly male-based societies, which may have cliques, or subdivisions, to differentiate between people of different generations. They commonly refer to their groups as extended families or clans, with whom they move between feud and alliance.[6] As the saying goes, it is "I against my brother, my brothers and I against my cousin, my cousins and I against the world." Warfare in these societies generally concerns issues of prestige and respect in the context of a general scarcity of resources. They fiercely protect their territory but rarely battle over the conquest of land in the way that nations fight over land to "take it over" or to colonize it.[7]

Gangs share many characteristics of these groups. For instance, gang members construct rigidly defended neighborhood areas, with defensive boundaries that are marked not by fortified walls, totem poles, or natural mountain contours but by fortifying graffiti and urban contours like freeways or railroad tracks. The number of people in a gang can

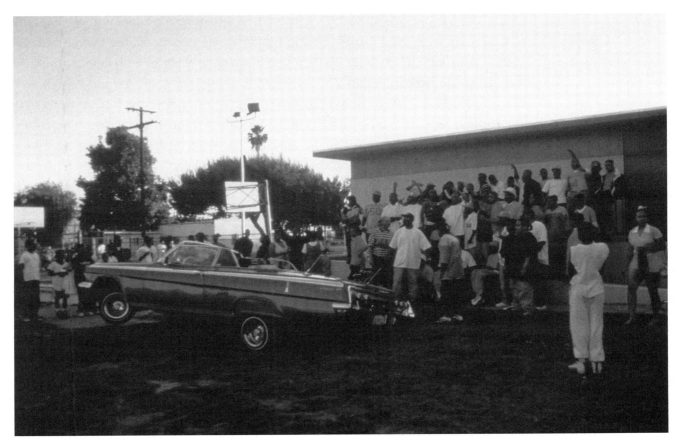

Fig. 2.2. Local group with car: the Five Duse Pueblo Bishops on a gangster holiday (1997)

range from only 10 or 20 to thousands, but the average gang comprises about 50 to 200 individuals. Though women play prominent roles in gangs, they work within a gang system established and dominated by men, whose politics and prestige-based goals are centered around male activities. Just as twelve-foot yams in the Solomon Islands represent ritual power and individual prestige, in the United States gold chains and lowrider cars are almost parodies of themselves as hallmarks of gang conspicuous consumption (see Bright 1995 for an analysis of lowriders). The "circumscription" that Ferguson (1992) and Chagnon (1992) have described for the Yanomami has often been articulated to me by L.A. gang members, whose fear of enemy attack keeps them constantly on edge and comfortable only within the bounds of their own neighborhoods. The headhunting in which Ilongot in the Philippines have engaged stems in part from young men seeking opportunities to continue practices that have historically defined their masculinity (see Rosaldo

1980). This mirrors precisely gang members' needs to foment rivalries and seek out opportunities to make their names through violent action. Bedouin in the Middle East engage in years-long blood feuds that can stem from petty theft to retribution for murder; they designate territory, friend, and enemy by clothing, color, and insignia. Violence in the gang world is similarly dictated by such designatory markers and proximate reasoning. Further, gangs may attempt to control this violence through alliance-building tactics such as sporting events, picnics, and barbecues. These are similar to patterns of feasting with friends and enemies around the world—the "potlatches" of the Northwest Coast, the "mokas" of the Solomon Islands, or the "treacherous feasts" of the Yanomami. How is it that such parallels run between gangs and completely unconnected groups around the world?

Johnson and Earle (1987) have indicated that segmentary and acephalous systems with endemic conflict (what they call "local group-level societies") arise in circumstances where a lack of access to resources prevails and where there is no integrated apparatus for conflict control, such as a government. Their ideas are broadly applicable to the development of gangs in a modern urban environment. Ultimately, features like "lack of access to resources" and "inadequate mechanisms for conflict control" point to some of the questions regarding the state's failure to make itself a viable locus for political identity—the state is there, but it is not integrated; nor does it provide access to the resources necessary for daily survival. Within urban arenas, the more interesting questions become how an environment of scarcity arose in the midst of an existing state-level society, and what relationships of power led to its development. Why, after all, would reliance on a local group be necessary in a state-level society?

### Tribal Parallels

Approaching gangs as "local groups" helps to explain why people occasionally compare them to tribes. In the modern imagination, images of a tribal future without a state leave us in the hands of ganglike thugs and roving bands that bear an increasingly popular neo-primitive stamp. Gang members themselves make analogies to tribes: if infighting erupts among African American gang members in jail, for example, they may accuse one another of "tribalism" (Shakur 1993). Academics have also sometimes drawn such tribal parallels, though their theories have rarely been met with wide acceptance.

Bloch and Niederhoffer's *The Gang: A Study of Adolescent Behavior* (1958) was one of

the first to draw a tribal analogy. Their treatment analyzes participation in gangs as a coming-of-age mechanism that parallels male rites of passage in tribal societies throughout the world. More recently, Walter Goldschmit (1990) discusses "gangs as tribes" in a few pages toward the back of his book, *The Human Career*. He outlines the similarities between L.A. gangs and tribal groups across the world based on newspaper accounts he read of the Bloods and Crips:

> So the gang creates a context in which the boy, feeling rejected by the dominant culture or seeing no way that he can establish his worth within it, can find a self. He identifies with a group like a Tlingit does with his clan; he achieves acclaim within it by his show of bravery or bravado like a Cree warrior, and perhaps most important of all by his show of disdain for those who have disdained him.
>
> The strong ties to the 'hood, the evocation of images of slain comrades and the demands for revenge are essential features of gang culture. These aspects of gang actions are remarkably similar to the activities of such tribes as the Yanomamo or Ilongot. So are the killings, even to the killing of people who are not themselves engaged in the action. (250)

Even without referring to their segmentary nature, and in spite of inaccuracies present in the newspaper reports on which he relies, Goldschmidt demonstrates how aptly a cross-cultural tribal comparison seems to fit the gang topic. He describes what gangs are fighting about and how certain actions (such as L.A. Chief of Police Daryl F. Gates's "war on gangs") only feed the problem. Goldschmidt also addresses the moral issues all researchers working with gangs must encounter: balancing their judgment of the actions of the people with which they work and their knowledge of the context that makes these actions meaningful.

Lately another anthropologist has also drawn the tribal parallel. Clayton Robarchek, in his *Waorani: the Contexts of Violence and War* (1998), offers that the patterns in which gangs make war and engage in blood vendettas are similar to those of the tribe he has studied. He argues that comparisons between the two can model types of conflict control. Though both Robarchek's and Goldschmidt's analyses are limited in different ways, they are important because they attempt to point to reasons for these similarities through cross-cultural comparison.

At one level the comparison between tribes and gangs is commonsensical. Geopoli-

tics is gang politics in many parts of the world—take Somalia, Zaire, Bosnia and Herze-govina, or Rwanda. Newspaper accounts in the United States confound words like gang, warlord, tribal leader, and thug on a daily basis. Current scholarship, however, has failed to explicate such intuitive mainstream confusion, lacking both the groundwork and in-terconnections of theory that make such clarifications possible.[8] Even Thrasher's note on the "intertribal" relations between gangs is more of a hint than a critical examination: "The broad expanse of gangland with its intricate tribal and intertribal relationships is me-dieval and feudal in its organization rather than modern and urban" (1927, 6). Tribal hints are everywhere in both the gang literature and our popular media.

John and Jean Comaroff have pointed out that depictions of people in the inner city have frequently met with characterizations of them as "primitives." They concluded from historical materials and analysis of the London inner city during the Victorian colonial era that "Often the mere use of metaphors in otherwise unconnected descriptions conjured up potent parallels: Talk of urban 'jungles'—in which the poor lives, like 'wandering tribes,' in 'nests' and 'human warrens'—brought the dark continent disconcertingly close to home. . . . The poor of Britain were 'strange'—as much 'other' as any African aborig-ine" (1992, 286–87). Such conditions in mind, missionaries of the time employed "con-quering" theories in the inner city, attempting to bring light, marriage, cleanliness, and general virtuous living to the untamed wilds of London streets. The Comaroffs argue that such parallels helped the colonial movement create its center in England as much as its periphery in Africa. Ironically, this government was able to spread itself round the globe but failed to integrate itself in its own backyard. "In London, as in Africa, the wilderness is unnamed, unmarked and uncharted" (288). Because of impoverished circumstances, people's ways of life differed dramatically; indeed, London's poor were subsequently ap-proached in a patronizing and exoticizing manner because society considered them to be so "different."

Besides endorsing colonial ideology, there may have been other reasons that the Lon-don bourgeoisie found itself drawing such parallels. Unnamed, unmarked, and uncharted territories are actually full of names, marks, and maps that designate affiliations completely separate from those of the larger society. The existence of alternative affiliations and ter-ritories within cities governed by larger state structures returns us to the original topic of gangs. In an essay on social change in South Central Africa, Clyde Mitchell discusses the "homeboy cliques," based on original tribal groupings, that emerged in urban townships:

[H]omeboy groups may develop among townsmen of different social classes and among both migrants and permanently settled townsmen. The "homeboy" groups provide the basis of residential groupings in single quarters, for mutual aid in times of emergency, and the basis for the organisation of sports clubs. It is implicit . . . that homeboys are essentially a clique of people who have grown up together. (1970, 93)

Leaving aside the uncanny similarity in the verbal characterization of such entities, the idea of groups of young men growing up together based in a locality, or neighborhood, helping each other out in times of "emergency" (most likely both economic and physical), and becoming the basis of sports clubs are the same factors that bring gangs together. In the United States, gangs develop within urban neighborhoods to offer help during emergencies as well as continued economic crises; members denote age-based cliques within their larger gang to differentiate between them. Also, both black and Chicano gangs in Los Angeles compete not only through violence but through sport—football in particular is central to gang activities today. As Thrasher himself notes, a plethora of such ganglike entities form to offer group assistance and support in urban areas around the world.

The question remains how help and mutual aid—benign enough, it would seem—wind up translating into the vicious and violent action that gangs display. Anna Simons's work on clanship and democratization in Somalia indicates a potential solution:

[W]hen individuals share a government but are not granted equal protection, equal rights to participation, or choice about who they identify with or how they are identified, they seem far likelier to engage in conflict at the level in which they do have fair representation from their perspective: the kin group. (1997, 277)

Thus, Simons suggests, when a state apparatus fails to integrate itself meaningfully into daily life, people may turn against the kin groups that have traditionally provided them with stable safety networks. Though the kinship aspects of gangs are more loosely generated, as I describe later, the basic idea is the same for gangs as the Somali groups Simons describes. Within the context of an indirect struggle for equal rights and representation, gangs in the United States fight groups similar to themselves not only for resources and protection of their neighborhood space, but to negotiate reputation and identity at the level where it carries the greatest impact: internally. Warfare with the larger society

makes little sense for them. What makes sense is warfare among people who are operating within the same system, so that they may most effectively influence their position within that realm.

In working-class or underclass situations, whether it be in East London, the Langa township in South Africa, or in South Central Los Angeles, groups may arise based on any number of factors that link people together in ways not commonly associated with the state. Though the "tribal" qualities of such groups presented by Mitchell and others (cf. Bruner 1972) may stem from direct links to tribal populations, such links would not need to exist without the need for protection and economic viability in harsh circumstances. As Johnson and Earle argue, it is the abject necessity for networks greater than the family that creates the local group—something that in turn helps an individual cope with daily life:

> It is not unusual for segments of a population that do not benefit from participation in the political economy to remain outside the law (outlaws) while within the borders (even at the center) of the polity. In contemporary urban areas—say, Washington D.C. for example—there are populations whose political and economic behavior more closely approaches that of local group level societies, with high rates of male deaths by violence, limited leadership of small groups by valiant males, loose collectivities of leaders (who sometimes coordinate from prison), and endemic violent competition over territories and resources. Although in the state, they are not politically of it. They live for the most part outside the bubble; the state tries to limit their disorganizing effects on the rest of society, but is surprisingly powerless to bring their behavior under control. (forthcoming)

Because inner-city groups are local in nature in the same way that the Yanomami or Somali are local, these groups may take intriguingly similar shapes in circumstances that are worlds apart, whether or not they are connected through kinship or to previously existing tribal populations. Thus, the intuitive "tribal parallel" with the inner city, though often an excuse for institutionalized racism or classism, may in fact stem from similarities as they exist on the ground.

I am taking a great risk here in offering this comparison. People may take "gangs as tribes" out of context and use it to further their own punitive or oppressive political agendas. But comparing gangs in the United States with similar entities around the world is perhaps the most powerful method for understanding why gang systems arise and how

they work. It is also perhaps the only way to disprove a notion that, although refuted by most of the gang literature, nonetheless remains rooted in the mainstream psyche—the idea that gangs are psychopathological entities and that gang members themselves are psychopaths. As Goldschmidt asks, "Yet if we are not to condone the bloody fighting of the Crips and Bloods, should we not also condemn the equally bloody fighting of the Ilongot? Are we sure that either of them likes things the way they are, that they are not both uncomfortable in their roles?" (1990, 251). As opposed to condemning them, he suggests we need to question what aspects of their environment might warrant such behavior. How do their behaviors arise from the circumstances in which they live?

Every time I have witnessed violence on the street or have seen its devastating effects, I am sickened by it to my core. It is visceral and disturbing, but very human in some ways—maybe that is why it is indeed so deplorable. It is almost pathologically human. It is as Bill Buford has indicated in his book about the violence of soccer hooligans in England: "We have no illusions about the potential depravities of our nature, except that rarely, despite our modern sophistication, do we admit that those depravities are genuinely our own: yours and mine" (1993, 186). It is easy for us to sit on the sidelines and condemn what most of human society has had to deal with at a much more immediate level for most of human history. We have the benefit of living in a country that has a government and an army; in cities that have police forces that are willing to protect us. These things free us from the need to respond to violence ourselves on a daily basis. We train special people to the task. They do our dirty work for us: they take risks, they kill others, sometimes they get killed.

For a variety of reasons, people in impoverished environments have always been on the wrong side of the police officer's gun. Police are natural enemies in places where gangs and the illegal economy flourish; the National Guard has itself been brought in to fight against populations like those in South Central, which have periodically rioted against police brutality and injustice. They cannot trust the police to help them, to treat them with dignity, or even to arrive at the scene of a crime in a timely manner. Despite the fact that gangs are themselves a cause of so much violence, gangs actually represent an effort to maintain a viable way of life and to provide protection to their members. As one man told me, "putting fear [into others] makes our places safer" (see the extended quote in the conclusion to chapter 3).

Gangs have grown up in environments of exclusion. They have not emerged from the

rugged landscapes of mountains or barren lands, for whose harsh realities we have only Mother Nature to blame. Gangs have grown up in the contours of the streets, which have themselves been shaped by the inequalities that capitalism manufactures, in places where red lines protect the interests of those with as much power as racial hatred. In examining this newly natural environment, then, we equally must examine the forces that created it.

### The Role of the State

Much of the modernist and postcolonial literature in political anthropology has noted the role of the larger state in fostering segmentation within colonized social systems. This literature argues that divide and rule tactics make such divisions as castes and tribes even more pronounced. In turn, this fosters damaging internal conflicts that facilitate tracking and control of colonized peoples (see Appadurai 1996; Dirks 1993; Ekeh 1990; Ferguson and Whitehead 1992; and Southall 1970). Even after countries gain independence from colonizers, such fostered segmentation tends to be thought of as "natural" and lingers to divide newly independent nations (Fried 1967; Hobsbawm and Ranger 1983). Analyzing the role of census enumeration of populations in India, for example, Appadurai (1996) notes that

> indigenous ideas of difference have become transformed into a deadly politics of community, a process that has many historical sources. But this cultural and historical tinder would not burn with the intensity we now see, but for contact with the techniques of the modern nation-state, especially those having to do with number. The kinds of subjectivity that Indians owe to the contradictions of colonialism remain both obscure and dangerous. (1996, 135)

Lingering remnants of colonialist oppression continue to haunt Chicano populations of Los Angeles today.[9] In much the same way, the legacy of slavery shadows the African American community. In both these populations, oppression doesn't stop with freedom or defeat; it is continually manifested in the racist continuities of the United States power base.

I am always amazed by the unintended overlap in the literature on political anthropology with the gang topic. Tactics colonialist governments are said to use to foster "tribalism" within their dominated populations are the same that the LAPD purportedly uses in Los Angeles to keep gangs fighting one another. These include, for example, exag-

gerating membership, leadership, and the organizational level of the groups, as well as selective persecution of members within established legal systems—how people are identified because of who they identify with or because of what neighborhood they live in. Conspiracy theories both Chicano and Black gang members tell me about the LAPD and the CIA fueling their conflicts often find counterparts in literature on colonialism (see, for example, Ekeh 1990). Though infighting is not necessarily invented by larger entities, it is certainly something that people in power can take advantage of to further their own agendas.

The state undoubtedly plays a role in creating and maintaining divisions in the African American and Chicano communities through techniques like those listed in the previous paragraph. But there doesn't need to be an actual conspiracy for gangs to exist. It is enough to have a legacy of racism that works at many levels. So similar are their concerns that many societies with internalized violence, legacies of colonialism, and punitive government forces share this similarity of rumor—the conspiracy theory. My point here is that the presence of these theories further links circumstances that have seemingly operated within entirely different social and ecological environments.

It is not resistance against the larger state but the struggle for existence within it that tangibly places gangs in a broader scheme of political relations. It is indeed the absence of politics, I argue, that ultimately excludes a group from classification as a gang. At first, for example, the crack dealers of East Harlem described by Philippe Bourgois seem analogous to gangs. They share heightened rates of poverty and violence; they come from the same types of neighborhoods; they rely on illicit economic enterprise and the organization of that enterprise; they have similar difficulties surrounding race, gender, and family relationships; they harbor intense frustration with the larger system at the same time that they long to be a part of it; and, ultimately, they are linked by a common search for respect that drives their activities. In fact, so aptly does Bourgois's work fit mine that it frees me from the intellectual labor he performs in scrutinizing questions of oppression, culture, and economy that have created inner cities in the first place. My view of oppression often feels as fuzzy as that of the people who are living in its wake. Indeed, they are living in places where, without a broader view of social process, "conspiracy" sometimes seems the likeliest explanation for their circumstance.

It is the absence of a politics of warfare, structured within an internalized system of political concerns, that differentiates Bourgois's entrepreneurial crack dealers from gangs

around the United States. It is no accident that the major gang systems of the United States—People and Folks, Bloods and Crips, and California-based Chicano gangs—have all flirted with overt politicization from time to time. Overt politics is an ever-present, though subordinate, part of their ideology from the street to prison. Antiestablishment sentiment is part of the politics of any impoverished group, including Bourgois's crack dealers. But their primarily economic organization is not impelled to engage in political struggle like the organization of gangs. The crack dealers instead direct their energies toward economic legitimization and the individual gain of wealth.

I demonstrate in the following ethnographic chapters that even within prisons, where street gang members may form more Mafia-like structures, it is the idea of a political (and racial) unity that keeps them together. It is also the segmentary, oppositional structure of gangs on the outside that prevents any inside organization from maintaining street-level control over economic enterprise for very long—the Mafia prison model varies greatly in its street-level impact. Where the focus of Bourgois's crack dealers is mainly money, gangs respond to the politics of their culture, which includes economic, social, and political aspects. It is, however, the political realm that characterizes what they do and that ultimately distinguishes them from other types of groups in similar situations.

Gangs have always been a part of modern capitalist societies, at least in the United States. Today, many authors cite how the conditions of late capitalism, such as rapid deindustrialization, seem to be increasing the participation and duration of gang membership (Cummings and Monti 1993; Hagedorn 1988). The deterritorialization of national sentiment in a globalized system and the emergence of city arenas that house local, ethnic, or gendered identity politics are beginning to assume more importance worldwide. In the United States, existing models of street gangs now serve as a predominant model of affiliation for inner-city youth—affiliations that today easily last into adulthood within well-entrenched gang systems that serve a variety of economic, political, and social purposes.

Gangs oppose the system without doing so in an overtly political manner. In this respect they are perhaps more clever than we might think—because no movement that is overt can wrestle with the powers of the global corporate politic and the machinations of the modern state. The only "revolution" that can happen today is the one that happens incidentally. Indeed, it has already taken place among those decentered populations that have been forced to radically shift their social and political affiliations just to survive. The affirmation of their separateness from the larger social conditions that have excluded them

is relevant only secondarily to the internal relationships that carry greater weight in their daily concerns. In their apolitical relationship to the dominant society, gangs have found their politicization. Without confronting them directly, gangs have successfully threatened the dominant social and legal systems of the United States.

The relevancy of an "overt" (and traditional) nationalist politics lays dormant beneath the street-level ideology driving gang behavior. This inchoate nationalism surfaces with changes in age and place and in concert with current events. The variable contexts of the gang life—namely, the construction of race (group), their relationship to the larger society (politicization and depoliticization), and how they connect their groups together (behavioral, linguistic, and material expression)—equally shift with these concerns. Gangs have created their own culture in the midst of a larger one. It is only by examining the internal politics of that culture that we can begin to understand why and how they make war and what they write on the walls around them.

Just as Wolf's peasants created closed communities to protect themselves economically and ritually, so the self-imposed segregation of gangs protects them from an environment over which they have little control. At this point, it matters little why or how this has actually happened. The gang systems I describe in the following two chapters are already in place. They are complete social systems in Los Angeles today. They have now become one of the dominant models for controlling the street, an option for people left out of mainstream work and ideals. As that population increases, nested systems of gang politics like those of Los Angeles may become the true legacy of deindustrialization in the United States and perhaps the world.

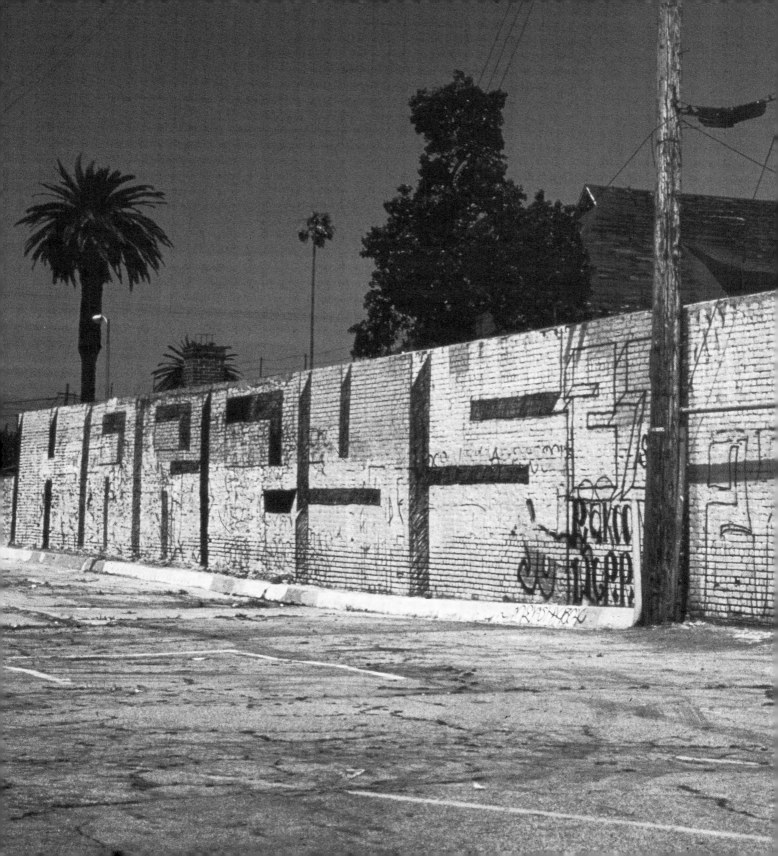

## 3 CHICANO GANG GRAFFITI

### ETHNOGRAPHIC LESSONS

Leo gave me my first lessons in ethnography. I'm not sure how he was able to know my job better than I knew it myself. But somehow his innate understanding forced me to see the consequences of my actions as an ethnographer and as a human being. Fieldwork is a slow and sometimes painful process. So much social and emotional angst accompanies trying to get to know the people you want to work with. It involves putting yourself where you do not belong, where you may not be wanted; making painful social mistakes; having to deal with issues of race, trust, honesty, money, class. Ethnographic fieldwork is made up of people with moods and personalities. You have your unlucky days and your lucky days, which makes fieldwork something of an emotional roller coaster.

Working with gangs in the city where one lives is not considered typical anthropological fieldwork. I was a commuter anthropologist. I never lived with the people I worked with but, in typical L.A. style, would drive over to my field site and hang out with them. I thought wishfully of moving to where my informants lived and envied those who could leave the country to immerse themselves in another culture. They didn't have to go back and forth all the time like I did, from real life to anthropological life. Such movement called out the superficiality of the ties that I made with people, how connections to them were driven by fieldwork and were therefore completely unnatural. I struggled with my lack of integration into people's daily lives and, as a result, continually deemed my fieldwork an abject failure in terms of traditional anthropology.

95

The contradictions that commuter fieldwork presented were difficult for me to recon-
cile. All anthropologists experience contradictions, whether or not they work in urban set-
tings. But for me, the traveling especially made me continually question the construction
of our city. Why did I constantly have to be aware of my own role as cultural oppressor?
I was a consumer and had to support the powers that be to live my daily life. It was diffi-
cult doing fieldwork knowing that I was the enemy to so many of those whose knowledge
I sought. In the long run, this back and forth process proved an important focus to my
view of the city, but during fieldwork I considered it a mild form of mental torture.

There were also times, however, when I was grateful to be able to go home. Even
though I was afraid of making stupid cultural mistakes (which I did a lot), some of the time
I was just plain afraid. Once in Watts I had such a bad time that I was relieved to drive to
the lily-white suburb of Torrance where I had been raised. It was a place I had deemed
"cultureless" and had learned to despise. But at least no one stared at me with hate on
the street there. How ironic that the place I best fit in was the place I least wanted to be.

As with most major cities, it is the nature of Los Angeles to segregate people. This seg-
regation makes you feel comfortable on your own turf and uncomfortable on somebody
else's. Because of the city's size (its famous sprawl), such zones of comfort can be enor-
mous but still manage to exclude entire populations from their midst. I had to develop
survival mechanisms for the hatred I encountered when I crossed those boundaries. I cer-
tainly felt exhilarated when I did so successfully—when I did fit in and felt welcomed and
accepted, and even wanted. Ultimately, the power of those moments made it possible
for me to do fieldwork in a city where divides of a few miles sometimes seemed greater
than those separating nations.

Leo was the first person to help me learn to negotiate those divides successfully, and
in the process he taught me how to deal with my own mistakes in the field. Fieldwork is
full of anthropologists making mistakes. Some of those mistakes can be costly indeed. But
mostly people understand them and try to help you to comprehend the nature of your
mistakes. In the process, they help you learn your trade: how to be an anthropologist and
how to understand the nature of their culture. I had relatively few dealings with Leo alto-
gether, but even after his death my experiences in the field always seemed to revolve
around him or to lead back to him somehow through his family and friends.

I learned many lessons from my first fieldwork. They were so painful that I long resis-

ted putting them to paper. They seemed to expose both the best and worst elements of my personality. My work with the 17th Street gang in Santa Monica was haphazard and unsystematic. It spanned over a period of about four years. It was embarrassing to look back at my glaring mistakes, my unmaintained ties, and the way I flitted in and out of the gang members' lives. I could rationalize my problems away, I know: my informants moved in and out of jail, my fieldwork wasn't all that bad. I had also just started in a graduate program for which I was woefully ill-prepared. But in my heart I knew I could have done better.

It was 1991. I had been taking pictures of graffiti for about six months but had somehow managed to avoid coming into contact with people. I think I was just trying to be careful, to get a feel for the whole street scene. But after all that time and all those photographs, I craved interaction with the people whose work I had documented almost daily. It was nothing other than a freak accident that finally gave me the opportunity to connect with the gang members from the Santa Monica neighborhood close to where I lived. I was on my way to take some more pictures. It was like any other summer day for me—I had my camera and planned to park my car and then walk to an abandoned house that was a popular graffiti target. Instead I drove around the corner to see the flashing lights of police cars and a crowd gathering. A car had driven itself literally up a telephone pole cable and was suspended, rear fender resting on the ground, at a forty-five–degree angle. After somehow extracting himself from this precarious position, the driver had fled, and I think the police were still chasing him when I arrived.

Among those gathered were two gang members distinguishable by their crisp white T-shirts and baggy black pants. I carefully positioned myself next to them as I started taking pictures of the scene. Pretty soon a third, older gang member on a tiny bicycle came riding over. He asked me if I was working for the paper. I said no, but sort of mentioned that I was actually on my way to take pictures of gang graffiti. He said that was cool. One of the younger ones was named Ruben. He and his friend told me that I could meet them later around the corner where they hung out. So I walked off to take a few pictures, and a bunch of little boys ended up giving me a guided tour of their neighborhood. I was grateful to them for their acceptance and company.

Across from the abandoned house was the apartment whose courtyard served as the hangout for the 17th Street gang. When we reached it, I said good-bye to the little boys

and told them I would see them again soon. I walked across the street toward the group of gangsters with my heart pounding. I was looking for Ruben, but only saw the older guy who had been on the bike. I went over to him. It was through him that I met Leo.

Somehow Leo was in charge. Either that or he was naturally a little interested in and very suspicious of my project. We talked, he asked me questions, but it seemed from the start he knew exactly what I was doing and, more, how I should be doing it. When I saw his tattoos peaking out from his shirt, I practically begged him for a picture. After he said, "No, I'm not about to take off my shirt and show you my tattoos," I kept pushing, asking, "please, please, are you sure?" Different people came by, curious, asking about my project. Then as Leo was just about to leave, he suddenly lifted up his shirt to pose for me. I was so nervous I could barely focus the camera. One tattoo around his neck read "I Just Don't Give A Fuck" in the beautiful Chicano gang script; over his heart was another of a rosary and praying hands with an inscription that read "Pardoname Madre Por Mi Vida Loca." Forgive me Mother for my crazy life. He also had a big "17" on the back of his neck, and some little "SM's" and "17's" here and there on his wrists and elbows, for Santa Monica 17th Street. He let me take the pictures at a variety of angles—but made sure never to show his face. A friend of his, Trigger, jumped in at the last minute to cover up his eyes on one of them just to be safe.

As I headed for my car, I heard them shout, "Hey, we could use a ride!"

I remembered the conversation with my mother just before I left that day. She was in Northern California and knew I was going to a place full of unknowns. The last thing she said to me, half joking, was, "Don't give anybody a ride!" I said okay. But when Leo and Pelon asked, I knew I wanted to give them a ride. I automatically trusted them, even though my brain told me I should be afraid. But I also hesitated, remembering the promise to my mom. After all, they were gang members. They killed people, didn't they? They committed crimes; they raped people, didn't they? So I refused them.

"Hey, we trusted you!" they responded. "We let you take pictures of us!"

I managed to say no, that I was just some stupid white girl with a camera, but they, they were real gangsters who could really hurt me if they wanted. I think I kind of flattered them in this way, which is the only thing that made my refusal even semi-acceptable. At the same time I felt confused by not being able to trust my own feelings. How could I negotiate this world if I was supposed to be afraid of the people I wanted to work with? I continually struggled with that issue throughout my fieldwork, but that was the only time

I ever refused a ride to anybody if I felt okay about it. Looking back I realize that it's good to do these things once, to help gauge decisions for the future. It's just too bad it had to be with Leo that first time.

The next day I went back there and Leo kind of sauntered over and just let me have it. I guess he had been thinking about me and had become more and more angry. He said I had been way too pushy the day before. Trying to defend myself, I said yeah, but I got what I wanted (i.e., the pictures). He countered that the only reason I got what I wanted was because he had given it to me. He had let me take those pictures, like a present. He asked, was I trying to study them under a microscope? Like they were insects? I said no. I tried to explain about anthropology, how it was learning about different cultures all over the world. But I was embarrassed. I said it would be so much easier if I were Chicana—that I wished I was. But as soon as I said this, Leo said, "No. Susan, you have to be proud of what you are."

I tried to know that this was true. Later I figured that this was one of the main things about doing fieldwork I first learned from Leo: you have to accept who you are in order to have others accept you. They were proud of themselves, that's what the gang was all about. I should be proud of myself too. He said he was proud of me because I came down there and wasn't afraid—but that I had been too insistent.

I went home that night almost in tears, feeling like I had made some terrible mistakes during my first experiences, which at the time seemed excruciatingly important. How could I have been so insensitive and disrespectful to them that first day? Being pushy, getting what I wanted, then not even giving them a ride? And that second day being so rude in my defensiveness. I hoped that Leo didn't think too badly of me, and I couldn't blame him if he did. But we were cool after that. He knew I was just beginning and that he was helping me learn. I gave him his pictures, and he liked them.

I got to know some other folks, began interviewing for a methods class I was taking, and had some crazy barrio experiences. I didn't see too much of Leo after those first days, but he was always around me somehow, in the background of my mind. His expectations were something for me to measure up to. From him I learned that you need to trust in order to be trusted.

The first time I gave one of the homies a ride, Angel's older brother Rafa was my passenger. I remember asking the older guy, Pelon, if I would be alright and he said yes. I also remember Rafa's mom taking a good, hard look at me through her window—would

her son be safe with me? It reminded me that I was the stranger here—I wasn't the only one who had to be careful. Apparently she sensed no immediate danger, so off we went. We got into my car and headed down 16th Street. I was to take him to a bus stop on Wilshire where he could catch a bus to his apartment near downtown. It was cheaper there, he said, but his heart was in Santa Monica. Later on he moved back to live in Santa Monica in the apartment right above his mother's.

As we headed down 16th, Rafa saw a homeless guy he knew walking down the street. He told me to pull over and rolled down his window to talk to the man, who was white with a smallish frame. I had seen him around Santa Monica before. He began to describe how he had been badly beaten the other day by some people out looking for a good time. As a result, he said, he had got a new knife for protection—an item that he promptly produced. The blade of the knife was shiny new and a good seven inches long. When he handed it to Rafa, still inside the car, my heart started to pound. I realized the precarious nature of my position. Had they planned this somehow? Suddenly I was sitting there next to a man I barely knew, a gang member with a huge knife who could do anything to me he wanted. I imagined him suddenly turning on me and asking me to get out of the car. Or worse, to stay in the car. I imagined the headlines the next day, "Girl in car stabbed by gang member." Maybe I should have listened to my mother after all. The course of events seemed no longer mine to choose.

Rafa admired the knife and tested its sharpness. I looked at his face and eyes, trying to read his thoughts. The homeless man continued to describe the perils of life on the street that necessitated a knife of this size, which the law required to be worn in plain view. Rafa only listened, nodded, and admired—and eventually gave the knife back. By this time I had relaxed and was sympathizing with the man's story. Before then I hadn't really been aware that people beat up the homeless just for a good time.

When we were on our way again, Rafa started to tell me about Leo. He told me that when Leo was only nine, Rafa had thrown himself over his brother to shield him from a trigger. Rafa had been shot a few more times since then and said that now people sometimes teased him because he looked like a zipper all the way up the middle. He lifted his shirt to reveal a long but neat scar that stretched from his abdomen to his neck. This scar was the result of I forget how many operations to remove triggers from his body. Rafa and I actually became fairly good friends and I later got to know his girlfriend, his daughter, and his little sons.

When Leo died, I didn't know it. I couldn't go to the funeral. Starting graduate school had been difficult for me, and I had let my relationships slide a bit and didn't go to 17th Street at all over Christmas. I approached his little brother one day in January, and was two sentences from asking him how his brother was, but didn't for some reason. Then another guy, Sal, came down the stairs and asked if I knew that Leo had died. When he saw the tears in my eyes he apologized. He thought I already knew.

It seemed Leo had shot himself in the neck early one morning, but no one knew whether it was suicide or an accident. There was no note. That night I tried to sleep, but my mind kept replaying images of Leo.

Time passed and 17th Street kind of seemed to die a little along with him. People eventually stopped hanging out there and instead began hanging around in nearby Virginia Park, the haunt of the Santa Monica Little Locos. I never knew if this was directly attributable to Leo's death, but it seemed like it to me. One day many months later, Rafa called me. It was Leo's birthday, and they were all near tears and drinking. People never get over the kind of pain that death brings.

I had met Leo's mom only once, after Leo's death. Rafa introduced us one day after discovering that I had never met her. She told me that she had some pictures of Leo that I had taken, and that she remembered when I had been around before. I thought of the impersonal, ethnographic pictures of Leo's tattoos that I had taken on that first day and wondered what kind of memories she associated with them. I told her that I had discovered another picture with him in it. She seemed almost resigned when she told me to bring it to her. It was a picture of Leo in profile, softly brushing the back of his fingers against a baby's cheek. Touching as it sounds, it is a terrible picture; I never could give it to her. I often wonder if I took it to showcase the Santa Monica tattoo visible near Leo's elbow, or merely to take a candid snapshot. Somehow I hope the latter, although I will never know for sure.

That is the kind of doubt that haunts me. I have never really reconciled using people's lives to demonstrate ethnographic facts. You notice the shallow nature of this practice even more when those demonstrations become your only concrete reminder of an individual. I treasure the semi-lousy shot of Leo with the baby, although I believe I must have taken it against his will. Even on those first days he made it clear he didn't want his face in any of the pictures I took.

The lessons Leo taught me about sensitivity, honesty, and trust I might have learned

in any barrio. I started my fieldwork in Santa Monica and felt a strong connection to that place. At the same time, I questioned my experiences there. Santa Monica had an established barrio—but it was a barrio that had access to rich West L.A. privileges like supermarkets. This, combined with the haphazard nature of my fieldwork, made me question whether my idea of the Chicano gang world was all that representative.

When I started research in South Central Los Angeles to study among Bloods and Crips, I expected to be overwhelmed—and was in many ways. I knew the streets were harsher there, and the black community was definitely unfamiliar territory for me. Violence was more pervasive. The gang members in Santa Monica seemed to live through periods of punctuated equilibrium: moments of relative calm interrupted by dramatic, violent events. Residents of South Central Los Angeles seemed to live and breathe violence. Someone's son was always getting jumped; someone always had their jaw wired. The geography was also much more intense. In contrast to the eight or so gangs that spanned the entire Westside (Culver City, West L.A., Venice, and Santa Monica), about forty gangs operated in the roughly eleven square miles of the Central Vernon area (see figure 2.1). People there were prepared for violence on a daily basis.

But whenever I met Chicano gang members (and I seemed to run across them wherever I went), I felt like I already knew them. We slipped easily into conversation. I was rapidly able to prove my trustworthiness to them, because I knew from previous experience how to relate to their culture. I could speak their language of respect and love. When they talked, I recognized their voices and the stories they had to tell. I realized that my time in Santa Monica had provided me a literacy in the gang culture that I could take with me anywhere I went.

Drama never ceases with gang members and neither did my connection with Leo. My field notes from a time much later relate how mystified and confused I felt by another death in the gang community:

7 July 1995

Nonna's [my grandmother] been visiting and it's strange to know that somebody's dead without knowing who or if I know them. For the past few days there have been a group of gangsters hanging around on Pacific Street. Foolishly, I had hoped it was their new hangout, but it turns out one of the guys who lived there got shot and died just a few days ago. His name was Ramon, but I don't know his

nickname and no one would tell me. I was walking down to the liquor store to buy some ice cream for me and Nonna and I saw Alfonso, who is there often enough so it didn't surprise me, and another guy who I didn't recognize. But Alfonso was crying. And there were people hanging around. Not just gang members, but family and bunches of men and women. Alfonso was wearing a muscle T and I couldn't help noticing the SM 17 tattoos on his arms. I don't know if they're new or not because the last time I talked to him he said he wasn't so into the gang thing. They're probably old. I only talked to him one or two times, but he always recognized me and waved to me from his car in front of my house one time. He's a friendly guy.

Anyway, I approached them and asked what was happening and no one seemed to be able to talk. Alfonso, that is, couldn't talk. And his friend didn't seem to know anything, just that the guy's name was Ramon and that he was a gang member. I keep on thinking that it's Gremlin, but I still don't know. Anyway, pretty soon a man came over to comfort Alfonso, who began sobbing in his arms. Anyway, Erik [my husband] thinks he knows Ramon, that he used to coach Ramon's brother in baseball, so I don't think Ramon is Gremlin after all.

How difficult it is to learn. And how difficult it is to deal with one's feelings. I continued walking down to the liquor store and the man at the cash register (who I didn't know) was talking to a guy about a funeral. So I asked was it the one for down the street. And he said no that it was another one: his grandmother had died. Anyway it came out that Ramon had died; he had been shot. I asked if by chance they happened to know his nickname because that's how I knew some of the guys from 17th Street—not by their real names. He got a little offended or standoffish. He said, "Wouldn't you rather know them by their real names?" I said that I had been doing some research and that I only knew them by their nicknames. He said, "Research?" Like he didn't believe me, or if he did, that he didn't approve. So I left the liquor store, too preoccupied even to say that I was sorry to hear about his grandmother.

Then as I was walking back, I felt kind of stupid. I knew I had to get back to Nonna because I told her I'd only be a few minutes and it was getting late, but I wanted to know if I knew the guy. So I walked past the women conversing, past the row of men drinking, to two older gangsterish-looking guys to ask them if they

would mind telling me his nickname. But the one guy's eyes were full of tears and he kept his lips shut real tight. Neither said one word to me. I said I knew it was a hard time and that I was sorry and sort of automatically rubbed his arm, but it was like I couldn't read them. They weren't projecting anything toward me: not hate or indignation or anything. It was as if I wasn't even there. They just looked at me as if I was some kind of a ghost. I think maybe the one I was talking to shook his head ever so slightly. And I think when I said I would go that I was sorry to bother them, maybe he nodded a little. Or maybe he just shut his eyes.

Then I went home to Nonna feeling stupid, frustrated, and sad, but also hating myself for disturbing those people. Who is to say that daily life is any less sacred than death? We prey upon people, take their stories, and make our livings off them. The funny thing is, maybe it's okay to do that if you've kept up and maintained contact, if people know you and you've done your work well. But if you haven't, then you haven't any rights to make a story out of it. You haven't any rights to use it for your own purposes. I feel that way right now.

I don't think I knew Ramon. But I knew Alfonso a little, and I don't want to use his pain or his family's pain or anybody's pain for my own benefit. How can I feel so many different ways at once? How also can I be worried about having made a fool out of myself (or perhaps an enemy) at the liquor store when I know that people are having a death to deal with, that Alfonso has lost his friend forever? I wonder if I will ever be able to reconcile these dilemmas. Maybe I'm not cut out to be an anthropologist after all. I figure that tomorrow I'll drive down 17th Street with Nonna to see if there is any graffiti that says who died. Then I may know if I know the guy.

## 11 July 1995

As Erik, Nonna, and I were on our way to breakfast at Ray's, I looked for memorial graffiti but there was none. On the way there, as we headed past Eddie's Liquor, I saw a bunch of gangsters carrying cardboard signs, sort of waving them around. Then on the way back, it became clear that they were signs for a car wash. I left Nonna and Erik at home and went back out to get my car washed. I pulled into the Burger King and saw lots of gang members that I knew. I had never seen so many together at once. There were lots of cars all in a line opposite from where

I was, but pretty soon they waved me into a space and seven or so of them descended on my car.

The first person I saw was Alfonso. He smiled at me and I asked how he was doing. He told me he was sorry he couldn't talk to me the other day. I put my arm around him and said he didn't have to apologize. There was a picture of Ramon there and his sister had on a memorial shirt. I met his sister and told her that Erik had known Ramon as a little boy, that they had played together at the boy's club. Her arms were scarred up and she had various tattoos, including one on her neck. The tattoos! The gangsters at the car wash all in their muscle Ts or without shirts, working diligently, some talking, some posing for photographs. I took one of a bunch of them so a girl could be included: it was with a 110 plastic camera—antediluvian technology. I didn't take any pictures with my own film.

I saw Diablo and talked to him. He said he got out about three months ago. I asked him about Bear and he said that he could give me his phone number and that he still had the picture I took of both of them. He told me that Uli was dead, but I didn't understand. I told him I didn't know Ramon, and he said Ramon was Leo's cousin. Then I saw Hector and he reiterated that Uli had died and that he remembered a picture I had taken where he was covering up Leo's eyes. I said that that was Trigger. And he said that Uli was Trigger. I am a little slow sometimes, I was also slow to realize that it was Trigger who was dead. I couldn't believe it. I told them I had some more pictures of Trigger at home, that I would bring them all. The older one said he didn't have any pictures of his brother. Hector also said that their mother would be happy, because normally Trigger never let anybody take his picture.

But I wonder, same as I wonder for Leo's mom, what bittersweet thoughts will she associate with the pictures I have of Trigger writing his gang name in spray paint? They are good photographs, but of the very thing that killed him: the gang life. It turns out he died about a year ago. He got shot. They showed me the memorial tattoos. I think Diablo even had a scroll, and Hector had an RIP tac [tattoo], one of the only ones he has.

I was dumbfounded when I found out that Trigger had also died. Diablo said, "Yeah, that's what I was trying to tell you." I am thinking of that picture of Leo holding up his shirt to show off the tattoos. Leo had arranged it so that his eyes would

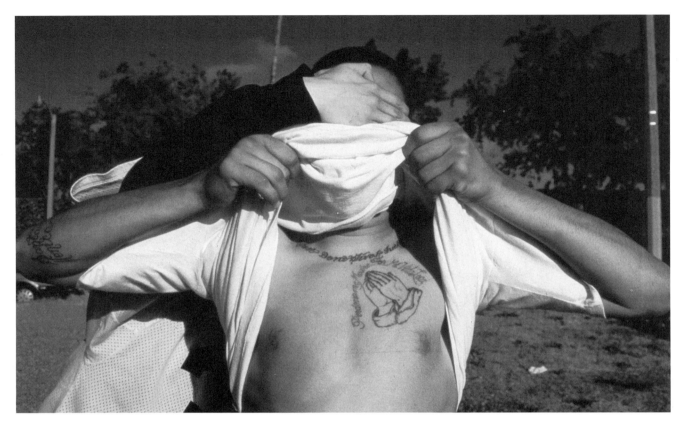

Fig. 3.1. Leo and Lil Trigger, Santa Monica (27 June 1991). *Rest in Peace.*

have been showing—it would have been a dramatic effect. But at the last minute Trigger jumped into the picture and covered up Leo's eyes. It's one of the best pictures I've ever taken. It's haunting to think that now they are both dead.

Tomorrow or Thursday I will go looking for them to see which pictures they want. Anyway, I felt accepted and happy to be around the gang members again. I realize I've had some contact with many of them in one way or another. I was amazed at how many I recognized. But they have good memories too. Alfonso was very sweet to remember me. Hector told me that the funeral was on Monday, everything would be at Holy Cross Cemetery, but he didn't actually invite me. Well I debated long and hard whether to go to the funeral. If it had been anyone I knew I certainly would have gone, but I felt weird about going. I knew in the long run that it would be self-serving in so many ways, me as anthropologist observing, and

I am not in the business of capitalizing on people's pain. I was riding bikes with Erik on Monday morning, and afterward, I decided that of course I could go, that I would go to pay my respects to 17th Street in general, to recognize their pain along with them. But by that time the funeral was already over. I guess they were going to bury him right next to Leo. Anyway, I donated $20 to the funeral at the car wash. And I've been keeping semi-track of the goings-on down the street.

Every night since the death people have been down there, sitting around outside. After the funeral they were there for hours. They all looked so nice and dressed up, wearing black and ties. Meanwhile I wonder how the gangsters are dealing with this. I never actually got the full story: I know it happened on the Fourth of July, but I don't know how or who did it. There was a gangster I didn't know at the car wash, who was drinking a 40 oz. and had started to tell me, but I interrupted him. He asked, did I know why they were having the car wash? That one of his homeboys had got shot and had died. I immediately somehow had to jump in and emphasize my whole end of the story. That I had been walking down the street, had seen Alfonso crying, etc. Even though I told myself to let him tell it in his own words, like a narrative of the event, I interrupted him anyway to assert that I was no stranger to the scene. I knew some of the homies, I had previous experience. So as a result I cut his narrative short. I should have said, "Yes, what happened?"

Then another thing happened, when I went to give the money to Ramon's sister. She asked me if I wanted change and I said no. And I expected her to say thank you, or for us to connect somehow, but she didn't, and we didn't. It made me feel stupid. Why should she give a damn after all? But somehow I sensed that she didn't like me, maybe she sensed that I was some kind of person with money and some kind of do-gooder. Exactly what I don't want people to think.

It's amazing how preoccupied we are with ourselves, even in the face of other people's death, unhappiness, and suffering. Each interaction I have with gangsters I learn so much. Some of my experiences are so full of lessons that it takes hours to write them all down. But at the bottom are the people who are really at the center. I am only a filter who gets to show a certain picture of the scene. But at the heart of it are Ramon, and Leo and Trigger, and their families and friends. They deserve to be left alone to deal with their sorrow.

## CHICANO L.A.

All my experiences in Santa Monica made me realize the number of contradictions in the gang life. How could these people be so nice? How could they have tattoos that showed a fierce commitment to Catholicism while they also had the ability to shoot out of their car windows and not even be sure of hitting the right target? How could they deal drugs and commit crimes and then complain about getting harassed by the police? How could they be so sorrowful when they lost one of their friends, and then turn around and do the same thing to someone else, only ensuring that the cycle continued?

These questions plagued me at first. But gradually they began to recede from my mind. As I got to know more gang members personally and learned about the Chicano community in general—and about being poor in Los Angeles—those questions no longer seemed relevant. These people were living in a different world. They had entirely different sets of concerns than I did. I came to realize that it was, in fact, the contradiction and the flexibility of gang identity that allowed gang members to negotiate the many concerns they had to deal with on a daily basis. Severing the moral ties I had to my world in order to understand theirs turned out to be less difficult than I might have thought. In fact, it worked so well that I constantly had to remind myself why those other questions continued to be important.

How gang neighborhoods like Santa Monica got started can either be considered a long history or a short one. To historians, it's just decades; to the homies, it seems like forever. For anthropologists, it's long enough to be an important lesson in the creation of culture. Before I go into more specifics about that culture, it behooves me to delve into its history a bit and provide a rudimentary context for the rise of Chicano gangs in Los Angeles.

Los Angeles's barrios developed on the outskirts of towns or in highly industrialized areas, such as railroad camps or brickworks, where migrants constituted the majority of the labor force. After their journey from Mexico to the United States, many Mexicans in the 1940s and 1950s found themselves in housing situations deemed as "slums" by outsiders (see figure 3.2).[1] However they were judged by the city, such areas and the possibilities for work offered there sometimes represented marked improvements from the conditions they had left behind. According to historian Ricardo Romo, "although a smaller proportion of Mexicans owned their homes than native Anglo Americans and European

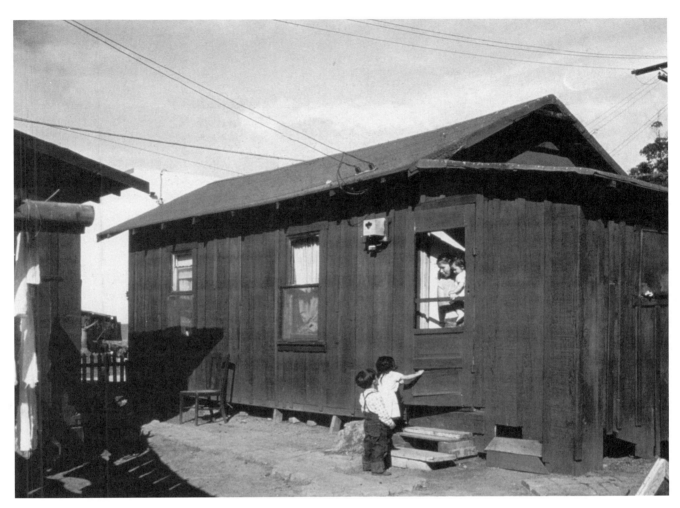

immigrants, many nonetheless found in the new barrios of the east side at least a partial opportunity to make a better life for their families" (1983, 88).

Despite the positives, relocation into slumlike conditions, often without electricity, indoor plumbing, or paved roads, separated Mexicans dramatically from mainstream, nonmigratory communities and the conveniences that went along with them. Mexicans bore the weight of some ugly stereotypes—they were pigeonholed as dirty, disease spreading, racially and culturally inferior to Anglos, and prone to violence. Children were sometimes forced to bathe before school and were punished for speaking Spanish on school grounds. In general, Mexicans were seen as a threat to an established system of Anglo-Saxon val-

Fig. 3.2. Residents of "slum" housing (1950). Leonard Nadel took this photograph for the Los Angeles County Housing Authority, which documented so-called slum areas to make a case to build housing projects and improve the living conditions of the urban poor.

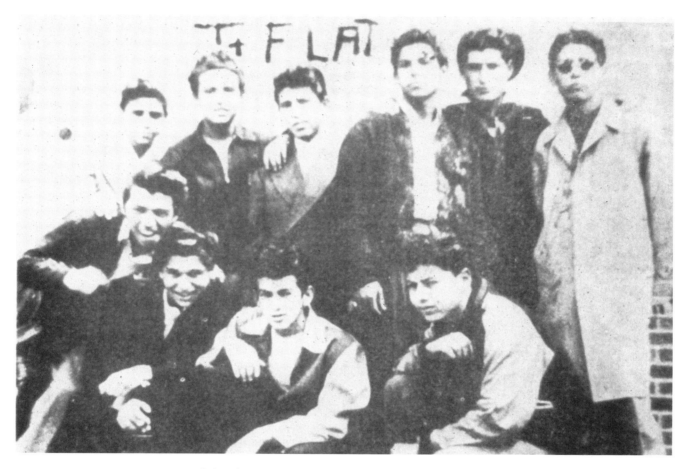

Fig. 3.3. Kids from the Tortilla Flat "Tx Flat" neighborhood (1943). Because a number of neighborhoods today refer to themselves as Tortilla Flats, it is impossible to say exactly where these young men are from. The one to the far right is wearing typical zoot pants, tight at the cuff, and a long fingertip coat. Courtesy of Lowrider magazine.

ues and, by the time World War II rolled around, many considered them a threat to national unity (Miranda 1990; and see Romo 1983). Their strong parallel culture, established early in the century with their own radio stations and newspapers, enabled young and old barrio residents to turn to one another rather than to the white world that had generated such hatred for them.

Barrio residents were forced to nurture their own forms of homegrown protection. Even things as basic as adequate police protection were denied to Los Angeles's Mexican and Mexican American residents (see Vigil 1988; Moore 1978, 1992; Mazon 1984). During the 1940s, for example, as groups of off-duty sailors entered barrio neighborhoods three consecutive nights to beat up inhabitants, the only protection the areas received was from pachucos, early zoot-suited Chicano gang members, who eventually rioted with

the servicemen in June of 1943 (see Mazon 1984). Already well established in the 1940s, groups of young men, like those in figure 3.3, who did not share their parents' notion of the barrio as an end in itself had formed a zoot-suited subculture that mediated an Americanized view of the places they lived while contesting their social place in a racist and paranoid wartime society.[2]

The first wave of 1950s cholos grew out of the zoot-suited subculture of the pachucos. Today, myriad new gangs spring from the gang groundwater that seems to bubble up through every crack in the L.A. asphalt. Some split off from older, established gangs; others are formed from neighborhood football leagues or hip-hop party or tagging crews. These are usually linked to larger neighborhood pressures—gang conscription in response to the circle of hostile neighbors. Thus in a variety of ways, gangs have expanded and multiplied through the generations.

The proximity of the border and the continued movement from Mexico to the United States, and the isolation of the Mexican community, meant that even Mexicans that did carry U.S. citizenship never became part of the voting pool in Los Angeles. Though they constituted an important part of the workforce, Mexicans were denied membership in unions of black and white workers that usually supported efforts to limit immigration. Later, Mexican farmworkers and braceros would be excluded from voting in the ballots to which other workers were entitled through the activities of white unions. Depending on the political climate, whites were alternately able to praise or scapegoat Mexicans for either "saving crops" or "stealing jobs." Deverell (1997) has indicated that whites attempted to construct Mexico and Mexicanness as part of Los Angeles's heritage—like the "Ramona" plays, romanticizing it as an aspect of its Spanish colonial past, but not its Anglo-Saxon future. Thus did whites affix the labels of noncitizen and migrant on Los Angeles's "brown people," turning them into "strangers in their own land."

Because many Latinos continue to enter the United States illegally, even men and women who shun gangs and work hard to support their families must avoid encounters with the dominant system when possible. Because they must use either quasi-legitimate or illegitimate means to earn a living, it is difficult for them to navigate the culture of the mainstream—and safer for them to exist outside it.

Today, as always, the barrios of Los Angeles house newly arrived immigrants as well as established third- and fourth-generation residents. New Latino migration from Guatemala and El Salvador continues to splinter this community internally, preventing a coalition of

Fig. 3.4. View of Los Angeles from the Diamond Street neighborhood, just north of downtown (1996).

political force or the development of a common identity (Navarro and Acuña 1990). This is due to the historical circumstances that removed Mexicans from the mainstream white (and English-speaking) society, as much as to the continued back-and-forth movement of its people across the border.[3]

In the midst of this fragmentation, isolation, and negation of their experience in Los Angeles arose the Chicano gang culture. Chicano gang members have continually carved out the symbols of their lives, as we see in figure 3.4, with Los Angeles looming in the background. The solidity and conservatism of this culture have made Chicano gang traditions some of the most stable features of the barrio landscape. The arrival of guns and crack cocaine, the explosion of new gangs since the 1980s, and the increased stigmatization that accompanies gang membership have made gang affiliation more intense and violent. But the continued lack of integration into society makes gang members even more fiercely dedicated to the sense of history, tradition, and community that gang membership continues to provide them.

## THE FAMILY OF GANGS

A popular explanation regarding gang growth posits that gangs are related to a breakdown in traditional family structures. The fact that gang members frequently refer to their gang as a "family" seems at first to support this view. But a more critical examination finds that gangs are not about replacing the family per se. They are rather about extending it in ways that enhance neighborhood security. Gangs use the model of kinship to bond themselves together and help prevent infighting so they can protect themselves from other gangs as well as the society at large. The ideology of Chicano gangs has always been linked to their focus on family (what Moore [1978] calls Chicano gang "familism"). The concept of "gang as family" intertwines with goals of pride and respect and the active process of "representing" their neighborhood.

Gang members, academics, and law enforcement officials agree: people join gangs for protection and security. Surrounded by their enemies, they take risks walking outside their neighborhoods alone or without weapons. This harsh daily existence requires something larger than a family to support an individual.[4] This may seem contradictory in a world where gang members spend their time making their own enemies; we could say they are damning themselves. But, as one of my respondents stated, making enemies is just part

of the lifestyle. And today, in large urban centers like Los Angeles, the lifestyle is something that many people find themselves growing into naturally from childhood.

Thinking about the gang as a family is always linked to greater ideas of representing and backup. One young man I interviewed explained it in this way:

> You grow up with your homeboys. And throughout time as much as people say, "oh, it's a bunch of lowlifes," it's not. We're like a little family. Because if I don't see my homie as often, the day I do we see each other with love and respect. And it's like, even though we're from different generations, we're still bounded for the same thing. We represent the same thing. Something happens to my little homie and they come tell me, it's just out of straight natural reaction that I might want to do something because, you know, that's my homeboy. And I know that if something was to happen to me, I was gonna get the same response back in return. So you know, it's a family.

Seeing gang members as a family that can provide reciprocal backup bonds people through the generations. While gang members may share blood ties within and across generations (cousin, brother, sister, aunt, uncle, mother, father), many do not. The familial terminology gang members use to describe their relationship to other gang members may only superficially indicate the replacement of "gang" for actual "family." Many that I know are totally integrated into life with their "real" families: young men and women alike help care for younger siblings, they attend birthday parties and weddings, and frequently visit relatives. They love and protect their mothers intensely. Others may come from broken homes with no fathers, and mothers who work full-time. Absentee fathers have been cited as a dominant factor in gang membership. I don't argue this basic point—in fact the disproportionate removal of minority males from the scheme of things indicates society's potential role in the breakdown of the traditional family to begin with.[5] In my experience, however, there is a lot of variation in the types of families that gang members come from.

Through the gang family, individuals are integrated into an extended network of kin and nonkin. This increases the number of people who can support them in daily concerns (lending money, borrowing cars); to share social and economic practices (hanging out, drinking beer, dealing drugs); and, perhaps most importantly, to back them up if they need it (instigating fights, protecting themselves from the threats of others). The translation of gang membership into the terms of fictive kinship heightens the tie be-

tween fellow gang members and represents their "all for one, one for all" attitude toward one another.

Far from pointing to the breakdown of the traditional family, gang membership indicates instead a society that has enabled the development of streets so full of poverty and anxiety that traditional families alone cannot protect their children from them. Another young man described his feelings about the gang as family:

> It's a bond that unites us. I mean, we argue, oh man! We fight. Just like a family. It's just like you and your brothers and your sisters. You argue all day and this. But I've gone down with a lot of my homeboys, and you give them their respect, and they give you your respect. And it's just little things you argue about. And you squash it, 'cause you're a family. And you know they're gonna be there no matter what. Even if you guys aren't talking right now? If it came down to it, he's gonna be there for you. Because he represents what you represent.

Issues of family, backup, and representing are mentioned continually by gang members when discussing the importance of the gang family. It's not that people don't argue within gangs. They do. However, their fighting must be "squashed" or the gang could no longer function as such.

Both young men in the previous quotes interweave topics of family with the bond of representing: "It's a bond that unites us." "Because he represents what you represent." Family parlance, then, is not so much about the family (or lack thereof) as it is about the group that creates a place where gang members feel comfortable while also enhancing their survival in hostile circumstances. Representing that same entity through individual and group action equally bonds gang members together.

Neighborhoods and names and individuals are intertwined until they almost seem to become a seamless whole. Gang members are willing to die for neighborhood places that eventually become charged with the meanings of their own lives and deaths. They are willing to die for the pride they feel in their neighborhood. Lefty, for example, got shot in the stomach three times and nearly died just a week after I took the picture shown in figure 3.5. Drive-by shootings, violent rivalries, and cycles of revenge, whether personally instigated or not, can claim any person at any time. Though specific individuals are sometimes targeted, it is as if the individual matters not—just the gang entity to which he or she belongs. A twenty-three-year-old young man elaborated on the significance of pride:

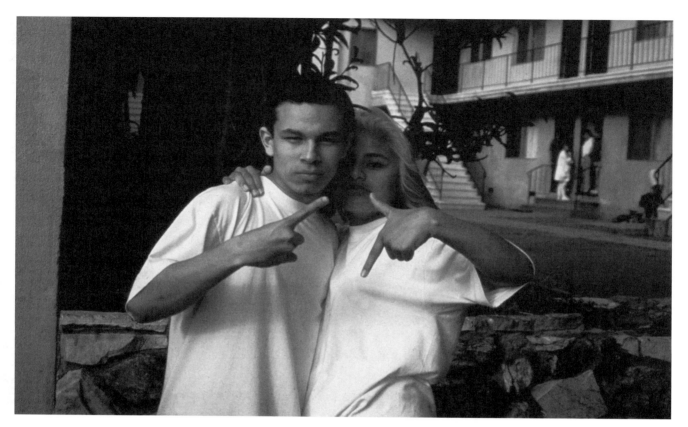

Fig. 3.5. Lefty and Chuca, signing "1" and "7" for Santa Monica 17th Street (June 1991)

Pride, that's what most of us die for. Respect and pride. It's our pride, you know what I mean? You gotta earn it. It's like a family, it's like your mom and your dad. You got love for them. And somebody disrespects your mom, your love and respect and your pride is gonna jump in the middle. Same thing here. We're a family. We're a neighborhood. This is a family right here. If somebody disrespects one of my homeboys and I'm there, of course, our pride is gonna jump in. Because you were disrespecting my homeboy. It's not like we're blood, but you know we're like a family. I ain't gonna just sit there! That's the way we're taught to handle things, we grew up to handle things. We ain't taught to sit there and say, "Okay, let's take a deep breath and count to ten." It doesn't work for us like that. If you get into an argument with somebody, you better be ready to die. It's your pride, it's your pride, you know. What you got in your heart. And that's what gets 90 percent of these people killed. It's your pride and your love. Your love for what you represent.

Making good graffiti, answering swift calls to action, being fearless: these things make the pride. And the pride is what draws people to the gang. Because there is nothing like being around people who have something to be proud of. Pretty soon, you want to be proud of something too. And you look around at your life and you realize that you have nothing that can match what they have. So you pay the price, you get jumped in (initiated into the gang), and maybe you get into a situation where you have to spray gunfire at someone's house one night—or drive the car for the gunman. Or you're pulling a stretch of nylon over your head and ripping off someone's house. Or stealing a car. Or maybe you're getting to know a few drug dealers, a few sources. You take a particular corner. This is how you start to make your living. But this isn't as important as the pride you feel for your neighborhood, for your gang's name, for your family, and your willingness to protect those things above all else. Gang members are bound up in the pride they share with their homeboys and in the group they represent together.

Being in a gang is not just about being a part of what you love: it's about representing what you love and actively creating it in the process. Representing is a practice that is public in nature. It shows your homeboys and your enemies who you are and what you stand for. Representing can take many forms: warfare, tattooing, graffiti, clothing—even when homeboys hang out on a certain corner they represent their neighborhood. These public acts become mechanisms through which gang members manipulate their neighborhood position in the gang world. Indeed, gang members recognize the active role they play in creating and maintaining their place within the family of gangs through such practices.

## REPRESENTING THROUGH GRAFFITI

Chicano gang members represent their neighborhoods in graffiti in a variety of ways and for a variety of reasons. Their graffiti ranges from the most minute writings on walls and concrete scratchings to larger-than-life gigantic images that require the use of ladders and crates of spray paint. These messages have the ability to stand on their own and act for gang members even when they themselves are not around; their public nature makes them an important locus to position self and group at a distance through shorthand symbols. Graffiti are crucial mechanisms for the acts of representing through which gang members intertwine their emotional and political concerns.

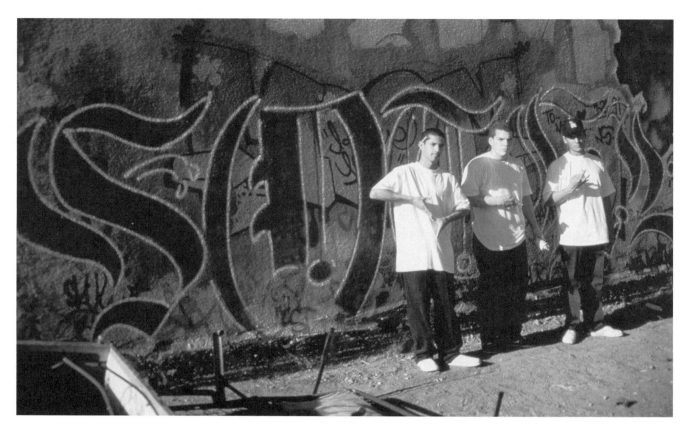

Fig. 3.6. "Sotel" in Old English letters (1992). The young men are signing "S," "1," and "3" for Sotel 13.

Gang members identify basically four interrelated but distinct types of graffiti: hitting up, crossing out, roll calls, and RIPs (memorial graffiti). They correspond roughly to the categories with which Ley and Cybriwsky (1974) designated Philadelphia graffiti: affirmative and aggressive. Through "hitting up" and "roll calls," gang members make positive statements about group belonging and membership (what Ley and Cybriwsky indicate to be roughly affirmative). Through "crossing out" or "challenging," they engage other gangs in discontinuous dialogues that are ritual struggles for power and recognition within their community (what Ley and Cybriwsky indicate to be aggressive). Constituting the last category are the memorial markers gang members make for homies lost during the course of these struggles; generally they are called "RIPs." These categories relate to different elements of gang life and membership. Through the text I link them as often as possible to the social concerns that further bind gang members to their neighborhoods and culture.

All gangs define themselves in part by who they are and in part by who they are

against. Because of their generations-long history, Chicano gangs seem to have a mostly positive form of identity, focusing on the production of pride-affirming messages. Gang members represent levels of identity through different kinds of events, body decoration, writing, and speech patterns. While the general forms this expression takes are common to all Chicano gangs, the specific content varies from gang to gang. Each neighborhood has its own name, specific color, hand signs, initials, sometimes insignias, and common nicknames. In figure 3.6, for example, Sotel gang members from West L.A. are signing S, 1, 3, for Sotel 13; and all sport the common threads of the 1990s gangster. Behind them is a composition in brown Old English lettering (brown is the neighborhood color) that I watched them complete together.

Graffiti is one among many gang practices that help gang members define their group within the spaces where they live. Examining graffiti and its links to other types of cultural production through time is a uniquely strong method for charting social and political change. Graffiti—a barrio's visual, tangible history—offers living proof of both changes and continuities in neighborhood concerns.

### *From Alley to Major Street: Hitting Up the Neighborhood*

To begin to understand gang writing practices, we must remain for a time within the circles of neighborhood streets to focus on the larger issue of constructing space—from alley to major street in the gang landscape. In addition to its role in marking out territories, gang writing is about embodying the gang within neighborhood space for a variety of social, political, and economic reasons.

"Hitting up" or "striking" is by far the most important graffiti activity for Chicano gang members. A "hit-up" or "placa" is a simple writing of the gang name, clique name, and the name of the writer and a few of his or her closest friends. Gang members make hit-ups on walls or other visually accessible areas in their neighborhood. A hit-up does a number of things: it shows a writer's support for the neighborhood; it delineates the position of the neighborhood in relation to other gangs in the system to a greater or lesser degree; it symbolizes the gang's presence in the neighborhood (as well as warning other gangs to *"trucha,"* or beware); and it generally assists the gang in its quest for respect and reputation.

In the process of achieving these goals, Chicano gang members have developed complex social and aesthetic practices in graffiti writing, making it what Sally and Jerry Romotsky call "the most interesting, subtle, and aesthetically complex graffiti in this

country—probably in the world, including the much publicized subway writing in New York City and the political sloganeering of Paris or Rome" (1976, 13). Since the Romotskys applied those descriptions to Chicano gang graffiti in 1976, the gang phenomenon has grown immeasurably, styles have changed, and competition for space has intensified. Chicano gang writing styles have affected the aesthetics of both black gang graffiti and tagging in Los Angeles. Because Chicano gang graffiti is the oldest form of community-based graffiti still existing in Los Angeles, news media and law enforcement as well as the general public have tended to classify all L.A. graffiti as gang related and have pigeon-holed it as merely claiming territory. This simplistic notion disregards the variable roles that graffiti play even within gangs themselves.

Gang members insert themselves into the scenery in a variety of ways. Their stories include references to the fence they jump over every day, the abandoned house where they once hid booty from a robbery, the place where a fellow homeboy died. Gang members write their gang names and personal nicknames on walls for their fellow homeboys to see—sometimes in their hangouts, on storefronts, or on particularly visible neighborhood walls. In this way, they create a landscape full of social and historical references that bind them to their neighborhoods and give them a sense of place. Yxta Maya Murray's recent novel, *Locas,* about girl gang members in Echo Park, describes how people in different neighborhoods share these sentiments: "They hate us and we hate them, but we all have the same kinds of streets and houses and trees memorized in our hearts" (1997, 177).

Personalized and group landmarks may include elements of the natural landscape, but also ones that gang members manufacture themselves. One in a line of similarly impressive writings on the side of the 10 Freeway, the photograph in figure 3.7 was taken in the Big Hazard neighborhood in the Ramona Gardens housing projects. Up close, these writings are old and cracked, but they embody the careful aesthetic for which Chicano gangs are famous. They are some of the few gang graffiti visible from Los Angeles's freeways. Graffiti as well as the people that continually hang out on a certain corner have joined the streets, houses, and trees traditionally serving as neighborhood landmarks.[6]

One young man from Santa Monica told me what he thought graffiti was about:

You usually write graffiti to let people know where you're at. To let people know who's on the streets at night. You see Clavo somebody, so and sos, you know, that

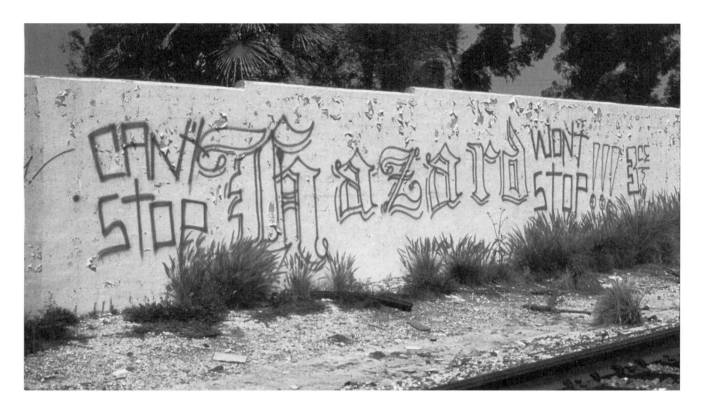

person is up there all the time, you know that person. I mean, that's a name. Now you know where you're at with style, with class.

Fig. 3.7. "Can't Stop Hazard Won't Stop!!! 3ce" (for trece, or "thirteen")

Besides simply marking out territory, graffiti helps designate which individuals can be found on the streets in the nighttime reigns of gang neighborhoods. You can get to know people even if you never meet them—a name on a wall represents an individual just as a gang name represents the gang as a specific entity, adding "style" and "class" to lower-income areas with high rates of absentee ownership. Hit-ups transform the walls into representations of the gang and the pride its members feel in their common bond to one another.

The younger brother of the Santa Monica man told me:

I think Chicano gangs . . . they put a lot of pride into writing. They don't just want it up there . . . you know. I think they want it up there . . . I think they want to be known by doing it, and plus, you know, how well they did it. You know, how nice they can do something like that.

Chicano gangs construct neighborhood spaces from the inside out, starting with an infusion of graffiti that takes years to produce and lasts as long. They encircle themselves with highly visible landmark compositions that are more prone to erasure or defacement. Gang members write on a number of different things: on storefronts, on abandoned houses, in alleys, and all over the streets surrounding their hangouts. In many smaller barrios, it seems like you just fade out of one barrio and into the next; the overbubbling core starting to recede, then resurfacing with the edges that sometimes house startling monuments in block letters. In denser gang areas, boundaries are more rigid. Graffiti is spread over every surface imaginable. Across one street, over two blocks—these are the beginnings and ends of neighborhoods; their territories are so circumscribed by enemies that even walking in the heart of one's own area seems a risk.

Appadurai writes how anthropologists have often described "the myriad ways in which small-scale societies do not and cannot take locality as a given. Rather, they seem to assume that locality is ephemeral unless hard and regular work is undertaken to produce and maintain its materiality" (1996, 180–81). Taking such a stance, even without external forces that wish to erase signs of their culture, these smaller-scale societies construct locality (akin to neighborhood) in material ways, through ritual, gardening, and architecture. In the process, they manufacture a common identity, a culture. With the threat of imminent attack from local enemies and the police, gang members are acutely aware of the action and process the protection of their few neighborhood blocks requires. It is perhaps ironic they rely so heavily on the ephemeral medium, graffiti, to claim their stake. But unless one has the ability to build pyramids, many elements of materiality require human upkeep. Rituals cease, gardens die, houses melt again into the land—only people are there to keep them alive.

When I first started taking pictures, I moved between spatial elements of gang neighborhoods: the alley, the hangout, the main street, the park, the storefront—usually small and privately owned, specializing in liquor and light grocery, the hallmark 1950s-style mom-and-pop store of Los Angeles's urban neighborhoods. For the gang members as well as myself, these stores quickly became old standbys.

Joe's Market (figure 3.8) was the first place I ever took pictures of gang graffiti. Covered on all sides, the owners waged a constant battle for graffiti-free walls. They were only victorious by celebrating patriotism of another kind with the GO DESERT STORM mural they eventually painted on the other side of the building. Flags and an eagle instead of

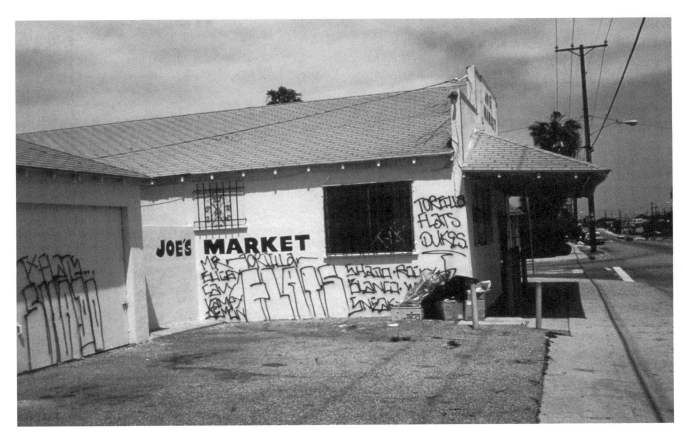

Fig. 3.8. "Tortilla Flats."
Joe's Market, Torrance
Boulevard and Berendo
Street (October 1991)

the "T's" and "F's" of the Tortilla Flats neighborhood. From the walls of Joe's Market, I learned about graffiti on my way to school everyday. As I stopped there, I was drawn further into the neighborhood by other images: down one street, hanging laundry; beside it, graffiti covered by overgrown purple daisies; over to the right, clucking chickens pecking hard at the dirt—soft dirt for the roses; further up the street, gutted houses on stilts with more than a regular paint job; then to the right, the shell of a 1950s car, missing windows and doors and "TxF's" decorating all sides. The graffiti helped me learn what was real here and what was important to know: where people were, where they hung out, who hung out with one another.

Gang members create material elements to act for them. They write graffiti neatly and respectfully to turn them into active messengers that literally and figuratively make their names. Cricket from Santa Monica described this process:

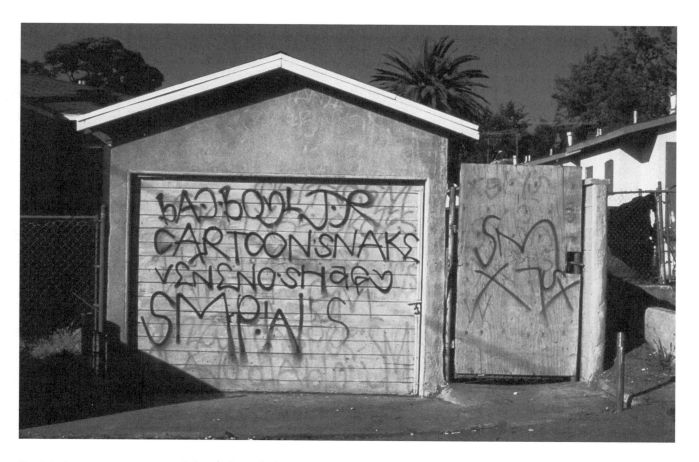

Fig. 3.9. Santa Monica alley garage door. Bad Boy, JR, Cartoon, Snake, Veneno, and Shagy are all gang member nicknames. "SMPW'S," in larger letters, stands for the Santa Monica Pee Wees (the gang and clique names combined). The "SM X7 st" to the right denotes Santa Monica 17th Street (the "X" is a roman "ten").

It just brings, let's say, I guess, publicity. You get known. You know, you meet somebody and they'll say "Oh I heard of you" or "I seen that writing you did on the wall, that was crazy." It just makes you feel like "dang!" you know. And it makes you want to do it so more people can find out about you, even if they don't know you. Most of the time the person on top gets the credit for doing it. I mean, it's not like they get paid, not that kind of credit. They say "Oh yeah, I seen what you did, x" or "what you did, it looks tough" or whatever.

Writing graffiti helps people "put in work" for their gang. By doing so, individuals manipulate their own position within the gang, their personal position within a local environment of gangs, and their gang's position within the local Chicano gang community. Surrounding themselves with manifestations of their own existence and symbology, gang

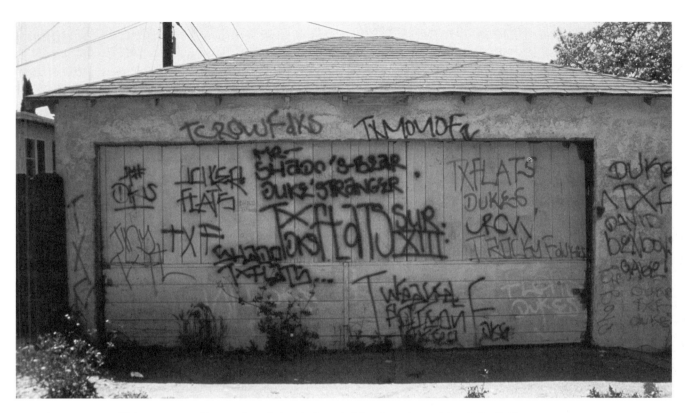

Fig. 3.10. Tortilla Flats garage door (1991)

members use graffiti to weave themselves into their neighborhoods and to delimit the boundaries of the larger gang social system and their place within it.

When I first started out, images like the one pictured in figure 3.9 were essential to my work. They were the heart of it, in alleys; the stable medium, a garage door. Left behind, these were the places homeboys could always go to make their signs—alleys were always chock-full of designs and lettering through the ages, sometimes overlapping one another. Other images were like figure 3.9: pristine, basic in message, neither astoundingly beautiful nor terrifyingly ugly. I relied on alleys for constant material and to give me the sense of urbanity that accompanied these hidden works: trash and broken-down old mattresses, the occasional scattering of watermelon seeds and rinds alongside words that would usually "stay up a little longer."

Figure 3.10 shows a garage door in an alley covered with hit-ups from a variety of writers in the Tortilla Flats Dukes, Los Angeles Strip area, where Shado, Mono, Crow, Rocky, Weasel, Tiny, and Joker have made compositions. When more than one nickname occurs,

the person named on top is generally responsible for the production of the piece. Shado's composition in the center of the garage refers to "Sur XIII," for Sur 13, connoting the gang's Southern California affiliation (which I will discuss later). Chicano gang members often use roman numerals in their compositions.

I learned a lot about the general writing practices of Chicano gangs in alleys. For example, the garage door in figure 3.10 is a good demonstration of the various ways gang members play with the initials of their gang and clique names in their compositions. Tortilla Flats is written as "TXF" (where *X* represents a period or a space), as "T Flats," and with the letters "T" and "F" surrounding the names of the gang members, as in "T Crow F." "DKS" stands for Dukes, the name of the current clique in this neighborhood. The small "R" on Mono's composition stands for *rifa,* or "rules." A "v" preceding the gang name in a composition (although none are present here) can mean either *viva* or *varrio,* the popular alternative spelling of the word *barrio.* In *Los Angeles Barrio Calligraphy* (1976), the Romotskys note the rectangular shape of most Chicano gang graffiti compositions. The works on this garage door show how writers creatively manufacture this rectangular shape with a variety of plays on their gang's initials. Alleyway compositions provide opportunities for both better and lesser writers to display their names in graffiti. Usually only better writers, sure of their abilities, venture forth onto more visible neighborhood streets.

In chapter 1, I quote Ben Lomas as saying that you cannot understand graffiti "by separating them from the walls on which they appear" (1973, 88). In this sense, alleys represent the precise nature of the gang world. They are the places no one looks at, the decrepit backyards of regular social life, where people shove out of sight their refuse, the unwanted or old, placing them conveniently into the hands of others. Simultaneously public and private, alleys also offer an intimacy—one of little-known shortcuts, holes in fences, temporary holding places for people's secrets.

Due to their isolation, alleys are places where gang members can generally write undisturbed. Thus the alley becomes a stable host for years of gang identity, with gangsters taking advantage of the nebulous space where safety, comfort, and place seem to be the opposite of what the nongang world values. What provides these things for gang members (dirt, graffiti, isolation) often represents danger for others who are outside their system. Through their activities and behaviors, gang members and other street elements that frequent such places as alleys or dead ends turn them into areas that people actually fear.

In some places, on the Westside or in the Tortilla Flats neighborhoods, I used to walk

or drive down miles of alleys at a time, taking pictures of every one of the multitude of images I encountered. I would run across dead chickens and birds occasionally, and had to jump out of the way of racing cars every once in a while, but I never encountered anything too hostile. I gradually learned to be more afraid of alleys as I moved deeper into the city—more afraid of abandoned places in general. By the time I got to South Central Los Angeles, I deemed alleys entirely off-limits. Indeed, venturing only a few feet into an alley to view some block lettering one day, I felt as though I were risking my life. So dense with trash, most alleys there are unnavigable with a car. Many remain unpaved and become extraordinarily muddy after a rain. For the drama of the fire truck, children periodically take joy in setting larger piles of alley refuse ablaze. It is one way to get rid of the trash.

I never met gang members who actually hung out in alleys, except when they constituted a sort of extended backyard for a real gang hangout. In Santa Monica, I had a few friends (see figure 3.11) that used to hang around the alley near Pico and 14th Street, in front of an apartment building that faced toward it. This alley was really more like a regular street, a popular shortcut for cars. The gangster presence there would occasionally be countered by birthday parties that decorated the entire front of the apartment complex with streamers, music, and laughter. I marveled at the flap in the screen of the second-story window through which one could toss anything from baby diapers to old beer bottles into the dumpster directly below. If you missed, what was the big deal? The thud of a heavy diaper or the shattering of glass—it was just an alley, after all. I watched people dealing crack out there; they explained to me that the little white rock was called a "duv" and cost twenty dollars—this is why twenty-dollar bills are generally called "duvs" in street talk. (I think the price has now dropped to ten dollars, or maybe it was just Westside inflation.) When I took pictures of nearby graffiti in the alley, the homies scoffed at me—those were nothing, not even worthy of a second look, they said. What I really wanted were those placas on the main streets, where people took the time to represent themselves well.

Often main streets did indeed house the best graffiti in a neighborhood. But sometimes the isolation of their neighborhood core enabled gang members to create larger scale, longer-lasting compositions; increased space available with abandoned areas like the one in figure 3.12 equally provided opportunities for graffiti that ran the gamut of neighborhood concerns.

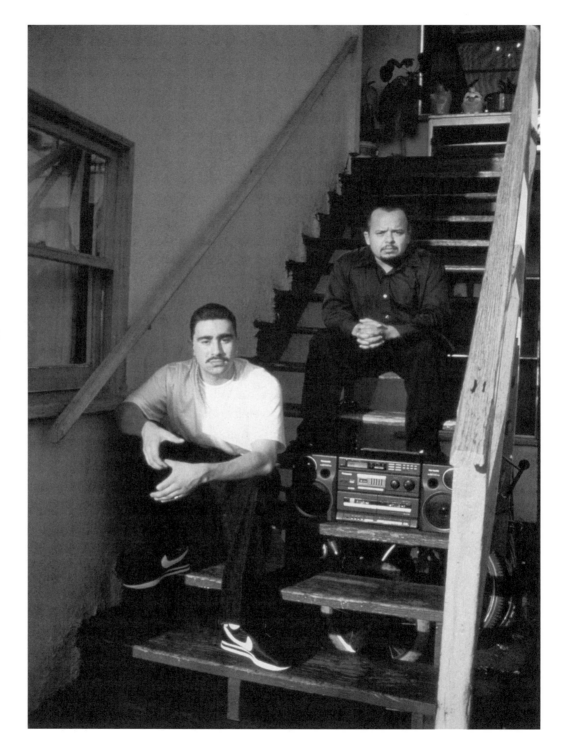

Fig. 3.11. Diablo of Santa Monica 17th Street hanging in the alley with his homeboy, Shorty (Santa Monica, 1992)

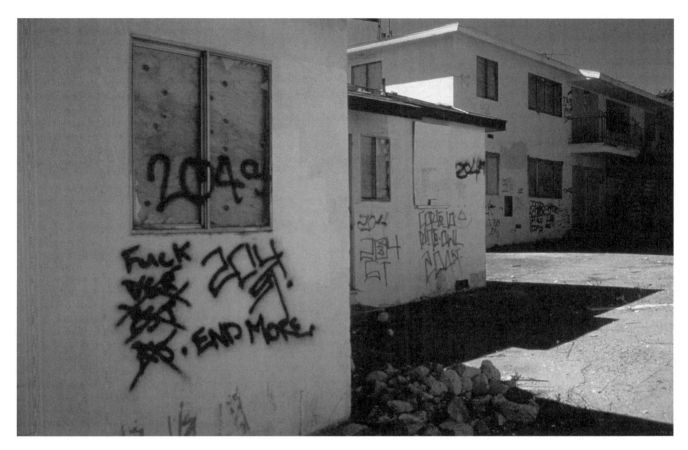

In this abandoned apartment complex on a bright, sunny day, I was surrounded by manifestations of the 204th Street gang. Red and black words were framed against a blue sky. Block and single-line lettering stood like monuments that were only visual hints from the vantage of the street. To get to these compositions, I had to walk by a hive of bumblebees the children had warned me about a few days earlier. Having learned to fear isolation, I thought others should accompany me when I ventured to such a hidden place. I brought along two friends who didn't know anything about gangs or graffiti. But the bright sun and the kids playing with their red ball nearby made me feel at ease. My friends, however, didn't pick up on those cues. Their vision was monopolized by the words around them: more graffiti in one place than they had ever seen in their lives. They got scared fast and, later, mad at me for their discomfort. I was angry at myself as well—for forgetting. How easy and interesting it was for me, while all they saw were the scrawls they knew

Fig. 3.12. Abandoned apartment complex in the 204th Street neighborhood (Torrance, Calif., 1991). The composition in the foreground includes a specific list of enemies, a practice more common among African American gangs.

only to represent violence and territoriality. I had to remind myself why other people did not share my naive excitement about graffiti. Later, I learned to ask gang members to give me guided tours of their neighborhoods, including those places to which I would usually be scared to go alone. They were usually hospitable and willing to explain what they were doing. When I first started, however, I believed even a little danger was worth the images like the one in figure 3.12—but I would never again drag my friends along with me.

I was able to photograph a number of memorable graffiti that day further into the complex, including larger-scale compositions like the one in figure 3.13. Peanut, first on the list along with Goofie and Gremlin, is probably responsible for this hit-up. He has written the name of the gang in two-dimensional block letters, using a regular round lettering to write his own name and those of his friends next to the larger, more intricate gang name. Gang members make use of what art historians call "hierarchical scale." That is, they make the most important thing the biggest. In gang situations, this usually means that the gang name or initials are larger than clique names or individual nicknames; they subsume the individual. The gang name is also usually the most elaborate, which will become increasingly clear in the following sections on block and Old English lettering.

Peanut's use of "I'm" in this composition is uncommon. More often, hit-ups read *"soy"* ("I am" in Spanish) or *"somos"* (or *"sms"*), meaning "we are." The names below Peanut's are probably his close friends (his "dogs") or people who were present or helped him with this particular graffiti-making venture. A young man from South Central L.A. described this process to me:

> Whatever goes on there, goes up, those are the ones that are representing the neighborhood. Not to say that the ones that are not on there are not representing. But the ones that are were part of that. They were there, watching out. Someone gots to go over there, someone gots to go stand on that corner. It's a work. It's a job. We give credit to everybody who was there. So to say to everyone that, "You know what? We did this." The first one on the list is the person who actually does it. It's just like an artist, you always strike up your work? But you give credit. You know, you'll give credit to your publishers and all that? Same thing, he just gives credit to the people that help him do whatever, finish his art.

Contradicting scholarly interpretation of graffiti as an aspect of the alienating urban experience, gang members generally make graffiti in collaboration with their fellow

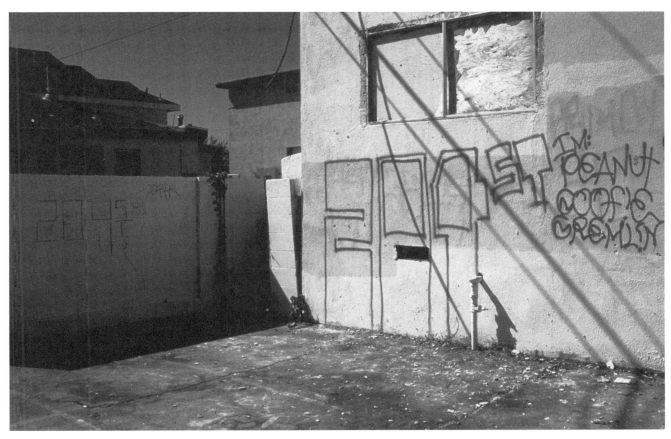

Fig. 3.13. Larger-scale composition in abandoned 204th Street neighborhood apartment complex (1991). "204st" represents the gang name; "Peanut," "Goofie," and "Gremlin" are the nicknames of the graffiti writer and his friends.

homies. Even if only one person does the actual work, the others who looked out perform essential roles and share in the excitement of getting the piece up there. The concept of "credit" transcends the boundaries of the immediate gang or clique. As writers give credit to those who assist them in their compositions, they additionally publicize the names of their companions, making the "I" venture an inherently "we" venture.

An abandoned building, a dead end, a nook, the house of a friend, a measure of safety in the apartment courtyard—inside or out, any or all of these can become gang hangouts and the places where gang members socialize on a daily basis. Hangouts constitute the symbolic if not literal core of a neighborhood; they are never on the fringes or borders but serve as common reference points for people across the generations. Their locations may remain stable for years, but sometimes they change with the emergence of new cliques. Beside them graffiti reside on every space imaginable, carved into trees whose

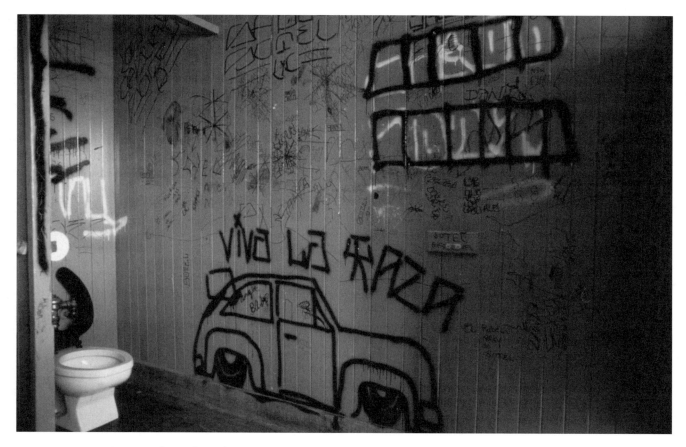

Fig. 3.14. Stoner Park Recreation Center, Sotel neighborhood, 1974. "Viva la Raza." Photograph by Leonard Nadel, courtesy of the Leonard Nadel Photo Archives.

branches also house secret stashes of weapons, sprayed onto sidewalks that have been marked with blood, written on buildings into which triggers are also lodged, painted on the black asphalt streets where gang members walk every day, etched into the glass of the cars they drive. From the ground up, with graffiti, tattoos, clothing, music, and the home-boys hanging out beside them, gang members create their neighborhood as a living, breathing entity.

In addition to spaces near the apartments and houses where gang members live, parks and neighborhood recreation centers often become main hangouts and essential features of the neighborhood landscape. Gang members may have mentoring relationships with park staff in such places. The gang presence may frighten neighbors away from a park, but often gang members maintain surprisingly peaceable relations with the local residents.

In the Sotel neighborhood of West Los Angeles, Stoner Park Recreation Center has

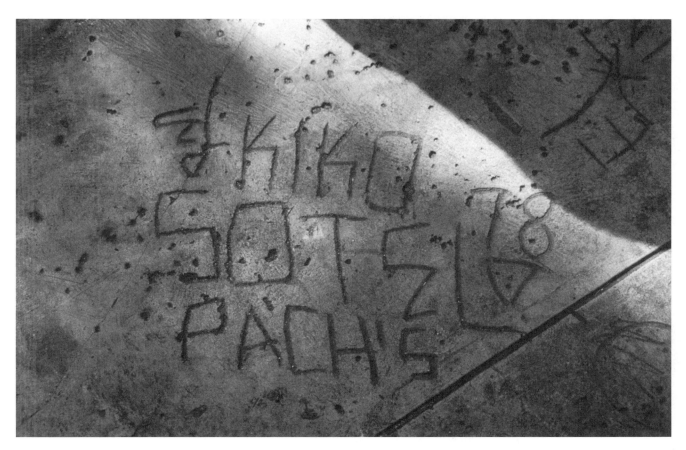

Fig. 3.15. Stoner Park Recreation Center, 1978. "El Kiko"; "Sotel 78"; "Pach's" (Pachucos).

been the hangout of the Sotel gang for nearly thirty years. "The Park?" one answered when I asked how long they had been hanging out there, "We've always had the Park." Figures 3.14, 3.15, and 3.16, a series of photographs showing graffiti from 1974, 1978, and 1991, demonstrate how Sotel gang members have used graffiti to declare their presence in the park across three decades. The content of these writings has remained stable, though the lettering itself has gone through some changes: from the early 1970s explosion of writing that overlaps with images of Chicano identity (such as the car), to a return to the basic blocks and precise lines in the 1990s. A wealthier neighborhood demography has since caused this park to be fenced off—forcing the Sotel gang members to go elsewhere to have their meetings, "jump in" their initiates, socialize on a daily basis, and write their graffiti. Wherever they end up, their associations with this park will ever remain scratched into the park's concrete infrastructure. Gang members use graffiti along with

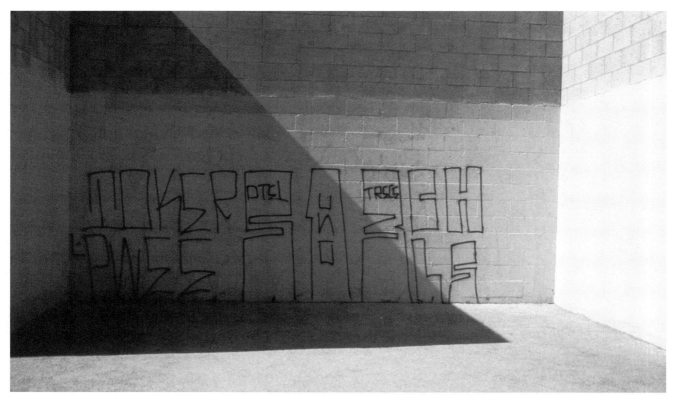

Fig. 3.16. Stoner Park Recreation Center, 1991. "Toker Pwee"; "Sotel Uno Trece" (13); "CH LS" (for chicos locos, the name of the clique).

other media to mark out the spaces where they live, the places that represent their own lives as well as those of their predecessors.

In addition to parks, main streets often house landmark compositions that are larger in size, more complex, and carefully rendered. This more visible placement enables writers to direct their messages toward the local gang community of rivals as well as allies. (This is what Ley and Cybriwsky called aggressive.) No matter how many times they are erased, these graffiti pop back up in the same places over and over again, transitory monuments in the collective memory of lookers-on. Driving down a certain street, I always glance to the left to see if it's still there. Other places, I look to the right, or up above to that special space of wall, to see what's new and fresh. You know a gang is changing, diffusing, or becoming inactive if these spots, the best walls in the neighborhood, remain without graffiti for any extended amount of time. With spray paint, graffiti writers fill the land with images of their own name, stand-ins for the breathing bodies that have made them.

A young man from 29th Street in South Central Los Angeles explained it like this:

It all comes down to basically politics, like everything else. Like you're talking about graffiti right now. That's the way we show . . . Graffiti . . . to us . . . what we write on the walls . . . is to mark our territory. Which you already know. A way of us marking our territory so people know. See right now we might not be here to represent our neighborhood, but they pass through this, "oh look this is where so and so kicks back." See, it does serve a purpose! That's what we use it for. But yet when we try different styles and different things. Because, believe it or not, we try to make our neighborhood look good. I mean, we don't want to write just whatever writing, we want to make it nice writing, you know what I mean? So our friends, so they'll take like a double look. We see it as trying to better our neighborhood. We don't want to write on the wall and just leave it all ugly, we want to write on the wall and make it look nice.

I held my breath after hearing this man begin, through his false starts that ended with territory. Gang members rarely articulate a sense of their lives being political—after all, they too live in a society where politics are limited to the activities of Democrats and Republicans. Though they sometimes fall back on mainstream notions they've heard so many times about themselves, gang members know that their writing and other activities have an effect and a purpose in terms of their relationships with people on a number of levels. The effects of graffiti this man articulated dealt with representing the neighborhood for strangers driving by, as well as creating stylish pieces in order to impress friends.

Whether in alleys, around hangouts, parks, on main drags, or on major streets, gang members write graffiti for themselves and others who understand their messages as acts of representing. Gang members use graffiti to organize the spaces in which they reside; in the process, they cover the streets with manifestations of their own identity. Like silent sentinels, the graffiti keep watch and inform onlookers of the affiliations and activities that define a certain area.

## Cliques: How Different Gangs Move around the City

Representing themselves within the bounds of specific neighborhoods is how gangs survive from day to day. But gang membership means more than an affiliation with a broad gang entity—each gang comprises age-graded cliques or subsets. Besides writing their gang's name in a basic hit-up, gang members also write the name of their cliques (Pee

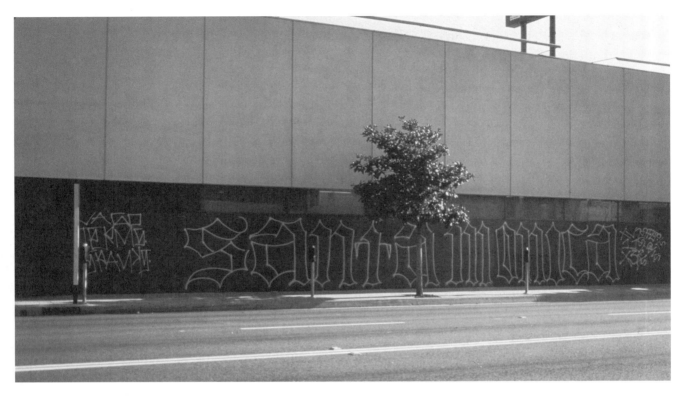

Fig. 3.17. Thrifty's drugstore, Pico Boulevard in Santa Monica (1992). To the right of the lowercase Old English letters reading "Santa Monica" are initials of the different Santa Monica gangs: "XV2ST TLs, PLs" for 17th Street and the Tiny Locos and PeeWee Locos cliques, "11ST CHVS" for 11th Street Chavos, and "X3 LL's" for Thirteen Little Locos. On the left are the writers' nicknames: Vago, Terms (for Termite), and Spanky.

Wee Locos, Dukes, Chavos, Nite Owls, Tinys, and so on). Today, Chicano gangs also comprise street cliques—subsets based on neighborhood geography as well as age.

One day, driving down busy Pico Boulevard in Santa Monica, I pulled over to photograph an impressive composition in Old English writing on the side of the Thrifty's drugstore (see figure 3.17). This was the kind of graffiti those guys in the alley had wanted me to photograph. Later, during an interview, I showed the picture to a young man from Santa Monica. He explained why this is a good composition:

This is actually really good, you know, it's not too easy to do. 'Cause this is shown on Pico Boulevard and there's not very much time that you could sit there and make all those letters all . . . all . . . you know, how straight they are. And all the same-sized letters. And then, you know he didn't have more than five minutes to do it, 'cause he could get in trouble, especially on Pico Boulevard, one of the busiest streets in Santa Monica. So this is really good. This is a person that's been doing a lot of writing on the walls.

Vago manufactured this piece not just in the name of his own clique or gang, but for the three different cliques that exist in Santa Monica. He wrote out the entire name "Santa Monica" instead of just using initials, something that involved even more effort and risk on his part. Because of the location he chose, anybody driving down Pico Boulevard would see it. This writer felt confident enough about his command of the Old English style to represent all the different cliques with it and to write it on a busy street. If he had made a mistake, it would have been there for everyone to see. These are some of the issues with which writers must concern themselves when representing, and therefore acting on behalf of, their neighborhood.

The man I interviewed referred again to this image to describe the relationship between the different cliques in Santa Monica:

> Just because they're from 11th Street and we're from 17th, it doesn't mean we don't like each other. We're like the same people, you know. It just shows different parts of, you know, places we live, where we grew up at. We believe that if you come from even a few blocks away . . . you know, it's enough to make a difference so we make different cliques.

Growing up even a few blocks distant involves a different landscape, a different set of neighbors, another group of kids to play with, a different bump in the sidewalk to associate with home. One side of the park or another, the rumblings of the bus to shake the house instead of the rush of the freeway. To represent these differences, gang members may create multiple cliques that concretize their particular view of the world under the umbrella of the same entity.

This sense of place, so important to gang members, flows from personal experience into material creations that eventually define their relationships with others. One young man from 29th Street showed me the tattoos on the back of his shaved head and neck, which indicated his gang name, his clique name, and his own name. He told me that he didn't know why, but it was important to him for everyone to know exactly where he was from and what he represented, right down to his own name. Place—that crucial question of "where you're from"—is the driving force of the gang life, one that gang members inscribe into both their environments and their bodies.

Graffiti and tattooing often overlap in the contexts of their use—people use each medium to position individual and group identities at different scales toward different

audiences. I remember Leo showing me his first tattoo. He got it when he was only nine years old, while his girlfriend watched: a shaky "Leo" on the inside of his fourth finger. California law prohibits tattooing of those younger than eighteen, but kids as young as nine or ten may tattoo themselves or one another with their names, a pachuco cross, or the three dots that symbolize "la vida loca"—the crazy life they are about to lead. Smaller tattoos require only the simple technology of a needle wrapped with thread, which is dipped in India ink and pressed into the skin. More complex tattoos may require similarly complex technologies, such as a tattoo gun (frequently homemade). Popular subjects are generic gang sayings like *"Mi Vida Loca,"* "Smile Now, Cry Later," or "Don't let no one get you down." Beyond the scope of specific neighborhoods, these sayings are shared by everyone in the Chicano gang system (and even beyond it), from Los Angeles, to San Diego, to Sacramento, to Mexico.

Specific connections to different places also link gang members together. The initials on the arms of Rudi in figure 3.18, for example, detail the links among different gang entities around the city, using written symbols seen in both graffiti and tattoo.

Through an inherently personal medium, Rudi has represented a neighborhood identity that begins to transcend local neighborhood boundaries. In three-dimensional block letters on his left shoulder he represents his gang, Clanton 14, with the initials "C 14"; his right and left arms boast—in the distinctively shaded Old English style—an "SC" for South Central (his regional area) and "31" for 31st Street (his clique name). The skull with an Indian headdress further places him within a framework of Native American lore mixed with the images of death popular among gang members. Rudi combines these with a Catholic rosary, something many gang members wear, along with sagging pants with stylish boxers beneath them. Thus, tattooing and clothing alike allow people to intertwine diverse elements of their lives, combining them into montages of identity based on personal and communal symbols.

When I first met him, Rudi was suspicious of me—flat-out refusing even to let me take a picture of the truck with "C14's" and "Clanton's" written all over it that had initially attracted my attention. But, as sometimes happens, the ones with the most reservations wind up being the most open in the end. After I explained what I was doing, he took off his shirt to pose for pictures of his tattoos, not even concerned with having his homeboys cover his face or eyes.

The content of Rudi's tattoos adds to what is already a fairly complex manner of

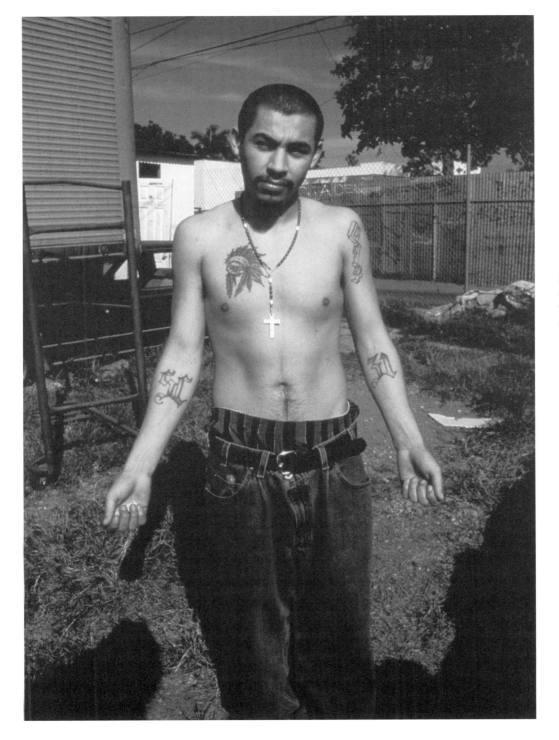

Fig. 3.18. Rudi from Clanton 14, South Central clique, 31st Street (1995)

subdividing specific gangs. The Santa Monica examples show how gangs divide themselves into cliques that are age graded, like the Pee Wees, Tiny Locos, or Nite Owls—different cliques names can thus represent different generations. But street cliques serve another purpose, as we also saw in the Santa Monica composition. Different gangs in a single area will differentiate themselves based on the streets where they live—17th Street as opposed to 11th Street, for example, as subdivisions of the Santa Monica gang. Some cliques are based around a particular street in their neighborhood, such as the 62nd Street clique of the Florencia 13 gang. In 1995, I was told that the Florencia 13 gang had thirty-two cliques, all claiming different numbered streets, mostly in an expanded version of the gang's original area near Florence Avenue between Alameda and Central Avenue (in what is traditionally called the Florence neighborhood). These street-based clique names (like 62nd Street) are already divisions of the larger gang entity (Florencia 13). They may be further subdivided into the more traditional age-graded Peewees, Dukes, or Nite Owls.

The larger gangs of today sometimes also have street cliques that transcend neighborhood boundaries entirely. In Rudi's tattoos (figure 3.18), "31" represents a specific South Central clique of Clanton 14, a gang that originally started in downtown Los Angeles. (The 14 refers to 14th Street [formerly Clanton Street] near downtown; some say this is the basis of the 13/14 division that I will discuss later.) The "SC 31" on Rudi's arms designates his affiliation with Clanton 14, South Central area, 31st Street clique. Many gangs have such cliques—gang annexes, really—because they have grown so large or because their members have changed location and transported their original gang name to the new area. Slight variations in name point to connections between different gangs around the city.[7]

Because of its marked demographic shift from black to Latino in the past decade, South Central Los Angeles is full of such gang annexes. In most cases, the divisions have more to do with movement around the city than with any kind of gang overflow. Sometimes, the shifts are not represented in graffiti at all. For example, repeated graffiti of "Clover 19," a gang originally based near Lincoln Heights on Avenue 19 and Clover, is also written by a part of the group that lives near Vernon Avenue in South Central Los Angeles—miles from the original location. From what I could tell, they had made no changes to the name to account for the new area, but still referred to Avenue 19 near Clover from which they hailed originally.

Other times the migratory roots of a gang are completely erased because gang mem-

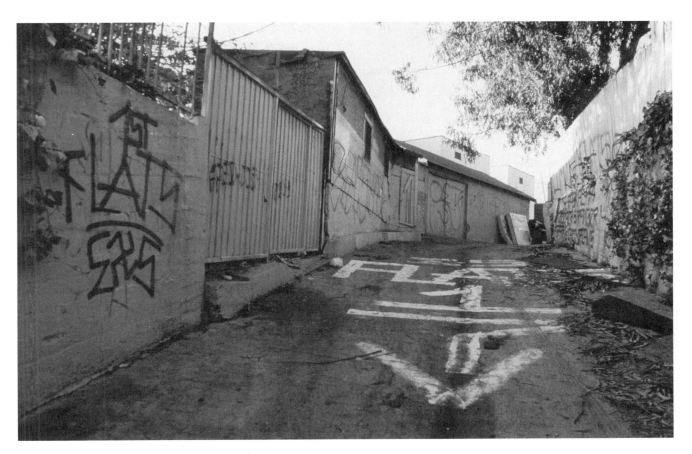

Fig. 3.19. Primera Flats
alleyway (1996)

bers choose an entirely new name to represent themselves. At first glance, the 36th Street gang, on 36th and Maple, seems to be entirely its own entity, featuring no visible or material links through similarities of name to other gangs around Los Angeles. But one day, some members of 36th Street told me about their gang's history.

In the beginning, there was East Side Primera Flats, one of the original East L.A. gangs. Named after Los Angeles's 1st Street in an area historically called the Flats, today this neighborhood is most closely associated with the Aliso Village housing projects. Figure 3.19 shows some Primera Flats graffiti written in an East L.A. alley as "1st Flats e s," for 1st Street Primera Flats East Side. So we're starting in East Los Angeles. Pretty soon, someone from Primera Flats moved to South Central, what East L.A. Chicanos consider the West-side—that is, anything west of the L.A. River.[8] There that person (or persons) founded Westside Primera Flats 23rd Street, whose new neighborhood was located on 23rd Street

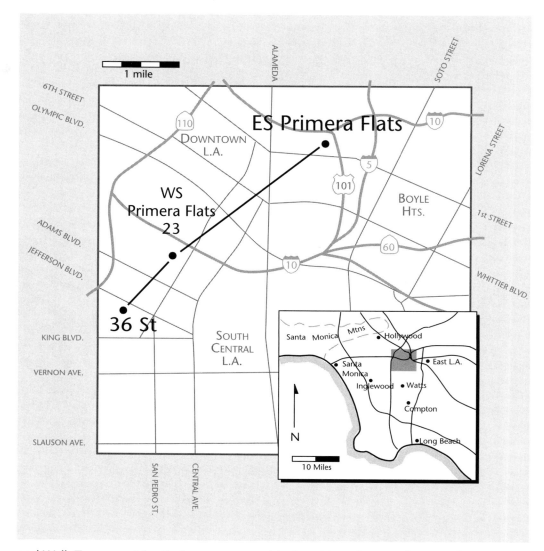

Fig. 3.20. Development of the 36th Street gang from its roots in Boyle Heights to its current base in South Central Los Angeles

and Wall. To account for their new geographical position, the members made subtle but important additions to the name, designating Westside instead of Eastside, and adding 23rd Street, though the Primera Flats label still held. Some of the members of this gang lived down near 36th Street and Maple, a hot spot for drugs at that time.

Because the area around 36th Street was already known for drug dealing, it was a kind of mutual territory where representatives from several gangs used to deal. The main players were from Clanton 14 and Primera Flats, then allies, with a few representatives

from Vickystown (now also in Modesto), White Fence, and Barrio Loco. While there, the two main powers would write things like "C 14 36 st," or "P 36 F," to show their geographically extended affiliations. But one day, the Clanton and Primera Flats gangs began to feud with each other. As their feud escalated into violence, the younger generation of guys who lived in this area decided to disassociate themselves from the two major powers. "They started claiming '36th Street' because they didn't want to get involved with that beef," one 36th Streeter told me. To account for this radical split, members of the new gang changed their name entirely, and, ever since, the gang has been known simply as "36th Street." In this case, though numbers may have been important in this conflict, the split was ideological. As a result, they chose a completely new signifier for their gang.

Despite their links with Clanton 14, the 36th Street gangsters that I have talked to always describe themselves as coming out of Primera Flats. This may be in part because 29th Street, one of their main rivals, has historical links and a continued strong alliance to Clanton 14. The map in figure 3.20 demonstrates the most basic pattern of movement and corollary name changes in this case.

Specific gang histories are often self-evident within names. As in the Clanton 14 case, attachment to neighborhood names is so strong that gangs members who move to a new area will retain the name as an ideological and historical link.[9] Other times, as in the case of 36th Street, brand-new names can indicate that a gang has split from another established gang.

Graffiti is a powerful tool for charting gang movements, but it doesn't tell the whole story—people must fill in the details. Still, basic neighborhood hit-ups can offer clues into the rich histories, ideological splits, and migratory paths that gang members have taken in their journeys through the streets of our cities. This theme reemerges in the discussion of the Bloods and Crips in chapter 4.

## Roll Call

Graffiti can also reveal the particular constituency of a gang through a device known as the "roll call."[10] Roll calls are extensive gang membership lists. If you are present on the list, you are working for the gang. There is no way your homeboys could exclude you from it. If they do, then that's "on you" (your personal responsibility)—it means you haven't been putting in enough work. Sometimes, to account for those who might be inactive or

forgotten, gang members will write *"y mas"* (and more) to indicate that some homies may be left out of a particular listing for whatever reason.

A roll call is a written list of names that defines who does and does not belong to a gang or clique. As Jack Goody has defined it, a list is something that "has a clear-cut beginning and a precise end, that is, a boundary, an edge, like a piece of cloth" (1977, 81). Lists, he argues, rarely exist in speech. They encourage the ordering and classification of things and "bring greater visibility to categories" (81). Spatially and clearly, the gang uses the roll call to order its system by including who belongs to the gang, the specific part of the gang to which they belong, and where the gang is located in relation to other, similar groups.

In order to be included in a roll call, a gang member must have a nickname and be initiated into the gang. Sometimes gang members who literally grow into the system can avoid getting "jumped in," the initiation ceremony. This practice takes different forms but essentially involves gang members beating up the initiate for a variable number of seconds, usually not more than thirty (they can be long or short seconds according to the whims of the timekeepers). Sometimes gangs have different numbers of seconds depending on their street name: 18th Street jumps in for eighteen seconds; 38th Street for thirty-eight seconds. Getting jumped in tests whether the initiate can protect himself or herself and back up the gang when necessary, bonding the people together through the pain, blood, and rebirth of ritual.

The values embodied in getting jumped in are highly practical to the gang, and black eyes and bruises may temporarily mark an initiate in the eyes of others as deserving of congratulations in one sense or another. Events like jumping in ceremonies allow members to engage in social action, which, like speech, is immediately effective. Memories of words and deeds extend the lives of these actions in the minds of their actors or observers.

When written on a wall, however, the roll call represents a belonging that is official. It represents a gang's membership though the gang members themselves are off doing other things. Nicknames that appear in a roll call can be invented, inherited, or contested. The stories behind people's names in the neighborhoods become almost mythic. They represent a common knowledge throughout the gang that links its members together. Gang members do not view themselves as monolithic groups. Rather, they consider themselves as diverse individuals that share a common interest in supporting the neighborhood. The roll call symbolizes a gang's ability to harness diversity by openly addressing

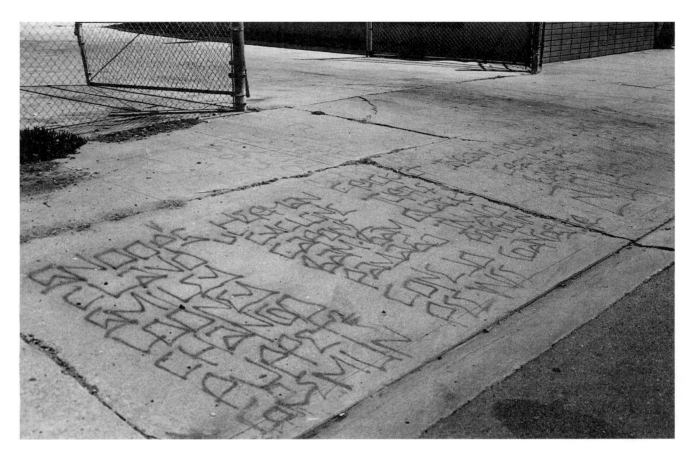

and accepting their differences—and even their flaws. This all-embracing philosophy contributes to the success and strength of gangs today.

The diverse characteristics for which these gang members are named come together under the guise of membership within a single gang entity. Others show relationships between older and younger members. Out of all the members in the figure 3.21 roll call, Puppet2 inherited his name from an earlier Puppet. Puppet2 might be called "Lil Puppet" to signify this inherited name. Sometimes this points out a special mentoring relationship between two gang members, or the relationship of an older brother to a younger brother. On the other hand, I have also heard of fights over nicknames because a gang member wishes to remain "one of a kind." Although the nicknames are particularly suited to each gang member, the types of names chosen are common to the entire Chicano gang community.

The 1991 roll call in figure 3.22, from the Eastside Evergreen gang in East Los Ange-

Fig. 3.21. The 204th Street gang roll call (Torrance, 1991). Gang members include Snoop's, Clavo, Smiley, Looney, Chango, Puppet2, Gremlin, Herman, Cyclone, Capone, Bam-Bam, Payaso, Conejo, Pee-Wee, Cricket, Turtle, Quack, Indio, Penguin, and Gangster. To the far right (barely visible in this image) is written "Insane, No brain, Crazy Ass Barrio 204st."

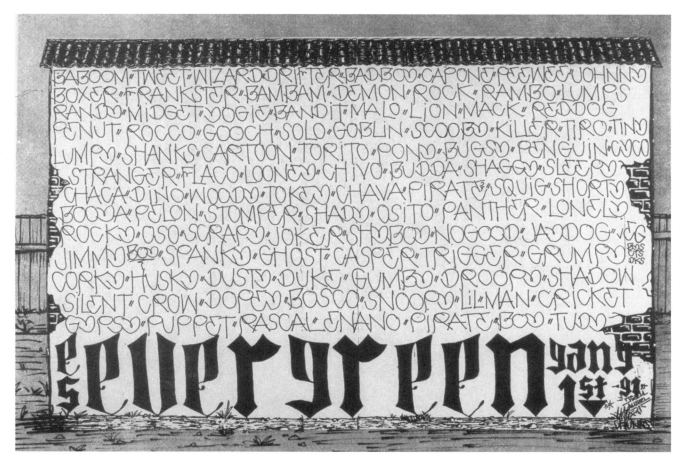

Fig. 3.22. Eastside Ever-green gang roll call (1991). Courtesy of Teen Angel's magazine, issue no. 107.

les, was written in the Old English style and sent to *Teen Angel's* magazine. Roll calls are often long lists that take up a lot of space and paint on a wall. As a result, gang members sometimes write them on pieces of paper. *Teen Angel's* magazine caters to a wide constituency of the Chicano gang population—both in and out of prison. Chicano artist "Teen Leo" makes the backgrounds, which gang members then fill in and send back to the magazine for publication. By sending the roll call to the magazine, the writer knows that it will reach a wider audience of individuals from all over the country. The specific meanings behind the list—that is, the individuals behind the names and the particular stories that surround the monikers—are only immediately meaningful to the gang that produced it. What is important about being published in *Teen Angel's* is the pride in seeing one's own group represented publicly, as well as the recognition of the writer's work by other gang

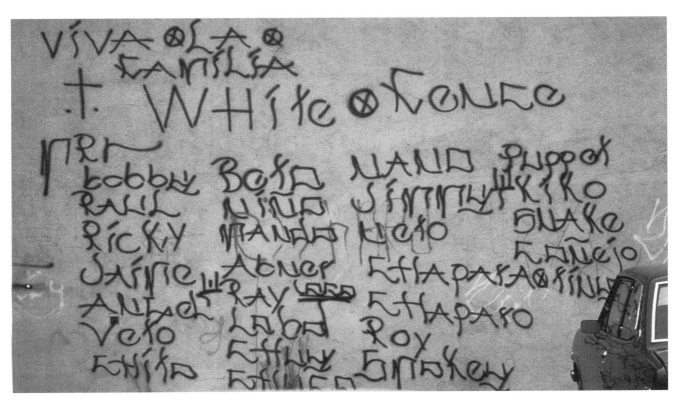

members. Because the strength in numbers rule applies among gangs, a list comprising many names demonstrates a gang's power.

Gangs have been using roll calls for years. The 1974 roll call in figure 3.23 was done by White Fence, one of Los Angeles's oldest gangs and the neighborhood where sociologist Joan Moore has focused much of her work. Twenty years later, roll calls still look very much the same, and are still used to define the bounds of membership.

In sum, gang members use graffiti to construct the spaces where they live, and toward neighborhood-based ends, such as recognition, representing, giving credit, and putting in work. In this way, they may subtly or dramatically influence their position in the local gang community. We have also seen how gangs from specific neighborhoods and streets can transcend boundaries and take identities with them even over large distances. One can chart gang movements both within and across city or national boundaries in this manner. Further, roll calls are systems of gang classification that demarcate individual membership as well as a gang's geographic position within a city.

Fig. 3.23. White Fence gang roll call (1974). Below "Viva La Familia White Fence" (Long Live the White Fence Family) are written the gang member's nicknames: Mr. Bobby, Raul, Ricky, Jaime, Angel, Veto, Chito, Beto, Nino, Mando, Abner, Lil Ray, Loco, Lobo, Chuy, Nano, Jimmy, Neto, Chapata, Chapato, Roy, Smiley, Puppet, Lil Kiko, Snake, and Conejo. Photograph by Leonard Nadel, courtesy of the Leonard Nadel Photo Archives.

But the local gang community is where the gang life just begins. As I demonstrate in the next section, gangs are also strongly affiliated with broader regional, geographical, and ideological boundaries that span the state and beyond. Ultimately, these boundaries and ideologies explain the shape of gang warfare and further types of affiliation.

## A SYMBOLIC SYSTEM OF BOUNDARIES

The gang world is thick with activities gang members use to represent their neighborhoods in personal and communal fashions. Most people already have a strong notion that gangs are somehow linked to the cities and streets where they live and that individuals constitute the membership of those groups. Among Chicano gangs, although those links are indeed primary, individual gangs are part of a system that reaches beyond just the boundaries of their neighborhoods and its immediate enemies. Through graffiti and tattoos, Chicano gang members represent themselves and their position within a larger Chicano gang political system that spans California and the Southwest.

To get at this system, I needed to wade through multiple layers of identity, every once in a while locking in a new piece to the puzzle, finding a new referent for the same symbol or a new symbol for an old referent. The abstraction of this system was one of the most exciting things about it. It was in abstraction where the action became the aesthetic and where material things could themselves become abstract; where people could learn from symbols instead of experience. Perhaps even more exciting was slowly discovering how these elements interwove into daily life, feeding people's behaviors in terms of racial issues and the role of the prison in constituting some of the major divisions.

I present this system to you in much the same way that I myself discovered it as a newcomer to gang life—that is, by starting with one of the most widespread symbols in L.A. Chicano gang material culture: the number thirteen.

### Thirteen and Fourteen; North and South

Several books about gangs that discuss graffiti point to the 13 as representing *M*, the thirteenth letter of the alphabet.[11] They suggest that the M stands for Mexican or marijuana, the latter of which supposedly connotes a general involvement in the drug trade (as also used by the Hell's Angels motorcycle gang, for example). However, none of these sources mention what seems to be 13's most powerful current referent: the fact that it is the sym-

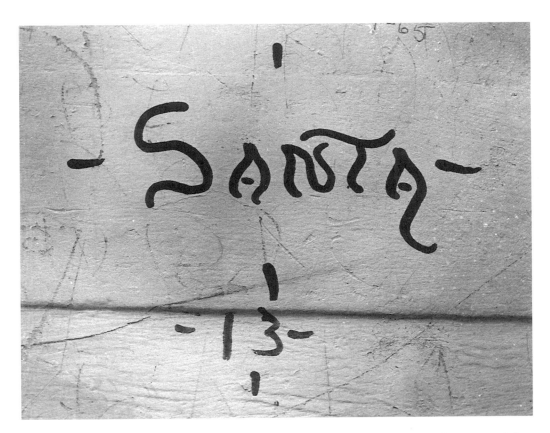

Fig. 3.24. "Santa 13" (Santa Monica beach, 1965). Scrawled above the graffiti is the date: "8-4-65." Photograph by Ben Lomas.

bol of Southern California. I first understood this when I was sitting on the steps of that apartment building that looked out onto that alley off of Pico. I was chatting with a man when I noticed two large tattoos in Old English lettering across his thighs: one read "SUR," the other "13." After I complimented him on the tattoos he proceeded to explain the entire system to me. He said that the 13 really meant "south," which is *sur* in Spanish. The initials S.U.R. could be further broken down to mean *Sureños Unidos Raza,* or United People of the South—meaning, of course, of Southern California, but also parts of Mexico and the Southwest. He also said that the M may indeed stand for Mexican or marijuana, but that its most important referent is the Mexican Mafia, a Chicano prison gang sometimes just referred to as "La Eme." All of Eme's constituents are Southern Californians. This was reiterated by several other informants. According to Moore (1978), EME can also be an acronym for *"El Mexicano Encarcelado"* (the incarcerated Mexican). The M is a good example of what Victor Turner (1969) has termed the "multivocality" of symbols—that a

symbol can represent layered systems of meaning. Symbols are used and understood differently by different people.

In creating this system and taking on what had been the pan-symbol of the Chicano gang world, the 13, La Eme willfully excluded participants from Northern and Central California. Not much later, Northern California prisoners decided to form their own prison gang. They called it Nuestra Familia (Our Family), and took on the letter N, which stands for "North," or *Norte,* as well as its corresponding number, the 14. Gang members from Northern California are *Norteños* (Northerners). Here's what one man I interviewed said about the 13 and the 14:

> From what I know about it, that's all coming down from the penitentiaries. Like they have say, um, San Quentin, which is located in San Francisco. That's like a Norteño prison. And Sureños from over here, you know, around this area, will go up there and they'll be like outsiders. If you notice no matter what city you're in, there will always be a 13 after it. Like Santa Monica *trece* [see figure 3.24], there will always be Venice *trece* or Sotel *trece.* You know, in case they're, you know, somewhere else. It's a source of identity just to say who you are and what type of people you grew up with and could relate to. I mean, there's different styles and when you say you're a Sureño, you're saying that from Fresno or whatever south are the people you can relate to, that you can hang out with, you know, you get along with.

This notion of "style" and the people you "get along with" are the things that interest me most about a division like this. These differences between groups, though clearly manufactured, embody key cultural factors that distinguish one from the other. This ultimately makes them into sort of "natural" differences. However, in their common identity as Chicano gang members, the similarities between divisions like 13 and 14 far outweigh the differences.

There are two places in which the 13-14 division is relevant to daily life: one is in prison, which I discuss later. The other is in Central and Northern California, where the 13-14 division is its most complex. With the powerful emergence of La Eme in the mid-1960s, and the subsequent development of Nuestra Familia, street gangs in various parts of California began to claim either "North" or "South," and to affiliate at the street level with the symbols and categories of those prison entities. To claim North or South, people didn't

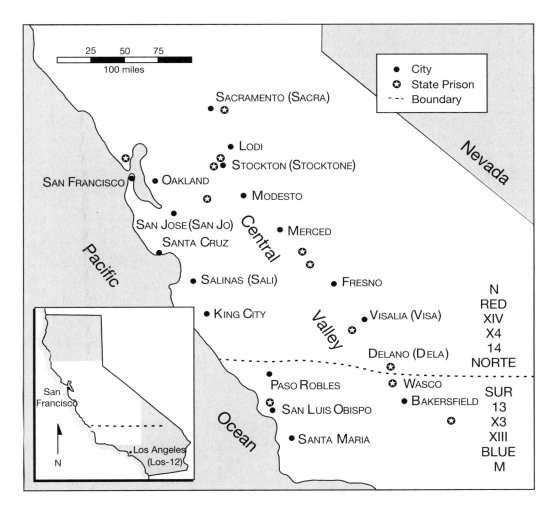

Fig. 3.25. Boundary between Northern and Southern California Chicano gangs

necessarily need to be members of La Eme or Nuestra Familia, but they began to adhere to the ideology of this division based inside the prison locales.

In 1977, a war erupted in Bakersfield between the North and South, which was so bloody that representatives from the Northern and Southern prison groups decided they needed to draw an official boundary. I was told that they drew it along two state-defined county lines—the Kern County line and the Fresno County line—but I have been unable to verify this. Delano, just north of Bakersfield, has long been the southernmost Northern town in the Central Valley. The map in figure 3.25 makes it seem as though there is a fixed boundary between North and South, but this is not at all the case.

It is the presence or absence of Northern gangs in any given town that defines this boundary today. Northerners have never been able to retain a solid block of North in Northern California the way that Southerners have in the South. Most cities in Northern California—Fresno, Stockton, San Francisco, Sacramento, and everything in between—are populated by both 13 gangs and 14 gangs. Therefore, the division is manifested within the immediate geographies and daily events of any given city. In other words, the 13-14 division of those central and northern cities resembles the separation between Bloods and Crips—a boundary based on a local rather than a statewide landscape.

There is a long history of Southern presence in the North due in part to the northward movement of migrant farmworkers and their children through the Central Valley. Close ties to Mexico and the Spanish language have thus become a basis for gang affiliation. In this manner, people not fluent in English—who speak it with an accent, or whose parents are from Mexico and speak only Spanish—may be pegged as Sureños on Northern California ground (Mendoza-Denton 1996; Landre, Miller, and Porter 1997). This is tantamount to an ideology of language (Schieffelin, Woolard, and Kroskrity 1998)—a Northern exclusivity, which manifests itself in terms of Chicano (Mexican American) pride while shunning the so-called pure Mexicans from the South, who, as a point of pride, continue to speak only Spanish. Despite this internal racism, Northerners are surprisingly open in other arenas. People of other races are reportedly welcome to join their gangs, and this also extends to the formation of cross-racial alliances between African Americans and Norteños in prison. Divisions between new and old segments of the community (Chicanos or Mexican Americans versus new Mexican or Latin American immigrants) are nothing new in the South either, but unlike the North they are not the basis for internal gang divisions in Los Angeles or Southern California. Thus, the boundary between North and South is in fact more rooted in ideological differences in terms of language, heritage, and race relations, which have subsequently become associated with Northern or Southern forms of identity.

Another reason for this Southern presence is prison overflow. California's prisons have historically been centered in Northern California, but the majority of people sent to prison are from Southern California. This means there has always been a lot of Southern representation within Northern California prisons, which also winds up translating into Southern representation on the street when families of prisoners move near the Northern prisons to be close to their loved ones. Even though most aren't formal members of La Eme,

Southerners as a whole represent a formidable opposition that retains economic and numerical primacy over the North.

Norma Mendoza-Denton (1996) has done the only work that examines the Norteño-Sureño division as it exists on the ground in the Bay Area. Working with women, she has done an excellent analysis of how girls use certain kinds of eye makeup and hairstyles—as well as the colors and numbers they share with their male counterparts—to designate these divisions in everyday school environments. For eye makeup, it's liquid, then pencil for the Sureñas, liquid only for the Norteñas; feathered hair for the Norteñas, a ponytail for the Sureñas. Body-centered mechanisms like these work only at a close range. As far as I know, cholas in Southern California who claim the South wear whatever makeup or hairstyle they wish. Their concern is not so much to position themselves daily against an enemy far to the North as it is to distinguish their affiliation with girls in other neighborhoods that are their local (and Southern) enemies.

For Chicano gang members on the street in Los Angeles, the 13-14 boundary represents a rarely experienced division between Northern and Southern California. It seems more fixed in "everybody's" geography: "everybody north of Fresno" or "everyone above Bakersfield" is a Norteño. This division is only perceived as a vague difference in style and is never experienced firsthand until they enter a prison where both groups are represented. Even in prison, where the North and South boundaries are most relevant to daily survival, Northern and Southern identities are based on ideological divisions between the two.

I was talking one day with a few guys from the Chicano gang 42nd Place, who are close friends with their African American neighbors, the Foe Tray Gangster Crips. I asked one of the Chicanos why he was wearing blue—whether that was his neighborhood color. He said no, but that he wore blue anyway because he was from the South. He went on to say that the guys from the North wear red, and guys from the South wear blue, just like Bloods and Crips. And the Foe Tray guy said, yeah, the Norteños were like Mexican Bloods. It wasn't just that they wore red, it was that there were fewer of them. They were the underdogs of the Mexican gang world, greatly outnumbered by their Sureño counterparts, just as Bloods were outnumbered by Crips. But the strange thing was that inside (prison) the Norteños—red and all—were actually allied with Crips. PeeWee said, "Oh yeah. Sometimes you'll see Gs (gangsters) that have been in the pen, and they'll have tattoos on their hands that'll say C14, for Crips 14," to demonstrate the Crips-Norteño

alliance. I would have thought that meant Clanton 14 (the Chicano gang to which Rudi in figure 3.18 belongs), but he assured me that this was not the case.

The young men I talked to that day told me that in prison Sureños ally themselves more with the Aryan Brotherhood, so that black-brown tensions inside stem mainly from Southern California Chicanos toward black gangs. Bloods, he said, hook up with Chicano guys from the Bay Area (he specifically mentioned San Francisco), because they don't really consider themselves North or South.

Other gang members confirmed that Chicano gangs wear red and blue to demonstrate their North-South division, and that in prison the Crips oppose Sureños and ally themselves with the Norteños. But still others indicated that Bloods actually were allied with Norteños as well, particularly due to their allegiance to the red color. Race relations that include these cross-racial alliances lead to what is perhaps the major living distinction that divides North and South. (I deal more explicitly with this in the section on prison divisions later in this chapter.)

If these things sound complicated, they are. Individual experiences from inside to outside prison vary dramatically depending on the prison, age, level of affiliation, and any number of other circumstances. Boundaries like the 13 and 14 may be shifting and unstable on the ground, but when people refer to them from as far away as Los Angeles, they are easily stereotyped. Everyone north of Bakersfield becomes Norteño. Many Southern California gang members who only experience this division in prison may have little idea how complex this system is on Northern California ground. But regardless of their prison experience and the daily irrelevance of this division, people in Southern California and Los Angeles materialize these boundaries on a daily basis in graffiti that includes their Southern affiliation through the number 13 and the color blue.

The picture in figure 3.26, taken in Delhi, California, exemplifies how the red and blue symbolism represents the Northern-Southern boundary. Shy Boy from White Fence, one of the oldest Southern California gangs, has crossed out the writing of the Northern TLVs (from Turlock?) by Bulldogg and Casper. You can see on the first panel how Shy Boy has used blue spray paint to cross out "Norte X4 B.dogg," written in the North's signature color, red. In the second panel, Shy Boy has demonstrated White Fence's Southern affiliation by writing "WF SUR X3," for White Fence Sur 13. Without knowledge of the circumstances surrounding its production, this composition can be interpreted in two ways: The first is that an East L.A. White Fence gang member was driving around in Northern

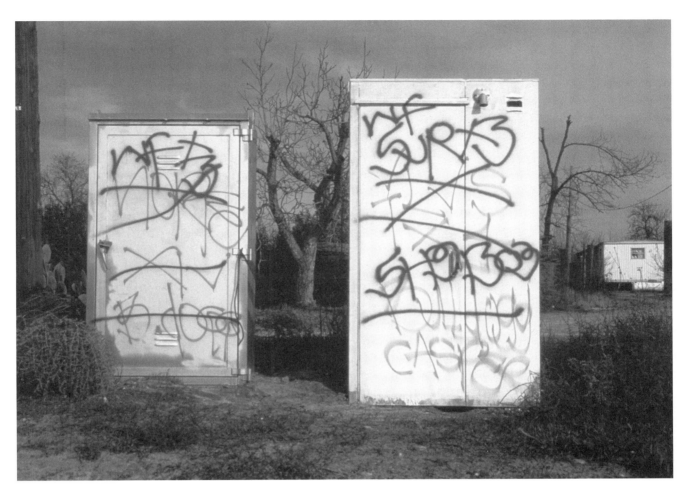

California and took the opportunity to cross out this Northern composition. The second and more likely explanation is that White Fence has a clique somewhere in Northern Cal- ifornia, and this represents their graffiti.

Sometimes, gangs will change their names if they make a dramatic Northern shift; other times they will not. For example, the initials of BMS, a gang from South Central Los Angeles, stand for *Barrio Mojados* or "Wet Town" (*mojado* means "wetback"). According to Rick Landre, when some of their members moved to Lodi, in Northern California, they expanded the meaning of their acronym to "Barrio Mojado Sureños" (telephone conver- sation with the author, 1998). The addition of "Sureños" helped BMS emphasize their Southern affiliation in an area dominated by the North. Similarly, on a trip to Delano, just

above Bakersfield, I saw some graffiti from Florencia 13, whose cliques operate in the Florence neighborhood in South Central. They had made no discernible changes to their name. It also may well be that a group from White Fence is now living somewhere to the North, while retaining their Southern identity. Whatever the specifics of the particular composition in figure 3.26, its colorful markings point to the larger North and South struggle through X3, X4, Norte, Sur, and red and blue.

The Northern-Southern boundary is one of the richest areas for study of the Chicano gang system. For Los Angeles gang members, divisions between North and South are seldom experienced or are based in "nonlocalities" like prison, where people from different neighborhoods intermix. In those same arenas, broader divisions, like region and area code, provide similar combinations of geography and ideology that aid in the process of enemy identification behind bars.

### Area Code

Beyond the primary North-South divisions are smaller, institutionally derived divisions of area code. A gang in Los Angeles differentiates itself from a gang in the San Fernando Valley, for example, by the 213 instead of 818 area code. Gangs in the Bay Area are "415's" or "209's" and in Northern California are "916's." When the phone company institutes a new area code in an area, gang identity changes with it. On the Westside, for example, older gang members still have tattoos that designate "213," while the younger generations all have "310's."

Area codes are frequently used as symbols in tattoos. Figure 3.27 shows the tattoos of a gang member from Michigan Street in East Los Angeles: the use of the Dodger's "LA" motif is common among Chicano gangs; the large "213" tattoo below it indicates his area code. Also notice the pyramid with the setting sun and the "M" for Michigan Street (or, of course, for 13, making it a double referent). All these things position this individual in specific ways: as a Mexican, proud of his Aztec or Mayan heritage; as a person from Los Angeles; as someone from the 213 area code. Finally, he positions himself within a gang: Michigan Street. This photograph just shows one-half of one arm, but already we can see how many layers of identity are represented through his tattoos.

Attachment to the area code is one of the most quirky things about Chicano gang identity. A sixteen-year-old runaway on Central Avenue one day told me how the area code focus comes from both juvenile and adult prison systems, just like the 13 and the 14.

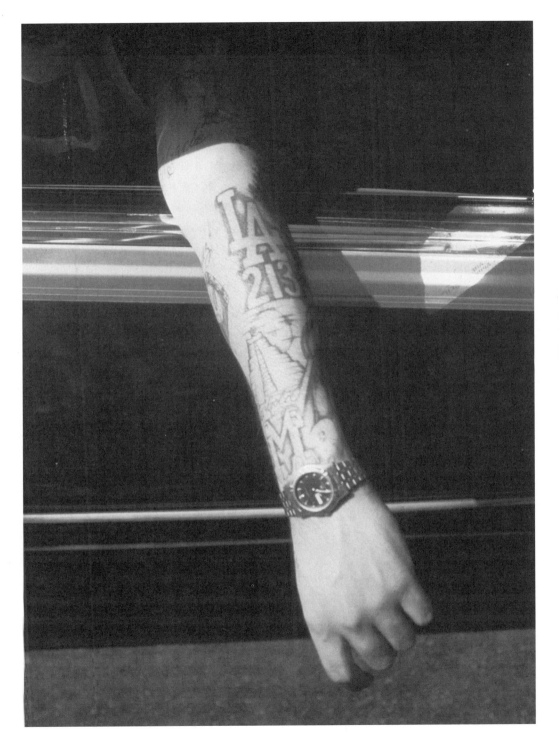

Fig. 3.27. Tattoos affirming broader elements of gang identity including region ("L.A.") and area code ("213")

An inmate's number, he indicated, carries this information right at its center. He said some-one in Youth Authority might have a number on their shirt that reads "5621348," with the "213" in the middle of the sequence if they are from the 213 area code, and that's why people were into dividing themselves up by area code when they were inside. This young man was full of soft smiles and looked as young as twelve. He wore his sweatshirt hood up because he was wanted for stabbing his stepfather in the neck—the man was beating up his mother. He was from the 18th Street gang; the prostitute with us was from Florencia 13. They joked about messing with each other due to their official enemy sta-tus, pretending to spar, then laughing because they both knew their circumstances pre-cluded any distant gang animosities to come between the friendship they had developed on the street.

Another young man told me that the area code was never officially included in the prison identification numbers, but that prisoners themselves used to put their area codes on the outsides of their shirts—where the number once was—just to let others know. The area code is particularly important, he said, because it is used to identify potential ene-mies in jail. If someone has a tattoo that says "BST," this could stand for "Blythe Street" in the San Fernando Valley or "Brooklyn Street" in East Los Angeles. An "818" or "213" area code next to those initials helps gang members figure out whether or not they need to be careful of a certain individual inside.

Shifting circumstances influence the relevance of opposition on the street as well as in prison. Equally influencing them are state-based practices, such as changing institutional area codes and the authorities' alleged practice of identifying regional affiliation through area codes on prison clothing.

### Region

Within the divisions of area code is a further division that I am roughly translating as "re-gion." For example, 204th Street, located in the Los Angeles Strip area, is part of a gang division called "Harbor Area," which includes gangs from Torrance, San Pedro, Harbor City, Wilmington, and so on (in what is traditionally called the South Bay). Chicano gangs divide themselves into specific geographical divisions that designate larger areas in South-ern California: Inland Empire, Westside, Hollywood area, South Central, Compton Varrio, the Valley, and so on.

Through these divisions gang members designate the specificity of their gang posi-

tion. The question "where're you from?" thus includes more than local neighborhood boundaries—it maps the state of California and beyond. Following the larger state divisions and area codes are more familiar gang names based on city and street names. Age-graded clique names, and finally, at an individual level, personal nicknames complete the system of gang segmentation. As they get closer to home, divisions and the symbols representing them become more personally meaningful to gang members on the outside (not in prison or the Youth Authority). The elements of their identities become inscribed onto the specifics of neighborhood space, instead of declared from afar through material symbology.

### Prison Divisions

When gang members go to prison—as gang members are wont to do—they take their personal and neighborhood histories with them in their minds and on their bodies. Individuals from different gangs without immediate personal connections are thrown together into situations where, for their common survival, they must get along. Sometimes, associations too close to home may be difficult to reconcile. One of my closest gang friends from Culver City described his experience:

> I'll tell you one thing right now. People are scared of each other. 'Cause when we were in jail, I met a lot of my enemies. And when they didn't have a gun, boy they were quiet. You know, they're like . . . they won't want to talk to you. But when they were out here and having a gun, they say, "Fuck you, punk! I'll kill you!" You know, and different story 'cause you got 'em right there. They can't hide in jail. You can't run and hide, let me tell you, you can't. There ain't no way. Not unless you gonna be running around all day. You know, between bunk beds and shit, and that's not gonna help, you know.

Although, as this passage demonstrates, their individual gang identities are by no means lost in prison, gang members begin to recognize in an immediately meaningful way the abstract, larger boundaries from North to South. Chicanos (gang and nongang members) band together for their common protection in racially divided subgroups that have developed within the prison system. However, tensions run high within racial groups as well as between them: Norteños and Sureños represent a major division within the Chicano prison population.

It turns out that one of the key differences between North and South is their relationship to African Americans, particularly to Bloods and Crips gang members. One gang member recently out of *la pinta* (prison*)* explained it in this way:

> See with the Southerners and the Northerners, the problem is this. Southerners are more united to their race: Mexicans. And the Northerners aren't, you know what I mean? The Northerners, they don't care. See, when you're in there, it's hard for you to associate with another race but your own. If you do, something's wrong. And the Northerners, they don't have that. They do whatever they want. It's like. Out here, it's different. I got a black homeboy. And if I'm drinking a beer, I could give him a drink out of the bottle. But if I'm in jail and I do the same thing, like I'm, you know, what's that word? *Traciodando* (betraying)? I'm betraying my race. Because I let a black person drink out of my drink. That's a jailhouse thing. It's still part of us, because, you know, it's just part of the system. But you know, that's a whole different environment. When you're out here, you adapt to this environment. When you're in there, you adapt to that environment. That's four brick walls, you're locked up. And when you get in there, you're automatically claiming the Southside. But them fools from up North got a whole different program than from us. They got a whole different lifestyle and everything.

Far from being some quirky jailhouse practice, the question of "drinking after" someone looms large on the minds of Chicanos on the street who are always passing around a forty-ounce bottle of beer. One Friday night I was hanging out in the park with a bunch of guys from Santa Monica that I didn't know very well. There was something in the air that night, because the big glass bottles kept slipping out of people's hands and exploding on the ground. After several trips to the nearby liquor store to rekindle supplies, one of the bottles finally made its way around to me. I knew about the gang practice of "drinking after" and didn't want to make them feel uncomfortable. I took it, gripping it hard, but passed it onto the next guy, saying no thanks when they offered me a drink. One looked at me and said, "Oh, you don't want to drink after us," just matter of fact, as if it was alright, as if they understood. I told them, "No, I thought you guys wouldn't want to drink after me." They said it wasn't the same as that. It was okay because I was white. If I had been black, then there might have been a problem. "We don't drink after *mayates,*"

one said. This is a jailhouse thing that extends into the streets. It may be bypassed for personal friendships within any given neighborhood, but never inside prison.

The betrayal of the race and disruption of the unity in prison circumstances concerns racial purity and danger—pollution and impurity that accompanies "inclusion" threatens the unity of the Southern Mexicans inside the four walls of prison. Because there is so much movement in and out of prison, gang members shift the relevancy of race as an issue to the background or foreground depending on the circumstances. What is appropriate racial behavior outside is not necessarily so inside and vice versa. Another gang member elaborated upon these racial divisions between North and South:

> Us Southerners are more, not just united, but more into the race and stuff. It's a whole different lifestyle. They got different styles, you know what I mean? We have more rules and regulations than they do. When you got more rules and regulations, you got more control. And when you got more control, you're more powerful. Them, over there, when you're not united? When you're not united, like we are, it's harder for them to take control of something. And when you're united, you control everything. You could control almost anything you want. That's how it works in there. So when you pull rules and regulations and you follow 'em, and, it's just like the way they do it here: politics. It's more politics. If you follow the rules and regulations, you're bound to get more respect and everything else you want. But when you don't got no laws or nothing, no rules to follow, you do whatever, you don't have no unity. That's how it is in there.

*Sureños Unidos Raza,* like the man told me explaining his tattoos: United People of the South. The 13 representing "M" for Mexican. The Mexican focus as well as the political designation of South assumes a whole new level of meaning in contrast to Northern politics of race (and power) relations. Whether or not gang members become part of La Eme, its ideology unifies Southern gangs against the North as well as against racial groups of other kinds. The strong Southern belief in Mexican unity pervades local environments in which gangs from diverse regions, area codes, cities, and gang neighborhoods are forced to share a common space.

Figure 3.28 shows a Sureño prison drawing that demonstrates the association of four men from different Southern California cities. Mr. Woody from the Westside Playboys made this composition and "Big Uli G." seems to be claiming East Side Santa Barbara XIII,

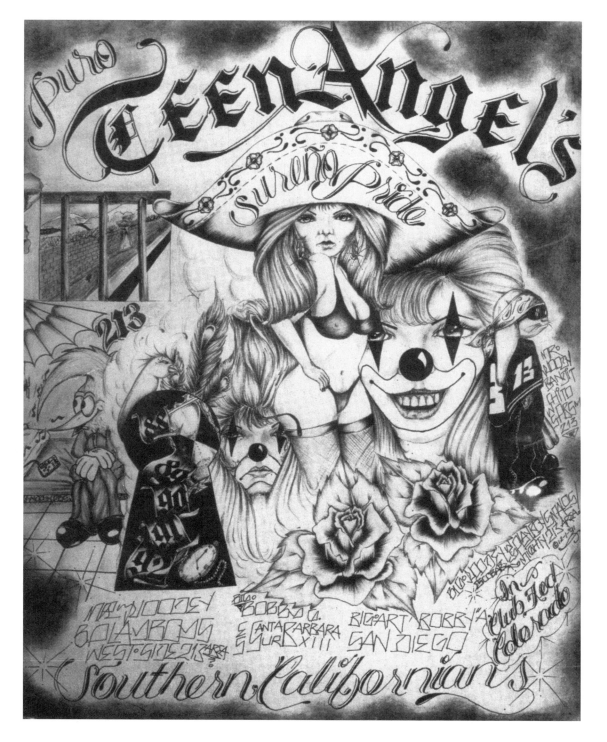

Fig. 3.28. "Sureño Pride." Courtesy of *Teen Angel's* magazine, issue no. 110.

but Big Art and Uli A.'s association with San Diego lacks any particular gang reference. Of these names, only "Woody" can be considered a traditional gang nickname. The lack of traditional gang nicknames or traditional affiliations in the San Diego cases make it unclear whether any of the individuals besides the artist are actually gang members. However, Woody demonstrates what they all have in common: pride in their Southern California heritage. His composition uses elements like the keyhole and calendar pages, roses, and "smile now, cry later" faces to stand for links from outside to inside, the passage of time, beauty, the paradoxes of the gang life. Woody uses these images to emphasize gang membership, prison life in general, and the camaraderie between these four Sureños at the same time as he declares his own particular gang affiliation, the Westside Playboys, within the 213 area code.

Prison art overlaps considerably in content and design with prison tattooing. Prison populations all over the world use tattoos to mark themselves as members of subcultural groups. The practice of tattooing counters the authorities' power by allowing prisoners to retain control of their own bodies. Chicano gang members are migrants of many kinds. In addition to perhaps a migration from Mexico or Latin America, a gang member may move in and out of prison several times during his lifetime. Thus it becomes important for prisoners to mark the places where they're from and the places where they've been. Practices like tattooing allow them to retain control of their pasts and harness the power of their affiliations.

On becoming incarcerated, prisoners are effectively stripped of other identifying markers; however, the tattoos remain as indicators of self and group identity. In most prisons around the world, tattooing is illegal. California prisons are no exception: prisoners surreptitiously manufacture tattoo guns out of sewing machine or cassette player motors, guitar strings, and Bic pens. They post lookouts to warn the tattoo artist. If a tattoo becomes infected, prisoners can be charged with defiling state property and given punishment time (Govenar 1988).

Complex, dreamlike mixtures of symbolic imagery are characteristic of Chicano gang prison-style tattoos and prison art. Roses, spiderwebs, keyholes, hourglasses, peacocks, women, and religious icons represent elements of the prison world: loneliness, pride, addiction, pain, faith, time. An older member of the 38th Street gang in Los Angeles once described prison-style compositions to me as "beyond graffiti" in many ways. Calendar pages turn to signify the passage of time. Crumbling bricks symbolize their eventual

freedom from confinement. Gang members oftentimes tattoo prison towers on themselves in the particular shape of the place where they served time: according to one respondent, Folsom's tower is triangular; San Quentin's is more rectangular. Prisoners end up walking out of prison, or remaining in it, with a body of evidence—a visual life history—that links their inside and outside experiences and shows their affiliations and where they spent time.

Prison drawings, tattoos, and compositions might be considered "beyond graffiti" perhaps because their makers have shifted from a basic gang ideology to a more general Chicano-centered ideology. The influence of the Mexican Mafia or Nuestra Familia unify North and South against each other, and, on an even larger scale, pervasive Chicano prison imagery preaches Mexican pride and heritage—from Aztec to Zapatista revolution and the mythical Chicano nation of *Aztlan*, which includes the territory in California and the Southwest comprised by the "original" state of Mexico.

Links between Mexico and the United States are strong in the Southern ideology of people from California and the Southwest. These links have been fortified by the movement of populations across the border, but Sureños in particular may have been influenced by the migration of many Los Angeles gangs to Mexico and their incarceration in Mexican prisons.

I first began to understand the nature of these Mexican ties when I met Scorpio on Central Avenue one day, where he was working for a tire shop. *El borracho* ("the drunk") of the neighborhood, he was constantly drunk and could generally be found staggering around, going to the liquor store for more beer, or lugging *llantas* around the shop. Sometimes he would disappear for days, weeks, or months at a time. When he was around, the tires were his bedtime companions if he didn't have anywhere else to go, which was most of the time. I saw him—and his tattoos—as he sat on the curb with a beer one day and knew I wanted to meet him. I peeked around the corner into the driveway to see a beautiful classic lowrider car that belonged to the tire store's owner. When the owner found out I was interested in graffiti and tattoos, pretty soon he had Scorpio all lined up to take pictures. I shot them thinking they were good examples of Chicano prison tattooing (see figure 3.29).

When I got to know Scorpio better, I would buy him a beer occasionally. I was surprised to learn that all of Scorpio's tattoos had been done in a Mexican prison. He had a tattoo of a spider on his neck (not visible in the photograph) that I would have associated

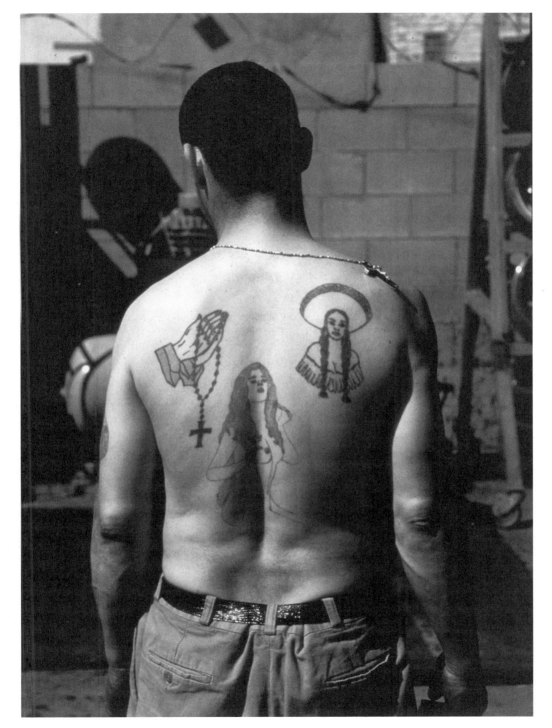

Fig. 3.29. Prison tattoos on Scorpio's back

with a broader prison gang affiliation, but instead he said he got it to mark the third year of his sentence. The teardrop under his eye had been for his first, and the "A" (the initial of his "real" first name) on his hand, his second. The butterfly on his arm, he claimed, had nothing to do with the South as it does in the United States—though it looked identical to the so-called Sureño butterflies. He said it was just pretty. The Jesus on his chest seemed par for the course—the tie between prison and religion is a strong one among Mexican Catholics, with Jesus standing for suffering as well as faith. Though they appeared identical in style to California prison tattoos, many of the meanings he assigned to them seemed much different. However, the naked lady on his back seems to speak a universal language. Scorpio liked to flag me down whenever he saw me walking down the street. He would call me over to him acting very serious, then, flashing a diamond-toothed grin, would surprise me with his favorite trick: making the body of yet another naked lady move with the muscles on his left arm.

As Scorpio's tattoos demonstrate, links between prisons in Mexico and California through the Chicano population may be strong, but remain unexplored. In the United States, prison imagery as Chicano self-representation is one of the most powerful art forms that prison has to offer. When African Americans get tattoos in prison, it is often Chicanos who do them. They are the experts—masters of a variety of lettering styles and the tattooing art form itself. Chicano nationalist prison art has found a surprising amount of legitimacy in the outside world. Their compositions bear more similarity to traditional two-dimensional art in general, and several gallery shows in Los Angeles and the Southwest have highlighted the prison envelopes and handkerchiefs that Chicano prisoners decorate so elaborately. In part because of this mainstream attention, but also because of the larger numbers of people for whom prison is a periodic, if unpleasant, part of life, one can now find T-shirts on Olvera Street or at swap meets with prison-based designs. Many conventional tattoo shops have begun to employ artists who specialize in these prison-style montage tattoos.

Since there is so much movement in and out of prison, gang members at all levels are constantly exposed to both gang-centered and nationalistic ideologies through the pervasive prison imagery as well as contact with the people around them. Gang unification movements often are started by older *veteranos,* who are continually afraid that younger gang members will refuse to cooperate. While the younger generation may be unable to relate to the relevance of the older members' messages, older gangsters are similarly frus-

trated by the youngsters' rash oppositional behavior. I have often heard older gangsters describe the younger ones as "messing up" and "crazy." Gang membership does not necessarily stop after adolescence; it simply may enter a different phase whose ideology is much closer to that of the larger ethnic community.

The boundary system manifested by the graffiti of the barrio and the imagery engraved on the body is central to the Chicano gang experience because it binds individuals into a social and political world larger than the neighborhood and its immediate enemies. The boundary system makes gang members part of a political unit that encompasses most aspects of their experience and accompanies them as they establish their curricula vitae: from barrio to prison and out again. Chicano gang members rely on material elements like graffiti or tattoos to declare personal histories and affiliations, as well as changes within them. The images themselves remain stable through these transitions. Due to the commonness of the prison experience, these images carry accompanying ideologies from place to place, making them available to larger groups of people.

## GANG WARFARE

The boundary system and jailhouse concerns discussed so far have pointed implicitly to the segmentary nature of gang membership and the selective relevancy of its elements during a lifetime. For example, in prison, race becomes a crucial issue and ideology may be more linked to broader ethnic concerns. Larger boundaries like the 13 and 14 become primary focal points of identification. Concerns with area code and region further place the gangs within a segmentary framework. On the street, however, maintaining allegiance and unity within a gang is crucial, along with negotiating respect and power in local arenas, primarily to protect a neighborhood from its rivals. In addition to leading out of the neighborhood, the system of segmentation brings us right back into it.

Figure 3.30 demonstrates Chicano gang segmentation as it moves from street- to prison-level circumstances. Within it are natural enmities where fighting traditionally occurs. There can be no chronic infighting at the clique and gang levels. Arguments within those entities are "squashed" unless the quarreling gang members have the critical mass to split off from their larger entity (as they did in the 36th Street case). In the absence of such a critical mass (which varies depending on the circumstances), external pressure from rival gangs generally keeps cliques unified.

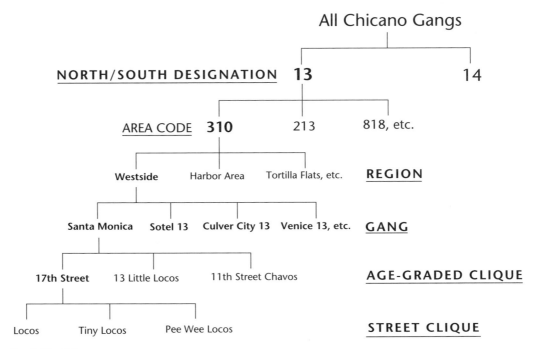

Fig. 3.30. Chicano gang segments

Chicano gangs have all kinds of relationships with one another. Some are friends; most are enemies. The gangs of the Westside (Santa Monica, Sotel, Venice, and Culver City) have gone through shifting patterns of alliance through the years, mostly due to outside pressures. As closest neighbors, they are natural enemies (see figure 3.31) and every so often exchange gunfire. These "natural enemies" are the result of common histories within a segmented system of concerns. My friend Bear from Culver City once explained to me how the vicious feuding between Venice and Culver City began as a theft that extended into murderous rivalry. For years he thought he could never go to Venice because of all his enemies there. But the last time he got out of jail, in 1995, he said he was "tripping out" when he realized he could go just about anywhere he wanted. The Westside had a truce going, and the fighting between the two rivals had stopped.

Battles like those between the gangs of the Westside have traditionally occurred within the ethnic group; for the most part they continue to do so. Many times the traditional infighting of Chicano or black gangs easily incorporates a new enemy outside their immediate system but with whom they are in conflict for neighborhood-based rea-

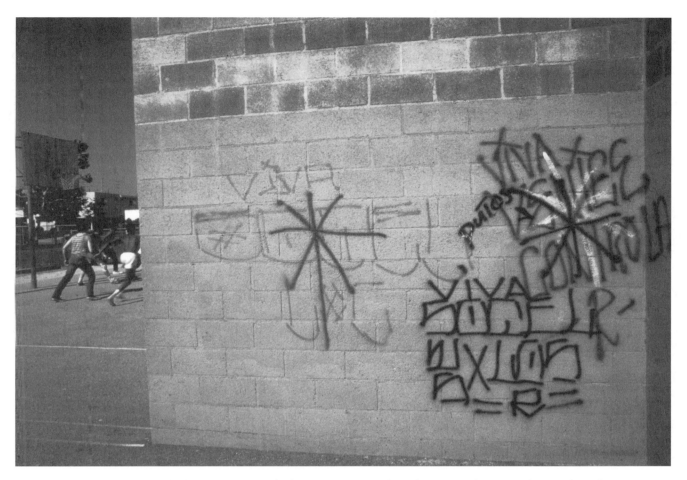

Fig. 3.31. Graffiti representing the long-standing rivalry between Venice and Sotel (Stoner Park, 1974). The star-shaped cross-outs were popular during the early 1970s. The composition reads "Viva Sotel LC" (Los Casuals), which is crossed out by Venice, who write "Viva Venice Controlla [controls] R [rifa, or rules]." Sotel has then crossed this out, writing "Viva Sotel, Ws Los [Westside Los Angeles] R." Sotel has also written "putos," with an arrow directed toward their rivals. Photograph by Leonard Nadel, courtesy of the Leonard Nadel Photo Archives.

sons. Instead of being focused between two Chicano gangs, gang warfare in Venice sometimes extends between African American and Chicano gangs—with the Shoreline Crips and Venice 13 fighting, or Shoreline and Culver City 13 periodically battling it out. Waves of brown-black violence periodically shift around events, and rivalries once started are hard to renounce. Some have predicted that black-brown violence will be the future of gang warfare in Los Angeles, but for now, primary enemies remain within

ethnic groups (among Chicanos or among blacks). Cross-ethnic warfare shifts with local events and has not yet been systematized.

### Crossing Out

Though it has behavioral and often violent implications, the "aggressive" graffiti of the barrio—crossing out or challenging—is a manifest element of Chicano gang rivalry. Far from being mere disputes over territory, crossing out instead represents a gang's continual struggle for respect within the larger Chicano gang world.

Gang neighborhoods are traditionally and historically defined and territories well-established and well-known. Enmities on the street exist between groups that are usually closest neighbors: their geographic proximity means that closest neighbors have the most interactions, and, thus, the most conflicts—as in the rivalry shown in figure 3.32 between neighbors 38th Street and Loco Park. Graffiti challenges constitute a discontinuous dialogue between gangs, which oftentimes involves substantial risk for gang members who enter a rival barrio to accomplish their task. Challenges represent the gang's quest for the most powerful position within their community: the "biggest and the baddest" to "controla todo" (control of everything everywhere). Seen in this way, the dialogues are not simply battles over contested territory but symbolic battles for primacy within a wider political community. As one Santa Monica man explained it:

> The way that gangs are known for, the reason of crossing out or putting a line through the name of a gang would be a form of disrespect. In other words, saying "F this neighborhood!" and, you know, cross it out. And then they'll put a little signature of their gang name so that the name that they cross out knows who did it. They could have been looking around for somebody to shoot and they didn't find nobody, so that was another way of getting to them, just crossing out their name.

The action of crossing out gives gang members a nonviolent way to antagonize enemies. They disrespect the name of other neighborhoods to show them up in risk and daring and to take away the power of the sometimes beautiful gang compositions by defacing them.

Figures 3.33 and 3.34 present two dialogues between the Santa Monica and Sotel gangs that occurred in 1992, each in the neighborhood of the other. In figure 3.33, in a public area of Sotel's neighborhood, a gang member from Santa Monica 13 Midget Locos

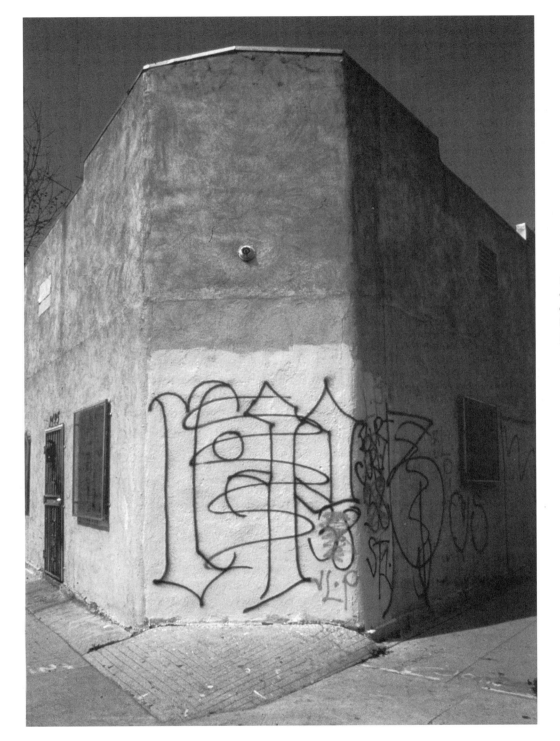

Fig. 3.32. 38th Street crosses out Old English graffiti by Loco Park, but Loco Park ultimately prevails (1995).

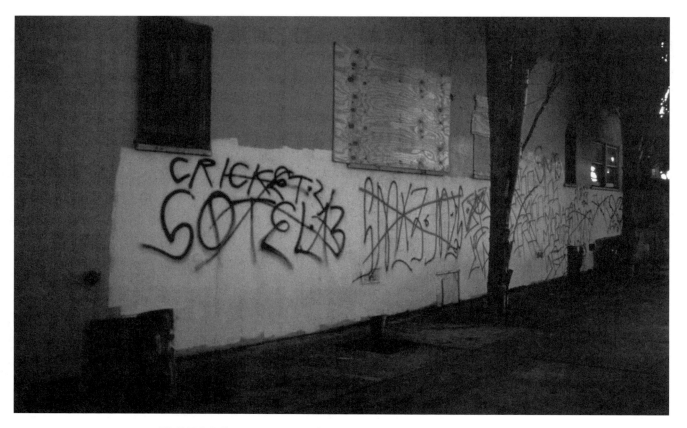

Fig. 3.33. Santa Monica and Sotel cross out each other's graffiti (in Sotel's neighborhood, March 1992). Santa Monica crosses out a hit-up by Cricket2 of Sotel 13; Sotel responds by crossing out Santa Monica's composition.

(SMX3 MLS) crosses out a placa by Cricket from Sotel 13. Sotel 13 then uses brown (their neighborhood color) to cross out Santa Monica's challenge, writing "S13" next to it. Just to the right, Santa Monica also crosses out Risko Fresco Bird from West Los Angeles (the letters "W" and "LOS" surround the names), writing "SM13" above their composition. Later, Sotel crosses out Santa Monica's placa in hot pink. Their hot pink "S13 LGS" (for Sotel 13 Little Gangsters) left undisturbed represents the end of this particular dialogue between the two gangs.

Figure 3.34, another dialogue between the Santa Monica and Sotel gangs, takes place in the heart of Santa Monica 17th Street's neighborhood. Gang members from Sotel target the abandoned house usually reserved for Santa Monica's hit-ups. Tiny, Spyder, and Bugsy from Sotel paint over a placa by Bago (Vago) and Bad Boy in such a light pink you can barely their challenge. They write their names as well as simply "Sotel." Santa Monica comes back to cross out Sotel's work in yellow, writing the derogatory nickname

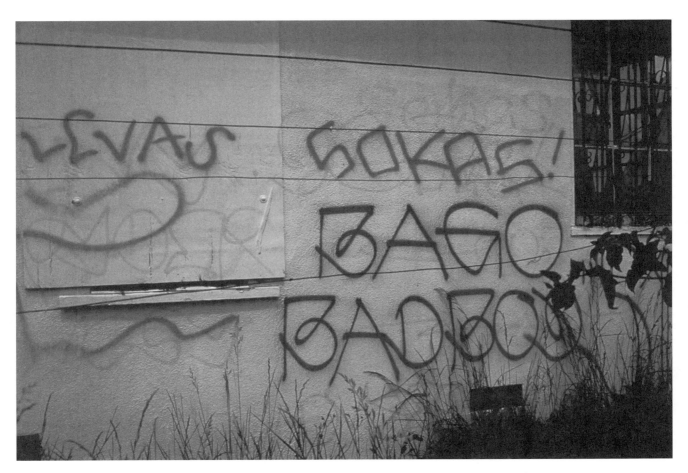

"Sokas" above Sotel's work. Later, another member of Santa Monica performs a second cross-out, this time writing "Levas Sokas!" (*leva* is a jailhouse term that means "weak"; *sokas* is a way of calling them "suckers") in red.

The image in figure 3.34 is interesting for two reasons. First, both gangs make use of unconventional spray-paint colors: Sotel's light pink barely shows up against the white wall; nevertheless, it represents enough of a challenge to be taken seriously by the Santa Monica gang, who answer initially in yellow. Only later does Santa Monica use a darker red to emphasize their response. When they have a choice, gang members will use their neighborhood color to write graffiti. Sotel's color is brown and Santa Monica's is black, though neither color is represented here. Their use of unconventional colors shows the opportunism probably involved in Sotel's challenge. Because the house is in the center of

Fig. 3.34. Santa Monica and Sotel cross out graffiti (in Santa Monica's neighborhood, April 1992). Sotel challenges Santa Monica; Santa Monica answers with two resounding "Sokas!" the derogatory nickname for Sotel.

Santa Monica's neighborhood, it represents a daring action on the part of the Sotel gang members. It was, however, probably unplanned—both the challengers and respondents used whatever spray paint they happened to have on hand to represent themselves in this conflict.

In their *Los Angeles Barrio Calligraphy* (1976), the Romotskys point out that gangs will often write whatever insults they have for the other gang (like "ratos" or "putos") in messy writing—"as if unstylized letters increase the contempt" (47). Figures 3.33 and 3.34—not the most awe-inspiring compositions to begin with—show that today's gangs write insults in variety of scripts, both sloppy and neat. The opportunism of such graffiti challenges accounts for images of average and bad quality in many places.

The graffiti in figure 3.34 also demonstrates the Chicano gang practice of derogatory nicknaming and name avoidance. I describe in the next chapter how Crips and Bloods cross out the "B's" or "C's" that represent their enemies. In a similar manner, Chicano gang members avoid ever saying the real name of a rival gang in speech or writing. Sotel gang members, for example, always refer to Santa Monica gang members as "Smakas." Folks from Santa Monica get mad if members of their gang say "Sotel" instead of "Sokas." On the Westside, Culver City becomes "Caca City," gang members from Venice are "Vergas" (Dicks), and 18th Street is replaced by "Faketeen Street" in the derogatory labeling of their rivals. Derogatory nicknaming and name avoidance in speech and writing are used to dehumanize other gangs, an activity that finds coherence in its repetition. I saw one young Santa Monica woman playfully training her baby to say "Caca City" within earshot of a gang member from Culver City—she was doing it to make fun of him during a Westside truce. In a world where naming plays such an important role in identity formation and maintenance, denying a name to a rival group is a powerful message indeed.

Eighteenth Street and Mara Salvatrucha are two of the most powerful Chicano gangs in Los Angeles (see figure 3.35). Eighteenth Street is certainly the largest and has recently gained even more notoriety through a three-part series in the *Los Angeles Times* detailing their growth and activities. Though not quite so large, Mara Salvatrucha is one of the fiercest L.A. gangs, whose very existence points to an important fact about the L.A. gang system: Mara Salvatrucha's constituency is largely Salvadoreño. When people talk about "Salvadoran gangs" in Los Angeles, they are often referring to Mara Salvatrucha. However, to understand these gangs within an L.A. context, it is important to realize that Mara Salvatrucha's cliques operate within the traditional Mexican-based gang system (what I

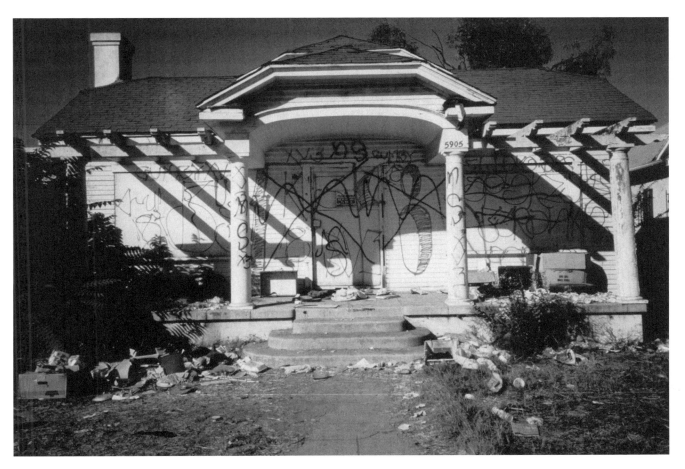

keep referring to here as the Chicano gang system). A 13 follows their name, signifying their allegiance with the South. They constitute their social and political identity in a manner almost identical to Chicano gangs, and they fight almost exclusively with other Mexican gangs in that system. None of this downplays the importance of Mara Salvatrucha's Salvadoran heritage, however. It is something to be emphasized and to be proud of, something that sets them apart from "regular" Mexican gangs.

The Venice Oaxatruchas gang is largely composed of people from Oaxaca, a state (and city) in Mexico. Its members shift between fighting their nearest Chicano rival, Venice 13, or joining up with them to fight the Shoreline Crips. Membership in both Mara Salvatrucha and Oaxatruchas is based on ethnic heritage, but in Los Angeles these identities are maintained within the established Chicano gang system. In fact, the *trucha* suffix

Fig. 3.35. House showing rivalry between the 18th Street gang ("18") and Mara Salvatrucha ("MS"; the "X3," stands for 13), on Avalon Boulevard just south of Slauson (1996)

itself stems from Chicano gangs, who often write it in graffiti to warn other gangs to "beware"—to stay out of their territory. The appearance of specific ethnically based gangs, along with the development of newer groups in general, is significant in terms of expanded participation in the Chicano gang system. But these groups have not themselves created significant changes within Los Angeles's traditional Chicano gang structures.

The struggle to be the "biggest and the baddest" is something that each gang strives to realize internally. Because all gangs are competing, they will never say, "Oh, those folks over there really deserve the credit this time." However, gangs do have reputations. Gang members continually warned me to be careful of their enemies, "Because over here we're nice, but over there, they don't care, they'll just shoot you."

Gang warfare makes sense for those struggling for limited resources within similar neighborhood environments, and this competition sometimes also causes enmity between black and Chicano groups. But, for the most part, rivalry seems to be founded on issues of pride and respect embedded within these larger environmental influences. Thus it is still negotiated internally, within the larger system of Mexican gangs.

There are proximate and ultimate reasons for gang violence. Proximate factors include theft, retribution, revenge, history. Ultimate issues are a little more complicated. You can ask gang members why they are fighting, and they might say, well, they shot my brother, they raped my sister. Or they might say they don't know. That is the bigger question: why are gangs who are so similar fighting each other? It is a question that ultimately goes back to why gangs have developed in today's urban worlds. We can understand the shifting relationships of enmity and alliance, the shifting relevancy of racial issues and of insider and outsider enmity. Many of the proximate causes of gang violence and the specific inward focus that it takes can be easily understood by looking at the diagram of segmentary opposition outlined in figure 3.30. You see natural breaks and divisions where enemies and allies are realized through local and geographical concerns. But we still have a lot of work to do to figure out why groups like gangs are becoming so popular today.

It is with the gang practice of "representing" and not with warfare that gang territory is at stake. Gang members are not fighting over "turf." If territories shift, they do so because gang members are no longer able to represent their gang within a particular area. Perhaps many of the members were put in jail, or moved, or got older. Then perhaps members of another gang moved to that area and began to represent a new gang there. This is how most neighborhood areas change. As a public act of representing, graffiti is

part of this process. When gang members challenge each other, they usually do so within well-defined neighborhood areas, or areas that belong to no one at all. These struggles are not necessarily about land; they usually concern even more important issues: respect, reputation, power, prestige. Though tied to neighborhood economics and sociality (as the section on African American gangs details more intricately), such struggles are negotiations of local politics and identity rather than of the land itself.

Whatever the reasons, people do die as a result of gang warfare. Sometimes they are gang members, sometimes they are not. Death brings us to the fundamental level of the gang life, the harshest realities that the gang world has to offer. A few weeks prior to this writing, I dropped off a copy of the manuscript for this book at a new clothing store called Westside, co-owned by ex-members of the Santa Monica and Sotel gangs; it had just opened on Lincoln Boulevard two blocks away from my house. The ex–gang members were interested in seeing their graffiti featured in this book, and they explained that the name *Westside* and the store's co-ownership demonstrated a strong statement of unity and peace among gangs. The store's opening, however, coincided with the resurgence of violence between gangs in Santa Monica and Culver City, mostly in retaliation for the death of a Culver City gang member near Santa Monica High School. Two shootings followed within just two weeks. Then, days later, a Culver City gang member entered the Westside store and shot four people, killing two of them.

In the introduction to this chapter, I indicated how the gangs of the Westside seem to experience waves of violence followed by periods of relative quiet. But violence is not simply an abstraction, a star on a diagram indicating where the killings take place. Violence is a chaos that demands attention, stealing life and sapping strength from both its victims and survivors. Commonplace warfare and violence puts everyone at the same level of judgment, to realize—even if for a second—that gang membership is ultimately a failure. It is a cause for grief among gang members and the nongang populace alike.

## RIPS: MEMORIAL GRAFFITI

The death of a gang member is a painful time for family and friends. Gang members write graffiti during these times to honor dead homies and to ensure that they are "gone, but not forgotten." A young man from Santa Monica described the practice of making memorial graffiti by referring to Leo's death:

There could be different instances. Like, say a homeboy got killed. Maybe that night, after the funeral or whatever or that same night. A few guys that usually were the closest to him would go around and write on the walls his nickname and put "rest in peace" and put whatever depending on how they're feeling. Sometimes they'll put um . . . For example, a friend of mine died on Christmas. It's gonna be two years now. He had died and I remember seeing some hit-up . . . some that said "Leo rest in peace. Santa Monica loves you." Just in memory of the person that died. Or they'll wear a sweatshirt that says "Leo rest in peace. Santa loves you" and the day he was born and the day he died. So just like a reminder to keep his memory alive.

Catholicism is in many ways at the center of Chicano gang culture. Gang members use strongly religious imagery to help them express their loss. Praying hands, the Virgin of Guadalupe, clouds, and scrolls can be found in many memorial compositions—in *Teen Angel's* magazine or in tattoos as well as on the street. Even on a daily basis, gang members may additionally portray themselves or their gang as the Grim Reaper or as skeletons to emphasize that death may be waiting for them right around the corner. They realize that just as they take the lives of others, their lives may also be taken—"what comes around goes around," as another saying goes. One friend of mine from Culver City reiterated this sentiment:

> You know, when you shoot somebody, when you kill somebody, you'll have it in your mind all the time. Hey man, you gotta watch your back, because they say it comes back to you. If I kill somebody it's going to come back to me. I could be walking the street and then Boom! They'll shoot me.

Gang members feel guilt about the crimes the commit—particularly violent ones. But in a world that offers little room for weakness, guilt becomes something to which they must harden themselves in order to keep living the gang life. At funerals and the times surrounding a death, however, gang members are free to express the depths of their emotions for their lost friends. Many people pitch in money for funeral services and burial by holding car washes that also help pay for memorial T-shirts or jackets to commemorate the dead. Memorial graffiti is just another part of the process that ensures that homies stay alive in the memories of their fellow gang members.

The process of death and remembrance seems to be a never-ending cycle among

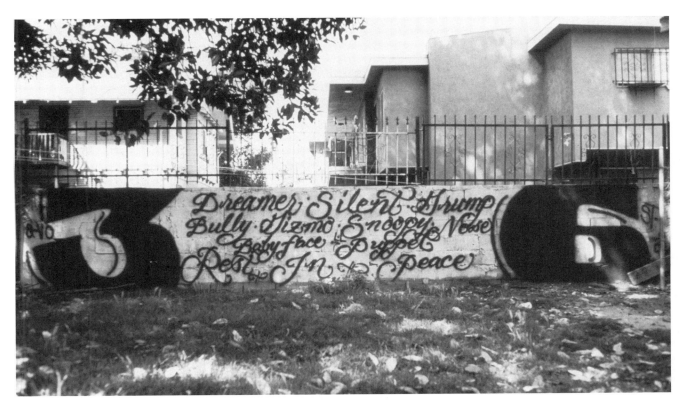

gangs and one with which they are well acquainted from a variety of perspectives. One afternoon, two gang members from 36th Street took me into the depths of their neighborhood to see the memorial in figure 3.36, located in someone's backyard. The beautiful script lettering showed the names of all the homies lost from the 36th Street gang since 1989. Dreamer was the first, the rest followed. Since I took this picture in May 1996, one additional homie has died, killed in a nongang confrontation. The two young men who shared this memorial composition with me went to jail for murder shortly thereafter, thus extending their own experience of loss by creating loss for another.

Sometimes RIPs are not special compositions to honor recently fallen individuals, but simple inclusions of friends who have died on basic hit-ups around the neighborhood. Even if they themselves are gone, their names live on in the writing, always designated with a small RIP to the side. Other memorials may honor dead gang members in general, rather than being dedicated to a specific person.

The spray-painted memorial in figure 3.37 by the 18th Street gang with its abundant

Fig. 3.36. An RIP for 36th Street gang members Dreamer, Silent, Grump, Bully, Gizmo, Snoopy, Nose, Babyface, and lil Puppet (1995). A "3" and "6" (representing the gang) enclose the block of names; "Q-vo" means "what's up."

religious imagery is a complex composition for graffiti. Memorials of this complexity are more commonly produced on paper. Such a large composition, which required a significant amount of time to create, was almost certainly made with the permission of the store owner. This would also account for the lasting nature of this particular piece (dated 1990), which would have been whitewashed quickly had it been illegal. Store owners may even encourage works like these—even though they are gang related—because they can actually discourage "uglier" kinds of graffiti on their walls.

One of the most touching stories I ever heard centered around many aspects of the gang life, including how, even in death, families begin to accept the strong emotional ties their children feel for their gangs. As his homies listened on, an older *veterano* (in his twenties) told the story of one of their homeboys who had died young:

When he died, his mom told us . . . his mom called us up one day and told us, "My son died representing what he loved. You guys dress him like you guys want him to go." Like it was him. You know, they didn't put a suit and a tie and all that. When he went, he went all gangstered out. He had his beanie, his bandanna, his Cortez's [shoes]. And you know what, it comes to a point where your family accepts it. There's been situations where we been backed up by other people, by our families. He was with a beanie; he had everything, a cigarette at the side, triggers in his pocket. And that's how we dressed him, like he was him. That guy, we used to steal cars to go see him out in San Fernando, in the hospital. And steal cars to come back. They said he was brain dead. He wasn't brain dead! 'Cause you would look at him, and he was like, and he would get all happy. And you would tell him, if you know who I am blink your eyes. He'll blink his eyes. And, you know, you make up a name, Am I Bam-Bam? And he'll keep his eyes open. Am I so and so? No. Am I Yogie or whatever? And he goes, yeah, he'll blink his eyes. He knew who you were and everything! He wasn't brain dead. And he would cry, dog, he would cry when we would leave him. He would cry 'cause he didn't want us to go. We used to come over here. . . . Look, I got chills remembering that little fool. There's just a love there that you can't express. That's what it is. It's just a love you can't express. And I still go, I go over there to the cemetery and clean his little stone or whatever. And it's things like that you wouldn't expect people like us, you know, "they don't have no heart." They don't know. They just don't know.

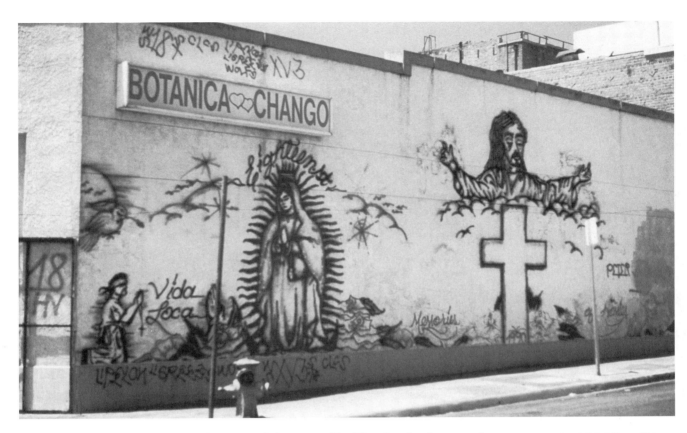

Fig. 3.37. RIP graffiti mural near MacArthur Park (1990). A religious theme is emphasized by the Virgin of Guadalupe and Jesus, seagulls and roses, and the praying homeboy (with a reference to la Vida Loca, or "crazy life" of gangsters. (The lower left corner of the composition has been whitewashed.) The memorial is dedicated to all 18th Street gang members who have died: "Memories of Homies."

In some ways, death lies at the core of the gang life. The rituals of car washes, presenting money to the parents, grieving fiercely over a loss, then avenging the death, seem only to continue the spiral of gang involvement that causes such deaths in the first place. But, as the *veterano* demonstrates, sometimes parents grow to understand their children's strong associations with the gang entity, because they know what is at stake on a daily basis. For both Chicano and African American gangs, I have heard stories of people's mothers backing them up, demanding that others respect their sons and daughters. "I was out their fighting with them," one mother told me, explaining that "they were disrespecting my son, and he needed my help."

Gang culture perpetuates a cycle of deplorable violence. Stories like the *veterano*'s; the black eyes on women; descriptions of rape, of men brutally carving gang initials into young women's bodies or writing with markers on the forehead of a dead victim; seeing young men wrapped up in gauze with recent gunshot wounds—these things periodically

shock me into remembering that the gang life is nothing to be envied. The rest of the time, I found myself thinking how cool gang members were. I caught myself looking at the bullet holes in their cars full of admiration, almost as I would be for some kind of war hero. "See what happens when we go to the liquor store for some milk?" one said, pointing to the row of four neat holes across the door of his El Camino. These people deal with life-and-death issues on a daily basis. As I continually redefined my own relationship to a city notorious for its superficiality and lack of depth, finding people with deep feelings, commitment to a cause, and a culture driven by something other than consumerism at times held me rapt within their intensity. Though for me such feelings were always short-lived, they helped me to understand the draw of this culture: the importance of the individual connected seamlessly to the intoxication of the collective. Brutal, endemic violence and early death are a severe price to pay for the culture they represent.

## THE GANGSTER TOUCH: AESTHETICS AND STYLE

There is a style to violence. It's that gangster touch—the gangster aesthetic—that makes gang members seem "cool" even in the face of their crimes. The topic of style testifies to the variability of this life, its members constantly moving back and forth between pain and violence, creativity and fun. People sometimes accuse me of glamorizing the gang world when I talk about graffiti. But the gang world is already glamorous without any help from the outside. The glamour is in part what draws people to the gang to begin with, not just the hate and suffering. Sometimes people who have looked death in the face and won evoke the kind of admiration I caught myself feeling, which is often shared by kids growing up in the neighborhood.

Gang members create their identity beyond the bounds of specific neighborhoods through enmity with other groups, through illicit economic practices, and through references to the statewide system of boundaries. The visual imagery expressed through graffiti and tattoos is an integral part of the process that connects gangs together and binds them into a culture. It constitutes a style that distinguishes Chicano gang culture from the other gang cultures around it, as well as from the larger society. The style of this expression becomes the tie that binds these neighborhoods into a cohesive culture.

How gang member represent "just them" or "themselves" often alludes to style; for example, the *veterano* dressed his dead homie to represent who he truly was—that is, not

someone in a suit and tie but someone in the right clothes with the right things that represented him as a gangster, the way he felt most comfortable. For individuals who join gangs, style becomes something of feeling and of selfhood, as well as of group—the "I" and "we" merged into one through specific forms of practice.

As much as dress and demeanor represent these values, the different types of lettering that gang members use in graffiti and tattoos also take on such representative qualities. Aesthetics constitutes an essential social practice in its own right as well as one of the most beautiful elements of gang material production. One gang member described what makes the gang style what it is:

It's the gangster touch. Look, we'll see a design. Let's just say an NFL team or something like that. Or whatever, you see a letter on a certain wall. You get that letter, and you change certain things on it so it could fit what we represent. You know, 'cause if you put a letter, you know a way-out letter that people don't understand, you could strike it up on the wall. A tagger letter won't look right. Tagger letters? Those bubbles? That shit wouldn't fit in with us. People would say, what's wrong with them fools? We're not dressed right. We got to give it the gangster touch so it could straight give up what we're representing. And, you know, and at the same time, the homie that strikes it up happens to be good at what he does. So he touches it up real good. And at the end of that little, that block [graffiti], when it's done, that's block's representing our neighborhood. And it's representing him and whoever's name is on that wall. You could put your name on a fucked-up ass block and still represent. But, you know, you always want to be proud of what you got. You know, you want your name to look good! Because when people drive by they're going to be like "oh, that's such and such." It'll stand out and let it be known that we're there . . . we're there to represent. That's why we say we have a gangster touch.

Standing out to be known, to represent in a way that makes you proud, that others will admire: this passage demonstrates how gangsters have created a unique style to reflect their own values, but that the style ultimately creates who they are. Representing is a process of feedback, of recursive creation and imaging. Well-written graffiti becomes a way to manipulate both a person's position within a gang or a local gang community and his neighborhood's position within the city. Their stylish work is for friend and foe to see; through graffiti they "show off to them." This is akin to the hip-hop "style wars," where,

instead of individuals or crews competing, each gang neighborhood tries to outdo the next through the production of good graffiti.

I get the sense that graffiti is one of the most enjoyable aspects of gang members' lives. Graffiti is something everybody loves to talk about. When someone mentions it or sees a photograph of some graffiti, people usually get excited and start laughing and talking over one another. Though the content of graffiti relates to more serious concerns like gang warfare and representing, its aesthetics and style make graffiti full of fun. One gang member excitedly described the process of writing well like this:

> Other neighborhoods, you know, they do big writing, but they don't write it like . . . it comes out nasty! But us, we got, we do big old writing, and it comes out clean. They were tripping out, wondering who these little fools are. Because you see them little homies' names up on the wall, and that motherfucker, he thrown some down ass blocks! And they know my homeboy's short! They know he's small! Yeah, how's he gonna do that? He got some big ass blocks, six foot blocks! How did he do that? Well, they get on top of each other to do the top, then they do the bottom. Sometimes I get on my homeboy's shoulders. You know, we actually sit here and we'll figure a way to do things. 'Cause we always want to create, do something so they say "Damn, them guys got talent!"

Stylistic prowess is one way to gain a reputation in your local area for being good writers with talent. Surprisingly enough, gang members generally do show respect for other gangs' well-written graffiti—even across boundaries of their worst enemies. A host of established and newer styles—combined with the "gangster touch"—enables Chicano gang members to "be proud of what they got," to gain a local reputation, and to influence their own position in the gang.

Style is never an easy issue. Art in general tends to baffle anthropologists—it seems to operate on visual, visceral levels impossibly distant from our everyday ethnographic techniques. As Clifford Geertz points out:

> Art is notoriously hard to talk about. It seems . . . to exist in a world of its own, beyond the reach of discourse. It not only is hard to talk about it; it seems unnecessary to do so. It speaks, as we say, for itself. (1983, 94)

But at the same time, Geertz notes, art has an impact on the world and evokes our curiosity. We want to talk about it, and we do. But for all the social elements we can tan-

gibly discuss regarding gang graffiti, for example, we find in equal amounts those intangible things—the aesthetic, the style, the feeling. The following sections attempt to link some of these intangibles with social and political analysis by combining a focus on subject, object, and form with local and historical accounts of stylistic change.

In the following sections, I outline what seem to be central elements of style in graffiti, starting with how such styles shift through time (and in and out of overt politics) and how we can approach changes in style from an archaeological perspective. (It is, after all, archaeologists who have "gone to town on style," as one archaeologist friend of mine put it.) Then I address some specific styles of today and the role of the artist in their development and manufacture. Last, and perhaps most important, is how style also becomes a focal point for defining race and culture as well as gang; style can either accentuate or detract from differences between groups and individuals.

### The Archaeology of Style

Archaeologists are famous for identifying past societies, reconstructing time periods and cultural flourescences, even locating sites of resistance and colonization through the analysis of stylistic shifts in the artifacts they excavate (see, for example, Sackett 1977 or Wobst 1977 for an account of style as information exchange). Though their analyses usually span hundreds or even thousands of years, we can approach a similar stylistic archaeology of graffiti that may, with luck, span decades. Without knowing specific barrio histories, it is difficult to estimate the age of spray-painted Chicano gang graffiti, which rarely bears a date. In alleys, images are seldom erased. Though they may survive, the spray paint usually becomes increasingly faded or subsumed by newer images. Sometimes longer-lasting images can be found scratched into concrete. Such writings dot the sidewalks of many traditional neighborhoods and are some of my favorite forms of existing graffiti. These graffiti lend the barrio an explicit sense of history—perhaps its only written history.

Because it is exceptionally underdocumented, research into changes in graffiti style has been as exciting for me as it has been difficult. Apart from looking to the occasional concrete graffito, I was unable to think of even approaching the topic of stylistic change before I had access to the work of previous scholars. Some of my most exciting days have been spent looking at older images. When I first gained access to the graffiti Lomas and Weltman had collected in 1965, for example, among the photographs were some written notes. Reading through them I saw one card that said, "C-T# R-S#," from a wall on

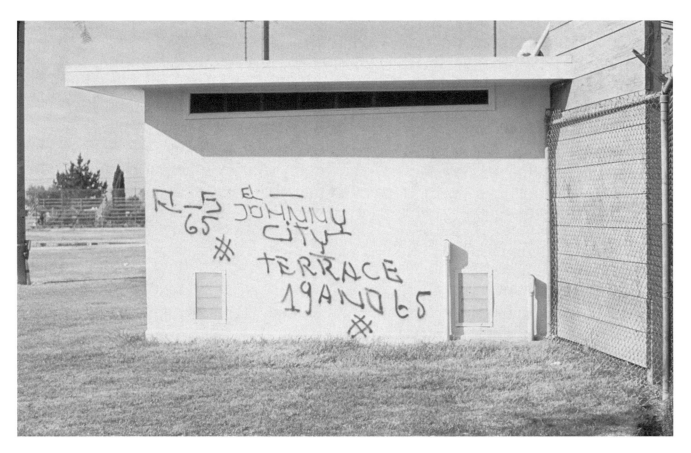

Fig. 3.38. "El Johnny" from City Terrace (1965). Photograph by Ben Lomas.

103rd and Wilmington in Watts. At first, I had not even an inkling that it could be Chicano gang graffiti. I even thought that just maybe they had mistaken for graffiti the cryptic writings of the phone company or some such entity—it was that unrecognizable to me as gang related. Soon after, however, the corresponding image (see figure 3.38) along with other photographs of Chicano graffiti helped me to realize that remarkable changes had taken place in what had seemed previously to be a fairly conservative written tradition through the ages.

In figure 3.38, el Johnny from City Terrace has written graffiti that indicates his nickname, his gang name, and the year. After seeing this image, now the mysterious card made obvious sense as a City Terrace composition, probably by the same individual. The pound signs ("#") and the "R-S" were two elements that clearly meant something, but they are no longer used in Chicano gang graffiti—significant changes have occurred in

content and decoration. With only these elements and initials for which I had no context, the meaning of the card was indecipherable. Another reason the card had been so confusing was that Johnny was dramatically out of his territory. City Terrace is in East Los Angeles, nowhere near the middle of the black community in Watts where he wrote this graffiti.

The lettering on Johnny's composition is fairly straightforward. The things that confused me on the card were as much a result of the content as the extinct decorative devices—dashes separating letters instead of the (then) more common slash (now people use a dot or quotation marks to separate words or initials); the pound signs, which may have had their own symbolic meaning in the 1960s; and the mysterious "R-S." These things are so long gone there is not even a hint of them in any alley, nor in any book on graffiti—nowhere at all. Looking ahead toward 1974, some pound signs still abound as decorative devices, but the R-S disappears altogether.

As of this writing, the R-S is beginning to lose its mystery. One of the first explanations of it (which I heard from an older gang member) was that it simply meant *rifamos,* for "we rule." But I found this explanation difficult to accept. It seemed to me that the "R" and "S" should represent different words, thus adhering to long-standing traditions of Chicano gang initialing. It wasn't until recently that I found out that the "S" wasn't a letter at all, but a number. A member of the Vagos Green Nation Motorcycle Gang (whom I chanced to meet at a tattoo convention) told me that the graffiti actually read "R-5," for *Rifa Cinco,* or "Five Rules." This man didn't know exactly what *Rifa Cinco* meant, because he had never been a gangbanger, but he had clear memories of the "R-5" from growing up in the barrio during the 1960s. I am convinced that his interpretation of the early graffiti is indeed the correct one. So far, I have been unable to find anyone who knows the referent of the mysterious *Rifa Cinco*. But I am confident that many people in Los Angeles remember the context of its original usage; it's simply a matter of finding them.

In figure 3.39, "Chief" from Lil Valley writes his name in striking red paint. Though this picture was taken in 1965, the graffito is written in the classic early style of the pachuco era. The tiny cross at the head of the image gives it an almost sacred quality, and lines surround the words as a mandorla, or almond-shaped aura, would surround the Virgin of Guadalupe. At this point, I don't think it is possible to underestimate the religious influence upon Chicano gang writing as well as some of its designs. A recent conversation with Jerry Romotsky, coauthor of the 1976 *Los Angeles Barrio Calligraphy,* confirmed

Fig. 3.39. "Viva Chief de lil Valley" (1965). The writing resembles the classic early style of the pachuco era. Photograph by Ben Lomas.

this. He told me that "the Catholic church taught kids rigid rules for writing. Good writing had status. The emphasis was always on the beauty of the script" (1998). Between their Catholic and Aztec roots, Mexicans in the United States come from a culture already steeped in the power of visual imagery. The presentation of writing has always been an important focus for Chicano gang members.

Changes in technology, including the introduction of the spraycan in 1948, have also dramatically influenced the aesthetic presentation of graffiti. As artist Chaz Bojórquez notes in the book *Street Writers:* "Old graffiti was always done with a brush. But spraycans and felt markers have changed everything" (Cesaretti 1975).

Aside from the "R-5," changes in the content of Chicano gang graffiti have generally been limited to lettering styles and decorative devices—basic symbolism and writing patterns have remained startlingly consistent since the early days. The most fascinating changes ever since the introduction of spray paint have been in the presentation of letters themselves. Lettering styles, on the other hand, have gone through periods of elaboration, with the simple writings of the 1940s leading to the development of specific al-

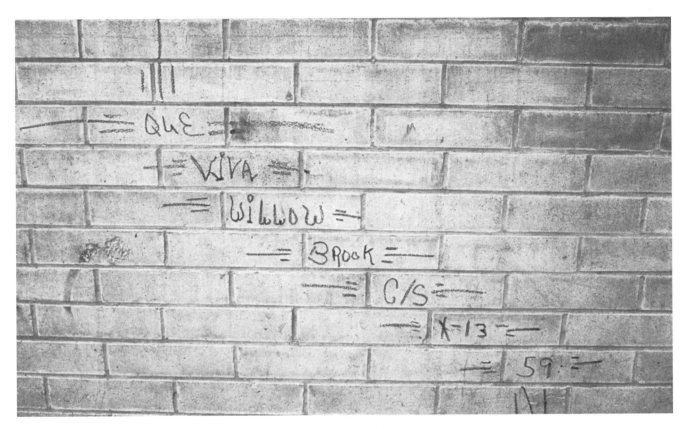

phabets through the decades. As gang members play with initials, names, and symbols, they also manipulate the shape and form of the letters that represent them.

The graffiti in figure 3.40 reads "Que Viva Willow Brook," "C/S" *(con safos,* or protected by God), "X-13" (representing the 13 and "M" symbolism) and "59" for the year (1959). Many older graffiti include the date with their compositions, perhaps because people were not nearly so vigilant in erasing them in previous decades. Willowbrook is a small city near Watts. Though it played an important role in the 1965 Watts Rebellion as well as in the African American gang truces of 1992, its name is rarely associated with the Watts and Compton of South Central rap and riot fame. As we see in figure 3.40, Willowbrook also had an early Chicano gang constituency. A softer lettering style, with the rounded double curves of the "E," the "Ws'," and the "L's," is part of a hallmark 1960s alphabet, the same alphabet used in the composition in figure 3.41. The lines surrounding the composition are a common stylistic device appearing into the 1970s, but they are no longer seen today.

Fig. 3.40. "Que Viva Willow Brook" (Hooray for Willowbrook) (1965). "C/S" means con safos, or protected by God); "X-13" represents the 13 and "M" symbolism; and "59" is the year of composition. Photograph by Ben Lomas.

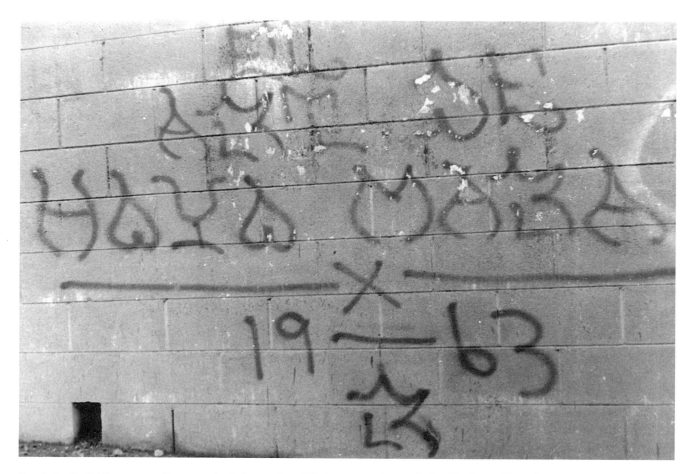

Fig. 3.41. Graffiti from the Hoyo Maravilla ("marvelous hole") gang (1965): "El Art De Hoyo Mara 1963 R" ("R" for *rifa,* or "rules"). Photograph by Ben Lomas.

Two symbols here, the C/S for *con safos* and the 13, lasted into later eras. Each older instance—here, in a composition from 1959—of the 13 reminds me of the conservative nature of the Chicano gang community. The 13 is the *longue durée* of the gang world, the same symbol lasting through changes in meaning, relationships, and history.

Figure 3.41 presents a similar form of the lettering style used in figure 3.40. El Art De Hoyo Mara has written this graffito for Hoyo Maravilla (a gang name meaning the "beautiful or marvelous hole"). Letters with a curved fatness toward the center gives them a grace particular to that era—the "Santa 13" in figure 3.24 also displays this more gentle style. The "R" for *rifa* (rules) at the end already hints at Old English—if it were not for the "R's" in "Art" and "Mara" above, I might not have guessed the final element was a letter at all.

James Diego Vigil writes about Hoyo Maravilla developing a gang as early as the 1920s

or 1930s in a barrio that was originally in an unpaved dirt hole. Vigil indicates that El Hoyo lost some of its isolation with the urban expansion of World War II, when "rival youth gangs developed to vie with El Hoyo for street supremacy. Interestingly, these new barrios took on the Maravilla generic name, adding distinctive street or regional modifiers to distinguish themselves from El Hoyo" (1988, 67). Marianna Maravilla, Lomita Maravilla, Arizona Maravilla—supposedly seven *Maravilla*s in all. I've always thought that the *maravilla* label expresses a sense of the love for the places—the holes and ditches—where Chicano barrios first developed, where neighborhoods and lives are carved from nothing through cultivation, living, and naming. The letters of the composition in figure 3.41—the heart-shaped curves of the "O's" as well as the Arabic shape of the "A's" and "M's"—combine curves and angles, practices carried over into later styles of lettering, across the Maravillas and other Chicano barrios of the time.

Sometimes the best thing about graffiti is the challenges it offers. When I first saw the image in figure 3.42, it took me a while to interpret the second line. The "Los" and "Lil" at the top were clear, the "Trece" down below sensible enough, and even the word "Mota" at the far bottom was easy enough to decipher—although it only made sense to me when my husband told me that *mota* meant marijuana. The word in the middle, however, troubled me until I realized that the "A" in "Mota" matched several letters in the second line. I finally figured it was the word *Arañas,* meaning "Spiders." An old-fashioned gang name to boot—few Spiders or Dukes abound in Los Angeles today. (Joan Moore [1993, 28] has compiled a list of all the clique names of El Hoyo Maravilla and White Fence that shows changes in naming styles.) Devices such as the pound sign are now recognizable as part of the 1960s Chicano gang style. The writer also used squiggles at the top and double lines on the bottom row to form this composition into a square, as the Romotskys would have anticipated.

Figure 3.42 shows how gang members combine rigidity with curves; the different letters contain both angles and rounded lines. Far from being a speedy venture, such an alphabet requires one to use more line strokes; the "N," for example, necessitates four separate strokes—much more difficult than the three-in-one stroke of today. "Mota" here alongside the "trece" was another meaning for the "13," before the days of the North-South division.

The amazing thing about Chicano gang culture, as well as with that of the Bloods and Crips, is that it is still possible to encounter people from all generations. When I go to the

Fig. 3.42. Graffiti from the Spiders (Arañas), an older L.A. gang (1965): "Los Lil Arañas"; "Trece" (thirteen); "Mota" (marijuana). Photograph by Ben Lomas.

liquor store near my house, I see the man with his pachuco cross and tattooed beauty mark popular in the forties. I can go to a friend's house for a barbecue and talk to his grandfather, who describes the sharkskin zoot suit he used to wear and recounts how, even in those days, Santa Monica and Sotel weren't getting along so well. The people are here and living; the images testify to the details of a past they are sometimes hesitant to talk about. How transitory is our knowledge, indeed—but also how unchanging the concerns of *los vatos locos.*

The 1970s brought an explosion of writing. Unlike the 1960s, the 1970s are part of a collective consciousness of the current Chicano gang past. In the 1970s, gang areas overflowed with graffiti in a fluorescence of single lines still alive in the current generations of gang memory. Kids in gang neighborhoods grew up surrounded by words that seem to have always been part of the barrio landscape.

The graffiti in figure 3.43 from Varrio Nuevo Estrada in the Estrada Courts housing projects are good examples of classic 1970s script. According to the Romostkys, Lil Art's is the single-line version of Old English lettering (as, for example, in figure 3.52). Lil Smiley uses

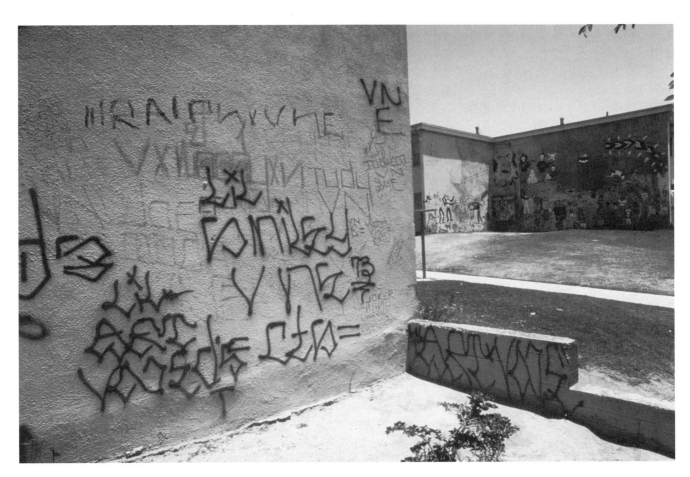

another form of angular writing popular at that time. Notice the murals on the background walls of the projects, part of the politically active environment of neighborhood pride and brown power—as much anti-Vietnam as pro-Chicano.

During the politically active years of the 1970s, links between graffiti and politics were more than mere juxtapositions of murals and gang writings. Gang members merged political views with traditional gang messages, integrating their neighborhood voice with one of political awareness and nationalist dissatisfaction. Chicano empowerment movements in the 1960s and 1970s gave Chicano political efforts great visibility, something that radically affected the growth of barrio artistic production. Because of the political emphasis, people created a confluence of barrio styles, allowing themselves to look to the pachuco era and the native cholo with dignity instead of shame. People combined graffiti

Fig. 3.43. Estrada Courts housing projects (1974). "Ralph VNE"; "Lil Smiley VNE, 73, Cts" (courts); "Lil Art VNE d's" (probably for Dukes); plus miscellaneous other graffiti. Photograph by Leonard Nadel, courtesy of the Leonard Nadel Photo Archives.

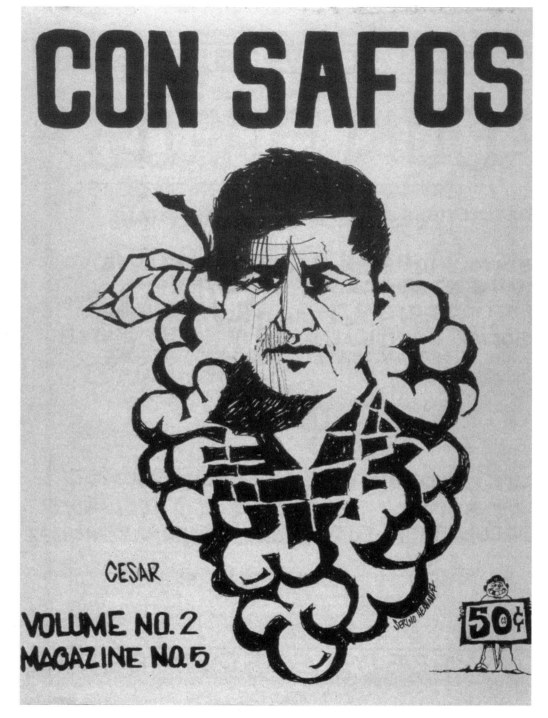

Fig. 3.44. *Con Safos* magazine: *Reflections of Life in the Barrio* (1970). The contents of this edition include articles such as El estado de las uvas (The state of grapes), Social comment in Movement Art, the famous gangster poem "Retrato de un bato loco," and, of course, one of the "Barriology Exams." Cover design by Sergio Hernandez. Courtesy of Ralph F. López-Urbina.

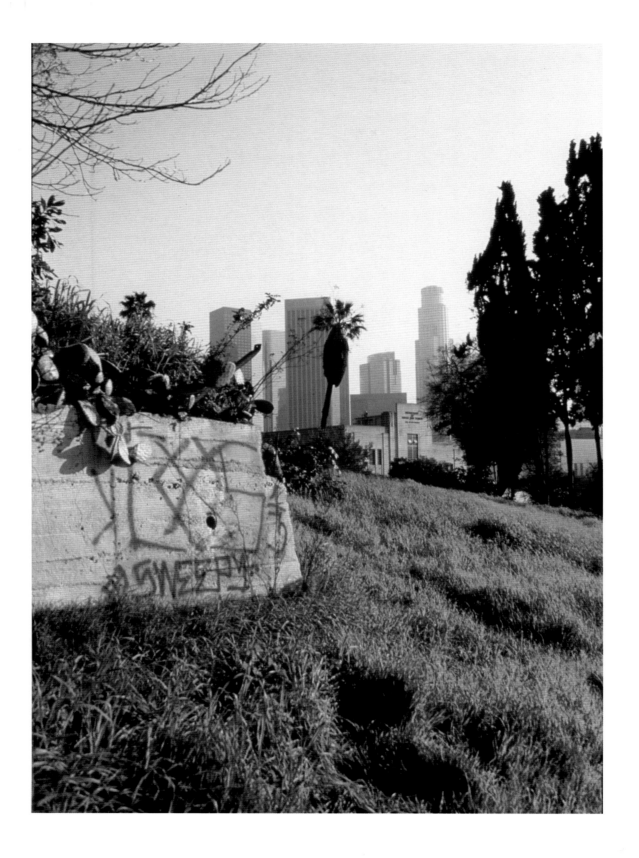

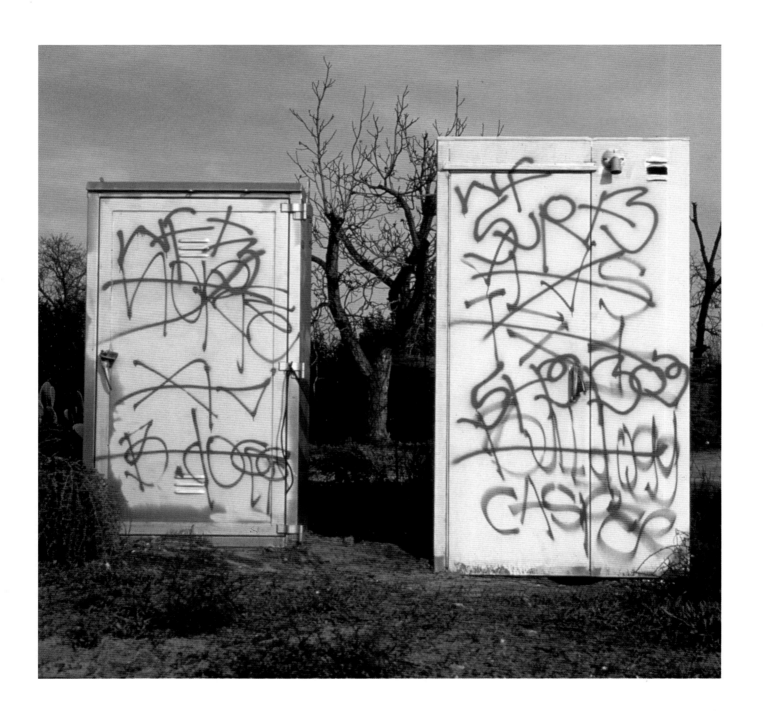

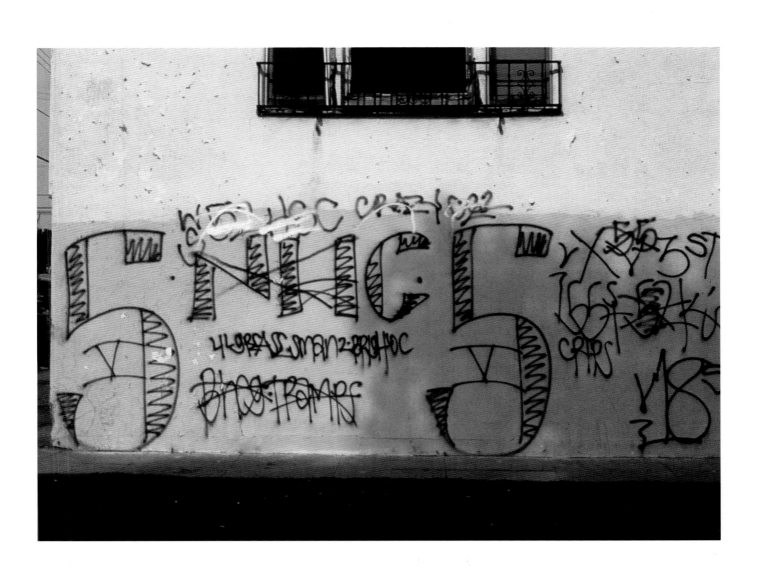

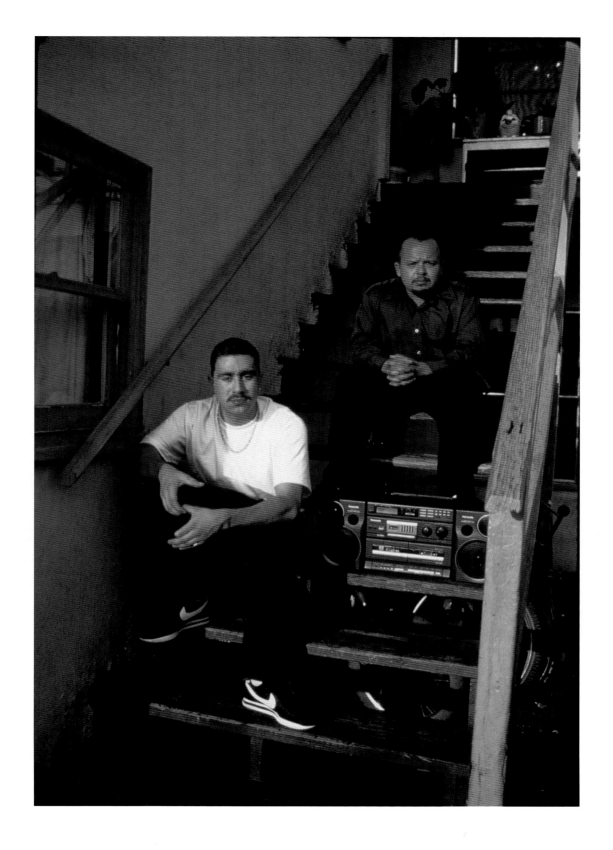

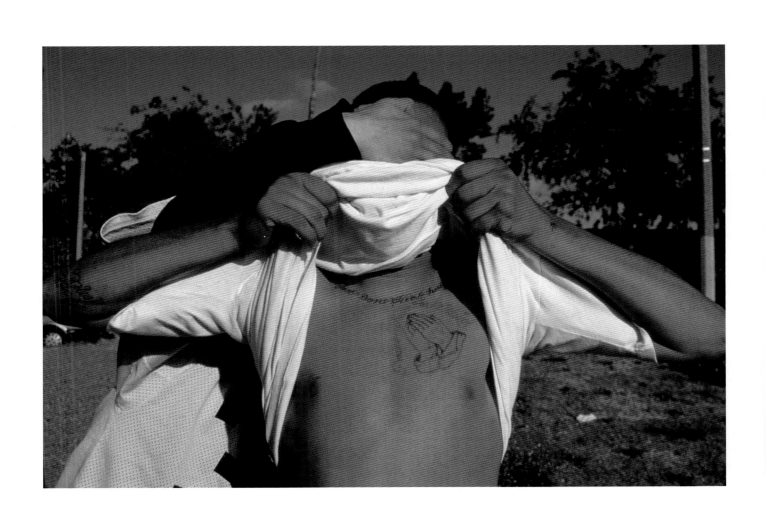

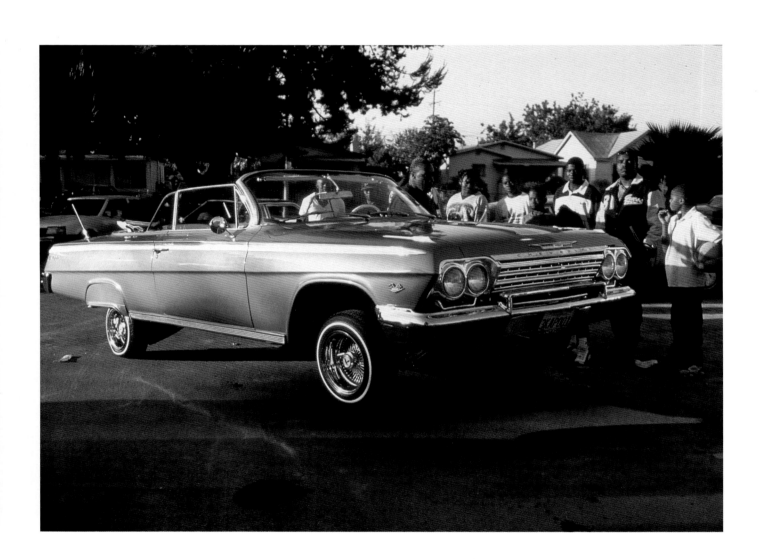

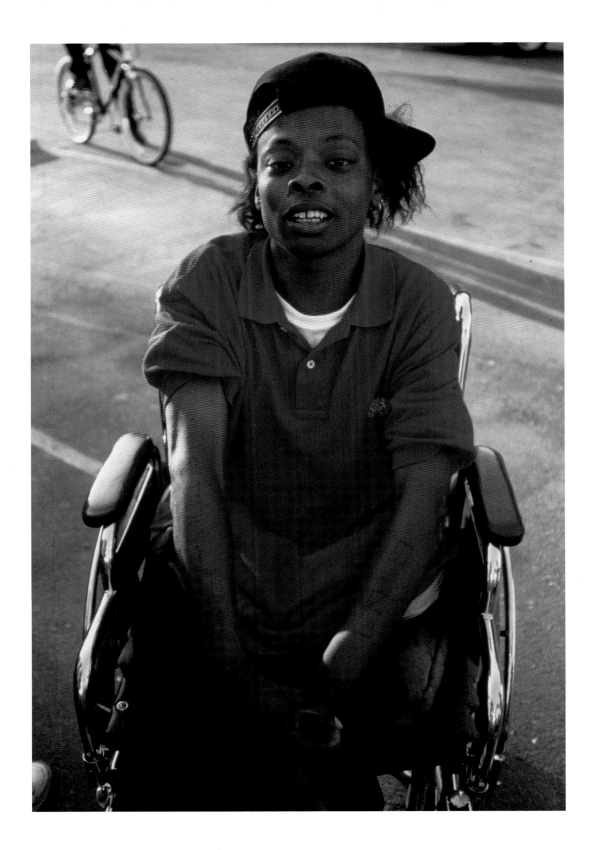

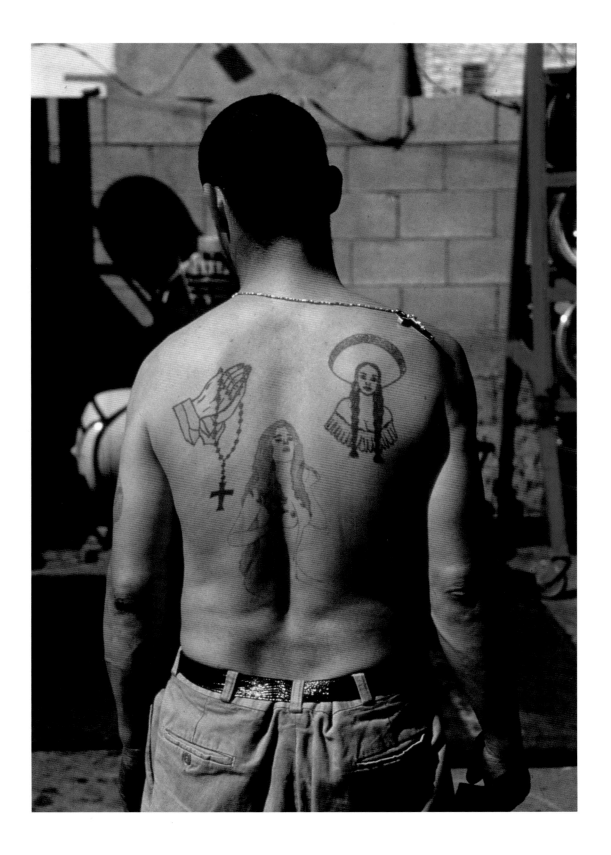

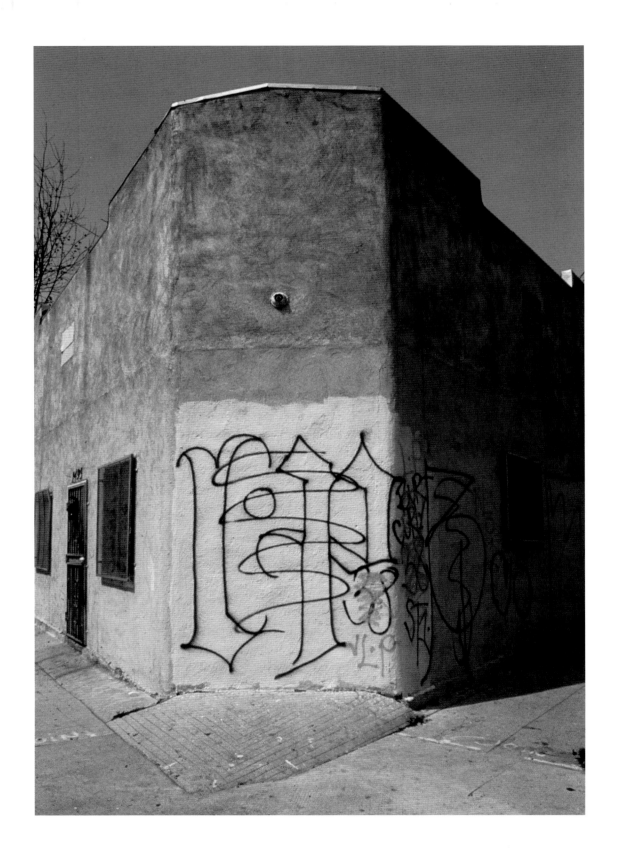

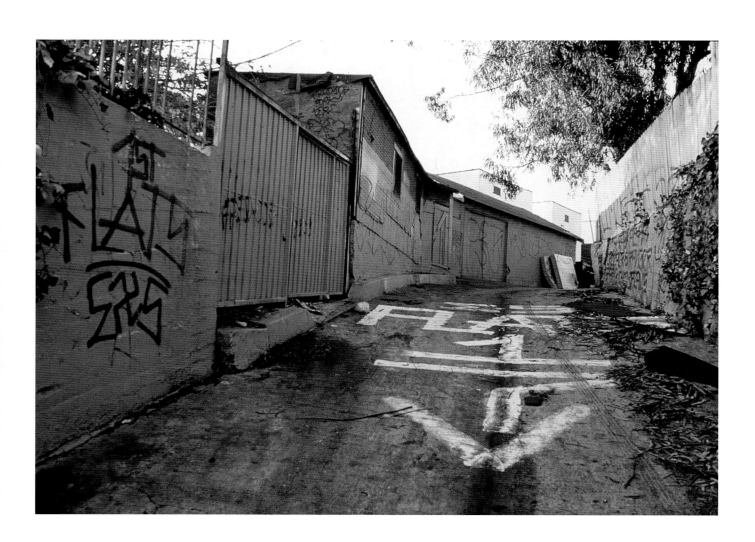

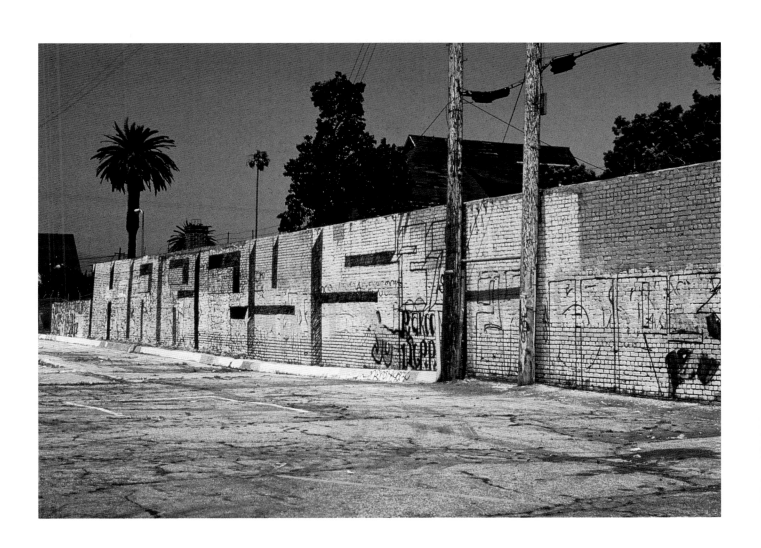

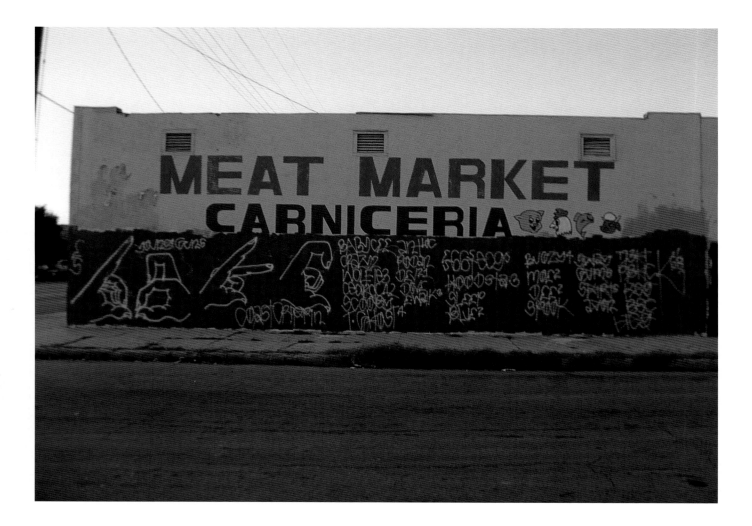

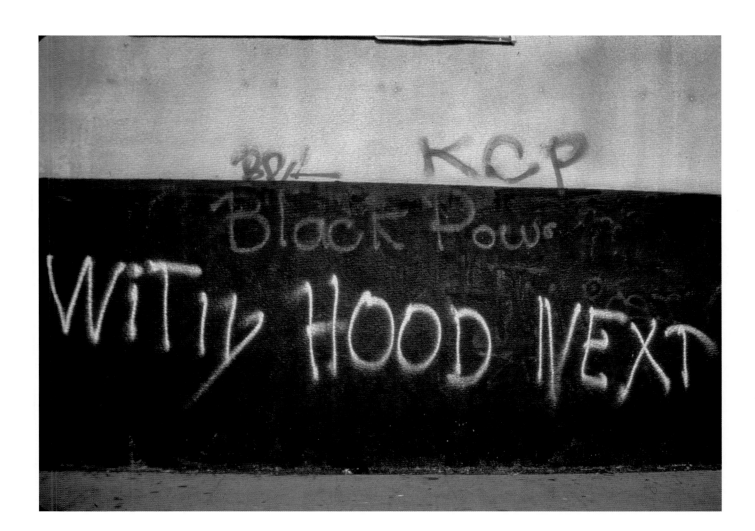

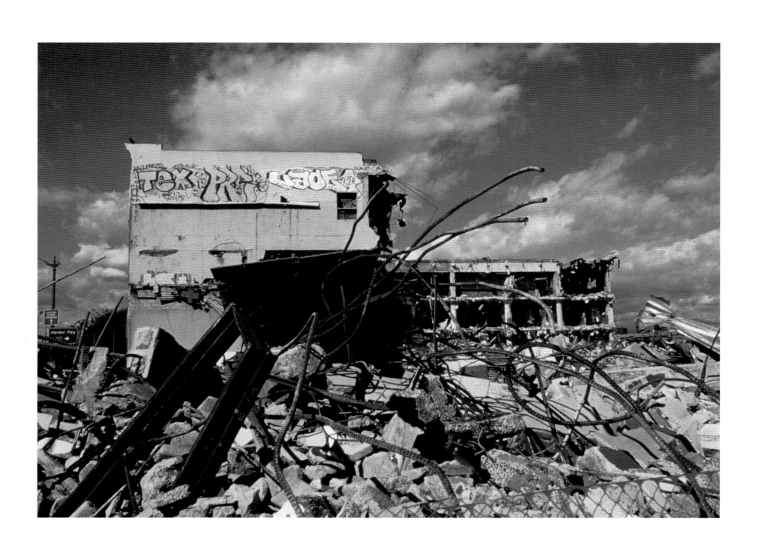

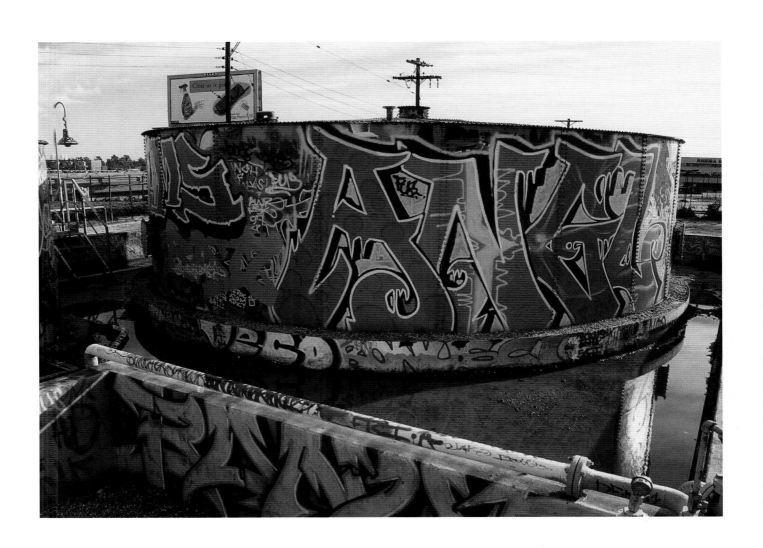

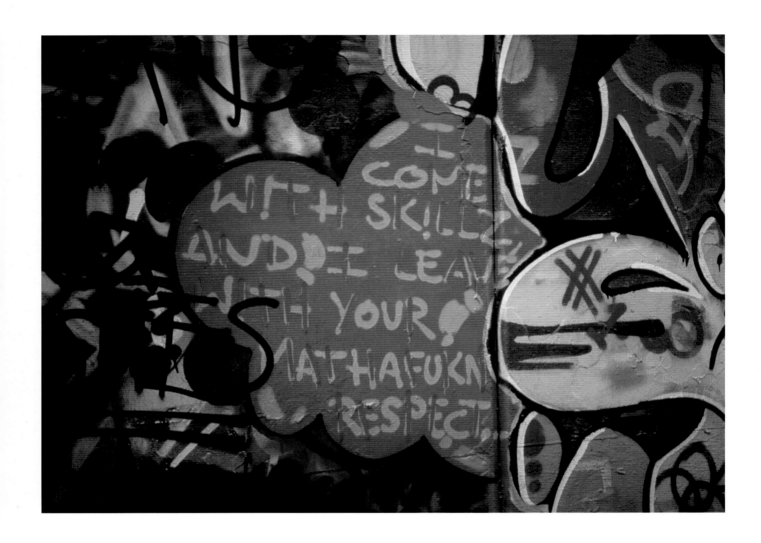

with muralism, personal styles of art production with political statements—divisions were less clear with the common link to *el movimiento*. Theatrical performance groups like *El Teatro Campesino* and groups like ASCO played on typically Chicano elements within a more mainstream style of protest—taking ownership of their community, the latter would leave graffiti-like stenciled proclamations reading "Property of ASCO" in their wake. Places like Self-Help Graphics in East Los Angeles were established to teach kids printmaking techniques while disseminating an overtly political Chicano ideology. (Still going strong today, the gallery and workshop now stands as a landmark in the community.) Home-grown publications like *Con Safos* magazine (see figure 3.44) juxtaposed often strongly gang-related barrio aesthetics with the overt politics of farmworkers strikes, boycotts, and brown pride movements. ("*Con Safos,*" or "C/S," is what Chicano gangs once wrote on the walls to protect their placas—the evil eye of the neighborhood, it means "protected by God," or "same to you" if you touch this.)

Sally Romotsky, who worked with her husband Jerry Romotsky in the early 1970s documenting L.A. Chicano gang graffiti, explained to me in a 1997 telephone conversation how graffiti seemed to lead them in so many different directions; with such endless subsets of type and style, it was almost overwhelming. The Romotskys began their research with Chicano gang graffiti on the walls of the barrios, but eventually moved toward the study of street muralism and more individually driven forms of art.[12] Those were the places where the graffiti ended up taking them. Marcos Sanchez-Tranquilino (1991; 1995), along with Eva Sperling Cockcroft and Holly Barnett-Sanchez (1990) also studied Chicano graffiti and muralism of that era. Sanchez-Tranquilino's various publications always link graffiti with Chicano mural movements. This is in part because he worked in *Varrio Nuevo Estrada* in the Estrada Courts housing projects, the walls of which are a museum of some of the most famous murals ever produced in Los Angeles, including Ché with the raised fist: "We are NOT a Minority."

Gang members often interwove political sentiments with their traditional gang graffiti during this time. In figure 3.45, graffiti from the Geraghty Lomas neighborhood in East Los Angeles pleas for *varrios* to unite while still retaining a strong sense of specific neighborhood identity. With its antiwhite and antipolice sentiment, this composition represents a forceful combination of overt and internal political elements. The second writer, who placed another "GL" insignia (for Geraghty Lomas) between "Gringo" and "Laws," crossed out the words he didn't like: "Gringo," "Laws," and "Dead"—leaving the "Chicanos"

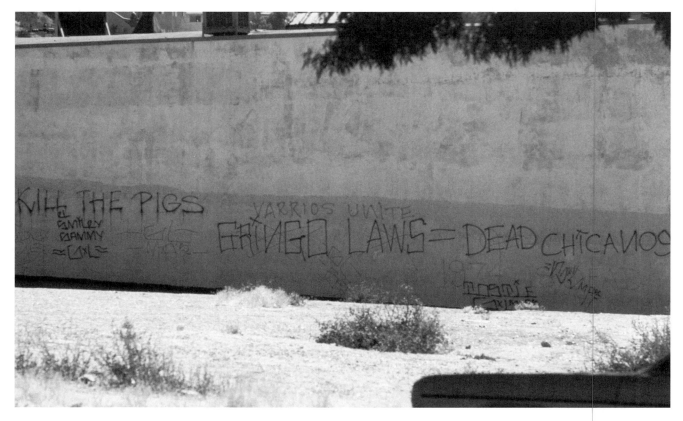

Fig. 3.45. Political sentiments in the Geraghty Lomas neighborhood (1974). "Kill The Pigs"; "El Smiley"; "GL" (Geraghty Lomas), "Gringo Laws = Dead Chicanos"; "Varrios Unite." Photograph by Leonard Nadel, courtesy of the Leonard Nadel Photo Archives.

untouched and writing "Varrios Unite" over the top.[13] Gang neighborhoods struggled for unity against a common enemy—their true enemy—the police and white laws that harmed Chicanos while feigning equal justice.

Apparently such a unification also followed the Zoot Suit Riots of 1943, when previously warring pachuco gangs realized the futility of their enmity toward one another. The pachucos subsequently espoused an ideology of antiwhite sentiment and Mexican unity. Unification against a common enemy is a widespread pattern in many societies with internalized violence. The major riots of twentieth-century Los Angeles (the 1943 Zoot Suit Riots, the 1970 Chicano Moratorium, the 1965 Watts Rebellion, and the 1992 L.A. Uprising) were all directed against the white authority, and all contributed to gang unification movements (I discuss the impact of both the 1965 and 1992 riots in chapter 4).

The 1970s were a crucial period for Chicano gangs. The Chicano movement cemented sentiments of empowerment and pan-Chicano ideology as an ever-present foun-

dation of gang ideology. Today, however, these sentiments are rarely overtly expressed at the street level. Artistic and cultural boundaries in Los Angeles are increasingly rigidified between gangs and politics. Certain types of behaviors are condemned and others accepted—even co-opted. This has happened as both the media and community expression have matured. It has also happened as politicization has proven increasingly ineffective in the fight for empowerment. Where graffiti used to be incorporated into murals that projected leftist or revolutionary ideologies of Mexican nationalism and brown power, neighborhood pride murals today are constructed primarily as implicit antigang messages. As always, many forms of street muralism act as antigraffiti measures, from home-grown store advertising systems to full-blown, city-endorsed muralism programs. In the 1970s, increased politicization helped to merge these forms together in the Chicano community, bridging legitimate and illegitimate boundaries. But the open-ended politics that fused graffiti with different kinds of productive arenas no longer carries the impact it did in the 1970s. Instead of joining the community together, mural practices may even pit neighborhood elements against each other.

Few guerrilla artists survive in a city that seems entirely depoliticized—if they do, they are almost institutionalized in their individuality (I am thinking of the political poster work of Robbie Conal, for example, or of the famous "Joey," the L.A. silhouette artist of "Lost Angels" around town). Others, like Peter Quezada (Kim 1995), have managed to take the stylized lettering of gang graffiti and turn it into street-based messages of unity as well as a productive line of work.

Links between graffiti and other art forms have always been present in the Chicano community. The strongest ties between legitimacy and illegitimacy in current gang communities continue to be through forms of artistic and cultural production: rap music, graffiti lettering, and general urban fashion. In the 1990s, links with hip-hop have replaced those with overt politicization in many circles. When gang and hip-hop styles have merged, it has usually been through fashion in the creation of an altogether urban aesthetic, which has crossed over into advertising and entered startlingly mainstream circles.

Change as well as continuity mark graffiti through time. Shifts range from minor decorative devices to styles of lettering, some lasting, some in and out of fashion like last year's hat. They also embody broad, community-wide shifts in political engagement. Regardless of era, insignia, or level of politicization, several things are ever the same with Chicano gangs. The nickname, the gang name, sometimes the insignias have remained stable.

*Viva*—that they live long; *Rifa*—that they rule; the 13—their Mexican heritage, the marijuana trade, and Southern claims. Both the R-5 and C/S are gone. It is difficult to say exactly when the long popular *Con Safos* went out of usage, but it was hallmark of Chicano gang graffiti over a span of at least twenty-five years—well into the seventies, if not the early eighties. My guess is that it has been replaced by the more confrontative "*¿y que?*" meaning "so what?" (What are you going to do about it?). In one sense, this switch indicates the shift from passive protection to protective aggression. *Y Que* and *Con Safos* are analogous terms; perhaps using both would be redundant in the violence of the current gang world. Whatever the reasons, gone are the days of the C/S, of the beautifully complex lettering of the sixties and seventies. Chicano gangs have cut them out of their writing system just as they have shaved off their ducktails and thrown away their hairnets. These elements can only be rekindled here thanks to earlier documentarians.

### The Styles of Today

With massive deindustrialization in the inner city during the 1970s and 1980s and the introduction of crack cocaine, gangs went through a kind of growth spurt. Not coincidentally, I think, while the 1960s and 1970s spawned numerous single line alphabets, the 1980s and 1990s are known for the production of gigantic and refined forms of block lettering. With the explosion of gangs, competition for space between neighborhoods has increased. Where gangs in many parts of the city used to be separated by a "no man's land" of neutral territory, today's graffiti compositions help divide the territories of gangs that are sometimes only blocks apart. Gang compositions need to be more visible from a distance, and, regardless of placement, they communicate all the power and prowess invested in the gang name. Figure 3.46 shows one of my favorite images (taken from the middle of the 110 Freeway); it stayed up for years but has since been subsumed by tags and throw-ups.

**BLOCK LETTERING**   Graffiti that represents the gang usually embodies ideals of writing within the Chicano gang community—straight lines, no drips, a rigid sense of design that involves a balance between the composition and the space upon which it is made. One man I interviewed indicated his preference for these more complex lettering styles:

> Well, you see, block letters and Old English—that I can appreciate. But to go up
> and "pspspspshshsh" [onomatopoeia] and then sometimes not even be able to

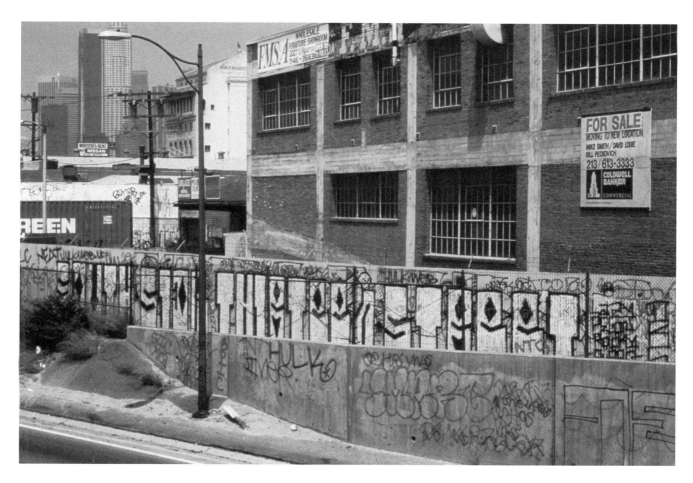

read it? I mean, oh God, get away from me. I mean, you know, if it says "Santa Monica" like with real pretty letters, hey I could live with that. Hey, you know, you have style and class. But if it's "pshshshs" . . . a real skinny line, no style, no nothing. No creativity. It's not even a form of expression.

Of the more intricate styles, writers most frequently use block lettering to distinguish themselves and their gang. Letters may or may not be filled in, they may be made in two or three dimensions, or they may have a positive or negative relationship to the wall. The letters rarely have bottom lines, making them seem to grow literally out of the ground. As gangs spread like cancer, graffiti grow like weeds—and oftentimes they grow in the form of block lettering.

Fig. 3.46. "South Side Thirteen Street," photographed from the 110 Freeway (1991). Exceeding six feet in height, this style still retains a gangster touch and can be found in many *Teen Angel's* compositions on paper.

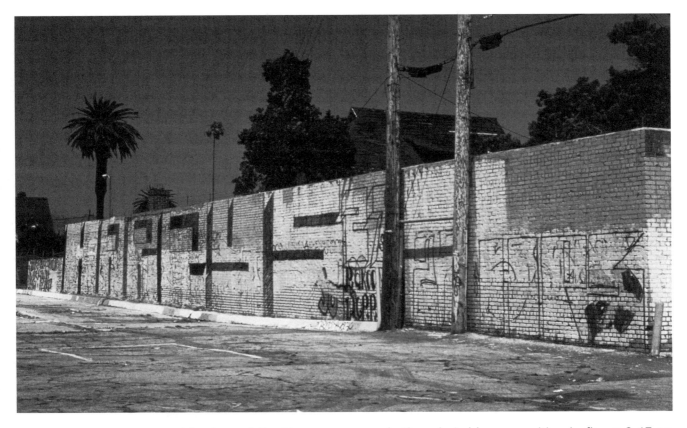

Fig. 3.47. "Harpys 27," on Adams Boulevard near Hoover and the University of Southern California (1992). This enormous (approximately eight feet tall) piece of graffiti demonstrates the effectiveness of three-dimensional block letters with shading.

Members of the Harpys gang made the admirable composition in figure 3.47 on Adams Boulevard near Hoover in Los Angeles. The angularity and regularity of the three-dimensional letters, as well as the public placement of this composition, are testament to the writers' skill and daring in the production of this piece. The shadowing makes the letters stand out dramatically from the wall (which has since been knocked down).

The close-up work required to produce graffiti like that in figure 3.47 necessitates a strong mental visualization of the composition as it is being produced. Oftentimes gang members will use existing brick, cinder block, or wall lines to help guide their compositions. Creating giant-sized block letters is analogous in many ways to the work of old-style billboard painters as they dealt with the close-up manufacture of gigantic toothpaste tubes or vegetables in advertising.

A more delicate block lettering style by the 38th Street gang, one of the oldest gangs in Los Angeles, is shown in figure 3.48. Oftentimes the most impressive compositions are

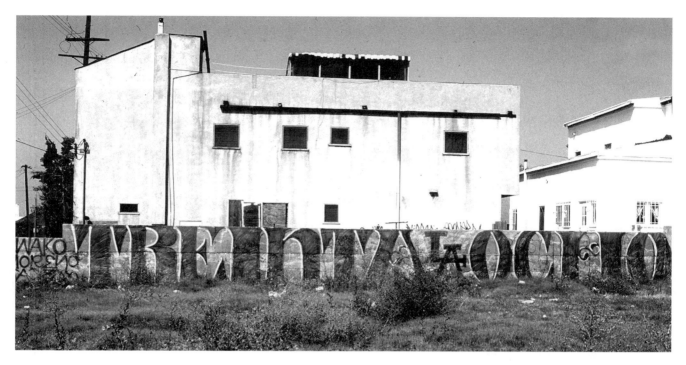

done in two colors, as here, where the 38th Streeters have highlighted their black letters in white. Creating a large-scale piece like this usually involves the following steps: the writer makes an outline in the main color (in this case, black). Next, the writer and/or a few of his (or her) friends begin to fill in the letters in the same color (black). Then the main writer goes back with the same color to correct any slight errors in the initial execution of the letters, making sure they are even and regular. Only then will the person in charge do the highlights and outline in the complimentary color (in this case, white). One young man who had been admiring this composition said this, shaking his head:

> Most of us don't got no talent. I can't write. I can't write nothing like this. But my homies that can, they're the ones who do it. They're good at it. We got some good people, they're like artists. What they do is this. They put their first copy down on a piece of paper. So they can see how it's gonna look. Just like an architect. An architect puts it on paper first, on a plan, and then he goes and he designs it.

It is costly—economically and legally as well as socially—to practice a complicated style with spray paint. Good graffiti writers spend a lot of their time doodling on pieces of paper

Fig. 3.48. "Treinta Ocho" (thirty-eight); located on Vernon Avenue near Long Beach Boulevard (1996). Painted in black with white highlights, this graffiti measures approximately five feet tall. Note the use of the L.A. Dodgers insignia to separate the two words.

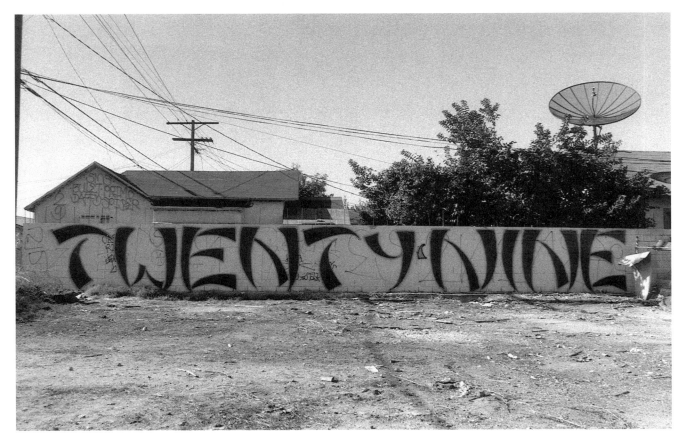

Fig. 3.49. "Twenty Nine," on Maple Street in South Central Los Angeles (1996). Puppet, from the 29th Street gang, painted these "bamboo letters" in black and outlined them in blue.

or on their school notebooks, though not all make detailed plans on paper before executing their compositions. They may, however, perfect a style (like that in figure 3.48) on paper or in pen before attempting to hit it up on a wall.

In figure 3.49, Puppet from 29th Street in South Central Los Angeles used an unusual Asian-style "bamboo" lettering in a four-foot-tall proclamation. I had seen Cambodian and Samoan gang members use bamboo-type lettering, particularly in their tattoos, but there were no such gangs near the 29th Street area. Puppet told me a little about this piece and about how he creates different lettering styles in general:

I got those Asian letters from a math class in jail. That's where I got them letters from. [From a math class in jail?] Yeah. They had some math cards, like little math cards. And they had those little letters like that. So I just did them a little different.

But I got 'em from the jail. I get my letters from magazines. Wherever and then just change them a little. I combine different ones. [Did you have to practice first on paper?] No, I can just look at letters now and see how they would be on a wall. I just go up and do it. I put a few little touches here and there, or combine a few different kinds of letters. I just like to see my neighborhood in blocks, I don't know why. I don't know what it is about me, I just can't write small. See that? [He points to nearby placa.] I can't do that little shit. I do things big.

Puppet has a remarkable command of the spraycan for these larger compositions. I've heard he can even write with two hands at the same time. An exceptional artist, he later shared the following with me in his soft-spoken voice:

> You know, all those guys back there? None of them can write. That's something that I can do, so in a way, it's fun for me to be better than them. I learned from another guy, he trained me and all that. But then I started getting better than him even! So sometimes now, he's better than me, sometimes I'm better than him. It just depends. I look for letters, I like new styles. All those letters that you see, those are letters all my own. I don't like to just copy what I see. Me, I make all different styles. Like all different styles I mix it in one. And it looks good!

Most hit-ups are average compositions with average neatness. Some, however, are extraordinary and a lot of care and effort is put into their production. Certain individuals with exceptional talent are sometimes responsible for the majority of graffiti in a given area. Even though a certain rigidity of design constitutes the Chicano gang aesthetic, there is still room for individuals like Puppet to develop new lettering systems. It takes a combination of practice and talent to be able to translate a lettering scheme from paper onto a wall in spray paint just by looking at it—and all this without a computer, upon which so many traditional font editors have come to depend.

Partially because of Puppet and his homies' talent, the neighborhood of the 29th Street Locos in South Central Los Angeles is usually filled with an assortment of different lettering schemes. Though many are original to that neighborhood, some, like the one in figure 3.50, are common to many neighborhoods around Los Angeles. One of the fastest ways for anyone to represent their neighborhood on a large scale is to fill a fire extinguisher with paint. With such an instrument a person with or without talent can create

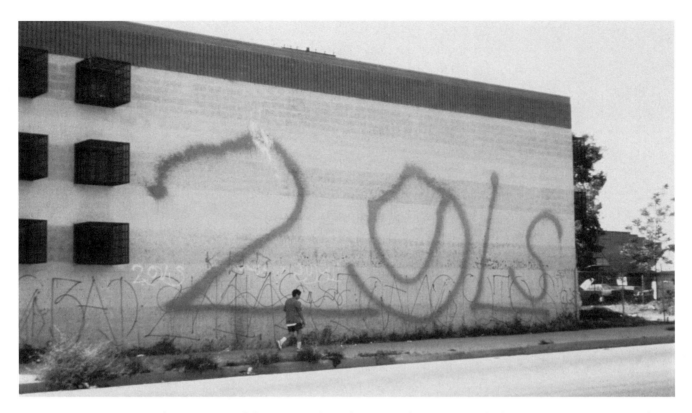

Fig. 3.50. Gigantic spray by the 29th Street Locos (1996).

huge sprays of the name. Though not overly "neat," such designs are impressive and legible for a few blocks if positioned correctly. Another alternative to spray paint is composing with rollers on long poles and traditional house paint. The irony of this is that the paint gang members use sometimes comes directly from graffiti removal programs who had intended their wares for a slightly different purpose.

GENDERED GRAFFITI: HANDWRITING    The "handwriting" or "double handwriting" characteristic of Chicano gang tattooing is seen sometimes in graffiti. Although it is less common than previously shown styles, gang members consider it beautiful. This type of writing in graffiti is most commonly associated with women, as in figure 3.51. However, men often use it in tattooing and prison art compositions; also, in memorial compositions, handwriting—along with dignified Old English lettering— offers a softer alternative to the hard-edged block letters. As a gang member from Santa Monica indicated:

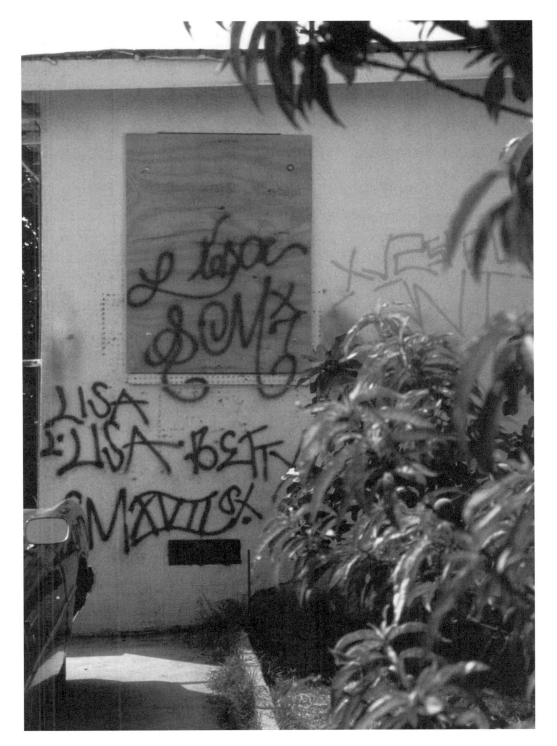

Fig. 3.51. Handwritten graffiti, Santa Monica (1991): "Lisa SMX7," for Santa Monica 17th Street. Below, "Lisa"; "L[il] Lisa"; and "Betty SM XVII St" (also for Santa Monica 17th Street).

> A lot of people respect that style, you know 'cause . . . I think it's nice, you know?
> The way they can make a plain letter look so . . . with so much style, you know?
> With so much to it, more than just three lines making an "n" or one line making
> an "i." It's not just a line with a dot, it's a line with, you know, like a little swirl for
> the dot. It gives it a little style, you know it looks nice.

In figure 3.51, female gang members have used this type of graffiti to support and represent their neighborhood in Santa Monica through an everyday hit-up.

Not all gang members are male. Women usually have their own cliques within any given gang; they are not merely "girlfriends" of the male gang members. They participate actively in the gang, have their own meetings, and—as evidenced in this composition by one of the Santa Monica Lokitas—write their own graffiti.

However, like the larger Chicano community from which it is derived, the gang community is male-dominated. Women may be excluded from things like gang meetings of the male cliques. They may also bear the brunt of early pregnancies and suffer from the violent outbursts of their boyfriends. For few women is the gang a form of empowerment that one might expect—as Klein has stated, "This is no world for the feminist" (1995, 64–67). Neither are they immune to the harmful effects of gang violence: Betty, listed in the composition in figure 3.51, was herself killed in a gang confrontation. The lives of cholas are difficult—see Harris (1988), Moore (1991), and Sikes (1997) for excellent accounts of Chicana gang life. Depending on the context, graffiti styles like handwriting may carry gendered components. Even when men do use handwriting styles, they call up characteristics stereotypically associated with women: when it is a time to be softer or emotional, to show links in tattoo with death or children and the love they feel for their gang name.

**OLD ENGLISH**    The Old English lettering style is one of the most prestigious Chicano gang styles. This classic script is difficult to master. Letters like those in figure 3.52 that are not filled in require that the writer get proportions exactly correct the first time—there is no room to correct slight errors later as with filled-in lettering. As Woody from Santa Monica once told me:

> If you were to go up to a wall and try to write, I'm sure you'd have to stand way
> back and look and see or maybe write some little guidelines or something. These

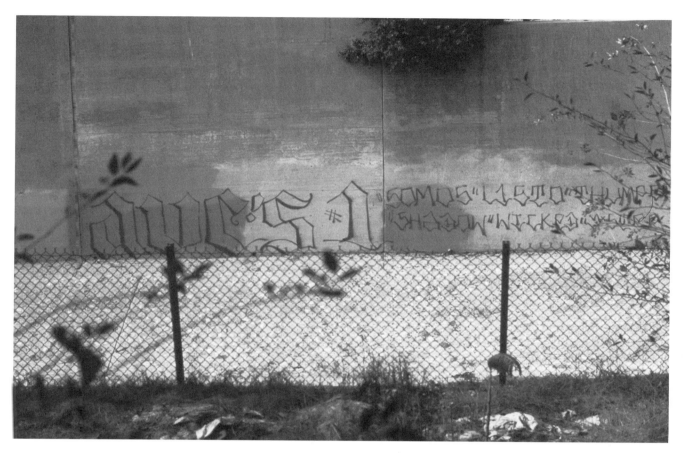

guys don't do that, they just go up there. They write it up there and it comes out nice. Old English is pretty hard. It shows how much you believe in putting your whole neighborhood on this wall, and how much of a risk you're willing to take.

The successful presentation of Old English requires natural ability as well as practice.

I have found no definitive explanation for the use of Old English letters by Chicano gangs, but some relate it to domestic architecture in Los Angeles (Sanchez-Tranquilino 1991) or to traditional Mexican religious imagery. Old English type has also been used for the *Los Angeles Times* masthead for years. No one knows when Chicano gangs started to use Old English letters—I have heard people casually offer that they go all the way back to the forties. Looking through the fifty or so photographs of gang graffiti from 1965, I didn't see even a hint of Old English lettering though—nor any attempts even at basic

Fig. 3.52. Hit-up by the Avenues 43 neighborhood, painted in bright blue Old English letters (about seven feet tall) on the banks of the L.A. River, off the Pasadena Freeway (1995). "Ave's #1"; "somos (we are) Listo, Thumper, Shadow, Wicked, Y.ster" (youngster); "Calle 43rd" (for Avenue 43).

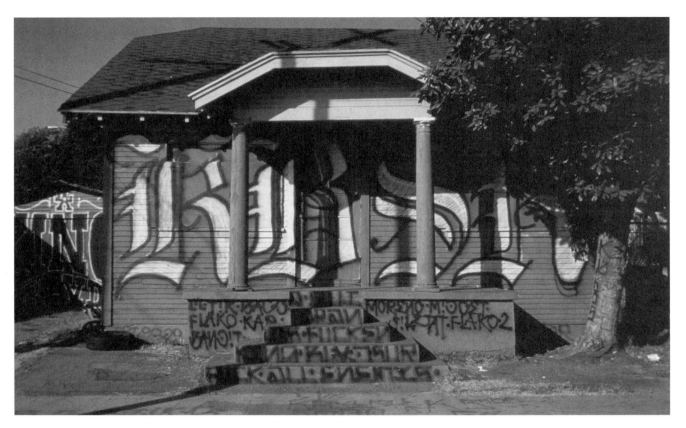

Fig. 3.53. "KBSh" designates this area, near Martin Luther King Jr. Boulevard and Avalon, as King Boulevard Stoner hood (1995). This abandoned house is located in the core of King Boulevard's neighborhood.

block lettering. Some Old English is evident in the work of the Romotskys as well as that of Marcos Sanchez-Tranquilino, who studied in the early 1970s. But Leonard Nadel's rich collection from 1974 entirely lacks the Old English genre; his travels through Los Angeles were far and wide, extending from Hollywood to the Westside to East Los Angeles to South Central. My guess is that Old English did not come into play as a focus for graffiti until a few years into the 1970s.

Old English is a style people are curious about. Admiration for it is shared among gang and nongang populations, the latter of which often marvel at the skill with which Chicano gang members produce it. Those who do not live in gang neighborhoods and who may only be familiar with hurried scrawls or crossings-out, or with the tags they take for gang writing, are often surprised when they see the care and beauty invested in the highly aestheticized lettering.

The writer in figure 3.53 creatively incorporated the beige paint used to buff the house

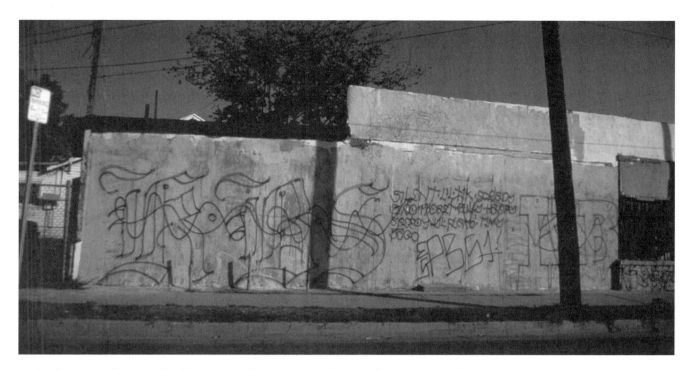

and adjacent walls to make this composition more visible. On the garage of this house (in the background), note the "LA King Blvd." written in an increasingly popular lettering style called Old Western. The placement of both compositions in the heart of the gang's neighborhood gave the writer(s) time to render it without interruption. In addition, it has remained pristine for a longer period of time—free from other gangs' challenges or authorities' constant erasing. Compare its detail and quality to the image in figure 3.54 by the same gang. It reads "KBS" for King Boulevard Stoners, but the letters are not filled in. The East Side Playboys, major rivals of the King Boulevards, have already crossed out the composition.

One of my favorite things about graffiti rivalries is the sharing of styles across gang lines. When encountering a complex composition in Old English or some style of block lettering, sometimes gang members with similar initials or numbers replace their own initials or letters in the same style. Thus "29" becomes "26" by carefully rendering a "6" over the "9." Similarly, KBS graffiti is often claimed by the East Side Playboys, who must only change the first letter to make the composition "PBS." This use of other gangs' styles indicates their own mastery of sometimes new and different forms and allows them to usurp the power of neatly done lettering for their own gang.

Fig. 3.54. "KBS" (King Boulevard Stoners) in Old English, crossed out by "PBS," the Eastside Playboys (1995).

Old English is an older, prestigious style. It is a "classic," like the classic lowrider cars and the classic oldies that gang members listen to. Some neighborhoods have no Old English letters in them. I always assumed this was because no one in that neighborhood had enough command over the notoriously difficult style. But a friend in one such neighborhood offered a different explanation:

> Old English is a style that's been played out. We moved on from there. Because that's where all of us really came from. That's our roots. But then again, you know like anything, you don't forget where it comes from, but you just improve it. Take it to the next level. But it never goes away. It's something you pass from generation to generation. Generations change from the seventies to the eighties to the nineties. Each generation has different shit they like. Like the gangster rap. The oldies got played out. But gangster rap, it meant the same thing for them. It's the same shit. Everybody has a different style in anything. In music. Like, us? We have a style different from another neighborhood. They might just hear oldies over there. We hear rap, we hear everything here, you know what I mean? The way that people dress might be totally different from other people too. We might . . . It gets to a point where you could tell that guy's from so and so, that guy's from so and so. Because he dresses the certain way he dresses.

Specific styles can differentiate neighborhood from neighborhood, generation from generation, while the media through which people mark these differences remain stable through time. As the man in the preceding quote indicated, clothing, cars, graffiti, and music have long been concerns of Chicano gang members. But because their specific form changes, specific styles represent particular gang eras and gangster geographies. Though most neighborhoods still use Old English in tattooing as well as graffiti, the newer styles of block lettering (like Old Western) and other ways of hitting up (like the gigantic fire extinguisher sprays) have become increasingly popular in the late 1990s.

Style can differentiate time periods, gangs, and neighborhoods. I've heard that Eastside, Westside, South Central, and so on all have their own styles. Specific variations in the gang media distinguish era from era, gang from gang, north from south. But the particular form of such variations also mark the graffiti productions as specific to Chicano gangs in general. This is their heritage. It's where they come from, and what makes them who they are today.

*The Style of Race*

I asked some Chicano gang members one day why they thought style and aesthetics were so important to them in contrast to the African American Bloods and Crips that lived next door. One said to me:

> Everything's racially divided. You know, everybody be gang-banging. But the Latinos got their own style of gang-banging. The blacks have their own style of gang-banging. Yeah, you don't see them getting into details and striking up their neighborhood, because Latinos do that. Blacks do it, but they do it in their own little way. They write and they put their hands up or whatever, they let people know what neighborhood . . . but they're not into blocking and striking up like we are because that's a Latino thing. Everything's divided.

Even though the black and Chicano gangs in this area share the same walls to write their graffiti, the manner in which they do so differs radically in content and form. The Chicano gang member went on to describe how such practices represent racial and cultural differences, as well as simply "gang" differences:

> It comes down to our culture. It comes down really to our culture. Their culture, the way they did their thing was through music. The way we used to do our thing is through art. You know, the Aztecs, they always were into painting, and they put their feathers. Dude, that was for looks, Dog! They did that to look good. That's what they were representing and they wanted to represent it good. And that's how we express ourselves, through art. It's an expression. So if you want to express yourself, you always want to do it better than everybody else. You go out there and you say, to me, Mexicans do this better, Mexicans do that better. That's what you like to hear. You always try to make your race like that, you know what I mean? And I think that's what it is. When he [the neighborhood graffiti writer] writes to his people, he represents 29th, but he always represents our culture. Mexicans. Look, when we're dressed, you see creases, you know. When we go out, we're always ironed. We're always clean-cut, you know, you got to be clean-cut. You got to be clean. That's our style. Them, they got different styles—they want that grease on their hair or whatever. That's their style. There's nothing wrong with it, but it's just the way they do it. We do it our way.

And if one of 'em, like our homeboy's black, right? They want to associate with us, they got to be like us. Eat the same food. Wear the same clothes. Head shaved. Remember? Flaco always had his head shaved and pants creased? You can't be walking around with Jheri curls and represent what we represent.

Style can either accentuate or diminish racial difference. As gang members of African American and Latino decent increasingly share the same neighborhood spaces, style becomes a marker that reaches beyond locality or neighborhood. Chicano gang members frequently contrast their Aztec roots with the African American experience of slavery, mentally intertwining the gang style with the "racial" style of Mexico—of Mexicans in general. Perhaps for my benefit, most gang members at least make attempts to put on a facade of cultural relativism and nonjudgment about stylistic and racial differences. In practice, however, they may disdain such differences. Although I did not push him to elaborate, this is implied by the gang member's description of Chicanos as "clean" and African Americans as wanting "that grease" in their hair.

Manipulating style gives gang members the ability to control their relationships with others. Thus style itself and not "color" may indicate belonging in a gang or racial group. Chicano gangs may include a token white or black guy. Oftentimes you find the token Chicano guy in a black gang. Usually these people adopt particular gang expressions (and accompanying lilts to the voice) and styles of walking, dressing, and so on. Stylistic markers of gang identity can thus erase race as well as produce it.

Gang members see style as a form of practice and often equate it with their concept of culture. It differentiates them from nongang members, marks them as being from a certain neighborhood or area, and indicates the larger ethnic groups to which they belong. Being a gang member is not just about making the letters or ironing your clothes, listening to music or lowering your car. It is about the highly specific methods gang members from specific gang systems and gang neighborhoods use for engaging in these activities.

Through these tactics, gang members represent their neighborhoods as well as the racial divisions that increasingly define life in L.A. neighborhoods. Analyzing style archaeologically and historically, we can begin to see how people have driven their development, how certain styles got "played out" while others have remained gang classics. How stylistic changes relate to shifts in larger community-wide interests remains an even more intriguing question.

## CONCLUSION

Gangs may seem to offer glamour, excitement, and kinship in cultures rich with style and symbolism. But most gang members that I have talked to do not wish the same lifestyle on their children. Given the choice, they would take them out of the barrio and put them into a place "where they could live good, so they don't have to go through what I went through," as one man told me. Often, the arrival of a child may signal to many gang members that it's time to stop banging and get serious. Sometimes they are successful, sometimes not. The gang system and concomitant illegal economic enterprises often provide more economic viability than regular employment. Even if they want to, gang members find it difficult to disassociate themselves from their homies and their neighborhoods. These are the people and places that they know, with whom they feel most comfortable— but where old rivalries promise to dog them till the last.

After a lifetime of gang membership, gang members may find it hard to get legitimate jobs. As one man told me:

In gang life, it's hard for a guy to get a job, you know. If you live like a straight cholo, they ain't gonna hire you, you know what I mean? It's called discrimination, but we can't do nothing about it, see. Because we don't have enough . . . we don't have the money to be, you know . . . paying for a nice lawyer, or you know. . . . 'Cause they could get bigger lawyers than us, see. You know, they're more smarter than that.

Because they work outside the law, gangs have in effect sabotaged legislation or stipulations that might otherwise limit their activities. Gang members rely on expressive media like graffiti that, because of their illegality and inherent flexibility, are essentially uncontrollable. Having developed within it, Chicano gangs have subverted the state's prison system by making punishment simply another aspect of their lives. In this way, gang members meet their needs for self- and group expression, financial independence, and meaningful identity by avoiding the control of the dominant system.

Most gang members with whom I have talked feel slighted by the larger system and may occasionally seek empowerment through the promotion of brown power and anti-white sentiment (see figure 3.55). At the core of the gang's rich system of boundaries, symbols, and aesthetics, the nationalism that came to fruition in the 1970s occasionally

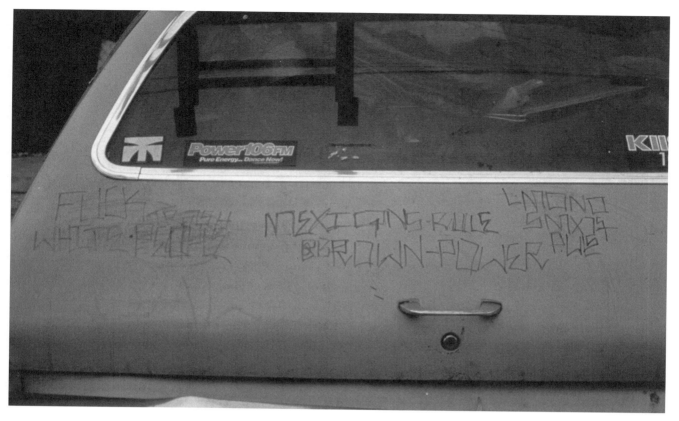

Fig. 3.55. Nationalist sentiment expressed in writing by Lil Mono (1991). "Fuck White People (Trash)"; "Mexicans Rule Brown Power"; "L.Mono SMX7st, PWE" (Santa Monica 17th Street, Pee Wee Locos).

sprouts anew in everyday street life. One young man described his frustration with the outsider views of gang members:

> I don't know if they think that gang members wake up one morning and say, "God today I'm gonna kill somebody!" It has to be more than just that . . . there has to be a reason, they just don't want to take the time to find out what the reason is. Gang members are people too . . . they have feelings and fears, and they get scared just like everybody else.

In my field research, I heard countless stories of substance abuse, domestic violence, and rape of both men and women. Every once in a while, sometimes in reaction to a painful loss, someone would say, "The *Calle* [street] is not worth it." One of my respondents once said, "When the U.S. government attacks the Persian Gulf, it's called war. When we attack one of our enemies, it's called murder."

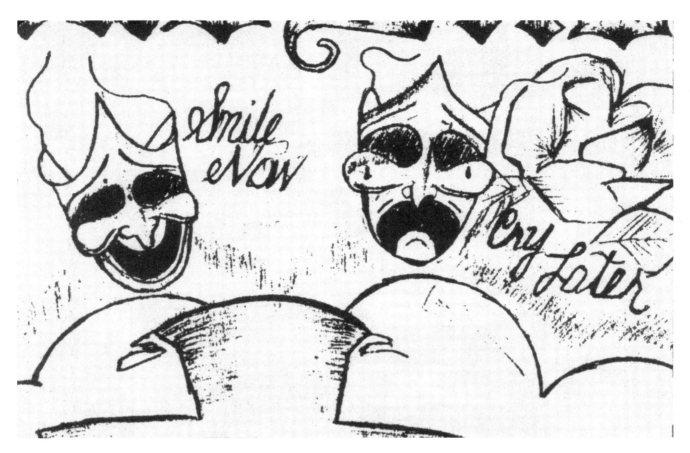

Fig. 3.56. "Smile Now,
Cry Later." Courtesy of
*Teen Angel's* magazine.

Chicano gang members live in a heightened state of paradox. Their illegal activities are simultaneously their greatest strength and their greatest weakness. This contradiction is not lost on the gang members themselves. With the "smile now, cry later" masks of comedy and tragedy (see figure 3.56), Chicano gang members continually define themselves and their community as one with an irreconcilable dilemma. Twenty-seven-year-old Bear from Culver City described the risks and a general lack of mainstream recognition that taint gang membership in the later years:

> I ain't gonna talk good about 'em, cause there ain't nothing good to talk about 'em. They don't pay you for shooting somebody. You know, you don't get a medal for it. When I get older, I don't get a medal for it. You know, it ain't like the army or something. . . . It's not worth it, you know? You get scars, you get shot, and

sometimes you barely live, you know. And what the hell. Then your friends gonna party the next day if you die anyhow. If you get killed, it's like, they're gonna live their life again, you know, they're still gonna go on, you know. They're gonna forget about you. Not really forget about you, but in a way, you know, their life goes on. Your life is under, six feet under. And it don't go on no more.

Another young man from Santa Monica described gangs as a type of support net:

I swear to God, if it wasn't for gangs, I bet my life that the suicide rate of young people would go through the roof, without that support net, that drop net that is called gangs. I mean you have an individual young person who doesn't have no support at all. He probably feels so isolated that he doesn't even want to be on this earth. I know I wouldn't. I was close to it myself. And the only thing that I lived for was my neighborhood. And to this day, the only thing that I do is work for my neighborhood and make sure that my homeboys . . . A lot of these homeboys can't stand me, because of some of the things that I say. And some of the things that I'm part of just to keep them alive, you know, so we can stop going to funerals. They don't understand that now, but sooner or later they will.

Even as gang members strive to understand themselves, those of us who look more closely at their lives find that issues surrounding gang membership are neither black nor white, but uncomfortably gray. Far from being the dehumanized animals and savages that the media depicts, gang members are caught between dilemmas and paradoxes, trying to balance the weight of their daily struggles with loftier ideals that often parallel those of the larger society. The only way to address gangs is to take away their reason to be. They are a support system, a net that people have woven to stop themselves from falling any lower. In the process, they have created a fatal attraction. Every iota of strength, creativity, and support invested into such a system ultimately works to destroy its makers.

In many neighborhoods of Los Angeles, gangs are better at sustaining themselves than the current dominant system. They offer a more meaningful, more immediate, more intense, more closely held and closely felt relationship. But these last quotes and the interviews that I have done, the conversations that I've had, all point to the fact that gang members are acutely aware of the contradictions that rule their lives. They love their neighborhoods, at the same time realizing that their love sometimes results in needless

disaster. They realize they wouldn't have had to suffer such harsh consequences had they had other opportunities. Most would jump at the chance to go "legit" for themselves and for their children—even today, when the gang system is already so well entrenched. This, I think, is the ultimate hope. All is not lost in this city. Never could all be lost when such native strength and intelligence, only a tiny portion of which is represented in the words and images in this chapter, continues to flourish in the hearts of L.A. barrios.

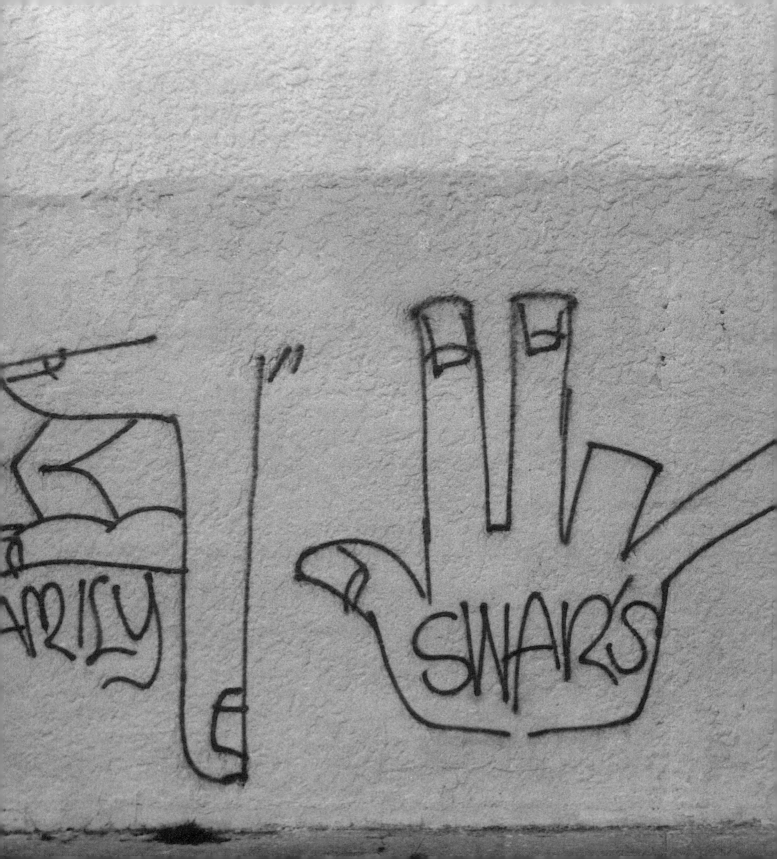

## THE GEERTZIAN GHETTO

I dreamed one night that I was writing this book—furiously and furiously writing it—and that, in a flash of brilliance, I titled one of the sections "The Geertzian Ghetto". In my more muddled waking hours, I was frustrated that I wasn't being accepted by some Bloods I was trying to get to know. Instead, they were suspicious and alternately shunned or ignored me. I knew I needed a Geertzian moment.

The anthropologists in the crowd are certainly nodding their heads, acknowledging the reference to the famous moment when Clifford Geertz and his wife, Hildred, were accepted into the Balinese community where they were working.[1] After a police raid of an illegal cockfight, the Geertzes fled along with the other spectators, hid out in someone's house, helped to declare everyone's innocence upon being questioned, and, having thus proved their allegiance to the Balinese, were integrated into the Balinese circle of friends. The Balinese knew that the Geertzes could have avoided all the trouble by simply explaining to the authorities who they were, but Clifford and Hildred were smarter than that. They knew, perhaps even unconsciously, that this was an opportunity to ally themselves with these folks—who, until then, had ignored them.

How I longed for a Geertzian moment, one that would work magic on my relationship with the gang members. I imagined myself attending a dogfight with lots of gambling and people manipulating their social positions in deep and interesting ways. And then I imag-

ined the police breaking it up, forcing us to flee into somebody's kitchen, where we would drink forties (forty-ounce beers) over it later. But not a shred of luck did I have toward that end. For quite a while, it seemed that all I could do was alienate myself further from the people from whom I was supposed to be learning. After a number of these incidents, I came to the perhaps optimistic conclusion that anthropologists might learn just as much from getting rejected by a community as from being accepted by one.

I used to think of South Central Los Angeles as the ultimate in field experience. If I could ever get there, I really would have done something. The dangers of the 1992 L.A. Uprising loomed large in my mind; many believed white people who walked or drove down a South Central street would get shot on sight or beaten like Reginald Denny.[2] But I had experienced some of its richness of life just months after the Uprising and knew firsthand that those beliefs were based on myths—little more than panicked racial constructs. South Central Los Angeles is the traditional heart of the black community and the landscape in which Bloods and Crips first came into being—and I was determined to work there.

For years, racial segregation in Los Angeles was enforced in both private and governmental realms. At the government level, a practice called redlining graded communities and areas on the basis of desirability, where race and homogeneity were determining factors in the categorization of a neighborhood. This classification was then used by banks to determine loan eligibility (see Jackson 1980). As a result, nonwhite and mixed neighborhoods with low ratings were often denied loans. Compounding this problem, private real estate enterprises enforced racially restricted covenants, which designated the racial makeup of both the buyer of a certain property as well as to whom the property could be sold. The ratings and covenants forced the African American population of Los Angeles to live in the fairly compact region now commonly referred to as South Central. In the 1950s, the Supreme Court banned the use of racially restrictive covenants, but the damage had been done. A ghetto had been created whose social and ideological boundaries continue to chart the territory today.

Redlining was only one factor that contributed to the beginnings of a severely segregated black and white Los Angeles. As Massey and Denton have stated in their book *American Apartheid,* "No group in the history of the United States has ever experienced the sustained high level of residential segregation that has been imposed on blacks in large American cities in the past fifty years" (1994, 2). They regard this segregation as the "missing link" between African Americans and their persistent underclass status in urban areas

of the United States. This description is particularly apt for Los Angeles, where social divides seem inherent in the sprawling geography.

I conducted most of my fieldwork in the Central-Vernon area off of Central Avenue, a major jazz hot spot until the 1950s. Because the area is swiftly becoming a Latino majority, one can see few remains of its famous black center in the streets today. Perhaps predictably, this marked Latino shift has been accompanied by a wave of 1930s and 1940s nostalgia. These have included efforts to revitalize the region around the historic Dunbar Hotel and to document this rich history before it is lost (see, for example, the recent *Central Avenue Sounds: Jazz in Los Angeles* [Bryant et al. 1998]).

South Central is a common referent in specific geographical areas of Los Angeles.[3] Driving down Central Avenue (actually South Central Avenue), one sees countless references to the South Central name: South Central Tires, South Central Senior Citizen's Center, South Central Auto Body. As the historic heart of black Los Angeles, the Avenue itself is only a small part of the area that its name now encompasses. Supposedly, the term roughly indicates what is central to and south of downtown Los Angeles before you reach other cities like Compton or Inglewood. However, media insensitivity has frequently managed to equate South Central with any area of Los Angeles that is "poor and black." It is itself a point of pride for gangsters to define their lives in a place synonymous in the media with danger.

There is an Eastside and Westside to South Central Los Angeles. Everything from Main street to Alameda is the Eastside (Main Street leads straight to City Hall); everything from Main Street west is the Westside. Any Los Angeles map proves the official nature of this division: West 41st Street becomes East 41st Street when it crosses Main Street. The Eastside has a reputation. Houses are more dilapidated, roads are worse, services are fewer, dead dogs and cats tend to find themselves in the gutter more frequently. People are on the whole poorer and more desperate. The "evil side," the "low bottoms," they call it, or just "the lows"—the Eastside, according to many of its residents, is just about as low as you can get. "We in the projects. You know, we at the bottom. That's why they call it the 'low bottoms.' It's the lowest of the low," one young man described with a measure of pride. Another said, "The low bottoms. That's just it, without anything further down except us."

From W. E. B. Du Bois's *The Philadelphia Negro* ([1899] 1967), to Drake and Cayton's *Black Metropolis* (1946), to Eliot Liebow's *Tally's Corner* (1967), to Carol Stack's *All Our Kin* (1974), to Elijah Anderson's *A Place on the Corner* (1978), scholars have long captured in rich detail the lives of urban African Americans. Important work has come out of such cities

as Chicago, New York, and Philadelphia, but Los Angeles seems to have failed to produce any substantial body of ethnography on African Americans street life or neighborhoods.

Today in Los Angeles, residential segregation is less rigid—at least in one sense. It does not mean that blacks are living with whites, although this has happened in some areas of the city. In South Central Los Angeles, for example, it's the "Chavezes" (Mexicans) that have "taken over" areas that once were strongly black. Gangs are perhaps the most tenacious elements of the African American community within such dramatically shifting demographics. Many are not exactly friendly with their Latino and Chicano neighbors, but some are surprisingly so. The Eastside of South Central Los Angeles in the late 1990s deals with black-Latino race relations on a daily basis. African American gangs have in some ways become the last strongholds in leftover pockets where the rest of the black community has slowly migrated west to the Crenshaw District, or much farther east, to the Inland Empire and San Bernadino County.

It took me a long time to feel comfortable walking the Eastside streets. I was the one element—the white element—that was completely outside of the black-Latino neighborhood equation. For almost six months I floated around the area, taking pictures, feeling alternately at home or like a guest, an alien, or an intruder—scared at times. Because I knew the transition might be difficult, I decided to volunteer at a local organization of some kind, preferably one that focused on women or on health. Through my mother-in-law's work in nonprofit organizations, I found the Well, the California Black Women's Health Project, right on 54th Street and Central Avenue. The women there were warm and welcoming, and they provided a safe atmosphere in the midst of a harsh environment. I found myself bombarded with all kinds of new information at the Well. None of it taught me about gangs directly. But it did teach me about problems of emotion and communication in impoverished environments, about the impact of health and gender issues, and about the contradiction of a male-oriented gang system in the midst of a singularly female-centered community. I learned at the Well that African American women outnumbered men by three to one from the ages of fourteen to twenty-five; that African American men were 100 times more likely than white men to get shot during their lifetimes; that black babies died at twice the rate of white babies. Our ZIP code (90011) had the highest teen pregnancy rate in the country. I learned at the Well—from women—to see the injustice in this, to recognize the disproportionate burden of being black and male, and the concomitant burden of being black and female, with children, and most likely alone.

I began to map the gangs in the roughly eleven square miles of the Vernon-Central area and identified about forty-two: twenty-nine Chicano gangs, twelve African American gangs. and one Cambodian gang (see figure 2.1). Because the Well was in the vicinity of two Bloods neighborhoods, the Blood Stone Villains and the Pueblo Bishops, I focused my work there. I eventually went on to make other friends in the Foe Duce, Foe Tray Gangster Crips, the 52 Hoovers, and the Mad Swan Bloods. My journeys through their territories were not always without incident, but I thrived in the new area. I loved going up to the thrift stores or down to Mr. Muhammed's for a chicken sandwich and a bean pie or to Tam's for a grilled cheese. The gentle curves of the planned housing projects and the carefully tended gardens with their draping vines sometimes made ratty old houses look like secret worlds of green and light. At first I would take long walks down Central, as if I needed to prove to myself and everyone around me that I wasn't afraid. That spectacle of me walking was almost like my own graffiti, something for everyone to guess at. What the hell was I about?

## A Cockfight of One's Own

One situation in particular crystallized some of the issues at stake for me as I tried getting to know people in the neighborhoods where I was doing ethnographic work. As with the Chicano gang in Santa Monica, these moments at the beginning were crucial: I attempted to negotiate my position, to establish myself as a credible researcher and as a trustworthy person. It seemed that instead of being confused by my feelings, as I had been with Leo, I had trouble even knowing how to feel most of the time. I was so used to shoving away the hostile stares and accusations that it began to be difficult to know when to take them seriously. These people weren't asking me to be there. Nobody seemed happy I was doing the work I was doing; mostly they just wanted to be left alone. If that was the case, I continually asked myself, how could I do this work and show respect for people's privacy at the same time? I am still not sure I know the answer to this question.

One sunny Friday in February, I decided to walk down to the post office from the Well. Walking to the post office was quite an undertaking. I had attempted it only once before, with minor difficulties and harassment along the way. But now I had more experience as prepared for my adventure. The distance was about twenty blocks: a long walk, particularly by L.A. standards. Along the way, I took pictures of graffiti and painted Latino storefronts, I walked in industrial areas that looked like ghost-town movie sets, saw a sweaty

dead cat in a box, and on my way back met some Chicano guys from Florencia 13 and Clanton 14—gangs whose graffiti I had admired. One guy even posed for pictures of his tattoos (figure 3.18). All was sunny and cheerful and, as I walked briskly toward the Well, I caught myself once or twice actually feeling comfortable on the street. I was off my guard—"slippin,'" they call it in the gang world.

Just one block away from the Health Project, I ran into problems: specifically in the form of a very large black man with a doo rag (an almost Arabic-looking black nylon piece of cloth tied around the head). He stood in front of the apartment building commonly known as the "Motel," a crack house that served as the Blood Stone Villains hangout—where I wanted to get to know people. I had waved and smiled at him earlier from the other side of the street when I saw him looking curiously at me. Now all of a sudden I was upon him and a little group of four or five shady-looking folks, not the gangsters that I had spoken to a few days before.

My friend in the doo rag looked to be about thirty-five years old, towering above me with muscles bulging through his black shirt. At first he was all smiles and seemed genuinely curious about what I was doing. I said I was mostly taking pictures of gang graffiti. Then he wanted to know who I was with. I was perhaps too eager to let him know that I wasn't afraid of him. My friend and contact Robert had told me that people respected me in the nearby Pueblos neighborhood for walking around alone in the projects where most white people were afraid to even drive. I told the man, kind of laughing, that it was just me and the Lord out here. Instead of impressing him, this answer irritated him. What he really wanted to know were my affiliations. Working in gang neighborhoods where affiliation often determines the course of friendship or violent action, I should have known this.

My answer clearly dissatisfied him and he began to offer "caring and concerned" advice in a kind of aggressive way. He told me I was white in a black neighborhood. That I shouldn't be there. He threatened me: he said if the gangsters ever saw me taking pictures there again, they would beat me up, they would take my camera, everything I had. He told me never to take pictures on this side of the street again, ever. I countered that I had permission from the homies to take pictures there. I had asked them just the other day. He said it didn't matter.

Until he wanted to know what was in my bag, his hostility was par for the course. I had started to carry my camera in a brown grocery bag for camouflage on my longer walks. But I knew he knew my camera was in there and that I might be in deeper trouble if I at-

tempted to lie. He asked to see it. I handed it to him, intimidated by his stature. I was afraid of getting beat up, but reasoned that if I gave it willingly, he might just as willingly give it back. I guessed it was my own version of "more people are flattered into virtue than bullied out of vice." But the second he had the strong, die-cast body of my Nikon in his hands I knew it had been a mistake.

As soon as I gave it to him, his entire demeanor changed. The smiles were gone and real intensity began. His eyes bored into me. He was doing what they call "schooling" me. Telling me how I should and should not behave. Talking up a storm. Me, just listening. Nodding. Feeling embarrassed by the fact that he was lecturing me in full view of a group of about four wayward folks to our left. The crack house was a strange place. It always seemed like people were having to squeeze in and out of holes to get into its dank, graffiti-covered interior. After my few previous interactions with gang members there, I had decided it was simply too much for me. I would stay in the Pueblos projects where I felt at least a modicum of safety. But here I was, listening to this man who had positioned himself just in front of the open doorway that led into the Motel. At a certain point an emaciated woman who I had judged to be a crack addict came over to ask me for a quarter. She was wearing a tight ribbed dress, sleeveless and inside out, with some old terry-cloth slippers that were just a mite too small for her. I reached into my pocket and gave her the quarter as I continued to answer this man's pointed questions: Yes, there's film in the camera. I just have a few other rolls in the bag, that's it.

At one point he said, "How do we know who you are?" In a flash of brilliance, I said I knew Robert, that Robert could vouch for me (everybody knew Robert around there). He admonished me, saying, "Well you should have said that to begin with." But it was too late for even Robert to save me.

Another man from the adjacent group asked whether I had another quarter. I knew if I gave him one I would look like a total idiot, so I said I didn't have any more. But as I shifted my weight from one leg to the other, some change jingled in my pocket. The man with the doo rag looked at me severely: "It sure does sound like you've got a quarter in there." "Oh, yeah, I guess I do." So I reached into my pocket and gave the man a quarter. I was liking the situation less and less.

The doo rag man continued. He beckoned for me to come over to one corner with him, towards the alley and farther away from the others. I hesitated. "Don't worry, I ain't gonna do nothin' to you," he said. I kind of laughed, saying I wouldn't go; that I was

scared to. The woman in the sleeveless dress standing nearby said, "You should be." I stood my ground, somehow vindicated by her comment.

He continued just a few steps from where we had been standing, trying to maneuver the two of us away from the rest of the group. He bent down close to me and said in a fierce whisper, "Now there are people watching me right now. I know there are. They're watching me with you and with this camera and they're wondering what I'm talking to you about. What am I going to tell them?" I opened my mouth, but nothing came out. Clearly, he already had the answer. Though I was the victim here, this man was appealing to my sensibilities, to sympathize with his compromising position in even having a conversation with me. I could see his point, which made me feel even worse.

Then he wanted to know how much money I had on me. I said hardly anything. He looked at me suspiciously. I had already lied about money once that day. "Now don't lie to me!" I said maybe five bucks. It was like he already knew how much money I had and was asking to see if I would lie.

Still holding the camera, he started in again and gave me his terms. He said he wanted all the money I had. "You give me all your money, I'll give this back to you and you get on your way." My mind was frozen. I didn't know what to think or how to feel. I tried to imagine him dragging me off to God knows where in that building, bloodying my mouth, holding me hostage, raping me or beating me to a pulp in that alley. Me dragging myself back to the Well afterward. But none of that seemed real. I was tongue-tied in the here and now, a little moment on the street in which I had to make a decision or consider that he might make it for me. My precious pictures, including the ones of the Chicano gangster's tattoos that you don't see every day, were in that camera. I did the only thing I knew how, which was to reach into my pocket and give him what turned out to be seven or eight dollars. I fumbled around trying to count it since he had been so curious to know. But he gently grabbed it away from me. We were on the street; if you handle cash on the street you do it quickly. Then he handed me my camera.

I guess I half-expected him to hang around moralizing about the symbolic meaning of our exchange, but he was off like a shot, walking north on Central. There was no moral to the story. I just stood there for a minute, bewildered. I couldn't figure out where he was running off to so quickly, but I had the sneaking suspicion that he didn't want the others to know what he had done.

The man to whom I had given the quarter returned. He said, "Did you just give that guy your money?" I said yes and that I was feeling rather stupid about it. He said "I bet you do feel stupid." His name was Dante. He had a scar over one cheek. He said that I seemed like a nice person, but that I had to be more careful. I needed to walk around with nothing on me of value. I told him that I had to have my camera with me, what would I do without it? He said that I should walk around until people got to know me. Then I could carry my camera with me and they would say, "Oh, it's just her."

I walked back to the Well humiliated and felt lucky to find the place empty. I didn't want people to learn what I had done, how stupid I had been. I felt like the word was out on the wire. Now I had a reputation as an easy target, as someone to take advantage of. This guy didn't have to hit me or really even threaten me. He just intimidated me into giving him what I had.

The guy was right when he said that people were watching him to see what he would do. But people were also watching me. It was my reputation on the line, not his. I couldn't afford a reputation for weakness or stupidity in that neighborhood. If I had pointed this out to him, he might have just dismissed it as he did everything else I said that day, or he might have seen my point and laid off me. It might have given him an excuse not to rip me off. I was, after all, playing the perfect victim.

My embarrassment about this incident was acute. I just wanted to hide from everyone and not say anything. I was afraid my friends and advisors would lose faith in me and my ability to do fieldwork. But I gradually started to talk to people about it. Almost everybody had an opinion about what I should have done. People telling me I never should have given him the camera, I should have tried to talk my way out of it. I never should have told him the truth about what I was doing, people take the truth and they hit you over the head with it. What was I doing walking down that street alone in the first place? Now I was marked, I would always be a victim. Other people, however, praised my gesture of trust, giving him my camera. I had conducted myself beautifully. He had fucked up and not me, that I really had no choice and had done the right thing. Now people on the street might be even more protective of me than before.

With these and my own thoughts to torture me, I questioned everything I had done and the way I do fieldwork in general. Walking around alone out on the street. Waving to people. Smiling. The lack of angry feelings. These I had thought would protect me, not

showing fear, being a nice person, feeling comfortable. But after this incident I decided I must have rules on the street. I needed to be tougher. No giving out quarters to everyone. Nobody touches my camera except me. Things like that.

But soon I realized that my initial instincts were probably correct. I operate believing that if you trust people, they will basically be trustworthy. I was not about to treat this man like a criminal and have him act like one or accuse me of being a racist. I was trying to be open, telling the truth and putting myself on the line so that people would know I was on the up-and-up. Getting caught in the lie about the quarter firmly convinced me that I could never lie about anything on the street and get away with it.

Money is a big issue on the street. Though I had no standard policy regarding money (and still don't), I realized the two people who had actually helped me that day were the people to whom I had given quarters: the woman in the dress advising me to be scared and Dante, offering closure to a situation that otherwise would have been extremely open-ended.

In that situation, I couldn't be sure what that man's intentions were. I knew we were standing in front of a crack house. I knew there were hard-core criminals around. But I didn't know that much. I found out more later: that people were beat up on that corner every day. That the building inspector had nearly been beaten to death for his wallet just a week before, that people there robbed folks by dragging them off the street into the little alleyway. That they used to shoot people from the roof and the upper-story window (I have a collection of bullet shells to prove it). That two people had died there that year. And the more I found out, the more I felt I got off easy.

One important lesson I learned from this incident concerns my emotions in the field. Remembering emotions I've had before helps me cue myself on the street. I taught myself to recognize an emotion I felt for the first time that day—a kind of fear and frustration. It happens at some point during an interaction when you suddenly realize you have lost control. Instead of being a somewhat equal give-and-take, it is suddenly the other person who directs the course of the conversation, your responses, sometimes your actions, and particularly your feelings.

As soon as I recognize this emotion, it signals me sharply to be aware of what is happening. In this way I have been able to step back and pay attention to the mechanisms people use to achieve this state of control. They employ a range of linguistic and behavioral methods, like rhetorical questions, shame tactics, lies. Looking you straight in the eye,

challenging, making themselves taller than you, intimidating, testing. Assuming a preaching style, using blanketing statements, asking questions, acting as instructor, treating you as student, giving you no room to respond, defining the power dynamic between you. Instead of getting frustrated and freezing or reacting defensively from the gut, experiencing this emotion now helps me to check my reactions, take me out of the situation, and turn me back into an ethnographer. It reminds me that these control tactics are not necessarily lethal. It's like going over the falls of a wave, its powerful currents jostling you around in the whitewash and smashing your face into the sand—but eventually you pop up, tousled and out of breath, but alive. My fear that day had kept me in check, and I think my instinct to trust the man had kept me from serious harm.

It was like Dante told me on another occasion: "You can't trust your brain out here. You have to trust this [your heart]. This is the only thing that you can count on, because your brain can't work that fast, and it might be wrong. What you feel inside, that is what will keep you alive."

Eventually, a Chicano guy, clothing designer Max One, bought that crack house, kicked everybody out of it, and let me take pictures inside before they cleaned it up. Soon after, I got to know some of the Blood Stone Villains who hung out next door. Suddenly, that alley and those places that had seemed so fraught with danger became familiar and safe places for me. When I was with the Villains' girls I had started to become friends with, I knew that no one would dare bother me on the street again. I was getting excited. I was meeting people. I was finally beginning to feel a little bit of acceptance.

But then one early morning just a week later, the LAPD launched a major bust and suddenly all my newfound friends were gone—twenty-one of the Blood Stone Villains in jail and the rest laying low. Central Avenue seemed deserted. All the work I had done and the risks I had taken were snatched from me, made worthless by the decision of someone completely removed from the situation. I hated the LAPD at that moment. They had ruined my project. They had taken my Geertzian moment and shoved it in my face. And they had potentially put me in more danger than ever before. Would the Villains somehow associate the bust with me? White girl hanging around, then a gang sweep?

Heart pounding in terror, I tried to appear casual but concerned as I talked to the street people and occasional Villains that were left. I was forever grateful that somehow they knew I was not to blame. We commiserated together about the big hole left there on Central Avenue where the Villains had been such a presence. But I questioned myself. How

could I mourn this loss when for so many it represented a badly needed respite from gang-related crime? True to their name, their tenure on Central had been something like a villainous reign of terror. A few of the Villains had even described to me their systematic target of Latino businesses—the people they felt were taking over their neighborhood. They committed terrible crimes on that street. People were their victims both physically and emotionally. I felt lucky I could count myself among their friends (anyone not an enemy is a friend, after all) and lucky that I had escaped their violence when I hadn't been.

### Low-Bottom Communication

One of the most important things about the hood is that you are judged not on what you say, but on how you act and what you do. It is essential to be aware of the reactions of those around you, noting minute details of face, body, and demeanor. Ghetto kids all know how to do this. They are taught not to trust what people tell them, but rather to judge other people's actions on their own. The kids I know in the projects never ask a lot of questions. If they did, they wouldn't get a lot of answers. They learn by observation, and astute observers they are. Their knowledge of their environment is detailed and profound.

This seems markedly different from middle-class strategies that indulge children's endless curiosities; it seems on first glance unfair to the child not to do so. But parents rearing their children in impoverished environments have to prepare them for the harshest realities of life, where people do take the truth and hit you over the head with it, where you have to be tough and self-reliant, where your mom or your dad may get taken away from you at any moment. You have to learn to protect yourself early on. As a result, you pay attention to what people do, not what they say. Because it's practically impossible to trust anyone, you learn to judge people by their actions. This might seem contradictory to the African American community's rich oral traditions of preaching, joking, storytelling, insulting, signifying, the dozens, rap, and so on (see Abrahams 1964 for descriptions of these). But it seems like form takes precedence over actual message, which may be disguised in layers of symbolism.

In the hood, people always judged me by my actions. If I made a mistake and tried to "explain" myself, I always failed. I had to think in the long-term perspective of day-to-day involvement, sustained interest, and the maintenance of relationships. This is what all anthropologists are supposed to do, but it was difficult and exhausting to continually have

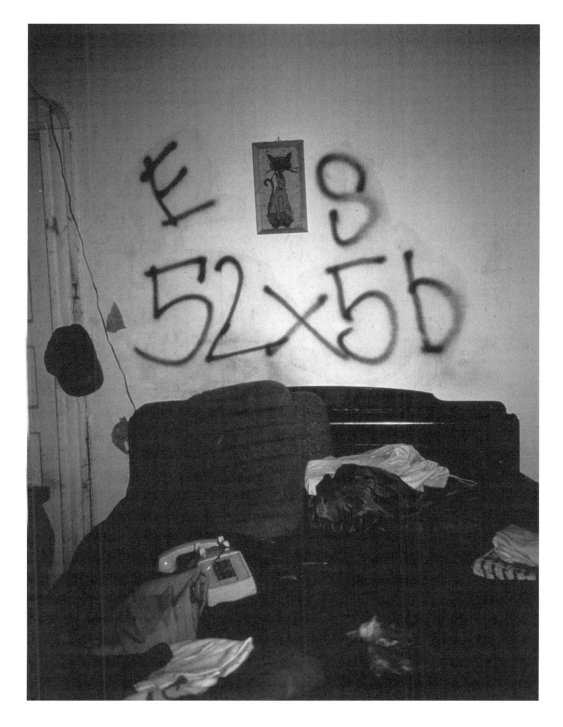

Fig. 4.1. The Blood
Stone Villains' "Motel"
(May 1996). The letters
read "ES 52x56" for
Eastside 52nd and 56th
Streets, the Villains
hood.

to prove myself. I had to discard my middle-class framework of talk, talk, talk. Though I was full of good intentions, I wasn't always able to live up to them, and I felt frustrated when people condemned me for my subsequent failings.

Methods became particularly important. Not just adopted methods for making me feel comfortable on the street, but actual research methods. If I wasn't using methods people recognized as research strategies, like taking photographs or passing out questionnaires (which I never did), they grew suspicious. People didn't understand the primary anthropological method of "participant observation." This means basically just hanging out with people—laughing at their jokes, participating to a greater or lesser degree, being part of what they do. Although I viewed this as a most valuable research tool for myself, the gang members seemed to count it as somewhat sneaky or subversive. What was I doing there? It wasn't anything active. Somehow I was never able to communicate how this hanging-out methodology made sense in terms of my study of graffiti. Even so, utilizing recognizable research methods could be equally as damning at other times—people often have visceral reactions of hate to seeing a white stranger with a camera lurking around. There is the sense that information is a commodity—worthy of both money and their protection.

I made the mistake of hanging around the Pueblo del Rio housing projects on a day when it was "hot": 5-0s (cop cars) rolling all over, ghetto birds (police helicopters) hovering. And then me. It seemed clear to the gang members that I was an undercover cop helping out the rest of my brigade. I am still not sure I managed to shake that day off my record—some of the Pueblos are still not convinced I'm not a cop. To top things off, the police had stopped me a handful of times to ask, Was I lost? Was I okay? To tell me that "I sort of stuck out around here, you know."

My first three months in South Central drove this point home. The only white folks I saw there were a couple of guys one day laying pipe for the city on 54th Street. Besides the Caltrans workers, the only other white people ever seen in many parts of South Central Los Angeles are those from "institutional Los Angeles": social service workers, justice system representatives, and the police. This limited experience provides such segregated communities only a partial understanding of the motives, personalities, and reasoning behind the white front; just as a limited experience can also skew the perceptions of workers who deal only with criminals, drug addicts, and wayward families.

A nineteen-year-old member of the Blood Stone Villains once told me about his ambivalent feelings toward white people:

I been in the face of the white man all my life. Ever since I was five or six years old. Going to court, the judge: "Who do you want to live with?" Then going to jail. Getting fucked with and dropped off in enemy hoods by those motherfuckers. But some white people are okay. It depends on the person.

Another day, a group of guys from the Pueblos projects asked me whether I used to call black people "niggers" before I started doing my fieldwork. They didn't believe me when I said, "Never in my life." They laughed, like I was trying to put one over on them, implying that it wasn't worth it for me to lie. They knew all white people did that when they were by themselves: it was part of our culture.

Any animosity I felt on the street, I tried to understand in those terms: the assumption of racism, of hatred and ulterior motive. Still, it hurt terribly when people would look past me as though I didn't exist. But it wasn't an institutionalized hurt; it was just a tiny taste of what folks had been dealing with for hundreds of years coming from the other direction. I experienced emotions I hadn't felt since I was about five years old (they were having a party and they didn't invite me; no one liked me; no one wanted to be my friend). I also experienced emotions I had never felt in my lifetime. Anger, frustration, and fear all mixed up hood-style into one convenient package—that was a new one for me.

That particular complex of emotions is what I have come to think of as the true meaning of the word *ghetto*. Ghettos are places where people are boxed in—circumscribed by poverty, their own feelings, their own fears, their families, their neighbors, as well as the larger society. In the ghetto, if you seek resolution, many times what you find is violence. You either have to be strong enough to handle that or to know when it's time to let things go unfinished. The resolution and advice that Dante had given me in my situation with the doo rag man was unusual. This is another kind of strength, I realized: the ability to let relationships fester until enemies can be stirred up with one sour word or to allow arguments to be forgotten altogether. Strength comes with the ability to deal with not knowing how someone else feels. That is what makes the ghetto almost a ritual of noncommunication, where people determine friends and enemies through the extremes of subtle visual cues or overtly hostile violent action.

No single moment defined my entrance into the black gang world. Clearly, this was no singular community. But in searching for acceptance, experiences on the street and in the projects constituted the core of my ability to juxtapose everyday interactive styles with

the communicative style of graffiti. They also let me see firsthand why gangs are almost a necessity in an environment where instability, enemies, and danger are the most stable features of the land.

## BLOODS AND CRIPS IN THE CITY OF ANGELS

Getting to know the street people around South Central Los Angeles—crack addicts, prostitutes, homeless folks—I soon came to the conclusion that gang members are an extremely stable bunch. Their violence seems not to stem from any kind of community-wide psychopathology. Rather, it is something that people have to get hyped up for, that they do because it's their responsibility and the primary way to gain a reputation. They need to protect themselves and their families from the danger that is all around them. The danger, of course, is partly of their own making. But the violence seems to go hand in hand with substance abuse: the PCP that gives you false courage to go out and commit a crime; the alcohol that numbs your senses.

What are Bloods and Crips? Are they just like the Hatfields and McCoys—vicious blood feuds stemming out of some petty argument? Never-ending cycles of revenge? Are they ethnicities? tribes? nations? Well, they are sort of all these things mixed together. Without recognizing hierarchies and leaders, we risk falling into the same trap as with Chicano gangs—that is, characterizing gang members as sociopathological or clinging to notions about gangs as groups that offer belonging and a sense of importance to people. Though vague, these last are certainly things that gangs do. But the specific ways in which gang members achieve such goals as belonging and self-importance are more important to explore.

The gang system of Bloods and Crips lies somewhere between nationalism and tribalism. It's not that I want to put forth the notion that gangs are "tribes," nouveau primitives, cultural throwbacks in a modern world. Or worse, that somehow African American gangs and the divisions within them are natural, structural extensions of the African people from whom they are descended. This is precisely the opposite of what I wish to argue. As with Chicanos, the Bloods and Crips system of groupings seems decidedly out of place within a contemporary, state-level society. Yet at the same time, the gang system is generated by that entity. Gang systems like Bloods and Crips have been driven into being by the circumstances of a very modern age. Thus they constitute a nonstate society that exists within a larger, state-level system.

Strong similarities exist between Chicano and black gangs in Los Angeles. To a degree, all gang development has fed off patterns established early on by Chicano gangs, the original L.A. gangsters. In chapter 3, for example, I emphasized how Chicano gang membership works as the construction of an extended family that helps protect people in harsh environments. This is equally true for African American gang members, perhaps even more so. In the same way does the notion of the extended family intertwine with issues of representing and backup. In the following section, I review three core concepts that define the African American gang community that also cross over with Chicano gangs. I treat them here because such concerns seem more relevant to the African American gang system; it was in African American gang neighborhoods of South Central Los Angeles where I really began to understand what they meant.

## THE THREE R'S: REPUTATION, REGULATION, AND RESPECT

A friend of mine from the Pueblo Bishops once told me about what he called "street morality." He said there were two main rules of the streets. "Rule number one: Respect the next person as they respect you. That is the main rule of the streets. Rule number two: Not to forget about rule number one."

Respect is the number one commodity in the hood. It is something that is bartered, bandied, achieved, actively sought and created. It is nothing that the law can take away, or that the bank can repossess. Land is important, yes, as a locus for resources broadly defined. But respect and reputation: these are the resources that count. They ultimately add up to protection from the hostile forces that threaten life and livelihood.

The Main Street Crips, I've heard, get a lot of respect because they're well organized within the criminal economy and they don't infight—they're rich. The Hoover Gangster Criminals have a reputation that they don't get along with anybody, the only friends they have are other Hoovers. One young man told me about the Hoovers:

> The deepest gang in the Crips to me, that's like Hoovers. [In the background: "It's East Coast man! You crazy!"] They don't get along with . . . they write CK, BK, OK. It's like CK is for Crip Killer. BK is for Blood Killer. OK is for, you know, "O's." Like seven-Os, forties, sixties, whatever ends in an "O." To me it's sixties though, I got to say. So they write all that. So they don't get along with anyone.

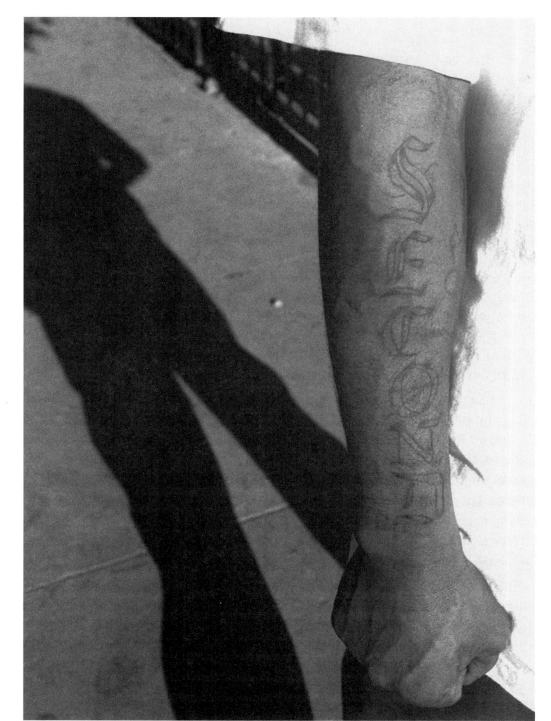

Fig. 4.2. Foe Duce (42nd Street) Gangster Crips tattoo: "Second." The Old English letters are the work of a Chicano tattoo artist; the "Forty" that begins the composition is tattooed on the other arm. The crossed-out "o" indicates enmity with all gangs whose names end in zero.

Even though the East Coast Crips far outnumber the Hoovers, this man attributed the fact that they didn't get along with anyone as making them "deep." This ability to stand alone without allies gives them respect—most gangs need alliances with other gangs in order to survive.

Making your own name and your gang's name go hand in hand. As with Chicano gangs, "representing" your gang means that you stand for it. What you do influences the gang's name and reputation as you and the gang simultaneously create each other. Tattoos like the one in figure 4.2 symbolize intensely felt personal commitments to communal symbols; thus do gang and individual identities begin to merge.

The way you behave as an individual influences your gang's reputation. If you behave badly in the gang world, you risk giving your gang a bad name as well. You represent what your gang stands for, and your actions influence its reputation. By the same token, what the rest of your homies do affects what people think of you as an individual.

One neighborhood near where I work is known for the fact that "they killed one of their own homeboys." People always refer to that mystical "they" as a collective, as if the entire gang got together and killed one of their own. Even they themselves say it this way: "We killed one of our own homeboys." As the story goes, during some fight or other, an individual lost his temper and killed another homeboy—he tried to kill two in fact. It's rumored that the killer is in jail. But now the rest of the set—outraged—is "after" him. He's been completely ostracized from the gang. His individual actions reflected on the entire gang and gave it a reputation of disunity, something that continually characterizes this neighborhood in the far-reaching geographies of the gang world. It is always considered a shame when people from the same hood turn against one another in such a radical manner. Such news may indicate that a gang is weak; the violent punishment for such infractions is an attempt to control the type of infighting that would ultimately destroy a gang by eating away at the core elements that hold it together: the unity of its members.

Killing is a part of the gang world as it negotiates such abstractions as reputation and respect. A young man from the Blood Stone Villains once told me:

> It don't mean nothing to kill somebody. Unless there's a reason. Like I could kill you right now, and you'd just be gone. Off this earth. It happened before that way. But if I kill someone for a reason, now that's something.

When I pressed him to explain what he meant, he spoke of power and reputation, that in this way killing became part of something that "mattered." The repercussions of death

and cycles of violence that can result from killing in the gang world are there for a reason. You kill to protect yourself; you kill to protect your name—that was the something. If you kill people outside the system of gangs, it may help enhance your reputation for fierceness in general, but there are no direct consequences in terms of relations of power within the gang system. This, ultimately, is what gangs are striving for.

Even though establishing a reputation through violent action might seem foolhardy at the time, it is ultimately what will protect a person in the future. A gang member's reputation must be protected at all costs and enhanced whenever possible. This might involve risking life and limb or committing heinous acts of violence or other crimes—not an eye for an eye, but a fierce one-upmanship that gets more destructive as it goes along. Individual respect feeds into group respect and vice versa. In the long run, fighting for reputation and respect is not what will get you killed in the gang world; it is what will allow you to survive. As one young man stated, "Survival is the key to living. And you need respect to survive."

Another man from the Pueblos described the process of getting respect in this way:

For a person to earn respect, you have to put it down, you know what I'm saying? You been done so much, you been whoopin' some nigga's ass, beat somebody ass, shoot a bunch of niggas, something. If you handle your business, you know, that will get you respect. And you got to give respect to get respect, you know what I'm sayin'? A lot of people sort of live off they respect, you know, the OGs [original gangsters] live off they respect. They both kinda the same thing, really, like you whoop somebody's ass real good, that's like your respect, and that's your reputation and all that.

Another Pueblo described the difference between these two overlapping concepts in this succinct way: "Some people reputation get them respect; some people reputation don't get them respect."

Reputation and respect feed into each other, at times so beneficially that the two seem to be one and the same thing. But people make mistakes: they get scared, they act disrespectful, or they don't back up the hood. All these things can get them a bad reputation. Respect is the ultimate goal in the gang life. Reputation is what you wind up with along the journey toward it.

Negotiating such a commodity as respect constitutes the core of concerns in societies

like gangs. Many societies of a similar nature rely on such abstract concepts as honor, prestige, and respect. Bourdieu ([1980] 1990) discusses the notion of honor as symbolic capital among the Kabyle, for example, noting how even in market systems, economic success is translated into symbolic capital. Similarly, in her study of Bedouin honor and poetry, Lila Abu-Lughod describes how the male-based concept of honor is linked to toughness, dealing with challenges, and self-control. Comparing her work with Bourdieu's, she writes how "In both the Awlad'Ali and the Kabyle codes, men of honor share a general orientation toward assertiveness and efficacy" (1986, 90). Gang members similarly prize the ability to "take care of your business" and "do what you gotta do." Action and anger arise in hostile, yet controlled, situations that allow people to build respect and in turn translate that quality to protection for themselves and their families. They begin to live off their symbolic capital.

In warlike situations, firepower and the reputation that goes along with it are the best protection for self and community. Reputation and concomitant respect protect an individual from people "fucking with you." Because something like respect will allow you to survive, you must negotiate it where it will be most meaningful: internally. This means that gangs concentrate on developing reputations among people within the same social system of gangs, among groups equivalent and either allied with or opposed to them. Gangs negotiate such relations of power at the level of warfare where it carries the most relevance, among people who understand its significance and whose lives are influenced by its outcome.

Hand in hand with reputation and respect is "regulating." Regulating is one of the most all-encompassing gang practices, involving social, economic, and political arenas. It is one of those words that can mean a lot of things. It can mean putting together a hustle, setting something up for a little bit of money on the side: paper fraud, bad phone lines, a drug circuit, somewhere new to fence, whatever—even telling someone a lie can be considered regulating. Taking care of yourself and your own. Regulating can also be political: it means being in charge of knowing (and therefore regulating) who comes in and out of your neighborhood, what their business is there, what their intentions are. Guidelines for regulating mirror classic divisions between self and other, friend and enemy, and they reinforce exclusive control over neighborhood space. I remember feeling like I personally drew a lot of attention in my fieldwork—gangsters always approached me and asked what I was photographing. I was happy to explain it to them—

they were the people I wanted to talk to anyway. But soon I realized that it was no generic sense of curiosity that aroused them to this end. It was actually their responsibility. They were regulating.

As a white woman, my experience is certainly different from that of African American men who experience regulation on a much more immediate level. The shouted queries: What set you from? Equivalent to the Chicano: *¿De donde?* must be answered without hesitation. These can be intimidating and potentially volatile situations for people outside their normal range of wanderings. Often not being from a gang can be just as bad as having other affiliations. One young man described his experience to me at South Park, where the Avalon Gangster Crips and a bunch of heroin addicts hang out. "They sweated me so bad. I even said 'sir' to them trying to tell them that I wasn't a banger." They let him go without incident, but told him to leave immediately.

How strictly an area is regulated seems to depend upon how much illicit activity goes on there at any given time. It can also depend upon who is in charge of regulating on a given day. On the first day I decided to walk through the Pueblos projects, my friend Robert later told me that I had been lucky. The OGs (original gangsters) had been regulating, and after I explained myself, they let me go about my business and even pointed me in the direction of some particularly noteworthy graffiti. These were the older guys with sense; not the volatile younger ones. According to Robert and other Pueblos, if the younger Gs (gangsters) had been regulating that day, I probably would have ended up getting ripped off or beat up. However, even when the younger guys were regulating, I often found them to be more understanding of my project than some of the older guys— younger folks do tend to be more interested in graffiti.

Before the bust, the Blood Stone Villains used to regulate Central Avenue from a place they called "the roof," a terrace belonging to the apartment building where they hung out on Central and 55th. Around this hangout, graffiti reading "Welcome to Hell, BSV" (see figure 4.3) and "Welcome to the Villains Hood" warned people of their current whereabouts in gangland. (Inside the crack house, the welcomes read "Welcome to the Villains Slum" and "Welcome to your own Death." That last one sent chills up my spine.) People used to plan ahead and cross the street so they didn't have to walk by there, as I should have done to avoid the doo rag man that winter day. The Villains' specific targeting of the Mexican community was also a form of regulation. So many Latino families had moved into "their neighborhood" and opened businesses that the Villains felt should

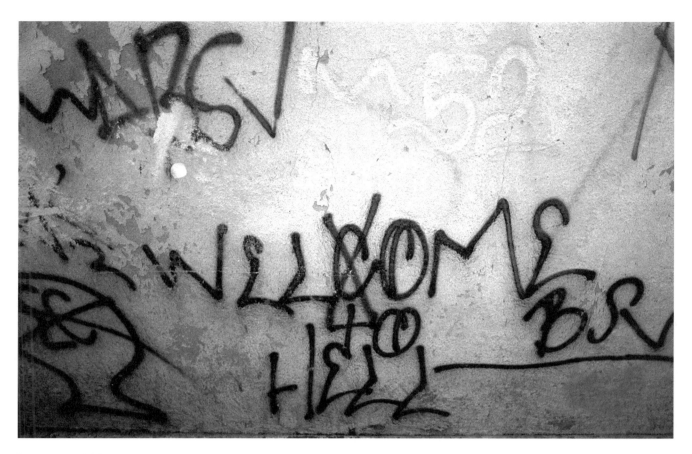

Fig. 4.3. Blood Stone Villains hangout, Central Avenue and 55th Street (1995): "Welcome to Hell. BSV." The crossed-out "c" designates enmity with Crips.

have stayed black. Their targeted crimes were like an enhanced form of regulation: a big message saying "Get Out!" Everyone from the Villains and the streets around there told me that things had always been bad in this neighborhood, but that this was the worst time ever because of all the Mexicans. Even the *Los Angeles Times* (4 July 1996) noted the change in the neighborhood's composition, referring to the Villains as "a street gang that authorities say terrorized a Latino neighborhood." That neighborhood, which had at one time been the center of the black community, was now mixed. When blacks share, they lose—that was the lesson one girl told me.

The Villains were the last holdout. After the only remaining Central Avenue jazz club closed that year, and ninety-six-year-old Mr. Smith moved out from the apartment below the Villains, with few exceptions the fifties blocks on Central were either abandoned or acquired by Latinos. Occasionally, the graffiti of both groups that usually coexisted on the

same walls would get crossed out in moments of interracial tension. Many people on the street even predicted race riots in the not-so-distant future.

The practice of regulating works as a safeguard that can signal acceptance or rejection of others in racially mixed or homogeneous neighborhood areas. Where the 1960s Chicago gangs emphasized helping the neighborhood in its entirety, L.A. gangs today concentrate on helping themselves and their immediate families. They don't hand out free lunches. Gang members will, however, watch after someone's mother, siblings, or children while a person is in jail, making sure that they have food and that nothing bad happens to them. They share money among members and help one another out when they need it (sometimes more successfully than other times). Protecting familial and economic interests are the goals of regulating in each neighborhood.

Graffiti and hand signing enhance regulating as an activity. They let people know where they're at and who they're dealing with. The comprehensive enemy listings that black gangs favor in their hit-ups also indicate who is likely to have trouble in any given area. Graffiti is one of the ways you learn to read the landscape, something that can have real practical value in life as a gangster. One young woman told me, "if you didn't write graffiti sometime somebody could come into your neighborhood and might not know you're there." Graffiti helps a gang establish a presence in their neighborhood, even when the people are absent.

Hand signing is usually done from a distance, with passing cars or folks walking on the street. Signing uses both letters and numbers, and sometimes mimics the shape of gang insignias. Unlike official sign languages, gang hand signs usually physically resemble the letters and numbers they represent. Spray-painting such hand signs on walls is one of the distinguishing graffiti styles of Bloods and Crips, much more so than their Chicano counterparts. The effect of these marks is particularly powerful in neighborhoods where there are a lot of hand signs on the walls. As you drive past them, it just seems like the people are right there signing, larger than life. Their bodies have been reduced to the hands, elemental signifiers of gang identity. Writing hand signs in graffiti turns something behavioral into something material. In this way, the symbolism achieves a deeper layer of meaning: it becomes a gang practice (graffiti) about a gang practice (signing).

The image in figure 4.4, by a member of the Family Swan Bloods, shows two hands signing the common signs for the Swans gangs. The first hand signs a "7" and "9" for

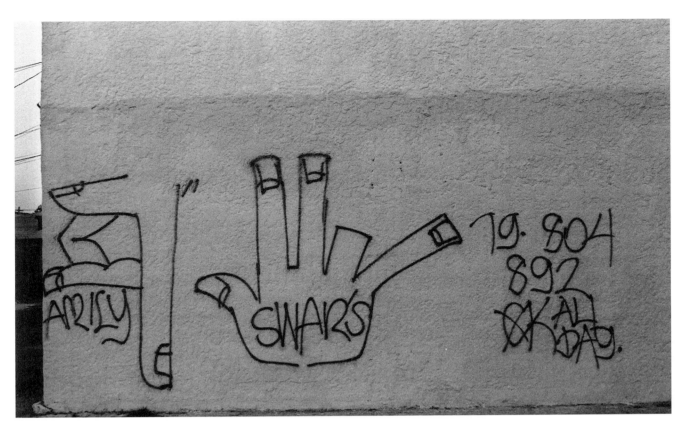

79th street and an "F" for family. The next symbol mimics the swan itself, the fingers of the hand representing the head, two wings, and a tail. Beside the distinctive hand signs are written an assortment of numbers—79, 80, 84, 89, 92—that represent streets that constitute the extended territory of the Swans neighborhood. The composition ends with the common rhyme "CK [Crip Killas] all day."

Different gang media generally say the same thing. Signs, tattoos, language plays, graffiti, the shouting out of names: they all declare the gang and its position in relation to other gangs around it. But each medium is important at different times. Tattoos may be more important on a personal level, among family and friends or in prison, with close-quarters contact. Graffiti can stand on their own without their makers to define an area, declare a presence, and help regulate a neighborhood. Hand signing works both to enhance an in-group identification and either to prevent or instigate intergang

Fig. 4.4. Hand signs from the 79 Family Swan Bloods (1996). The first hand signs "7, 9, F" for 79th Street Family; the second represents the swan itself.

confrontation. Both graffiti and signing can be used as checks, "preregulation" activities that might actually prevent conflict at certain times. Actual regulation implies person-to-person interaction, which is always risky.

The story of the Cambodian gang in the Pueblo del Rio housing projects exemplifies concepts of regulation and respect in a racialized situation. One of the Pueblos told me about it one day when he was taking me to see some noteworthy graffiti in their projects. He said that recent immigrants from Cambodia (usually on their way to Long Beach, which has a larger Cambodian population) frequently find themselves planted smack in the middle of Bloods territory in the Pueblo del Rio housing projects. When a group of them first arrived, they began to form a gang, which they called the Oriental Boys. But the Pueblo Bishops were not ready to tolerate another gang in their neighborhood. They figured they could bully them out of existence and began to antagonize their Cambodian neighbors both physically and mentally (this is the regulating). One night, though, a few Cambodian young men turned all this around. It seemed they had brought a number of AK-47s with them from Cambodia. With some of these weapons in hand, they managed to force a few unsuspecting Pueblos against a wall and proceeded to fire into the ground at their feet. The young man smiled as he remembered it. Their action gave them respect, he said; the ability to stand up for themselves demonstrated their heart as well as the weapons to which they had access. With so much new firepower in the neighborhood, the Pueblos decided it might be beneficial to coexist with their new neighbors, and the two immediately began negotiating trades for a number of the AK-47s. The Oriental Boys subsequently adopted a Bloods affiliation and the two have more or less been friendly ever since.

The practice of regulating allows gang members a measure of control over neighborhood space. This is how they protect the hood and its interests, both familial and economic. Regulating allows gangs to control certain areas and maintain their group within them, ensuring that they remain in charge of how a neighborhood is used and for what purpose. The successful regulation of neighborhood space ultimately enhances their reputation and gives them respect within the gang community. This protects their bodies as well as their good name.

If gangs can seen as be a moral community, the morality that links them is based on the notion of respect. The next section describes how linguistic plays in graffiti that respect and disrespect gang letters and numbers are crucial mechanisms for representing position and ideology in the larger gang community.

## BALANCING PRACTICAL AND IDEOLOGICAL ENMITY

People usually associate African American gangs with economic enterprise. Although the rise of black gangs was certainly precipitated by the crack trade, economics cannot explain the major divisions that exist within the black gang community. Bloods and Crips are pure politics, a division that has no explanation other than history and idea. Warfare that takes place within the Bloods and Crips system makes sense within a framework of local concerns. This in marked contrast to the primary division among Chicano gangs, which encompasses the entire state of California.

While Sureños in Los Angeles are geographically removed from daily interactions on the street with their distant Norteño enemies, Los Angeles's Bloods and Crips have their primary enemies in each other, within the city's bounds. This makes the divisions between them simultaneously practical and ideological. Their warfare is based on geographical proximity at the same time as it is driven by ideological positions. Bloods and Crips shift focus between generalized, broader gang categories that constitute their enemies and the specific gang sets with which they have histories of antagonism. In this way, abstract concepts are embodied within specific groups and thus constitute the direct application of the ideology that defines their gang system.

As with Chicano gangs, there is no president of all black gangs, nor does anyone lead all Bloods or all Crips. There are higher-ups in prison, the "generals," those "on the paperwork" who sometimes call the shots, but their real power relies on the willingness of others to follow. Often there are not even people who are leaders within neighborhoods—there might be a few guys who are respected. Sometimes they might not even get along with other gang members or leaders, and they may not seem obvious, as one young man told me:

> It might be the quiet one in the back. The dude that just sits there—just soaking up the words of his homeboys. And then he get up and just start shooting, without even saying a word. That's the one who gets the respect. Not the ones who did nothin' but talk.

However, their natural amperage seems to need a boost to commit such crimes, whether it be through the words of their homeboys, through substances, or ideas. Action, not intention, is the thing that matters in the gang world.

The diagram in figure 4.5 demonstrates the segmentary nature of Bloods and Crips,

the two categories that constitute the primary divisions of the black gang community. Because in Los Angeles Crips outnumber Bloods by about three to one, Crips are the larger common enemy and all Bloods are unified against them. The selective pressure of the larger Crips entity keeps Bloods unified, while Crips infighting keeps Crips from completely taking Bloods over. Some sort of balance is reached here—a sort of status quo, where no group maintains enough of an alliance to completely overpower another. Bloods cannot fight with other Bloods because their unification keeps Crips at bay. Crips, on the other hand, oftentimes show fierce enmity with other Crips because their numbers afford them the "luxury" of infighting.

Depending on age, location, and day-to-day events, these divisions and the ideologies accompanying them increase and decrease in relevance. As with Chicano gangs, at the core of gang membership is a street-level identification and ideology. Gang members on the street exist as groups of unified street sets (or cliques) who share a larger neighborhood identity that opposes other gangs—usually their closest neighbors. For example, 52nd and 56th Streets are the constituent street sets of the Blood Stone Villains. The two cliques together form the single entity that is the Blood Stone Villains. As with Chicanos, when gang members get older, gain experience, and possibly serve prison time, they may focus on broader, ethnically based forms of nationalist identification. All gang members toggle between the sometimes conflicting ideologies that these contrasting elements offer.

The thing to remember about Bloods and Crips is that the similarities between them far outweigh the differences. It's like that nebulous difference between Sureños and Norteños. Like their Chicano counterparts, Bloods and Crips are pretty much the same people. They are members of the Bloods and Crips gang system; they share the culture of black gangs. To differentiate between them is to essentialize the other: "Bloods are more calmer than Crips," said one Blood. Crips are more showy, while Bloods tend to lay low a bit more. Bloods consider Crips foolhardy, while Crips consider Bloods chickenshit. Bloods consider themselves more "secretive," whereas Crips are known to snitch if it suits their needs. Bloods girls are said to be in it for the guys, while Crips women are supposedly adept drug dealers, in it for the money. All of these are stereotypes, easily contested, and often insulting.

I asked one young man what it means to be a Blood or a Crip. He said that if you are a Blood or a Crip, it's who you are. If you're a Blood you'll never feel comfortable being around Crips; you'll never feel yourself. Within these categories people grow into certain values, feelings, a sense of place and belonging. They frame identity. Thus Bloods and Crips have evolved from merely randomly assigned categories into divisions that carry

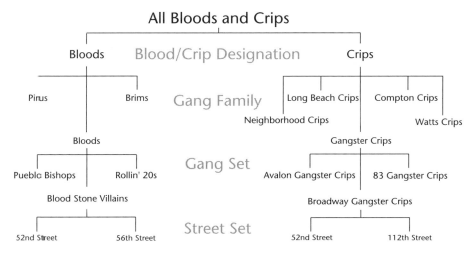

Fig. 4.5. African American gang segments

some intrinsic meaning in terms of behavior and personality difference. Gang members also harbor intense emotional connectedness to the labels themselves. This also gets carried over into the material expression of such differences.

"They are fighting over colors." This is something heard often enough in reference to Bloods and Crips. To begin with, this is not simply a question of color, no more than the internal conflict of the Scottish clans was simply a question of plaid. The colors red (Bloods) and blue (Crips) are the visual representation of this primary division in the gang world. Raised within all-red or all-blue environments, individuals develop intense emotional links with their colors. One young Blood, for example, told me, "Red is a color I like. It's just me. It's who I am. You know, it's bright and cheerful. It's just me. Blue is a color I don't like. It's dull; it's ugly." Another man described some of the emotional components of color identification:

> You see, what happens is that people, they get so they get mad when they even see a certain color. Like they feel it inside. Like they gonna go out and do some nigga over that shit. But we don't own these colors. But that's what some niggas be fighting to protect. But they ain't really ours, see. Colors ain't shit. How you gonna trust somebody that fight for shit that don't really belong to them? That gonna kill you over a color?

For people on the street, colors become the primary visual representation of the category "enemy." Perhaps the most defining moments of the color wars occurred in the late

1980s, when you could lose your life for wearing blue or red in the wrong place. People talked about red "flags" and blue "flags" (also "rags") in the days when red and blue bandannas were popular, draped out of back pockets or wrapped around heads. Bandannas would get stuffed in the mouths of dead rival gang members to signify primacy, to let others know who was responsible for the violence as a last power play in death.

Though bandannas have lately gone out of fashion in gang daily wear, their use has been artifactualized in graffiti. Gang members draw insignias wearing red or blue bandannas, or even dress up the letters and numbers signifying their street in the appropriately colored bandanna. In figure 4.6, the numbers of the Eastside Foe Duce and Foe Tray (for 42nd and 43rd Streets) Gangster Crips neighborhood are a lively bunch sporting their blue bandannas.

The 1990s have seen an increase in the use of different colors by gangs. Blue has long been the color associated with Crips; now gray is too (largely as a result of the L.A. County Jail's policy of dressing their Crips guests in gray garments, while Bloods continued to wear county blues), along with black. Similarly, brown and green are more associated with Bloods, along with the traditional red and burgundy—the warmer tones, as it were. Even these have more specific meanings: green signifies money, for example. I have, however, been in Bloods neighborhoods where people are wearing blue jeans and blue plaid shirts ("Blue still starts with the letter B!" as one girl told me). They sometimes drape red over the blue to show the red's dominance. Crips sometimes write graffiti in red and vice versa (using whatever cans are available at that moment), although I have never seen a Crip wearing red. But on holidays, gang members will sport their colors in all their glory. Even on a daily basis, there are usually a couple of people dressed in colors. Driving around South Central, you can still see a few people wearing all red or all blue right down to their beepers and shoelaces and the pens they write with. The issue of color, though more variable than at first glance, is still fundamental to that elusive root of gang identity.

People often think of gang feuding in terms of "turf wars" or wars over "drug territory," due in particular to the media's emphasis on this explanation. However, as one of my respondents said, "Naw, it ain't about that shit. That's just cause that's what the papers be saying about it. But it ain't like that." Marauding groups of Bloods don't go in and try to invade a Crips neighborhood to take it over. Crips don't marshal their forces to oust the Bloods on the next block. Neighborhoods have remained fairly stable through

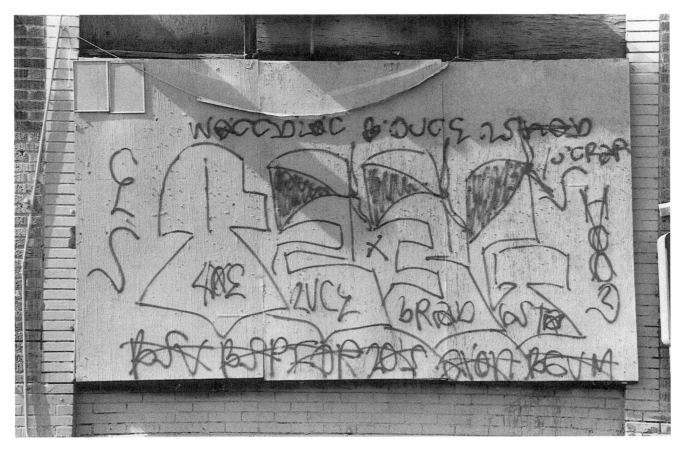

Fig. 4.6. Blue-bandanna-decorated graffiti of the Eastside Foe Duce, Foe Tray Gangster Crips, 42nd Street and Central Avenue (1996). "ES 42,3 G Hood." Gang nicknames are written above: "Waccyloc"; "Baby Duce"; "2Shay"; and "Scrappy." Their enemies are listed (and crossed out) below: "BSV" (Blood Stone Villains); "BSP" (Blood Stone Pirus); "FDP" (Five Duce Pueblos); "20s" (Rollin 20s); "Avon" (Avalon Gangster Crips); "Bgum" (Broadway Gangster Crips).

the years—most people know where the hoods are. If you cross Figueroa, then you're in the Hoovers hood; if you cross Vernon, you're in Foe Trays. This doesn't mean that gang territories never change. They do. But gang communications and movements are more subtle, and territories mostly rely upon the maintenance of membership living in certain areas. Neighborhoods require constant upkeep and a constant representation of gang membership within them. Thus gang members are not fighting for land as much as they are fighting over other abstract concepts like power and reputation that I outlined earlier.

These negotiations entail little verbalized political diplomacy as we normally think of it, because rival gangs primarily conduct them using nonverbal methods.

Creating and maintaining neighborhood space, establishing enemies and allies, mediating interrelationships between individuals and gangs: these are the political concerns of gang members. People tend to think of politics as verbal negotiation between parties. With gangs, however, speech is perhaps last on the list of intergroup communicative devices (it is action that matters, not words). When opposing gang members confront each other in person, no one has time for an extended dialogue on the subject. You have already pretty much figured out that you might be in enemy territory from graffiti on the walls; the people around you might know from the way you're dressed that you come from an enemy hood. Violence may happen in these neighborhoods because someone was driving through in the wrong-colored car, or because someone looked at someone else the wrong way. Enmity and violence are cued by visual signs.

For example, at a health festival, some Bloods friends of mine were walking around with us near the Dunbar Hotel on 42nd Street and Central Avenue, in a Crips neighborhood. The girl I was with said that some of the group of Crips walking around recognized her and knew she was from the Pueblo Bishops hood; they had been in school together. And even though they didn't know her cousin from the Rollin' 20s Bloods hood, he was sporting a Calvin Klein shirt covered in the "CK" logo. They knew he was a Blood. They confronted him by coming over, throwing up their sign, and saying, "This is Foe Tray Gangster Crips!" declaring his presence in the neighborhood of an enemy. This type of shouting out is a kind of shorthand, more akin to written identification on the wall. Thus intergang confrontation often becomes like verbal graffiti, messages that in a few words describe where you are, who you're dealing with, and what your relationship is to that area or group. We got out of there as fast as we could.

During intergang conflicts, even speech is reduced to an elemental form of classification. It is through the walls, through the clothes, through the signs, through the acts of violence that permeate this semistable atmosphere that gang members engage in larger forms of gang politicking. Nonverbal acts thus become the most reliable intergang communicative strategies. They divide the culture into political groupings, delineating who is on whose side, who is respected and disrespected. Gang members combine a variety of aesthetic and cultural practices to negotiate these political and territorial concerns; these practices together are what ultimately link Bloods and Crips from all over the nation.

## GRAFFITI AS GANG POLITICKING

The Chicano gang material presented in chapter 3 can serve as an overall guide to gang aesthetics and graffiti practices in general. Details of memorial graffiti or of crossing out do not differ greatly between African American and Chicano gang systems. The two gang systems have defined specific parameters of intergang relationships through space and ideology. However, though they may share neighborhood space and general characteristics, black and Chicano gang members constitute the groups to which they belong in radically different manners.

While Chicano gangs use elaborate gang letters and symbols and loosely compete with other neighborhoods through the aesthetic elements of graffiti production, black gangs focus in their graffiti on representing their hoods within an elaborate semiotic of animosity: how they draw the line between friends and enemies. Reasons African American gang members give for writing graffiti are usually highly practical—for instance, to mark off an area as "red" or "blue," or to designate what specific gang resides in a given area. One young man explained why he thought people wrote graffiti:

> Well, you see, this is a red neighborhood here. And up there, across the street, it's blue. So how you gonna tell the difference? You have to put graffiti on the walls to let people know what color neighborhood they in, to, how do you say it . . . to differentiate. You have to make this neighborhood a red neighborhood.

Though the aesthetics are sometimes striking, as in figure 4.7, graffiti's importance to Bloods and Crips gangs comes from their functional roles. Telling you whose hood you're in. Telling you who your enemies are.

A female gang member offered the following reasons for graffiti:

> I think most people do it just to let people know whose hood they comin into. Like we write Pueblos or whatever, so people know they in the Pueblos hood. Or to cross out your enemies. Or so your homies can see that you up. Like most of my homies or whatever, they do it because when you're drivin' into the neighborhood or walking into the neighborhood, you know what hood you're comin' into. Or so you can cross out your enemies.

As you can see in figure 4.7, driving down this main drag of the Pueblos neighborhood

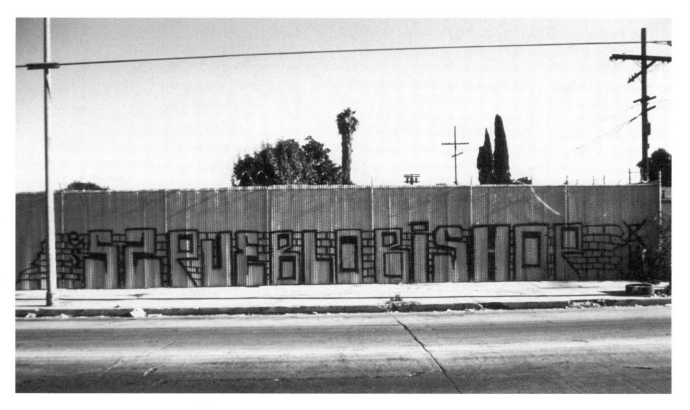

Fig. 4.7. Bloods strike, 55th Street near Long Beach Boulevard (1995). "52 Pueblo Bishop CK" (Eastside Five Duse [52nd Street] Pueblo Bishops, Crip Killas).

on 55th Street just past Long Beach Boulevard, there is no mistaking which hood you're in with these gigantic letters to help you: "ES 52 Pueblo Bishops CK": Eastside Five Duse (52nd Street) Pueblo Bishops, Crip Killas. Many people admired this composition when I showed it to them—Bloods and Crips alike. They would say, "That's a strike!" Or, "Those are some strikes!" *Strikin'* is the black gang equivalent to hitting up. Though Bloods and Crips graffiti may be as stylish as those of their Chicano counterparts, the reasons that African American gangsters give for these elaborate writings tend to emphasize utility: "to cross out enemies," "so your homies can see you up"(to let people know you've been putting in work, or representing the gang), or "to let people know what hood they're in."

My interest in gang material creations often spurred gang members to give alternative explanations for the production of graffiti, creating a vocabulary surrounding writing that wouldn't usually rise to the surface in their talks with me. While Chicano gangs elaborate upon questions of style in their dialogues on graffiti, African American gang members focus on issues of language. Heath (1993) also indicated this as a primary difference

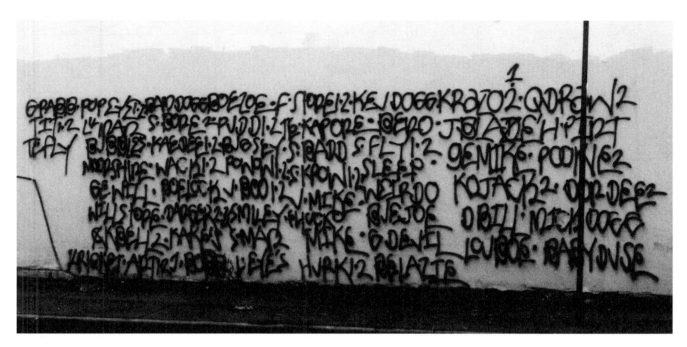

between African American and Chicano gangs, one that stems from differences between the larger ethnic groups. One man from the Pueblos explained graffiti writing like this, for example:

Fig. 4.8. Blood Stone Villians roll call, South Central Los Angeles (1995)

> It's a form of language. Because it lets you know where you're at. It gives the next person awareness of where you're at—Central's right here, Avalon's right here. It teaches you a sense of direction, because you can just look at a wall and find out what hood you in. It's another way of speaking.

In this way, writing becomes action. Graffiti always tells you something you can count on, even if it's something basic about territory or constituency. It can give you lists of members, a roll call to designate who does and who doesn't belong. It can define affiliation, enmity, and alliance. It is an action through which people can assess their situation and see the truth for themselves.

Gangs are networks of trust. The trust between homeboys is implicit, though sometimes difficult to maintain. These neighborhoods are so hostile, the people in them so desperate. Gang members grow up surrounded by potential enemies as well as by already established ones. Figure 4.8 is a roll call of the Blood Stone Villians in South Central; the

writer represents the entire set publicly on a wall to let others know who belongs in the neighborhood. To hang out there, one potentially has to deal with all the people on that list who are committed to protecting their neighborhood space.

The names in figure 4.8 may seem like a jumble, but each one stands for a person. Together they form a unified set of individuals that trust one another, help one another to live, and that place their very lives in one another's hands. The strength of their common affiliation to a neighborhood identity is something they have all had a part in creating. When "you never know when somebody is gonna stab you in the back," your homies offer a relationship of trust that extends beyond that of their own families. And graffiti becomes one of the most straightforward means of communication that the hood has to offer.

## HOODS AND ENEMIES: LEVELS OF G'STA IDENTITY

The division between Bloods and Crips constitutes the first level of gang identity in the Bloods and Crips system. This primary division begins with an already skewed relation of power, because Bloods are outnumbered by their Crip counterparts. Also inherent at this level are the automatic alliances and enmities that accompany the broader designations. A host of linguistic, material, and behavioral practices reify these divisions on a daily basis—in a world where there is little difference but what gang members create themselves.

At this primary Bloods and Crips level, gang members have developed a variety of creative practices to distinguish themselves from each other. Like their Chicano counterparts, they practice linguistic avoidance, shunning certain words and letters in speech and writing that stand for their enemies. Crips call each other "Cuz" and they call Bloods "Slobs." Bloods call each other "Blood" and they call Crips "Crabs." Crips never use the actual word "red"—the dreaded enemy color—never! Instead they say "dead": "Did you see that dead jacket?" Bloods say "flue" instead of "blue": "Check out those flue shoes." And in both speech and writing, Crips avoid using "B's" and Bloods avoid using "C's," crossing them out or replacing them instead with their preferred letters. Bloods call South Central "South Bentral" to replace the prominent "C" in that word. For the same reason, they call Compton "Bompton," as in figure 4.9, where the Campanella Park Pirus have written "Pirus rule the streets of Bompton fool's!" Bloods say they are "bickin' back being bool" ("kickin' back being cool"). Bloods are "bool" every day with one another and often drink "Bool-Aid"(Kool-Aid) to boot. Crips say "we cee chillin'" for "we be chillin.'" If a Crip

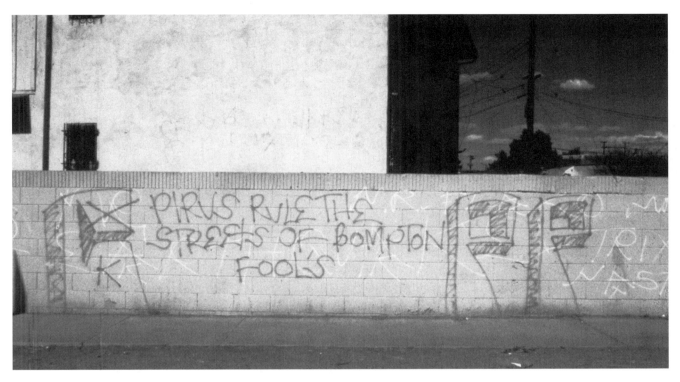

wanted to insult a Blood, he might ask him for a piece of "Big Dead" chewing gum. Bloods ask one another for "bigarettes." Linguistic avoidance constitutes a creative, if deadly, arena of gang behavior that crosses over in speech and writing.

Like many gang practices, speech enables gang members to deliberately reinforce themselves as a group through the process of manipulating the sound of enemy initials and names. In writing, linguistic avoidance of letters also positively manifests itself as "BK" or "CK"—Blood Killa or Crip Killa, or in the declaration "BK all day!" Notice also in figure 4.9 that the "C" for Campanella has been crossed out and a small "k" has been added to the letter, making it a "CK." Crips never write "CK" even as part of another word because it means "Crip Killa"; thus, Crips will always write "fucc" instead of "fuck." By the same token, any "C's" or "B's" that happen to come up in writing, as in figure 4.9, will be duly crossed out because of their representation of primary enemies.

The BK/CK phenomenon has impacted mainstream economic systems as well. In the late 1980s, British Knights shoes were popular with Crips for the prominent "BK" in that brand name (they have since gone out of style). In the 1990s, Calvin Klein products are

Fig. 4.9. Linguistic avoidance in Bloods graffiti (1996). "Pirus rule the streets of Bompton [Compton] fool's." The large letters on either side of the statement form the gang's initials: "C(k)PP" for Campanella Park Pirus (the "C" is crossed out and amended with a "k" for Crip Killas).

ubiquitous in Bloods neighborhoods because of the "CK" visible everywhere on products from T-shirts to boxers. In the same manner, gangs whose initials match the insignias of certain sports teams will buy sports apparel: Houston Astros ("H" for Harlem, Hoover; Chicago Folks love them for their five-pointed star), Pittsburgh Pirates ("P" for Pirus, Pueblos). Crips love the Dallas Cowboys (they wear blue uniforms and sport the large "C"—but I do know some Bloods who love them too); the Chicago Bulls are popular among Bloods because of their dramatic red uniform and the "B," and Jordan shoes are also popular among the Bloods. This is phenomenon also affects companies in other industries; for example, Chicano gang members buy Dickies brand work clothes, and graffiti artists prefer Krylon spray paint (in the old days, it was Rust-Oleum). In Detroit, the Michigan Ganster Disciples drink only Miller Genuine Draft (MGD). The resonance of these illicit behaviors in larger economic circles is one example that shows how gangs and other illicit groups never form systems entirely based on their own aesthetics—they incorporate certain aspects of the larger system that happen to suit their needs.

Through such daily practices as consumption, language, and writing, the categories "Blood" and "Crip" grow into dramatically differentiated entities. However, such practices and the categorization of self and other as Crips or Bloods is only the foundation upon which the interrelationships that guide gang existence are built.

### Specific Enemies and Ideological Categories

A second level of enmity represented in graffiti has to do with specific gangs or groups of gangs rather than the general Bloods and Crips division. Such enmities are represented by crossing out letters in passing. If you are enemies with "Hoover," you cross out any "H's" that happen to arise in the course of your writing. These may or may not have direct practical relevance and may be simply ideological in nature. Crossing out a zero or "O" means that you're enemies with all gangs that end in zero, like the Rollin' 60s and the Rollin' 90s. The Eastside 43 Gangster Crips author of the graffiti in figure 4.10 has written his own name, Twoshay Loc, plus those of his homies, Fudge 1, Preacher, Tikki, Cenoe (for C-note), and Waccy Loc. He has crossed out every initial that stands for an enemy: "O" for zeros (the zero is commonly pronounced "oh"), "H" for Hoovers, "A" for Avalons (53 Avalon Gangster Crips, specifically), and "P" for Pirus (and/or Pueblos). If you're thinking, "Those half-illiterate gang members can't even spell Waccy's name correctly," think twice. Wacky? There is a prominent CK there—as if a Crip would ever write "CK." The

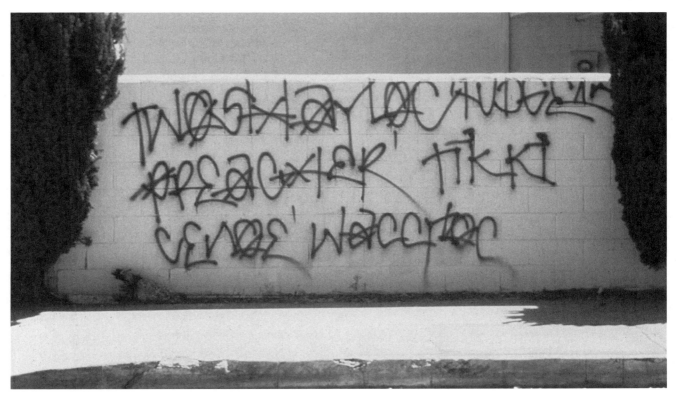

system of enemy designation works nicely, reinforced as it is at every available opportunity. In contrast to the pristine Chicano gang writings, the process of materializing all these enemies can make some gang compositions look like a tremendous, crossed-out mess even before the composition is attacked by rivals.

Many gangs are too far apart geographically to be warring continually with all gangs whose names end in zero or begin with an "H." But in crossing out "H's" or "O's," they simultaneously proclaim enmity with both a local adversary and an entire category of gangs. Recall the young man who explained how the generic "O" enmity gets translated into "OK," for "O Killa": "seven-Os, forties, sixties, whatever ends in an 'O.'" But, he added, "To me it's sixties though, I got to say." Thus, sometimes the "O" has more specific referents based on proximity. Such designations in part indicate that different gang groupings are ideological as well as practical.

Such extended designations can be loosely described as "gang families," linked by an initial, history, or common origin between groups. Pirus and another segment called

Fig. 4.10. Eastside 43 Gangster Crips graffiti (1996). "Twoshay Loc"; "Fudge1"; "Preacher"; "Tikki"; "Cenoe"; "Waccy Loc." "Loc" means loco, after the Chicano gang practice indicating craziness.

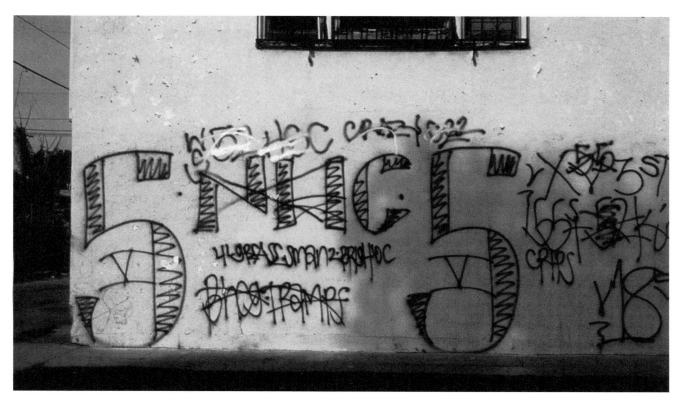

Fig. 4.11. Cross-out of a 55th Street Neighborhood Gangster Crips ("55 [VV] NHC") composition by the Westside 52nd Street Hoover Gangster Crips ("ws 52 HGC") (1992)

Brims, for example, are major divisions within the Bloods designation. (Pirus are named after Piru Street in Watts, but their reach has now extended all over South Central and beyond.)

Crips also have internal divisions. There are Neighborhood Crips, Gangster Crips, and Compton Crips. In figure 4.11, the "NH" in the 55th Street Neighborhood Gangster Crips' composition has been crossed out by the Westside 52nd Street Hoover Gangster Crips to indicate their specific enmity with Neighborhood Crips. Notice how the challenger from Hoover cleverly left the "C" in NHC alone, because it stands for the "Crip" to which both groups belonged. (At the time I took this photograph, shortly after the 1992 Uprising, the Hoovers were probably just beginning to disassociate themselves from the Crips label; they are now simply "Criminals" and consider themselves neither Bloods nor Crips.) Monster Kody (Sanyika Shakur) also discusses this in his 1993 book *Monster* (he was from Eight Tray Gangster Crips).

## Enemy Lists

The last and most specific enemy designations are explicit listings of enemies, usually included as the final or penultimate part of a graffiti composition. When you finish writing your own, shall we say, "positive" statement of self (albeit replete with crossings-out of enemy initials and any CKs, BKs, PKs, or OKs you feel like throwing in), you might include an explicit list of enemy names. These, of course, are duly crossed out as you write them. Generally, a gang's closest neighbors constitute these explicit listings, indicating that such enmities are founded upon active relationships as well as ideology. Geographically closer gangs are the ones with which gang members usually have the most interactions.

Similar to Chicano gangs are the quirky derogatory nicknames Bloods and Crips give to their main enemies, through which such hated and feared entities as the East Coast Crips become "Cheese Toast," for example. Through the many enemy hoods of the East Coast Crips are countless references to "Toast Killas" or simply "toast" crossed out with an X. In addition to its obvious expression of disrespect, it kind of deflates an enemy's power to manipulate its name in such a manner. Gang members use these nicknames on walls and during speech in some relatively humorous ways, though these derogatory practices can be deadly serious.

An excellent artist, Ghost, in the Swans neighborhood has created different cartoon-like characters not only for the Swans themselves but for all their enemies. As Crips become Crabs in speech and in writing, the Swans portray Crips through actual drawings of crabs on a wall. Figure 4.12, starts out with a hand signing "CK," crossed out. Then a piece of toast, for "Cheese Toast," the writing inside it is "Boast K" for "Boast Killa" (a Bloods play on the word "toast" or "coast"). Next comes the crab, complete with antennae and pinchers. Inside its body, Ghost has written "Fuck da Crabs," crossing out the crab itself, crossing out the word "crabs," crossing out the "C" in the word "Crabs," and adding a "K" after it, making it "Crab Killa." Ghost reifies his anti-Crip sentiment at every available opportunity. In the process, he manifests his worst ideological enemy, which itself embodies the rest of the enemies listed. Then he has drawn a chicken in profile, complete with bandanna. Ghost has written "KTCK" inside it, for "Kitchen Crip Killa." These poor Kitchen Crips quickly become Chickens in the gang world. Last, Ghost has drawn a nicely pleated skirt, one I wouldn't mind wearing myself (well, perhaps if I had it "expertly altered" at the cleaners behind the graffiti). Inside is written "SkirtsK," for "Skirts Killa."

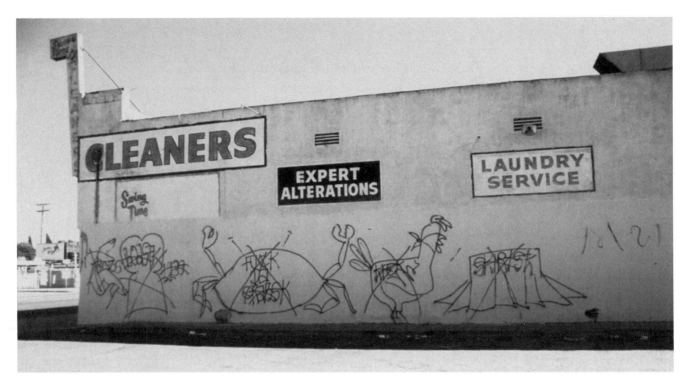

Fig. 4.12. Caricatures of Mad Swan Bloods enemies (1996). The slice of toast represents "Cheese Toast," derogatory nickname for East Coast Crips; the crab signifies "Crabs," the Bloods nickname for Crips; the chicken signifies the Kitchen Crips, or "chickens"; and the skirt ridicules the Main Street Crips, or "Mini Skirts."

The Main Street Crips are considered "Mini Skirts" in the gang world. As one of the Swans' worst enemies, they are precisely represented as such on the wall. The feminization of enemy names is popular. As Main Streeters become Skirts, Avalons become Avons, after that famous Avon lady. Consumption and feminization introduce another level of potential analysis within which gender and psychological issues merge in the daily practice of gangs and the collective definition of manhood.

Derogatory nicknames are shared across gang lines and are usually reserved for a gang's closest geographical or ideological enemies. Just as any Crip calls Bloods "Slobs," anyone who is enemies with the East Coast calls them "Cheese Toast" (or "Boast," as above). All enemies of the Broadway Gangster Crips call them "Bubble Gums" (for B.G.), or just "Gums." Ghost predicted that the use of these symbols he invented would start to spread: soon I saw evidence of this in the 52 Broadways neighborhood, where a large slice of crying toast adorned the wall on 54th and Broadway for a few days.

One day I was hanging around in the Pueblos projects when one of the homies and I started talking about derogatory names. I asked him, "So what do they call the Pueblo

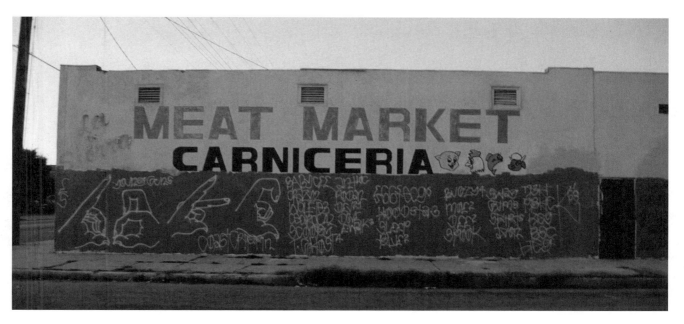

Fig. 4.13. "68 EC": Hand signs from the East Coast Crips (1995)

Bishops hood? What do enemies call the Pueblos hood?" He kind of hemmed and hawed and seemed unwilling to tell me. I had just asked someone for some aspirin for a headache, so eventually he said: "All I'm going to say is this. If you ever get a stomachache, don't go around this hood asking for the pink stuff, whatever you do. Ask for Mylanta or something, but not the pink stuff."

Derogatory nicknames are the naturally funniest part of a serious dialogue between elements of the gang world. We shouldn't be afraid to laugh at these, for it is through humor that we begin to recognize humanity. If even gang members are still able to laugh at themselves, this should give us a little hope that might have been lacking before. It offers the same to them, I imagine.

Elements of the gang world cross over all the time—people become signs on the wall, numbers become figures, letters become images, signs become people. Graffiti become permanent representations of the gang. If Bloods have to lay low because of their smaller numbers, the graffiti do a great job of representing them round the clock.

Picking apart one piece of graffiti bit by bit can demonstrate how gang members represent each aspect of their identity in writing. Figure 4.13 presents an image from one of the neighborhoods belonging to the East Coast Crips.

This impressive composition starts off with a small "es" for Eastside, then includes four

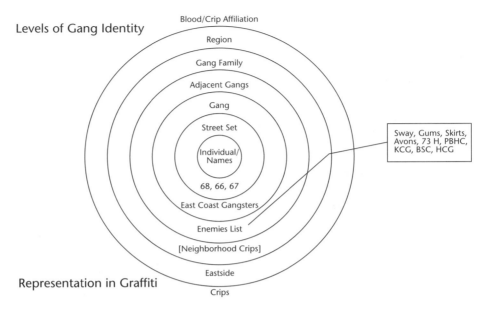

Levels of Gang Identity

Blood/Crip Affiliation
Region
Gang Family
Adjacent Gangs
Gang
Street Set
Individual/Names
68, 66, 67
East Coast Gangsters
Enemies List
[Neighborhood Crips]
Eastside
Crips

Sway, Gums, Skirts, Avons, 73 H, PBHC, KCG, BSC, HCG

Representation in Graffiti

Fig. 4.14. African American gang classification. Based on Evans-Pritchard's model of tribal identity (1940).

spray-painted hands, individually signing "6," "8," "E," and "C" for 68th Street East Coast. Underneath it reiterates "Coast Crippin" as a way of Crippin' (i.e., being a Crip) specific to East Coast Crips. Next is a list of members: Baby Cee, Crazy2, Wolfie3, Cedroc 1&2, Scooby, T.Ghost4, AntLoc, Rodan, Dev 2&1, Dove, and Ewalk3. Beside this list is a second hit-up, "es66st ECG" for Eastside 66th Street East Coast Gangsters. This, like the first, also lists member names: Hoodsta3, Sleep, Blue2, Bugzy4, Moe2, Dee2, and Spook. Notice how the "H's" and "A's" are crossed out, indicating their enmity with Hoover and Avalon. Following the gang and member names is an explicit list of enemies, the closest (and therefore most relevant) of which are listed first and identified by their derogatory nicknames: "Sway" (Mad Swan Bloods), "Gums" (Broadway Gangster Crips), "Skirts" (Main Street Crips), "Avon" (Avalon Gangster Crips), "73H" (73rd Street Hustlas), "PBHC" (Play Boy Hustler Crip), "KCG" (Kitchen Crip Gangsters), "BSC" (Back Street Crips), and "HCG" (Hoover Criminal Gangsters). This listing of enemies ends with a large "K" indicating "Killas," and the small "6,8,7" for 66th, 67th, and 68th Streets, which constitute this East Coast hood. The diagram in figure 4.14 shows how each part of the graffiti relates to an abstracted element of gang identity.

With Chicano gangs, most elements of a particular gang's position in the geographical system of boundaries are represented at some point in any given neighborhood. With Bloods and Crips, on the other hand, almost every single piece of graffiti incorporates all levels and aspects of gangster identity. Most of these material representations have to do with enemies. However, although it is less represented materially, intergang alliance is an enormous part of black gang relations and can usually be found in the graffiti of a particular neighborhood. As detailed in the next section, Bloods and Crips alliances are a rich aspect of the gang world that reemphasizes the basic need for protection and survival.

## THE LITTLE-KNOWN WORLD OF GANG ALLIANCE

When Bloods and Crips fight, or when Crips and Crips fight, single events can lead to cycles of violence that may eventually become blood feuds. One man explained to me how a rivalry began between two gangs in his neighborhood area:

> You know how that rivalry started? They say it started over a set of rims. Rims! One guy, somebody stole the rims off his car. Then that guy went around shooting. Then those guys, somebody die, those guys is like out for blood. Then pretty soon, it's like somebody killed your brother and you gotta take revenge, retribution, you know.

The disrespect inherent in a theft like this cannot go unanswered. Thus the problem of "rims" becomes a larger problem of protecting a neighborhood's reputation. Such violent responses to seemingly small circumstances are meant to help prevent similar or even greater harm from occurring in the future.

Because of these event-driven enmities, worst enemies in the gang world are generally closest neighbors. So are allies—to help protect a gang from those other neighbors they don't get along with. In the hood there is the idea that a gang must be part of a larger system in order for these alliances to be effective.

I once met a couple of guys who belonged to a gang comprising both blacks and Chicanos. They didn't affiliate with Bloods and Crips or with Mexican gangs. They kept saying, "It's a block thing." They said they didn't start stuff with anyone, but if someone came into their neighborhood with something, they would defend themselves. They said they didn't go for that "Bloods and Crips shit." When I told OG R., an older Pueblo, about this gang, he just shook his head, saying, "You just see how long they'll last. They'll be gone

within a year." The older gangster firmly believed that gangs must be part of a system that includes alliances in order to survive. "You gotta belong somewhere," he said. "You gotta have people to back you up if you need it."

Another young friend of mine once described the circumscription he felt living in the hood on a daily basis:

> You surrounded here. Sometimes the best thing you can do is "baaaa" like a sheep. It ain't like when you were little, when if somebody hit you, you hit them back. Now you don't know who's got a gun. It's like that song, "nowhere to run, nowhere to hide." You is surrounded by your enemies. You always got to be with somebody, you got to affiliate with people who can back you up.

Seen in these terms, the gang system is indeed a method of mutual protection. Many gangs have calls or special signals they yell if someone is in trouble or to warn people of the police. Although most enemies are gang neighbors, continual harassment can qualify the police for enemy status as well. For gang members, the LAPD can be as dangerous to life and livelihood as any neighborhood enemy.

At least one gang in South Central Los Angeles is neither Bloods nor Crips: the Hoover Gangster Criminals. They used to be Crips and still function within the Bloods-Crips gang system. But apparently after the riots, they stopped recognizing their Crips designation, claiming that they were just "Criminals." They moved away from a designation that they found was oppressing their people, a designation based on something that didn't "really" mean anything, something that may have even been imposed from the outside to keep the black community divided. "We're into families around here. You don't see our kids throwing up signs and shit. If it's time to take a picture, they just give a big thumbs up," one man said to me. As in figure 4.15, the Hoovers write "BK" and "CK": Blood Killas and Crip Killas, crossing out both the "B" and the "C." Normally, Crips would only write "BK," but the Hoover Gangster Criminals claim to have killed Crips as well as Bloods.

The reason the Hoovers can survive without a Bloods or Crips designation is because they have sets spanning throughout Hoover Street: on 52nd, 59th, 74th, 83rd, 92nd, 94th, 107th, and 112th Streets. Average sets range from 20 to 70 people; some sets are closer geographically than others. This is a critical mass when tallied—probably numbering from 200 to 400 people. The Hoovers have an almost mystical reputation in the gang world, as if people can't imagine what it is like not to affiliate with anyone: "You know who

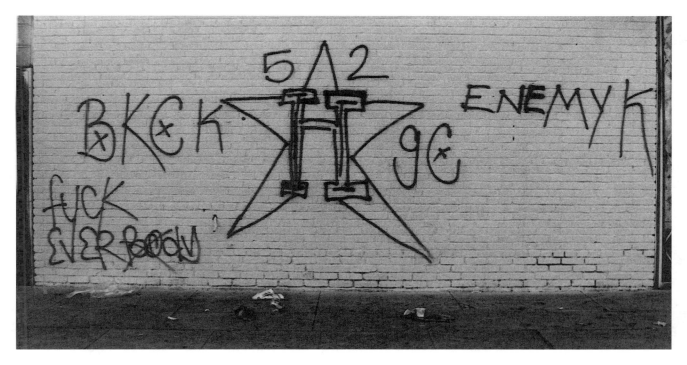

don't get along with anybody are Hoovers." "Everbody's they enemy." "With them it's nothing but Hoovers." Even their graffiti simply says, "Fuck Everbody" and "Enemy K," for Enemy Killa.

Other African American gang members are dead set against the Bloods-Crips division for similar reasons to the Hoovers, but their numbers do not afford them the luxury of disassociation. Another friend of mine from the Blood Stone Villains said that Bloods and Crips mean nothing:

> I don't believe in Bloods or Crips. Bloods and Crips ain't nothing. But Villains? Now that's something. That is a real word that you can actually look up in the dictionary; it means something. And that's who we are. We are Villains. Whatever it says in there, that's what we are. Evil. Doing bad stuff. We are Villains. Bloods and Crips ain't shit. They aren't even real words.

At least among the 52 Hoover Gangster Criminals, the idea of disassociation from the Crips label is something about which its members are proud and mostly agree. But this man from the Villains was one of the only Bloods I've ever met who wasn't proud of being

Fig. 4.15. 52 Hoover Gangster Criminals ("52 H GC") proclaim their enmity toward all Bloods and Crips gangs (1995). "BKCK" (both the "B" and the "C" are crossed out); "Enemy K"; "Fuck Everbody" [sic].

a Blood and who didn't consider the Bloods identity one of the most important things in his life. As with most Crips, the majority of Bloods consider the affiliation with their larger ideological group lifelong. Bloods need the built-in alliances their affiliation offers to help them survive surrounded as they are by Crips sets.

But Bloods alliance is not as straightforward is it seems. In the same way, a man from the Pueblos explained that his tattoo (see figure 4.16) includes both "CK" and "BK" because the Pueblos—even though they are Bloods—are killing just as many Bloods as Crips. (However, when I showed this picture to one Pueblette, she said that he included "CK" and "BK" because of the riots, a time when people began to realize the futility of that divide—but the owner of the tattoo made no such indication.) A checked form of violence exists between Bloods and is materialized in tattoos like this one, but the cycle of violence is different. It is not ongoing. Notice how this man has crossed out the "C" for Crips, but has left the "B" uncrossed, even though attaching a "K" to the end symbolically kills the category to which he himself belongs. Bloods will kill other Bloods for specific reasons, but they are not enemies with Bloods as an ideological category. (Bloods hostility may be more cyclical in places, like Inglewood or the Inland Empire, where Bloods are the majority. For Los Angeles, however, hostility between Bloods remains checked due to the presence of an immediate and even greater enemy.)

Sometimes the unification between Bloods temporarily breaks down over any number of issues. In general, however, Bloods are proud of their underdog status and go to great lengths to protect themselves. When alliances do break down between Bloods, fights may be short-lived. One young man from the Mad Swan Bloods explained it to me:

> With Bloods, we're all supposed to be unified. But it ain't really like that. You know, sometimes things happen. But with Bloods it might only go around once, then it will be squashed. Just dropped, instead of for years and years like it would be with Crips.

Another said:

> Crips don't get along with other Crips. But all Bloods get along. Except some, they don't. But like Crips? They'll have shoot-outs. Bloods, if they don't get along, they'll just have like fights and stuff. Crips go to war. They kill others of their own. If they got along, Bloods wouldn't be no more.

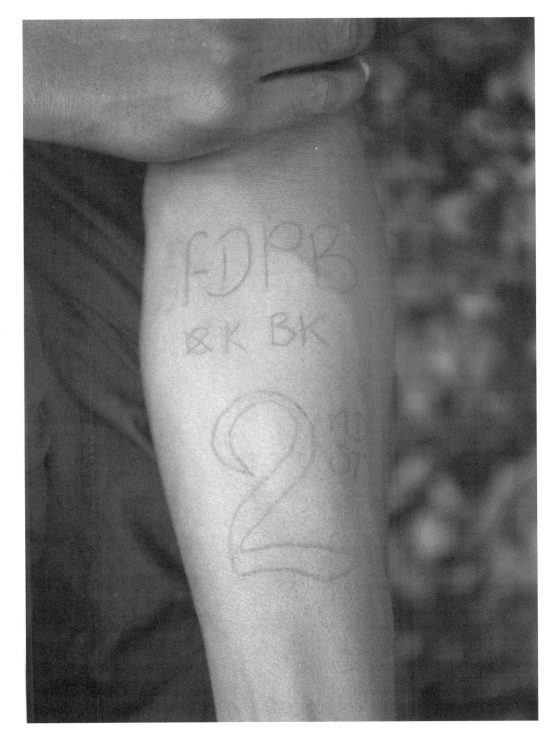

Fig. 4.16. Tattoos on the arm of a Five Duse Pueblo Bishops ("FDPB") gang member. "CK BK" signifies both Crip Killa and Blood Killa, but only the "C" is crossed out. The large "2" represents the latter half of "52nd Street"—the "5" is tattooed on the other arm.

The same pressures of daily life—drug deals gone bad, relationship problems, and so on—confront both Bloods and Crips. Though practical reasons of numbers and backup dictate that Bloods cannot infight chronically, they rely on specific practices to help them reach this ideological and practical goal. Although Bloods do fight, the repetitive cycling of violence is largely absent. Thus within the black gang community itself is a model for curbing never-ending cycles of violence and feuds that forever plague Crips.

When I first began my dissertation research with Bloods in July 1995, I soon started hearing about football games, picnics, and barbecues between the Blood Stone Villains and the Pueblo Bishops, the two Bloods gangs in my area. These were "events" in the traditional anthropological sense of the word, and I was drawn to them. It was only later that I began to understand their place in the gang community—that these events were part of the complex interactions that constituted "between Bloods" relationships.

For example, one man told me that Bloods often have huge parties to which all Bloods are invited. Any Blood can show up and will be welcome. Another friend of mine whose eighteenth birthday was in May said that she made flyers advertising her party and passed them around in several other Bloods neighborhoods in South Central. One young man told me that the way he got to know such a large area of South Central Los Angeles was by going to all the parties in other Bloods neighborhoods. A female Blood also mentioned that women can go to more parties than their male counterparts and are even sometimes able to go into Crips neighborhoods. (Interestingly enough, dating across gang lines is not so uncommon.) Crips, on the other hand, don't have huge parties to which all Crips are invited. If they did, rival Crips groups would crash them. The dangers of competitive feasting loom large in the minds of gang members who host such events.

Bloods football games and barbecues connect groups from all over the South Central area. Practically every Saturday afternoon in summer and fall, Bloods will travel to home or away games to compete with other Bloods neighborhoods. In the Pueblos neighborhood where I worked in the summer of 1996, the Pueblos played games with the Black P. Stones, the Blood Stone Villains, the City Stone Pirus, the Hacienda Village Bloods, the Mad Swan Bloods, and the Bounty Hunters, groups whose combined geographies span the length and width of South Central Los Angeles. As might be predicted, sometimes even these friendly events are fraught with tension. I knew the Bounty Hunters and the Pueblos didn't get along. When I asked about the football game, my friend said, "Yeah, that was about the last time we played them. They live in

another [housing] projects. Projects tend to think one is better than another. That always turns to chaos." When groups like this who used to get along allow their alliances to break down, it is called "set trippin.'"

The Pueblos and the Villains are the closest of allies geographically: most of them grew up together and attended the same schools, and many babies share mixed Pueblos-Villains parentage. Despite these strong links, a number of factors seem to antagonize the two. Male-female relationships have been particularly antagonistic, and the women of these two gangs are forever at odds with each other. Rumors among the Pueblos and Villains of the other group having AIDS are commonplace and might seem to discourage potential relationships that could further strengthen ties. I often heard that the Pueblos consider themselves more friendly than the Villains, that the Villains didn't really know how to respect anybody. For this reason they "don't get along." A number of factors seem to separate the two sets, dooming them to "set trippin.'" But this hasn't happened.

One morning in early July 1996, a major bust by the LAPD put twenty-one of the Blood Stone Villains in jail. Suddenly Central Avenue seemed deserted; everyone was laying low. A few weeks later, I ran into one of the remaining Villains on Central and told the folks in the Pueblos about it. Next time you see him, they told me, tell him that the Pueblos are "holdin' down the fifties" for them. The fifties blocks from McKinley to Alameda are what the Pueblos and the Villains control together. The Pueblos were helping to maintain this control by filling the gap left by the missing Villains. For the next few months, Pueblos graffiti ended up appearing here and there on what usually would have been Villains graffiti areas; I occasionally ran across Pueblos who were wandering around the Central area.

The graffiti shown in figure 4.17 symbolizes the connection between the two close allies. "PBSV" stands for the initials of both gangs combined: the Pueblo Bishops, who write "PB," and the Blood Stone Villains, who write "BSV." More common are simply hit-ups by the other gang in its ally's neighborhood. Of the twenty graffiti in the backyard of the Villains hangout, three identified the Pueblos hood. Oftentimes, Pueblos write graffiti with little Villains graffiti off to the side or vice versa. Similar patterns are seen in other Bloods and Crips neighborhoods, including those separated by larger distances.

Customarily, Crips never form alliances with Bloods. The truces between these two normally warring factions following the 1992 L.A. Uprising represented a unification of

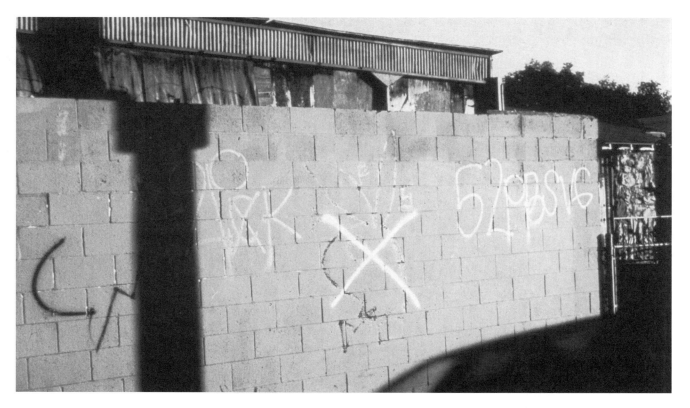

Fig. 4.17. Bloods alliance between Pueblo Bishops and Blood Stone Villains. "52PBSVG" stands for Five Duse Pueblos Bishops/Blood Stone Villains gang. "F2PCK" means Five Duse (52nd Street) Pueblos, Crip Killas. (The crossed-out playboy bunny is an insignia for the Chicano Playboys gang, whose initials PBS are positioned around the bunny's head; it is not part of the two black gang compositions.)

Bloods and Crips against a larger common enemy: the institutional structures of white racism and the LAPD. These truces were covered in the media with a degree of paranoia, insinuating that black gangs could potentially create an unstoppable force of violence against the white community. But the truces were event-driven and most dissolved within a year of the Uprising. They were not rooted in the day-to-day structures that persist regardless of—and, I argue, because of—the actions of the white community (I discuss these truces in more detail in a following section on the L.A. Uprising). Unlike the truces, the types of alliances I refer to here are essential to everyday survival. These are street-level alliances—"default" gang affiliations in lieu of an event that drives or forces them to unify against a common enemy. The exclusionary tactics of the larger system combined with Los Angeles's segregated geographies preclude the kind of interaction that would allow daily engagement between gangs and their "real" enemies.

## POWER IN NUMBERS: THE NEIGHBORHOOD AS A MYSTICAL SYMBOL

There is power in numbers in the gang world. You need backup; you need to maintain a presence in a certain area. Things like alliances help people to survive in places where their worst enemies sometimes live just around the corner. This is one kind of power in numbers. Another kind of power—a mythical, magical sort—also resides in numbers. Part of what links gangs together is their common history and affiliation with numbers and symbols that represent political designations. Regardless of history or referent, the embodiment of such designations soon begins to do what Michael Taussig (1992) has termed "erase signification," making numbers and other symbols seem as though power already exists within them, just waiting to be called into action.

Overlapping concerns of the neighborhood intertwine in images of letters and numbers. Groups of people, economic interests, potential relationships, and life experience combine to form a magical identification with the name, the numbers, and the land. In 1940, Meyer Fortes and E. E. Evans-Prichard argued for prioritizing political rather than social or economic motivations for group formation. They determined that "Bonds of utilitarian interest between individuals and between groups are not as strong as the bonds implied in common attachment to mystical symbols. It is precisely the greater solidarity, based on these bonds, which generally gives political groups their dominance over social groups of other kinds" (23). With multilayered representations of identity intertwining at every turn, the neighborhood becomes something like a mystical symbol, and the strongest link that gang members share.

Following Durkheim, Michael Taussig has described how "signifiers" become objects of devotion in and of themselves, mystifying the signification they supposedly represent (1992, 125–29): "It is fascinating that what we might call (with some perplexity) the *image itself* should be granted such a power—not the signified, the sacred totemic species, animal, vegetable, and so forth, but the signifier is itself prized apart from its signification so as to create a quite different architecture of the sign—an architecture in which the signified is erased. Thus can Durkheim make his final claim that what is 'represented' by sacred objects is 'society' itself" (1992, 128, Taussig's emphasis). This is part of the richness of gang numbers, neighborhoods, and initials, as gang members work to deify themselves

and their land. Because, at first, numbers and initials stand for something else, like a street name. Then, pretty soon, numbers begin to represent only their own image, becoming in and of themselves essential loci for personal and group identity. In this section, I review common gang numbering and related symbolic practices, then describe historical connections in their development.

### Playing with Numbers

I was amazed to find out how deep the numbering system went for African American Bloods and Crips, even just in terms of initialing. For example, the Pueblo Bishops write the initials "PB" usually. But sometimes they write "PFDB" or "FDPB." At first I thought those might represent different gang sets, but soon I realized that the initials stood for "Pueblo Five Duse Bishops" or "Five Duse Pueblo Bishops," because of their affiliation to 52nd Street. The neighboring Villains do the same: they write BSV usually, for Blood Stone Villains. But sometimes they write FDV or FSDV, for Five Duse Villains or Five Six Duse Villains, to signify their constituency of 52nd and 56th Streets. They may also write out the letters as they are spoken, just like Chicano gangs: Be Es Ve, for BSV, for Blood Stone Villains, Ce Kay, for CK (Crip Killa). Each gang neighborhood in the Bloods-Crips system has similar ways of manipulating their initials and numbers.

One young man's vivid description of his neighborhood's initials first drove this point home to me. He described to me the love of his hood, the Five Duse Villains. "FDV, FDV" he kept saying. Linked up with these numbers and initials were real events, his history and experience all over the streets, written in spray paint and in blood.

> I've seen so many of my homies die, like right in that alley over there. And I held my homeboys in my arms, dying with their blood all over my clothes, with their faces blown away. Some people don't be doing that anymore, they be afraid to mess up they clothes and shit. But I ain't worried about that. That ain't nothing. Because they were my homeboys and I love them. Because they died for something that I'm still representing.

He continued:

FDV. Five Duse Villains. Three little letters. That's all you need. And you know what those three letters stand for? How to do things, how to get away, and how to get money. FDV. That's the life right there.

Numbers, neighborhoods, and events play so deeply they seem powerful in and of themselves. Looking at graffiti and listening to these stories, I feel something that comes closer to the mysticism of this experience—the symbols are there and working, only hints at the events that really give them meaning.

Many gang practices demonstrate the black gang devotion to number symbolism. Chicano gangs have jumping-ins (initiations) that last, for example, eighteen seconds if you're from 18th Street, thirty-eight seconds if you're from 38th Street. With black gangs, depending on the gang, you might have special holidays or things that you do to celebrate your gang's affiliative numbers. Someone from the Eastside Rollin' 20s Outlaws might have a tattoo that says "200% Outlaw." Or a girlfriend of Andre, a member of the 52 Broadways, might have a tattoo that says "152% Andre."[4]

One day I was at the Pueblos projects and it seemed everyone was dressing up in their red, getting ready for something. I asked a friend of mine what was going on and he said, "It's Five-Duse day." I asked if that was a traditional gangster holiday, thinking how silly a question that was—as if gangsters have traditional holidays. But to my surprise, he said yes. He explained how every year on the second of May (5-2) the Five Duse (52) Pueblo Bishops have a huge party, kind of like a birthday for the gang to celebrate its main affiliative street. I was so enchanted by this idea I thought if I were to have made up a gang practice out of the clear blue sky I couldn't have thought of a better one. It so clearly crystallized this mysticism surrounding numbers, their constant reinforcement during daily life in a variety of gang practices.

When I went to Five Duse Day the next year, I watched as the gang slowly assembled throughout the day at Slauson Park, adjacent the Pueblo del Rio housing projects. Five Duse Day was a family affair with moms, dads, and kids, plus gang generations stemming back to the 1950s "Slauson Park Boys." Thunderous bass resounded from multiple boom boxes, homeboys hung out shooting craps and socializing, and catered food was available to all near the graffiti they wrote for the occasion: "es Five Duse Pueblo Bishops, 1952–1997."

Walking around on the street with one friend, we chased the lowrider in figure 4.18

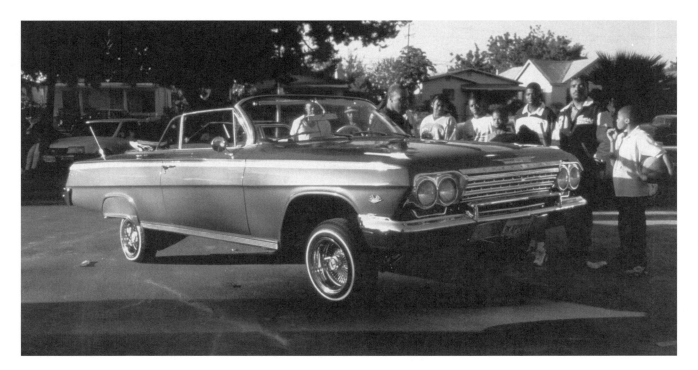

Fig. 4.18. A lowrider helps to celebrate Five Duse Day in Slauson Park (May 2, 1997).

as it hopped down the street, providing spectacle and show to all. The car, owned by one of the Pueblos, performed while kids gathered round, and its owner put it through multiple poses so I could take pictures while the audience looked on. Later the homies posed around it for the yearly photograph, wheeling the three homies in wheelchairs to the front, while the rest arranged themselves behind it. One of the older homies was the designated photographer, reminding me how gang members' self-documentation of their practices and lifestyle—including of their own graffiti—puts them in charge of manufacturing their own image by allowing them to be self-sufficient and creating representations that serve their own social and historical needs.

Many neighborhoods have practices like Five Duse Day, particularly those in higher-numbered blocks, from the 50s into the 60s, 70s, and 100s. I like to think of this as a wave of parties through summer that keeps moving south as the sun gets hotter. Summer is the traditional time for picnicking in general, and those gangs with street numbers that coincide with winter months may not participate in such extensive parties at that time. Former Westside Rollin' 20s Blood and gang researcher Alejandro Alonso told me in 1996 that the Twenties, for example, don't have a big party like Five Duce Day, but it is a big

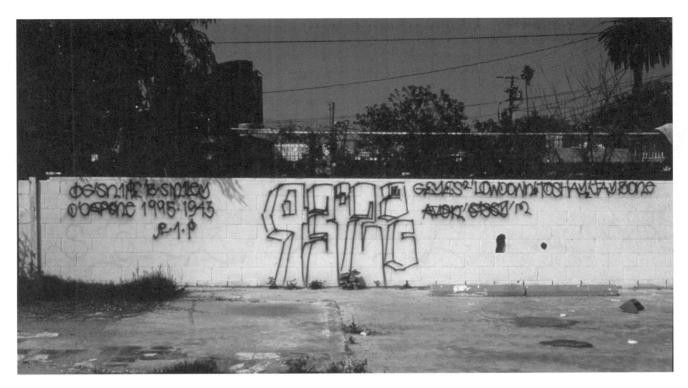

deal in that hood when a person turns twenty. He added that the name "Rollin' 20s" came from the idea of the "Roaring Twenties," so the gang shares a fond nostalgia surrounding the days of the original Chicago gangsters from the 1920s. There are "a lot of 'Kapones' in that hood," he said. (Kapone is a common gang nickname; Bloods spell it with a "K" because of enmity with Crips.)

Gang members from specific neighborhoods celebrate different numbers, dates, holidays, birthdays, years, and even entire eras to strengthen their affiliations and reify their concept of a common gang entity. Another example of how neighborhood number symbolism works on a daily basis is shown in figure 4.19. This RIP honors three dead homies from the Foe Tray, Foe Duce Gangster Crips: OG Snipe, B.Smiley, and D'Capone. The date reads 1995–1943. The year 1995 was clearly when they died, but "1943" puzzled me. I just assumed one of them had been born in 1943 (a double or triple OG by now). A guy from the Pueblos hood was the one who eventually pointed out to me that this was certainly not the year any of those folks were born. Instead, the writer was incorporating "43" into the year because they were from 43rd Street. In this way, all the homies share

Fig. 4.19. An RIP from the Foe Tray, Foe Duce Gangster Crips ("43,2 GC") neighborhood. The date reads "1995–1943" ("1943" signifies the 43rd Street neighborhood; "1995" is the year the homies—"OG Snipe," "B.Smiley," and "D'Capone"—died).

a mythical birthday in 1943, the year associated with their hood. He said that the Five Duse (52nd Street) Pueblos might write 1952–1996 for an RIP (or a BIP or PIP—Bloods in Peace or Pueblos in Peace; see figure 4.30). Similarly, in Monster Kody's book *Monster,* Shakur refers to 1983 as the "Year of the 8trays" (1993, 209), something heavily celebrated in the Eight Tray Gangster Crips neighborhood, based around 83rd Street. All black gangs share similar practices surrounding their numbers.

Shared names and numbers also link different gangs together into alliances. Such links can sometimes be a factor of histories in common, through connections that originated the groups. Many times, however, numbers and letters themselves hold the power to bond groups together. For example, I had asked one of the 52 Hoovers (pronounced "Five Deuce Hoovers") about the fact that the Hoovers didn't have any allies, and he said, "Well, sometimes we get along a little bit with the Harlem 30s. You know, because of the 'H.'" He knew I would understand such a basic link between the two groups. Similarly, the 52 Hoovers are also supposed allies with their neighbors, the 52 Broadway Gangster Crips, because they're both "52" Gangsters. (Such alliances are certainly debatable: I've seen the Harlem 30s on Hoover enemy listings, for example.)

Despite links through these numbers, the survival of the 52 Hoovers doesn't traditionally depend on alliances with Harlem or with the 52 Broadways. It depends instead on the maintenance of relationships among their own Hoovers sets up and down Hoover Street. However, rumor has it that lately two geographically close Hoovers sets, the 52 and 59 Hoovers, haven't been getting along and have even been exchanging gunfire. When I asked the 52 Hoovers about it, they said the 59s didn't really even exist (even though they do). Perhaps their own divisions within the larger Hoover entity are the reason they have sought connections through the letters and numbers of neighboring sets. Similar scenarios present themselves in other neighborhoods, and they become increasingly curious the deeper you go. The shifting complexities of intergang relationships never cease to amaze me.

Similar to connections through numbers and common history is allegiance to the signifiers of general Bloods and Crips categories. The numbers "2" and "3," similar to the Chicano 13 and 14, stand for the second and third letters of the alphabet: "B" for Bloods and "C" for Crips. Many gangs whose names end in three are Crips. There are, however, some Crip sets that end in the number two, such as the 52 Broadway Gangster Crips and the 52 Hoovers mentioned previously. Even when their sets don't end in that number,

however, the three remains a Crips designation. By the same token, Bloods feel a closer affinity to the number two, regardless of the number of their set. This knowledge is evidenced practically and materially through gang writing practices—in hand signing, for example, another generic sign for "Bloods" (usually based on the letter "B") corresponds to the number two.

Many gang members I asked about this elemental signification of numbers had no idea what I was talking about. Others said they had always heard about the two and the three, or that the older homies used to say that. Depending on neighborhood and individual relationships to historical designations, a variety of knowledge emerges regarding the history of certain practices. In the Bloods neighborhood where I work, both Bloods groups have "five duse" sets that end with two, though neither group actually hangs out on 52nd Street as the names seem to indicate. Even though the Five Duse Pueblo Bishops, for instance, use 55th and 53rd Streets as their main hangouts, their allegiance is to the two—and is thus what they write on the wall to represent their set.

In the listing of enemies by the Blood Stone Villains in figure 4.20, one of the Villains has lumped together gangs whose names end in the number three—referred to as "Tramps" by both Chicano and black gangs. Thus the Eight Tray Gangster Crips become "Eight Tramps," and the Foe Tray Gangster Crips become "Foe Tramps." The first crossed-out line in figure 4.20 reads "TR4342538311373PS," with the numbers in the middle written to replace the "am" in the "tramps." All but one of those numbers inside—43, 42, 53, 83, 113, and 73—designate Crips sets that end in three. (The 42 Gangster Crips are such close allies with the 43 Gangster Crips that they also merited inclusion in the "tramps" category.) At one time, the designation of gangs as "trays" ("threes") could be practically constituted—many of the trays were allies. But today, the alliance has broken down and the only connection is through this history and the grouped signification of the letter and number.

The other main listings of enemies in figure 4.20 are also specific. The second crossed-out line, "SN525974839294107112VAS," stands for the Hoovers, whose derogatory nickname is "Snoova." A listing of all the Hoover sets replaces what would have been the two "O's": 52, 59, 74, 83, 92, 94, 107, and 112.

Derogatorily known as "Nappy Heads," the last specific set of enemies is the "Neighborhood Crips" represented in figure 4.20 as "Neighbah3040465557586090ECK's." In this instance, most of the word "hood" is replaced by enemy initials. These are all sets of

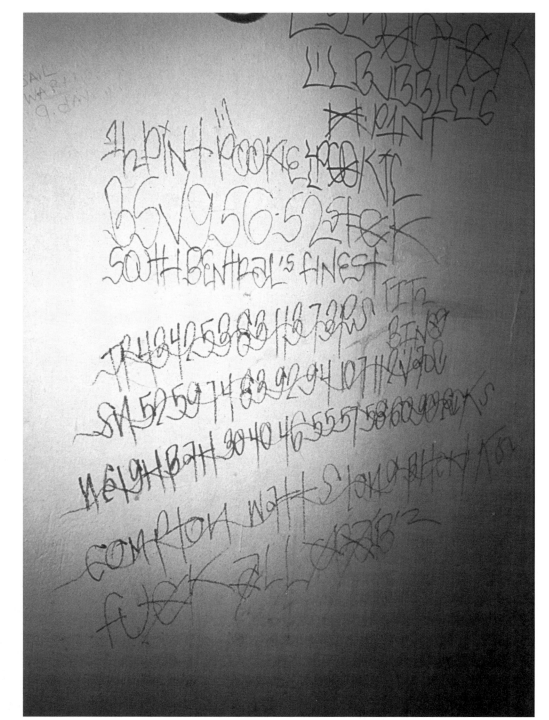

Fig. 4.20. Enemy list written by "1/2 Pint" and "Lil Pookie" of the Blood Stone Villains gang ("BSVG"; "56, 52 St" represent 56th and 52nd Streets; "CK" designates them as Crip Killas). "South Bentral's Finest" (enemies of the Crips replace the "C" in South Central with a "B"). "Tr4342538311373PS" for "Tramps"—Crips sets that end in "3"; "SN525974839294107112VAs" for "Snoovas," the derogatory nickname of the Hoovas; "NEIGHBAH 3040465557586090ECK" for Neighbahood Crip Killas; "Compton, Watts, Long Bitch K[illa]s"; "Fuck All Crab'z" (Crips).

neighborhood Crips: Harlem 30s, Rollin' 40s, 46, 55 (see figure 4.11), 57, 86, 60s, 90s, and EC for East Coast. Last on the list, the East Coast Crips is the largest African American gang in Los Angeles, numbering from one thousand to two thousand members. They often write "1 to 190" to show that they have sets from 1st Street downtown to 190th Street in Carson. Some (if not all) of the East Coast sets also carry a Neighborhood Crips affiliation, so here the Villains include them among a variety of Eastside and Westside gangs that share the neighborhood affiliation. Despite their eastern-sounding names, neither Harlem nor the East Coast Crips have links to the East Coast of the United States; East Coast, for example, is just another way of saying Eastside Los Angeles.

The composition in figure 4.20 (located inside the Villains' Motel—the crack house) is one of the most comprehensive listing of enemies I've ever seen. Grouping enemies in these traditional gangster categories, particularly the inclusion of the "tramps" category, is as unusual as it is helpful to me here. Similarly, adding "Compton, Watts, and Long Bitch" (for Long Beach) at the end further extends the normal geographical range of an explicit enemy list, which is usually limited to one's closest neighbors. Most neighborhoods have their own places where gang members write these larger lists, be it on a piece of paper, the interior wall of their hangout, or in someone's house. This one, inside the crack house, was certainly written just for the benefit of the gang itself.

## Gambling Parlance and Practice

In African American gangs, people pronounce and write numbers in a distinctive, gambling-related manner: ace, duce, tray, foe, five, six (I've sometimes heard "seece"), seven, eight, and nine or nina. Thus the two and three categories, "Duce" and "Tray" (derogatorily "Dummies" and "Tramps") are common in many gang names. Gang members generally spell *deuce* "duce" if they are Crips and "duse" if they are Bloods. All three versions are pronounced the same way and refer to the two in gambling. Similarly, the *trey* in gambling is spelled "tray" by gang members. Ace, duce, and tray are derived from numbers as said in cards and dice. In their 1986 *Story of English,* McCrum, Cran, and MacNeil indicate that this number pronunciation in gambling stems from the French Creole spoken in Louisiana and Mississippi riverboat gambling beginning in the nineteenth century.[5]

Gambling is an important part of generic gangster identity. From the Mafia to the black gangs of Los Angeles, gambling is as much a fantasy of gangster rap music videos as the underworld culture of crime. Street craps is one of the most fascinating things hap-

pening in black gang neighborhoods today. I was always drawn to it, amazed by the speed and ease with which gang members play the game, wondering how in the world they ever learned to tell what was going on. "Green" all laid out on the porch, people rolling and rolling, money passing from hand to hand, arguments breaking out over who owes what, who rolled what. Side betting, rituals that bring luck, even cheating and trying not to get caught—all these things make craps a most exciting gang practice, ubiquitous in any hood—especially during the summer months. If I thought counting dominoes was hard, craps was completely beyond my reach. My best times were when one of the younger homies would quietly translate what was going on for me; my worst, when someone would yell at me to leave, irritated with the abject fascination that inspired me to sit around and watch uninvited every once in a while.

The presence of gambling demonstrates how gangs have incorporated an impersonal system of transaction into their very personal system of gang membership. When they make money, they are essentially taking it away from their homies who have lost it. But what comes around, goes around. This kind of thing strengthens the gang system further. It allows the moral ties of family and trust among gang members to interpenetrate the impersonal transactions between them, making their relationships to one another more flexible and ultimately more powerful. Success at gambling really does come and go around; the status of individuals involved evens out in the long run.[6]

To demonstrate the presence of this vocabulary in gangster language, I take an example from the Jungles neighborhood, the domain of the Black P. Stones (the "P" stands for *peace*) Bloods set. Automatically, the "Jungles"[7] moniker conjures notions of urbanity rediscovered and appropriated, of Sinclair Lewis—the urban jungle, the concrete jungle, maybe even the blackboard jungle. The Jungles are located near Dorsey High School (speaking of blackboards), and the Black P. Stones are a Bloods set whose history I revisit in the next section. In figure 4.21, two additional Bloods groups, the Eastside Five Line Bounty Hunters (FL BH)[8] and the Westside Denver Lane Bloods (DLB), have represented themselves on a wall in the neighborhood of their allies. Rudely, they didn't even bother to include the Black P. Stones themselves. Later someone from the Jungles came back to correct this oversight, changing the "ES" to a "WS" for good measure, writing his own gang name, "Jungle's," above the others, and further adding "PS1" (for P. Stone 1) next to the "B" for Bloods in Denver Lane's name.

The composition in figure 4.21 brings up several overlapping issues regarding the

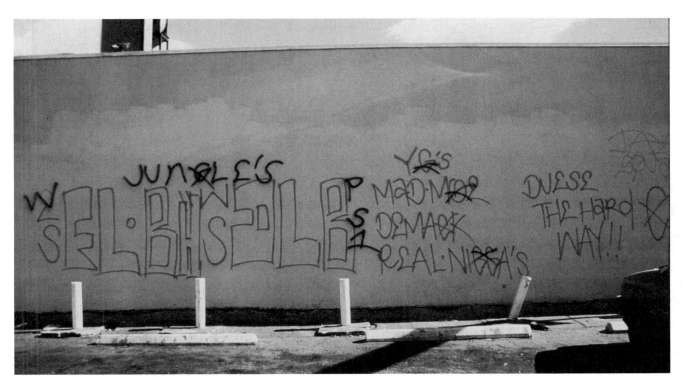

gang life. First is the alliance represented in red between three Bloods groups: the Bounty Hunters, the Denver Lane Bloods, and, finally, the Black P. Stones of the Jungles hood itself. This representation links Bloods sets from the Eastside and Westside of South Central Los Angeles, although, as you can see, there is a bit of tension expressed in the Jungles' rewriting of the E for Eastside into a W for Westside. YGs means Young Guns or Young Gangstas, and Mad Moe and DeMack, writers of this composition, list themselves as "Real Niggas." Last is written "Duese the hard way!!" The composition includes a "CK" (though I cut off the "K" when I took this picture) for Crip Killa. The alliance of three Bloods groups may seem commonplace knowing that all Bloods are allies, but it is rare for groups from such geographically distant neighborhoods to be represented together.

Another, perhaps deeper, aspect of this composition also demonstrates the power of numbers. It has to do with the phrase "Duese the hard way!!" and the gambling-related numbering system. What is "Duese the hard way!!" in figure 4.21 really saying? First is the reference to the number itself: "deuce" is spelled "duese" by Bloods to exclude the "c." However you spell it, this word originates from general dice and gambling practices. But

Fig. 4.21. The East Side Five Line Bounty Hunters ("ESFLBH") and Westside Denver Lane Bloods ("ws DLB") hit up their names in the Black P. Stone ("PS1") Jungles neighborhood ("ws Jungles"). The graffiti writers, "YGs [young gangstas/guns] Mad Moe and DeMack, Real Niggas," add "Duese the hard way!! CK."

it also means "Bloods," because the number two stands for the letter "b." Second is "the hard way," also a gambling reference. Generally, when you shoot something in craps "the hard way," you are rolling doubles. Double twos, threes, fours, and so on. Theoretically, it is impossible to roll a deuce the hard way. The "hard way" and "easy way" categories have to do with the probability of rolling any number—for example, to get a six the "easy way," either die has two chances (can either fall on a two or a four); to get a six the "hard way," both dice must fall on a three. There is only one way to get a two with two dice—by rolling snake eyes, or double ones. Since there is no "easy way," there can be no "hard way."

Another "hard way" in gambling has to do with blackjack. When you hit twenty-one the hard way, you do it little by little: you keep on taking the chance and hitting. When (and if) you reach twenty-one, you've done it "the hard way." The Bloods groups listed together in figure 4.21 are indeed a sort of piecemeal approach to the Bloods identity: little by little Bloods groups together form a force to be reckoned with. However, the hard way is more commonly a craps reference. "Deuce" has thus evolved into a generic term for doubled numbers or value. "The hard way" has also become a street slang term that means something like "totally" would mean to someone in the San Fernando Valley—here the total or ultimate in "Dueses."

This example demonstrates the material incorporation into a written system of a practice that is inherently ephemeral: the craps game. It requires the participation of people—the people are what make it fun and the gambling important, after all. The investment of gambling terminology in gangster language thus becomes part of the material record and designates political affiliation. The graffiti in figure 4.21 is one of those cases when a single image—in fact, a single phrase—can point to deep cultural links and crossovers within the system, as well as between a smaller system like gangs and the larger ethnic group and society.

## HISTORICAL LINKS THROUGH TIME AND NAME

Part of neighborhood affiliation with numbers comes from links with certain names and neighborhood histories. Graffiti can reveal the presence of formerly existing alliances and common heritage between particular groups. For example, the large lumping together of zeros into a gang category can now indicate any group ending in zero. This includes any of the 20s, 30s, 40s, 60s, 90s and 100s, and any other zeros we might care to men-

tion. However, the category including zeros traditionally refers to Crips from the West-side of South Central Los Angeles—namely, the Rollin' 30s, the famous Rollin' 60s, the 90s, and 100s. As Alejandro Alonso explained to me in a 1995 telephone conversation, at one time these four Crips groups were allies and could be practically as well as ideologically represented together. This alliance—like that between gangs ending in tray (three)—has since broken down. The connection with the common numbers and heritage survives only in the crossing out of "O's" (representing zeros) in graffiti.

As with the Chicano images, remarkable continuity as well as change is available visually through the analysis of older African American gang graffiti. One of my most remarkable experiences took place at the home of Evelyn De Wolfe Nadel, widow of L.A. photojournalist Leonard Nadel. It was exciting to see his photographs of L.A. gang graffiti from 1974—material representations of a crucial point in Bloods and Crips history—because I knew I could somewhat rudimentarily place them into the context of both history and the modern day. Even after a quarter century of everyday living, social cohesion, and the crystallization of the Bloods and Crips categories, the general practices like alliances and intergang relations between specific groups have actually changed little.

Nadel took the picture in figure 4.22, for example, in the same Jungles neighborhood where I took the "Duese the Hard Way" picture (figure 4.21) showing alliance between the Jungles, Denver Lanes, and Bounty Hunters. I could barely believe my eyes to see the same groups allied within the neighborhood of the Black P. Stones. (In 1974, the Black P. Stones were simply called the Black Stones after the Chicago Blackstone Rangers gang.) Dirty Red, the writer of this composition, supposedly later died in a car accident (Jah and Jah 1995, 207).

Such lasting alliances indicate the solidity of a common identity as enemies of Crips. All the groups listed in figure 4.22 later became Bloods; in the early days, most were Brims and Pirus. These groups solidified to form solid blocks of Bloods in Los Angeles, but many have remained in their original locations. Even without the larger Bloods umbrella in the early seventies, these groups represented themselves as common enemies of Crips, as well as of the Pigs (police).

The Black P. Stones have a remarkable history. The name itself is shared with a famous black gang in Chicago. An individual named T. Rodgers (T. Rex), a member of the Black Stone Rangers, came from Chicago in 1972 to start an L.A. chapter of the Blackstone Nation. He started this group in the more traditionally political Chicago manner, emphasizing

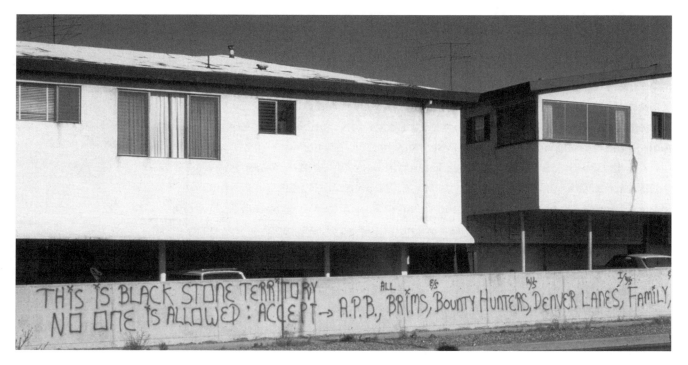

THIS IS BLACK STONE TERRITORY
NO ONE IS ALLOWED : ACCEPT → A.P.B., BRIMS, BOUNTY HUNTERS, DENVER LANES, FAMILY,

Fig. 4.22. Black Stone alliances in the Jungles neighborhood, 1974. The full composition reads: "This is Black Stone Territory. No one is allowed: Accept [except] A.P.B. [Avalon Park Boys or Athens Park Bloods], All Brims, e/s Bounty Hunters, w/s Denver Lanes, l/w/s [Inglewood Westside] Family, e/s Outlaws, e/s/Compton Pirus, Vanness . . . Bloodstone! No Pigs or Crips! Dirty Red [the writer]." Photograph by Leonard Nadel, courtesy of the Leonard Nadel Photo Archives.

neighborhood security, black ownership of property, and helping local people in his community. Rex took the revolutionary component of 1960s Chicago and attempted to integrate it into an L.A. gangster-style format. However, the Blackstones of Los Angeles quickly converted themselves into a gang to protect themselves from their hostile neighbors (see T. Rex's account of this in Jah and Jah 1995, 205–8). The historical link with Chicago in this case is already fairly unique for an L.A. gang. However, it is one whose revolutionary ideology may have had considerable influence on the nascent nationalism still pervasive in the ideology of Bloods and Crips today.

The word "Blood" itself stems from 1960s revolutionary ideology, when African Americans began referring to themselves as "Blood Brothers." During the 1965 Watts riots, for example, store owners would write "Blood Brother" or "100% Soul Brother" on their stores to designate them as black owned, just as they did in 1992. "Damu," the Swahili word for blood, also became a popular reference of empowerment. For example, just near the Pueblo del Rio housing projects is a "Damu Market," a little grocery/liquor store whose name is left over from that radical era. "Blood" came into use as an umbrella gang designation in the mid-1970s, but its history suggests familial, if somewhat radical, roots in

the unity of African Americans that dates back to the 1960s. Far from being a defunct 1960s practice, today's Bloods still commonly refer to themselves as "Damus," particularly in prison. Suge Knight even named his dog "Damu." (Knight, often described as a "notorious blood," owned the now-infamous rap label, Death Row Records.)

Crips history is no less peppered with revolutionary rhetoric. Godfather Jimel Barnes details some of the early history of the gangs in *Uprising,* saying, "When he [a friend] came over to me, he pulled out a picture of a baby's crib; he said, 'This is what I'm going to call our gang, Crips—like Cribs. It's from the cradle to the grave, C-RIP, may you rest in peace'" (Jah and Jah 1995, 152). Later on in the same book, Twilight, originally of the Circle City Piru gang, indicates that Crips is actually an acronym for "Community Revolutionary Inter-Party Service" (Jah and Jah 1995, 329). Though I have not done an exhaustive survey, Crips most commonly indicate that today the word is indeed an acronym, standing for "Community Revolution in Progress." As one man from the Original Valley Gangster Crips told me:

> You know what people say all about gangs being from poor people, 'cause of poverty? But it's not just a bunch of people from the ghetto. I mean, I'm from the Valley [a richer part of Los Angeles]. I did it to be part of the revolution, to be part of the Community Revolution in Progress.

Debated as are the origins of this word within the black gang community, I found the images in figures 4.23, 4.24, and 4.25 telling. The graffiti in figures 4.23 and 4.24 seem to support at least a limited original use of the word "Crip" as something added to an RIP for rest in peace. Separators like colons, dashes, and the then-common slashes made figure 4.23 difficult for me to read at first; several of its elements remain indecipherable without additional information. There is already one mystery—the "CA" in "CA: RIP." Its meaning can only be surmised (perhaps California?). "U/G" may be an early reference for "Underground Crips," who still survive today. "E/S" and "W/S/C" were common designations for Eastside and Westside Crips—the original groups under which Crip sets later splintered into rivalry or alliance. These pictures indicate that at least in some neighborhoods Crips may have indeed stood for something specific. Even though "CA" and "RIP" are separated in figures 4.23 and 4.24, other Leonard Nadel pictures, like the one in figure 4.25, show that the Crip category was already well established by this time in other neighborhoods around South Central.

According to several Crips in prison, the "CA RIP" may have come out of the practice

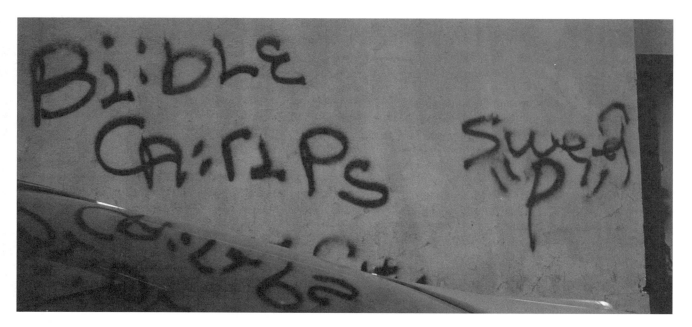

Fig. 4.23. Bible Crips graffiti (1974). "Bi:ble Ca:Rips" by "Sweet P." I am unsure what the colon (:) device was used for, but the word "Crips" seems to be separated into two distinct sections, which end in the prominent "RIP." The Bible Crips are now defunct, and I know of no direct descendants. Photograph by Leonard Nadel, courtesy of the Leonard Nadel Photo Archives.

of saying "Carip" in those early days. They indicate that this was just a play on the existing word, Crip, that didn't have any additional significance. The word "Crip," however, has been part of street slang since long before the 1970s. A song from the World War II era, for example, bears the title "Big Time Crip"; its lyrics describe the exploits of a streetwise hustler in Harlem. Another common explanation is that "Crip" is short for *cripple*.

Before Bloods became the umbrella category for non-Crips in Los Angeles, Brims were the largest components of non-Crips; in fact, they were much more well established than the Crips. One of the major current Brims areas is still on Bonsallo Street, just south of Slauson; Westside Brims still "run it from Bonsallo" near where the picture in figure 4.25 was taken. General Robert Lee, an original Brims member, described their early power:

Everybody was down with the Brims. The Brims were well loved, and still are well loved. The Pirus could have gone with the Crips; the Bounty Hunters, the Avalon Park Boys, the BSVs, all of them could have gone with the Crips, but they got down with us. We set the path for gang members. We don't get the credit now, everything is Crips now, but if you talk to any OG, they know. A long time ago when you said "Brim," they knew, "You don't want to mess with them Brims, they're deep, and they don't care, they're killers." (Jah and Jah 1995, 124)

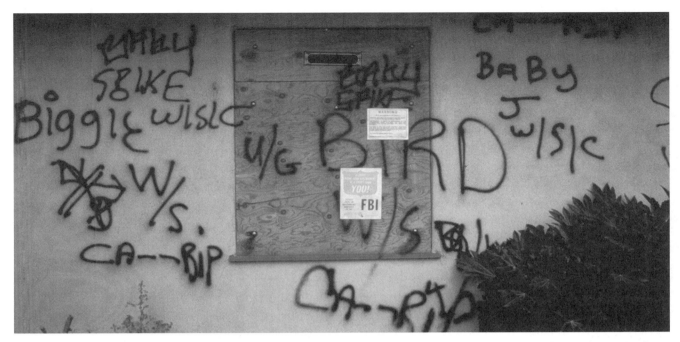

Fig. 4.24. Another graffiti demonstrating Crips ("CA—RIP") etymology (1974). "Baby Spike, Biggie; W/S/C" (Westside CA—RIPs); "U//G" is crossed out by "W/S CA—RIP." "U/G Bird"; "W/S/ CA—RIP"; "Baby J W/S/C." U/G probably stands for Underground Crips. Photograph by Leonard Nadel, courtesy of the Leonard Nadel Photo Archives.

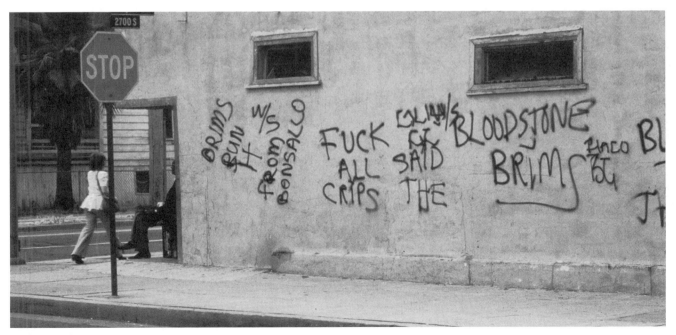

Fig. 4.25. Bloodstone Brims graffiti establishes use of "Crips" in other L.A. neighborhoods (1974). "Fuck all Crips said the Bloodstone Brims. Brims run it from Bonsallo." Photograph by Leonard Nadel, courtesy of the Leonard Nadel Photo Archives.

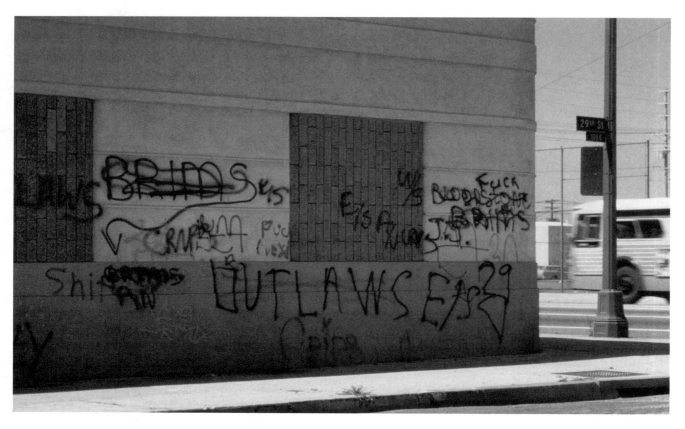

Fig. 4.26. The Eastside 29 Outlaws ("e/s29"), known today as the Rollin' 20s (27) Outlaws (1974). Here the enmity between Bloodstone Brims, Crips, and Outlaws (then representing the Brims?) is manifest in the many cross-outs on this wall. Photograph by Leonard Nadel, courtesy of the Leonard Nadel Photo Archives.

Brims retained exceptional power to unify diverse groups against Crips. Later on, they became a subset of Bloods, indicating their own espousal of an ideological "Blood" category, rather than one stemming from a particular street, area, or historical event.

Some gangs have been using their original names from back in the days before Brims, Pirus, Bloods, or Crips were even a glint in anyone's eye. For example, the Eastside 29 Outlaws in figure 4.26 later became the Rollin' 20s (27) Outlaws, according to Alejandro Alonso (conversation with the author, 1996). Instead of the 29, today's Outlaws use 27 as their specific affiliative street. The Outlaws started out along with the Slausons, Businessmen, Gladiators, Hat Gang, Rabble Rousers, Park Boys, Blood Alley, and a host of other gangs in the 1950s and 1960s. Most became forerunners for later gangs, which only rarely retain their original names. The image in figure 4.27 (taken by Ben Lomas in 1965) by "Sweet Dean of the P.J.'s" indicates that P.J. Watts, along with the Outlaws, may be an exception. The P.J.'s, Crips from the Imperial Courts housing projects, still use "P.J. Watts" to

Fig. 4.27. Early graffiti (1965) from P.J. Watts, whose name hasn't changed in more than thirty years. "Sweet Dean of the P.J.s" (P.J. Watts). Photograph by Ben Lomas.

designate their gang more than thirty years later. Though the full designation is not in this graffiti, Lomas's note on the slide reads "from P.J. Watts," indicating that P.J. Watts was already an established name by 1965.

In gang neighborhoods, sometimes the only place where the names and formerly existing connections appear is in writing. Thus graffiti becomes a place to house what E. B. Tylor once called cultural "survivals," things that arose in a different cultural context, but remain part of the culture nonetheless. In this way graffiti and the names they represent become a kind of recycling bin of gang heritage and a way to call up seldom mentioned gang histories.

In the Swans neighborhood one day on 78th Street right off Central Avenue, I was

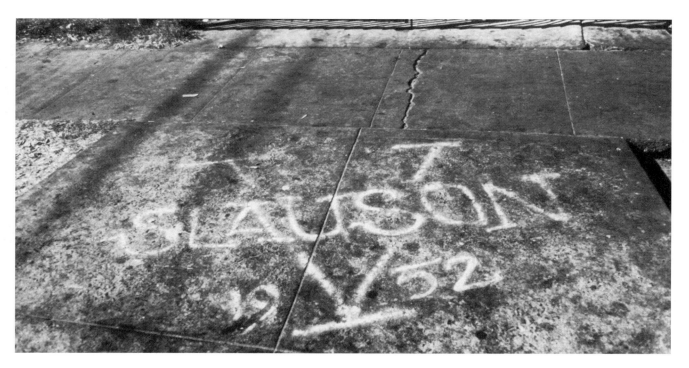

Fig. 4.28. Graffiti com-
memorating Slauson
reunion (1996). "Slau-
son V, 1952" (the "V"
represents the area's
original name, Slauson
Village).

surprised by some graffiti in a driveway that read "Slauson 1952" (figure 4.28). It looked
fresh to me, but I knew that the Slausons were the granddaddies of this generation's
gangs, along with the Businessmen and the Gladiators to the north. It turned out the Slau-
sons had just had a reunion the month before, and that they wrote the graffiti then. The
big V stands for "Village"; they used to call it "Slauson Village." You can still drive by this
corner and see a bunch of original Slauson members hanging out by the liquor store and
the cleaners (across from Ghost's crab and skirt graffiti in figure 4.12).

The Lomas and Weltman collection includes a photograph of an original piece of Slau-
son graffiti from 1965. Despite historical and geographical links with the Slauson gang and
with original Slauson members still living in the neighborhood, ties to that entity are invisi-
ble today from the material perspective of current graffiti (with the exception of the reunion
graffiti). The neighborhood where both Slauson images were located is now the domain of
the Mad Swan Bloods. Of the Mad Swans label, the "Swans" name itself stems from "S.N.S."
for 79th Street, on which the gang bases itself both geographically and ideologically. Ale-
jandro Alonso explained to me that they were historically linked with the Main Street Crips
(now their mortal enemies), which is why they both share the initials "MS" (1996).

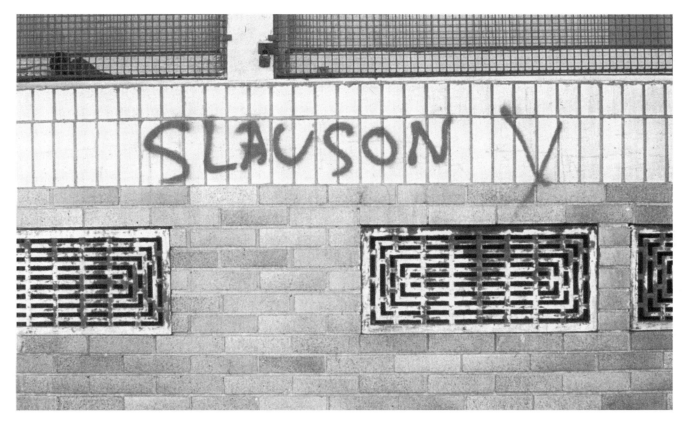

Fig. 4.29. Original Slauson graffiti (1965). "Slauson V." Photograph by Ben Lomas.

Older gang members writing old-style graffiti of original L.A. gangs is a rarity. However, present-day graffiti sometimes harbor information about specific neighborhood histories. When I first started working in the Pueblo Bishops neighborhood, for example, I kept seeing a mysterious "MCG" around. I considered it odd, thinking that maybe there was even another gang around. The C was crossed out, however, indicating a Bloods constituency. When I asked someone to decipher it for me, one of the homies indicated that this was just another way of writing Pueblos. He explained that in the early 1980s they used to have another name, the Mid City Gangsters. That group didn't last long, but Pueblos hit up the name still; it is part of their indelible gang history.

Also related to Pueblos history is the existence of a 92 Bishops (Nine Duse Bishops) gang further down in the nineties blocks. Was there a link between the 92 Bishops and the Pueblo Bishops in the fifties blocks? Why did they share the name "Bishops," a relatively unique name for a Los Angeles gang? One day, a friend volunteered this history to

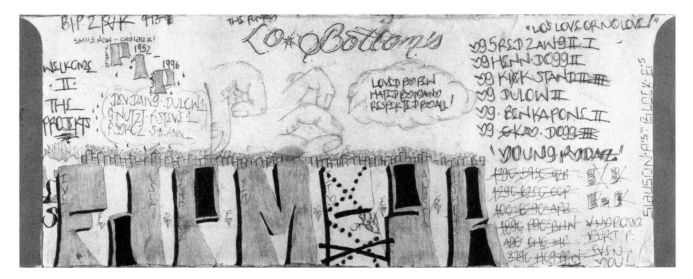

Fig. 4.30. Pueblos neighborhood gang history portrayed by Five Duse Pueblo Fred-dawg II on his school folder. Past neighborhood affiliations included Slauson Park, the Block Boys, and the Mid City Gangstas (MCG).

me, indicating that at some point, a guy moved up from the 92nd Street neighborhood into the Pueblo Projects and added a "Bishops" onto the Pueblos name. This linked them into a closer Bloods alliance with other groups with whom the Bishops also had relationships. However, relations have since disintegrated between the 92 Bishops and the 52 Pueblos. No one from the Nine Duse Bishops is allowed in the Pueblos projects (and vice versa, I imagine).

Obvious links appear in names and images around gang neighborhoods. Within specific neighborhoods, determining basic links in graffiti and naming can allow a researcher to investigate guarded assumptions regarding historical ties that may exist with other neighborhoods.

A nineteen-year-old Pueblos man made the two-dimensional composition in figure 4.30 on the back of his school folder to represent the multiple historical and ideological positions of his gang. The complexity seen here is only made possible by the choice of medium combined with his own breadth of knowledge surrounding neighborhood history. The composition starts out with a memorial to Tupac Shakur: "B.I.P. 2PAK 9-13-96" (Blood in Peace; the upside-down "A" in 2Pak shows enmity with Avalon; Shakur is an important figure for Bloods because of his affiliation with Death Row records). Further memorializing this composition is a "Smile Now, Cry Later" message more traditional to Chicano gangs, as well as a "P.I.P." (Pueblo in Peace, 1952–1996; "1952" represents 52nd Street. In the clouds beneath are the homies restin' in peace: "Dev Dawg, Dulow 1,

G.Nut2t, P. Steve, Psyko, S.Mann1." To the far left is written "Welkome II the Projekts," with the "Duse" emphasized and a conspicuous lack of "C's." Moving across the top half of the page are two hands signing "PB," both with little tattoos that read "FDP," for Five Duse Pueblos. Above is a sign in script reading "The funky Lo Bottom's," a reference to the Projects or the entire Eastside of South Central Los Angeles. Below that is another cloud bearing the common gang sentiment "Loved by Few, Hated by Many, Respected by All!"

Often works on paper give a greater potential for detail and multilayered elements than does a public, larger scale, and speedy medium like graffiti. Finer detail can be generated with a sharp pencil or pen, and compositions may be well thought-out in advance. In figure 4.30, Freddawg makes general gang sayings neighborhood specific; he combines elements of Pueblo history with ideological and geographical markers to make them part of a local identity. "Welcome to the Projekts," "The funky Lo Bottom's," "Lo's Love or No Love," and quips like "Loved by Few, Hated by Many, Respected by All" position the gang geographically in the projects, in the Low Bottoms (the Eastside), as well as ideologically in relation to those places and to other gangs. Traditional initials toward the bottom and a comprehensive list of enemies, as well as the "CK" (with the "C" crossed out) and "BK," boast more general affiliations. (As we saw in figure 4.16, Pueblos and other Bloods may write "BK" in addition to the more common "CK"—except they do not cross out the letter "B," which constitutes their primary affiliation.)

Besides the remarkable artistic talent evidenced in this composition, I found the inclusion of previous historical names particularly intriguing. The initials "MCG" for Mid City Gangsters have been incorporated into the Five Duse Pueblo Bishops name. The composition now reads "Five Duse Pueblo Mid City Gangsta Bishops," and the "C," riddled with bullet holes, is crossed out at the bottom. This seems common enough. But to the side are two additional names from Pueblos history that rarely get visual play: Slauson Park and the Block Boys. At a time in the 1960s, the Pueblos split into two factions, one closer to Slauson Park on the west side of the railroad tracks and one on the east side of the railroad tracks. They fought and took on separate affiliations; to a degree, the Pueblos neighborhood remains internally divided both socially and physically by those railroad tracks. Showing them together here emphasizes practical histories of affiliation and the passage of time.

Freddawg, first on the list and the creator of this composition, described to me on another occasion how important the history of his area was to him. We had been to the huge Swap Meet and shopping center adjacent the Pueblos Projects to get some stitching for

his red hat, and to get a red and black flag sewn together for Five Duse day, when every-
body sports his or her brand-spanking-new clothes.

> When my older homeboys talk I always listen. They say things, like what this neigh-
> borhood used to be, who we used to fight with, what we used to be about, this
> was the New Roman Twenties, this used to be Businessmen. How things change.
> Some people say, that was then, this is now. What does it matter? But I always pay
> attention. I know everything there is to know about this area. 'Cause you always
> got to know what you comin' out of.

Though it varies between individuals as well as between genders, knowledge of history
plays an important role in the construction of gang identity for almost everyone in the
gang. Part of their affiliation is reckoned in terms of previous relationships both within and
between gangs. This makes reference to history itself mythic. And the shared mythic his-
tory becomes the key to alliances as well as personal affiliation among black gangs.

Names, numbers, and the land. Abstract concepts of history concretized through writ-
ing and speech; practices that make images of numbers surge with life. These are the
things that bind gangs together, both within and across gang lines. Gang members know
who has played an essential role in their neighborhood's history, a tradition they continue
by representing their gang on a daily basis. History and numerical symbolism work at two
levels: both as the general practices that separate gang members from outsiders, and as
the specifics that distinguish gang from gang.

The world of Bloods and Crips is full of symbolic and practical interconnections. Al-
though the gangs of the 1950s and 1960s had some umbrella-type entities, I do not think
it is possible to underestimate the influence of Chicago gangs like the Vice Lords, the
Gangster Disciples, and the Blackstone Rangers, as well as the revolutionary ideology of
the late 1960s—particularly the Watts Riots—on the early development of Bloods and
Crips in Los Angeles. More studies of gang history in Los Angeles are documenting the
voices of original Bloods, Crips, Brims, and Pirus. I have heard of at least one documen-
tary film in progress on the rich history of Los Angeles's most famous gangs.

As graffiti are artifacts, cultural leftovers on a wall, so they artifactualize neighborhood
eras or local characteristics that have since ceased to be common referents. Thus, these
material expressions can inform researchers about the history of a gang or a neighbor-
hood, as well as point out potential links to other gangs in other areas, even in other cities.

As researchers actively exploring these issues with living people, we can look to the graffiti to point out potentially fruitful sites of investigation. As a written system of classification, graffiti is one of the most important media gang members use to negotiate the complex interrelationships between people, history, names, numbers, and the environment in which they live.

## AN "F" IN PENMANSHIP

As with Chicano gangs, African American gangs have their own formal systems of prison affiliation. The Consolidated Crip Organization (CCO), the United Bloods Nation (UBN), Blood Line (BL), and probably others constitute the formalized prison affiliations of Crips and Bloods. BGF (Black Guerrilla Family) and Blood Line (BL) are more militant groups, the latter described to me as "militant warriors" formed from Bloods. "It's like tribes," one man indicated over the prison telephone, describing the number of groups inside. "It's all people into they politics up in here."

In addition to their self-proclaimed "tribal" elements, black gang identity in prison is deeply infused with nationalism. All the prison gangs are modeled to some degree after the Black Guerrilla Family, the most traditional black nationalist prison group whose history dates back to the 1960s. Such ideological transformations are common in prison and often mirror the experiences Malcolm X detailed in his autobiography (1965). Prison often represents a time for contemplation, self-education through reading, and transition into religion. For those inside, increased familiarity with Islam may offer them a new name and a new focus. Even those who don't officially subscribe to the Nation may invoke the name of *Allah* when they pray.

There are links from the street to the pen. You never know who is "on the paperwork" unless you yourself are already a part of the prison gang or are in with the people who are. Not everybody has to become a member to survive in prison. As with Chicano gangs, prison affiliation simply extends the scope of gangster identity. Prison organizations are strict, more hierarchical, and more fundamentally political. Suffice it to say that I am on a need-to-know basis with these groups. Too much information about them can get you into serious trouble. So I am proud to say that I have been quite remiss in my research into the whole prison connection phenomenon—hence my grade of "F" in this particular subject.

I am satisfied knowing certain basic issues. Even at the prison level, there is no leader of all Bloods or all Crips, either individually or together. The Bloods and Crips division is retained behind prison walls to a greater or lesser degree. In fact, internal factions even further divide Bloods and Crips prison groups, breaking them down into fairly distinct militant and nonmilitant segments. Only during riot situations do the two larger groups come together in event-driven unity. Both Bloods and Crips, it turns out, are against Sureños, those Southern Mexicans and La Eme, who have allied themselves with the Aryan Brotherhood. But both Bloods and Crips are supposedly allies with Norteños (Northern Mexicans), who represent Nuestra Familia. With Bloods, this alliance forms specifically because Norteños wear red. Northern Mexicans do not hate blacks the way Sureños are known to, and although they do not get along with each other, both Bloods and Crips reportedly are friendly with Norteños (see chapter 3).

As with Chicanos, individual Bloods and Crips do not necessarily have to go through larger prison gang networks to survive in prison. Gangsters in prison may never join any of the groups that attempt to pressure them into membership. Monetary and familial support from the outside enable a prisoner to "do my time by myself" or "do my own time" without getting sucked into prison conflicts. If they do not depend on anyone inside, individual gang members (and nongang members) can survive in prison without broader organizational affiliation.

Whether or not they join such organizations officially, gang members in prison focus on larger affiliations, whether it be their identity as Blood, Crip, black gang member, black man, or human being. One Blood friend wrote me a letter from a central California prison, responding to my question about whether his prison had separate modules for Bloods and Crips like the L.A. County jail:

> No, it's not like the county jail, no one is really separated. Crips live right next door. Matter of fact, I have a Crip celly. He's from P.J. Watts [Project Watts]. Him and I gets along fine. He respects me, and I respect him. We leave the bullshit to them suckers that have something to prove. We have been down this line before. We don't have nothing to prove.

Issues of respect and reputation have as marked relevance in prison as they do on the street. Though carried through at larger categorical levels, such as with Bloods and Crips, reputation may revolve around smaller details of life. If someone steps on your shoes in

prison, you must stand up for yourself or that same person might turn around and do worse to you next time. Prison is so much more dangerous than the street that inmates must be ready at all times to instigate fights over the tiniest of circumstances in order to build a reputation. My friend and his cell mate have already established reputations. They have proven themselves. This allows them to respect each other without resorting to the "bullshit," unlike those who haven't yet made the names that enable them to survive unmolested. Later, however, my friend was stabbed in the neck and in the side during a riot between Bloods and Crips and was soon transferred. Prison is a dangerous place.

Another man told me about his pleasure regarding the fact that there was no set trippin' going on inside:

> I'm with peace and with earth. I treat every black man like a black man, and everyone else like everyone else. In here, I call my worst enemy my friend. That dude from Foe Trays? I got into it with him on the first day. But now we don't be trippin' off none of that gangbangin' shit. Fuck that shit. That shit ain't got me nowhere from nowhere. Now we share food, bring each other food if we need to, whatever. We be chillin,' talkin,' kickin' it. Not trippin' off that little gang shit.

Such sentiments begin to show how gang members expand their constructions of self and other at the prison level. Instead of prioritizing affiliation with a local gang neighborhood, being a black man, a black gang member, or just a Blood is what carries the most significance from day to day. Being able to "call my worst enemy my friend" powerfully demonstrates how the shift in settings transforms relationships between individuals from negatives to positives.[9]

Prison is one of the richest areas of gang research, where the gang system finds its politicization on a daily basis in the face of other ethnic groups. "I treat every black man like a black man, and everyone else like everyone else." As the categorization of self as "black" instead of "from Pueblos" or "a Blood" has broadened, so the broader categories that define "other" become increasingly extended. At particular times, any nonblack man can be the other, just as Crips as a general category can be "others" to the Bloods. This is certainly true in the L.A. County Jail, where Bloods and Crips are housed separately because of the fighting that has raged between them inside. The dynamics of specific penal institutions—jail versus state prison versus federal prison—have histories and constituencies that promote certain kinds of hostilities and affiliations rather than others.

In prison, black gang groups lack the rich aesthetic productions of Chicanos, but they are ultimately more politicized. They are influenced by the Nation of Islam and the Black Guerrilla Family, groups whose politics fall under classic black nationalism or separatism. The issues they preach and the relationship to U.S. politics they address find daily use in an environment where people are taken out of local neighborhood situations and forced into direct contact with a larger enemy—the guards they still call "the police"—that limits their movement and activities by keeping them locked up. Even in the face of marked and sometimes internal strife, they open their community up to the state by positioning themselves directly against it, something that rarely happens at the street level of gangs on the outside.

## THE LOS ANGELES UPRISING: A CASE IN POINT

On the street, Bloods and Crips gangs in Los Angeles seem to follow the pattern of a closed community. They constitute a segmentary system with no overarching leadership and endemic internal conflict. Gangs war with each other as gang members localize status and prestige within the gang system. In the process, they alienate themselves from the surrounding community and place themselves in opposition to law enforcement and the justice system. A gang's isolation from the larger society is continually reinforced through material practices: specialized language, symbolic dress, and deeply encoded graffiti illegally written on others' property seem to indicate a system entirely focused on itself.

In the face of all these closing mechanisms, L.A. Bloods and Crips simultaneously retain a latent nationalist edge, ultimately siding them with black nationalists against the white society—an incipient nationalist community. As recently as the 1992 Los Angeles Uprising, African American gangs became overtly politicized as they violently confronted the police and Korean store owners. This also happened during the 1965 Watts riots, when the major black gangs of the time came together against the police and Jewish store owners in their neighborhood. Two researchers who documented graffiti during that time, Lomas and Weltman, indicated that in those neighborhoods formerly undecipherable graffiti became overtly politicized in the time surrounding the 1965 events. "Burn Watts" and "Burn, Baby, Burn" were the cries in those days. Even during the heightened awareness of the 1960s Civil Rights movement, it took Watts to call together the forces of black gangs on the street that had continued to infight through the em-

powerment movement in that era. One OG described the similarity between the 1992 Uprising and August 1965:

> That's when they realized that there was no longer a need for us to fight each other. That's when the Gladiators, the Businessmen, the Ditalians, and Blood Alleys came to peace. They weren't going to fight each other anymore. That was from August '65 to the end of '68. There weren't any gangs fighting each other at that time. Everybody came together. It was a black thing. So when I heard that the rebellion was jumping off in '92, I said, "That should help bring about peace, but I hope this time they don't get tricked by the white man," because the white man will go and dress up like a Blood or a Cuz, and do a drive-by and holler out to your set to kick it back off again. (Jah and Jah 1995, 122–23)

In a similar manner to 1965, graffiti written to fuel the unity efforts of 1992 lasted only for the duration of the events. Messages soon returned to normal: encoded and inward—focused back toward internal gang politics that could be influenced by their production. In one moment black gangs had a stake in state politics; the next moment it was gone. The graffiti from the 1992 Los Angeles Uprising was striking in its difference to everyday gang graffiti. I spent a lot of time poring over my photographs and berating myself for not having taken more pictures. Of the many graffiti written during these events, gang-related messages particularly underscored political issues at stake in the community. People wrote graffiti that crystallized events and referred to community-wide symbols of oppression. Adorning the burned-out streets were declarations such as "Police 187," "Bloods and Crips together," "This is for Rodney King," or "Don't forget Whity's hood!"

Because of the crossing out of enemies, use of words like "Killa," and the traditional black gang code "187" (based on the California penal code for homicide), there is no doubt in my mind that the graffiti in figure 4.31 was written by an African American gang member. However, the style of the composition marks its author as an older person (probably a Crip, listed first). Those angular letters are no longer used by black gangs, and the "X" dotting the letter "I" in the word "Crips" is another rarity today. This is, however, precisely the style of lettering used by black gangs during the 1970s (see figure 4.22). It would make sense that an older member would write messages to foster more inclusive feelings of unity, linking not only different kinds of black gangs together, but calling for African Americans and Mexicans to unite as well.

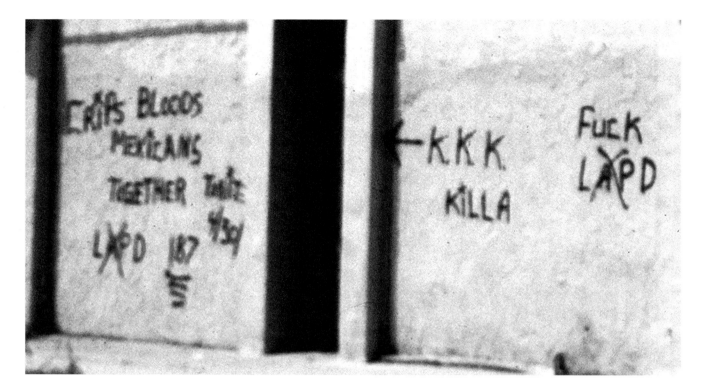

Fig. 4.31. Graffiti from the L.A. Uprising (dated "4/30/92," the second night of extreme violence). The composition reads "Crips, Bloods, Mexicans Together Tonight," and "LAPD 187." (African American gangs and other groups across the nation have appropriated the number "187," the California penal code for homicide, to mark enemies for death.) The graffiti on the other side of the wall reads "KKK Killa" and "Fuck LAPD."

Graffiti messages of the 1992 events crossed boundaries of understanding as gangs politicized in their outrage over the Rodney King verdicts—their messages were easier for a wider group of people to decipher. Gang members became less concerned with neighborhood affiliations and rather more concerned with positioning themselves against larger institutional structures like the LAPD. While gang members partially dropped their normally encoded graffiti in favor of more universally understood political messages, in some cases the visual style and symbology of traditional gang writing remained stable. Through action and practice, people changed the ideological focus of the gang community from inside (gang-versus-gang warfare) to outside (warfare with the white society) for the duration of the events.

Figure 4.32 shows how typical gang graffiti was changed to incorporate the new enemies. Most of it is traditional, starting with the gang name, the 67th Street Hustlas. But instead of writing his local enemies, the writer instead wrote and crossed out the names of his "new" worst enemies: the "LAPD" and the "KKK." He followed this with "187um" (again the use of the 187 code, marking them ["um"] for death). At the end of the com-

position, where he might have usually written a BK or CK, the writer included the empowering and overtly political proclamation "Black Thing!"—positioning himself not as a member of a specific gang faction, but as belonging to a larger ethnic group.

I find a lot of power here in a gang system that so easily was able to shift its emphasis to overtly political antiwhite sentiment and black empowerment without even changing the structure of ts graffiti. The characters changed, but not the categories. Just as easily, they changed back after the riots were over, when there was no more direct confrontation with the police and the forces of white racism, when the gang life returned to "normal."

Even before the Uprising, ex–gang members and community activists like Michael Zinzun of the Coalition against Police Abuse were working hard to foster truces between Bloods and Crips in different housing projects, something that had actually been achieved just weeks before the events. The temporary truces that came with the rioting expanded both gang and nongang participation in this struggle. But some of the gang truces, including the one that has endured in Watts for years, were the outcome of painstaking efforts by specific individuals in that community. They lobbied, preached politicized mes-

Fig. 4.32. Uprising graffiti declares new enemies in the 67th Street Hustlas neighborhood (1992): "LAPD" and the "KKK." They are marked for death with the use of the "187" code. The composition concludes with "Black Thing!" instead of the usual "BK" or "CK."

sages, had dialogues with the media, and managed to gather a constituency in a volatile environment. The media paid particular attention to their efforts, but reportedly the police continually hampered unification efforts. A *Los Angeles Times* article just after the events declared black gangs L.A's "newest political force" (Rodriguez, Sloan, and Scott 1992, M1). Combined on their own terms, as well as against the forces of white evil for the Uprising, black gangs were temporarily granted a stake in legitimate politics. But that tenure was short-lived.

Much of what causes gangs can be termed a systemic tragedy—the failure of a system to share resources (and respect) among its people, histories combining to exclude certain populations. In the face of such grand failures, it is difficult to explore how we might remedy these issues. But during the Uprising, gangs were negotiating truces on their own and helping themselves to stop the violence. Instead of being supportive of their efforts, the paranoia of the police and establishment fought against them—ultimately jailing the leader of this movement and stigmatizing it in racist and exclusionary terms. Police prowled around gang truce meetings and picnics where large numbers of gang members gathered together, as they did at South Park and at Willowbrook in 1992.

Truces and alliances are both aspects of the existing gang system of segmentation, as natural and important to gangs as warfare and enmity. Some of the same strategies of picnicking and partying together that I described between Bloods were used to foster good relations between Bloods and Crips during the truces. Peace does not happen automatically. People drive peace efforts, just as they drive warfare. As we look to the attempts at truce outlined in the book *Uprising* (Jah and Jah 1995), or to the Bloods models of alliance, it is clear that people must constantly forge such superhuman feats as alliance and truce. During the truces, mechanisms people used involved similar strategies to those of everyday alliances—things such as picnics and holding meetings. Communicative measures between enemy gangs that would have otherwise been confined to drive-by shootings and wallbangin' could instead be explored at more traditional political levels, through the spoken word. The acceptance of truces in general required the broadening of the gang mindset from street-level politics to outright nationalism, with which many gang members are already familiar from prison time.

Instead of allowing ourselves to fear such unification, we need instead to combine the best efforts of gangs themselves with those of the larger society. We need to work

for inclusion and trust. When efforts to stop conflict only work against each other, as they did during 1992, it just makes relations between both parties worse. The answers are out there.

Although notions of unity and brotherhood seem to contradict endemic black-on-black violence, they are nonetheless fundamental to the ideological structures informing African American gang behavior. This contradiction is not lost on gang members themselves, who balance the difficulties of day-to-day survival with ideologically motivated ideas of advancement and antiwhite sentiment. Though most truces are now defunct, the ideology of unity remains implicit in gang interactions.

The question remains why the ideology of infighting is more pervasive than the ideology of unity and empowerment. The relatively small role the larger society plays in the day-to-day lives of gang members bars gangs from the kind of overtly political participation full-time nationalism would require. Working-class African Americans, particularly males, in the ghetto that is South Central Los Angeles have little political, social, or economic representation within a society inherently structured against them. They seek empowerment through a gang system that promises to meet their immediate needs and may be the only political unit that they can influence. When the state's actions do carry relevance for gangs, as the graffiti in figures 4.31 and 4.32 testify, gangs reposition themselves to address the issues most relevant to their lives.

## THE GANG MANIFESTO

The words of the man I quoted earlier—"Survival is the key to living"—were not necessarily redundant. This statement comes out of a place where there is no guarantee of survival; where to be born black and male and make it to your twenty-fifth birthday is a major success. The man in figure 4.33, for example, has been shot eleven times on five separate occasions since turning eighteen. He now has bone disease from several of the bullets, but may eventually walk again. While the rest of us might be worried about going to college or choosing a career, in the hood you have to worry about not losing your life. In this way, survival doesn't just mean "living"—it also means not becoming a crack addict, not winding up in the gutter. Gangs offer some of the most effective means for people to do this, especially in the aftermath of Reaganomics and legislation that penalizes

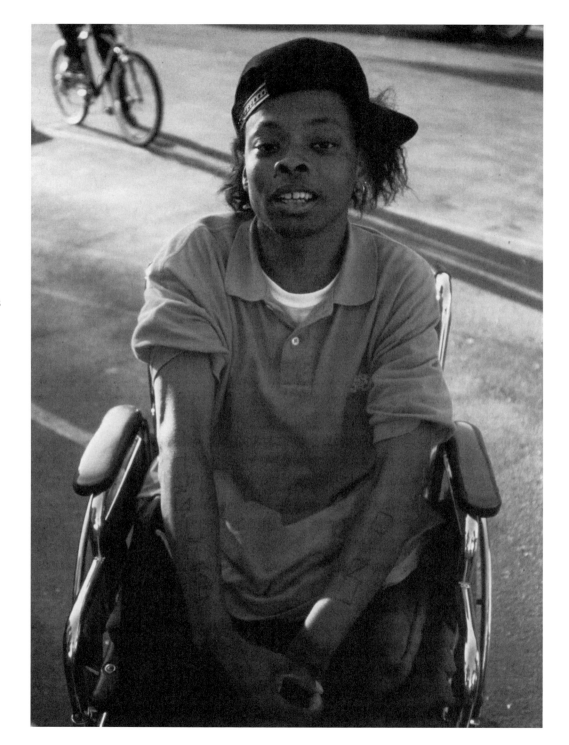

Fig. 4.33. "Slow Motion" from the Pueblos hood.

poorer communities by first putting their constituencies in jail and second withdrawing support from the few services that have actually tried to help them.

We are sorely mistaken if we continue to espouse the popular belief that gangs are simply excuses for symbolic suicide in hopeless communities. This couldn't be further from the truth. Gangs are forms of empowerment through which people take the best road for survival they see before them; it is a road they have carved out themselves.

It is easy for older gang members who are "living off their respect" and who "don't have nothin' to prove" to preach nonviolence to the younger ones. Those OGs and *veteranos* have already earned their reputations through violent action. But younger gangsters, who all around them see only people who have survived by creating fierce reputations, cannot afford the luxury of nonviolence. Not all gang members eventually find themselves transformed into nonviolent, black nationalists. But those that do see in themselves a kind of hope for their community. Right now, they are the only hope, more so than any other group that interacts with the gang population, including the police and more humanitarian antigang forces. The irony is that enlightened older gang members are fighting against a system they themselves have helped to create—the system in which reputation and respect equal survival. They have lived this system according to the rules of the street. The continued difficulties of daily life force the younger ones to do the same, even if they know through their homies' enlightenment that this may not be the best thing for themselves or their families in the long run. Decades of exclusion created the streets in Los Angeles; now everyone suffers for them.

Black gang members struggle with the illusion that they are fighting for things that are not "really" theirs. Their colors they don't "own"; they write graffiti on walls that don't "really" belong to them. Ultimately, it is not their own points of view that they take, but that of the larger society. With the transition from the street to nationalism, gang members incorporate the mores of the larger society and the Western world. This is why ownership and economic self-sufficiency play such a large part in black nationalist ideology.

Gang members' activities will never gain legitimacy. But their goals to meet basic human needs for identity, economic sufficiency, and self-determination deserve recognition. Although their members commit terrible crimes, gangs also play positive roles in people's lives—this is what draws people to them. Without addressing the system directly, gangs have completely subverted existing social structures of the dominant United States.

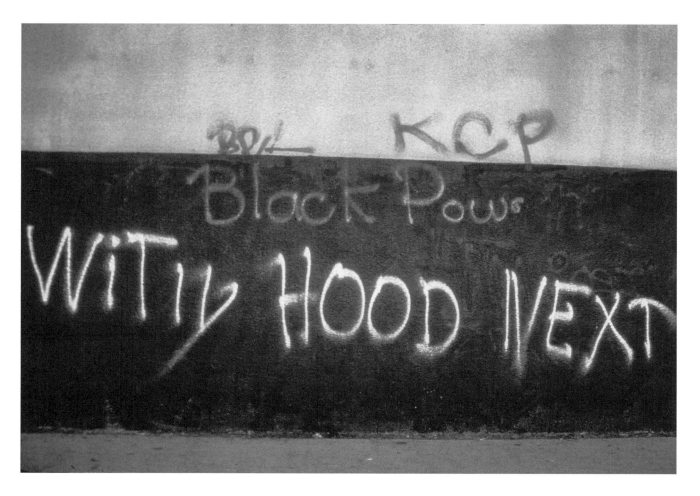

Fig. 4.34. "Witiy Hood Next" (Whity's Hood Next), from the 1992 L.A. Uprising.

And therein lies their power. Because these ground-level systems lack hierarchy, there are no key players that law enforcement can target to collapse the system.

Gang members might be the "revolutionaries" of our time. Their cause means more to them than their own lives or the lives of others. This is enviable in one way; in another way, deplorable. Because what is their cause? It is something internalized, self-maintaining, and ultimately conservative—something entirely without the "revolution" that would seem to match the gang member's fierce aspect. So ultimately even they ask themselves, "What are we fighting for?" and have no real answer.

Gangs are some of the most successful social groups that this century has seen. In order to deal with them effectively, people must pay attention to the good things that gangs do.

For it is only through such recognition that we can begin to address these issues through more positive forces. Of course, this would mean actually caring about the underclass, creating viable economies, offering people meaningful alternatives to the gang life—all difficult, perhaps impossible. But we must move beyond the blatant oppression that only fosters gang solidarity, and certainly beyond empty gestures in an environment where the only real hope is that which gang members have created for themselves.

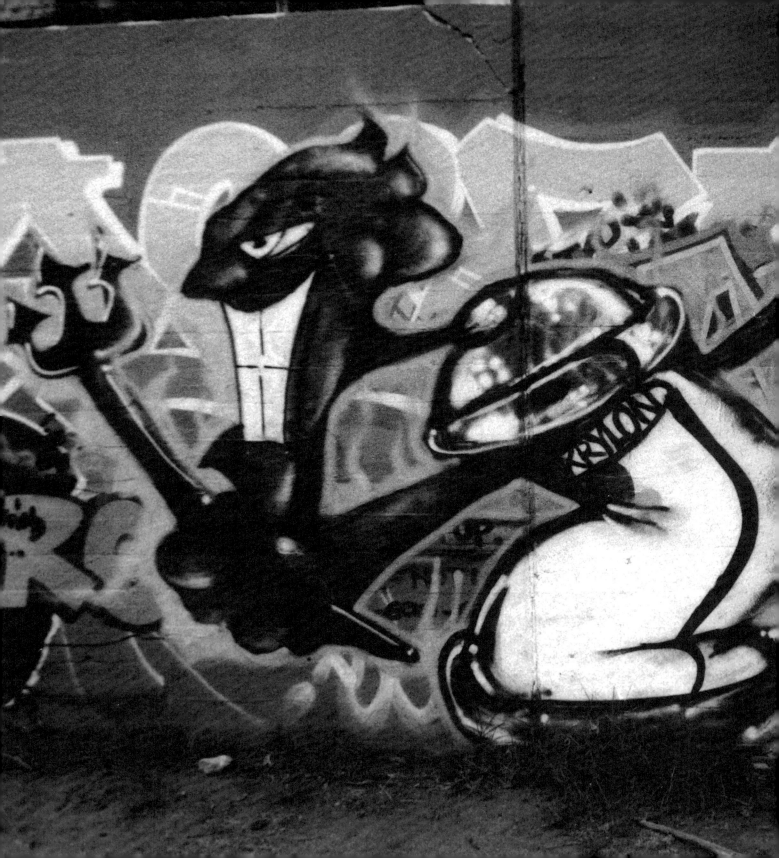

## BOMBING L.A.

"Transients and vandals," one city worker lamented, "were all that was left here." As we watched the demolition of the National Technical Schools building (figure 5.1) one February morning, he described how the illegal occupants had been throwing rocks at people from the upper story and had even set part of the place on fire one night due to their negligence. Now everyone was competing for the right to tear down the building; the city and the new owners fairly fought for the privilege. It seemed everyone's desperate wish that this building, badly damaged in the earthquake, be razed to the ground as soon as possible. I had gone inside it just before the demolition. The walls were covered inside and out with graffiti, the floors were wet with urine and old rain, wires protruded from the walls and ceilings, moldy furniture sat next to the impromptu garbage dumps of whoever had had the guts to enter here. During the demolition, the war zone atmosphere was accentuated by scavengers who would periodically raid metal from building parts to sell to recyclers. It was a living example of the *Blade Runner* aesthetic. Transients and vandals. It made me wonder about their relationship—what connected these tagging kids with those wayward souls? Two far-removed elements of the street life—this place itself seemed the strongest link between them.

Both transients and vandals take the throw-away places of the city and make them their own. Old train line areas people rarely see, abandoned tunnels like Belmont, neglected industrial buildings in disrepair. These are the places the city has forsaken. No one

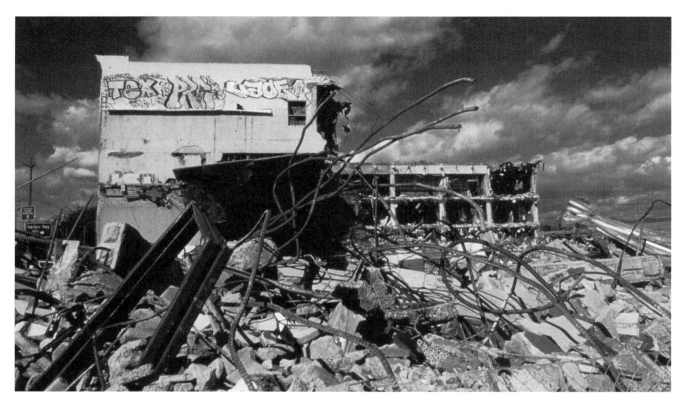

Fig. 5.1. The demolition of the National Technical Schools building (February 1996).

cares for them. This creates space for the linked elements of transience and vandalism to arrive slowly and take over physically and decoratively. Any building in practically any area of Los Angeles that boards its windows and posts a "for lease" sign becomes a prime candidate for tagging. In poorer or less visible parts of town, these buildings become potential locations for the homeless to set up camp, tags adorning the walls alongside their new homes. The city's homeless, taggers, and, in well-established areas of abandonment, accomplished hip-hop writers come together, setting their imaginations alight as well as sometimes the buildings they occupy. They make such places their own, not by claiming them as territory but by using the space toward their own ends. Urban nomads and the ephemeral art form; their tenure is reliant on the city's relationship to them. As was the case with the National Technical Schools building, sometimes their occupation ends in demolition. Like a bad virus, the constituents wind up destroying their own host.

All illusions to the contrary, it is not the main goal of hip-hop graffiti writers to destroy. People write hip-hop graffiti to represent themselves within an arena of hip-hop graffiti

writers; they work to establish a name and position within that arena for reasons that are additive and positive. Hip-hop graffiti is about creation, not destruction. Writers are hip-hop producers first, vandals second. Vandalism is what they wind up doing during the course of their work, but their main goal is generally not that of the vandal.

Hip-hop graffiti has always been linked to violence in the popular mind. For example, political geographer Timothy Cresswell (1992) has indicated that in New York, city officials used antigraffiti containment programs to create an illusion of control over other problems like violent crime, thus manufacturing direct links between the two. In Los Angeles, associating hip-hop with violence is an even bigger problem because of the strong traditions of gang graffiti here. Even the language itself—*Bombing L.A.* (a 1987 film) or Upski's (1994) popular book and poster, *Bomb the Suburbs*—seems to insinuate the ultimately destructive motives of hip-hop graffiti writers. One might also suppose that words like "battles" and "killing" equally indicate an embrace of violence in the hip-hop world. But these symbolic referents refer to manifestations in graffiti alone. Battles, for example, are competitions through writing; killing means crossing out someone's name. To "bomb" an area is to put up a lot of work there, firing names like pieces of shrapnel into unassuming bits of wall.

Hip-hop graffiti writers relish their antagonistic relationship to society. They rely on that antagonism to chart values for their work—the risk they take, the visibility, the challenge. All these things embody their antirelationship to society. In this way illegality itself is a core value of the hip-hop graffiti form. In point of fact, however, hip-hop graffiti seldom connotes actual violence, and graffiti writers themselves are rarely people to be feared. Often, the places they write are what invoke assumptions of danger, if just through the isolation and exposure of hyper-urbanity.

Drawing the distinction between hip-hop and gang graffiti is a crucial step in understanding graffiti in Los Angeles and most of the United States today. Obvious to those already literate in the graffiti medium, this distinction is geared primarily toward the lay public in whose minds these two radically different genres continually overlap. The purpose of this chapter is twofold: First, I compare the hip-hop phenomenon with gang graffiti in Los Angeles. This gives me a chance to detail briefly some of the depth of this genre, focusing particularly on levels of production and use of space. Tags, throw-ups, and pieces are the three levels of hip-hop graffiti production. Second, this chapter allows me to revisit certain gang and neighborhood issues from an alternate perspective. I offer that

experiences of hip-hop in the L.A. area vary along the lines of race and class and discuss how joining hip-hop graffiti crews acts as an alternative to gang membership in neighborhoods with a lot of gang pressure.

## COMPARING HIP-HOP AND GANG GRAFFITI

Hip-hop graffiti evolved in the frenetic urban environment of 1970s New York City, where it was an aspect of the generalized hip-hop culture that included rap music, break dancing, and advanced graffiti stylings (see Hager 1984 and the film *Style Wars* for accounts of the integrated hip-hop phenomenon). So-called graffiti crews consisted of concentrated groups of graffiti writers at varying levels of proficiency. Kids just starting out would enter into apprentice-type relationships with more mature writers, learning the tricks of the trade from the masters.

Hip-hop graffiti migrated to Los Angeles in the early 1980s, about ten years after its inception. Although there are some differences across the coasts, the basics remain the same. The levels of hip-hop graffiti production involve distinguishing "writers" who produce complex, multicolored "pieces" (after *masterpieces*), from "taggers" who limit their work to the simpler "tags" (after *nametags*) and "throw-ups" (they are "thrown up" on a wall). These three main types of writing—tags, throw-ups, and pieces—define the hip-hop graffiti style.

Hip-hop graffiti and gang graffiti differ at a few basic levels. First, hip-hop graffiti has few territorial or neighborhood correlates. Taggers and writers take the city as their canvas as opposed to working only within the confines of their residential areas and local surroundings.[1] Despite some geographical and social links, gang members and taggers are different people; gangs and crews entirely different entities. Crew members may act like gang members in that they are sometimes violent towards one another. But they are not driven by the context of protecting neighborhood space or themselves through the development of a reputation. Their goals always relate to their art: achieving fame and respect for themselves and their crew through graffiti production. Crews are about graffiti, plain and simple. Theirs are truly "crimes of style" (Ferrell 1993). Though belonging to a crew may involve group decision making, crews generally do not organize drug dealing or higher levels of crime. Further, a single tagger or artist can belong to several crews, whereas membership in a gang is usually individual and lifelong.

Respect is the fundamental goal of production for graffiti artists. Fame is the equivalent goal for the tagger. Such name-making goals stem from a desire for recognition from a community of peers. At first, these might seem to be precisely the same goals of gangs. However, gang members foster respect and garner a reputation for reasons that ultimately stem from their need for protection. When taggers and graffiti artists vie for respect in their community it is simply for the credit they get—for the symbolic capital that is built from the recognition of their fellow graffiti writers. Protection is not the ultimate reason for the respect and reputation they seek. In these diverse ends of respect one finds the primary difference between graffiti crews and gangs.

Gangs offer a strange combination of safety and danger. Because part of what draws people to gangs is their protective role, it seems therefore somewhat of a contradiction that gang members perpetuate an inherently violent lifestyle. As Hutson et al. (1995) have indicated, gang members in Los Angeles are actually 70 percent more likely to get shot or die of a gunshot wound than nongang members. Thus, the protective aspects of gang membership may improve the quality of life from day to day (that is, gang members are less likely to be taken advantage of, ripped off, beat up, bullied, and so on). But the punctuated violence of their rivals threatens the lives of gang members (as well as making them police targets) at a far greater rate than nongang members.

Soon after hip-hop began to arrive in Los Angeles, kids in lower income neighborhoods with established gang activity recognized hip-hop graffiti crews as an alternative to the gangs they acknowledged as ultimately destructive to themselves and others. Newly developed hip-hop crews, as well as other crews that functioned as gang alternatives (like "party crews"), started to compete with one another through style and production as opposed to violence. Taggers would engage in symbolic graffiti "battles" (the victor's name appears more often than his rivals) and party crews would compete to throw the best parties. But some of these crews wound up becoming more like gangs. Instead of writing peaceably next to one another, for example, taggers began to cross out the tags of groups or individuals with whom they didn't get along. In some cases, the competitive frame began to leave its primary mechanism (graffiti or party) and take on an overtly violent format, tagging crews aiming bullets at their rivals as well as graffiti cross-outs.

With the pervasive example of gangs that surround them and easy access to weapons, some taggers in Los Angeles have been dubbed "tagbangers"—combinations of taggers

and gangsters. They don't just bang symbolically through the act of tagging, they tag and bang for real. Although it is difficult to say how many graffiti crews are involved in such activities, most play an important role in keeping their members out of gangs and focused on art instead of violence.

The protection crew affiliation offers kids is occupation outside the realm of gang activities. It removes them from the pool of eligible gang members and allows them to occupy their time in support of another cause—that of getting their crew up, becoming known, acquiring fame for themselves, making their art. These goals propel kids outside their neighborhoods to locales where gang members rarely travel, finding themselves circumscribed through their own gang affiliation. Because crews go up all over the city, the people who join them break down the walls of imprisonment that gangs have so forcefully built up within localized neighborhood areas. They take city buses everywhere. They enjoy the benefits, as well as the rush, of occupation and career through the graffiti-making process.

Taggers and writers will talk till they're blue in the face about the fact that they "could be out there shooting people" like gang members. "At least we're not robbing anybody!" They share a sense of outrage that they are so persecuted for their work when their crimes could be of a considerably more violent and antisocial nature. As a partial response to this, some city and state authorities have persisted in spreading the notion that tagging leads to higher forms of crime. This may be true in some cases, but it is more equivalent to the allegation that if you smoke marijuana you will become a heroin addict. As I note later in this chapter, many kids who start out tagging and dedicate themselves to the hip-hop career wind up in art school, the gallery, and other mainstream work. Dedication to the hip-hop art form has enabled many to expand their horizons and overcome the constrictions of growing up among the urban poor.

The success of hip-hop in Los Angeles highlights two things: It points to the ultimate failure of gangs to serve their intended purpose—namely, to enhance neighborhood security and protect people from violence. It also counters the stereotype that writing hip-hop graffiti is a pathway to higher levels of crime. Hip-hop graffiti is many times one of the strongest paths away from violent illegal behavior. As we look for answers to what can occupy urban youth outside the realm of gang activity, hip-hop becomes a powerful, if illicit, example of how kids themselves have created groups to counter the draw of gangs in urban settings.

## FROM FAME TO RESPECT

Hip-hop is one of the most heavily researched graffiti arenas in Los Angeles and the United States. A wonderful literature exists on this topic, whose movement into New York City galleries in the late 1970s spurred controversy and gained the attention of scholars and city officials alike. Cresswell (1992), Castleman (1982), Cooper and Chalfant (1984), Lachmann (1988), and Spitz (1991) all researched this phenomenon in its native New York; their collective emphasis mainly rested within graffiti's move from the subway and into the gallery (see also Hager 1984). This shift radically affected local traditions of hip-hop production in that city. At the same time that the Transit Authority found a way to buff the trains that were the nightly targets of these guerrilla artists, some of the more mature artists' work made it onto gallery walls to be sold for a profit. Successful artists began to disassociate themselves from their lesser apprentices, and the combination of these factors all but destroyed working traditions of New York's train-centered hip-hop graffiti movement.

Other researchers have examined the movement of hip-hop from New York walls to those of other cities. Louise Gautier has researched the shift from political graffiti to hip-hop graffiti in Montreal, for example, detailing how it has developed in concert with the depoliticization of Montreal youth; Ferrell (1993) documents permutations of hip-hop in Denver, Colorado, noting how graffiti production intertwines with the politics of criminality. Much of this outstanding research extends graffiti into new theoretical territory that involves a multitude of perspectives, from psychoanalysis (Spitz 1991), to constructions of filth, control, and the "other" (Cresswell 1992), to graffiti as career and ideology (Lachmann 1988) and as a way explore issues of modernity and postmodernity (Stewart 1987), and, finally, to examining the political and local manifestations of a seemingly apolitical, global phenomenon (Ferrell 1993).

Though none of this work has focused on Los Angeles in particular, some of the New York–based publications had a tremendous impact on Los Angeles writers. Ethnographic works instantly hailed as classics include Cooper and Chalfant's *Subway Art* (1984), and particularly Castleman's *Getting Up* (1982), whose outstanding accounts are informed by extensive field research into local traditions and value systems. Norman Mailer's essay, "The Faith of Graffiti" (1974)—always simply described as "celebrated"—provides a rich treatment of the subway graffiti phenomenon in its infancy.

Together these works are now considered hip-hop classics. They are often cited, and

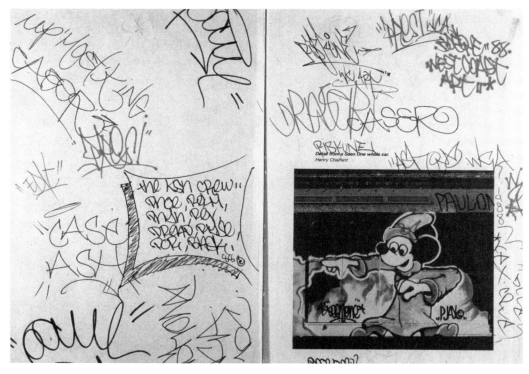

Fig 5.2. The opening pages of Castleman's Getting Up from the UCLA research library. The only picture in the original text is Henry Chalfant's photograph of Mickey in the middle of the second page; the rest are the tags of Los Angeles graffiti crew members who checked out this book. Left page, from top to bottom: Paul; Up Most King; Caser; Presi; Edit; Case, Ash; The KSH Crew: Phoe, Relm, Phyn (Fine), Rev, Dread, Ryse, Por, Bask; Paul; Ash One, WCA (West Coast Art), BC (Blue Crew, Beyond Control). Right page, clockwise from left: Risk One, WCArt; Presi, WCA, Dye One '88, West Coast Art; Draser; Caser; Risk One; Ash One, WCA; WCA; 1988; Ket, Blue Crew; Phoe One, Blue Crew. Notice how the train car rim now bears the repetitive addition BC WC BC WC, for Blue Crew and West Coast. The addition "Paul One" to the train has already traveled partway off the page with the imagined movement in the picture.

their authors have become quasi-gurus of the subject. The UCLA research library's copy of Castleman's (1982) *Getting Up* (see figure 5.2), has the tags of L.A. crews throughout, primarily by Asher from West Coast Artists and Blue Crew, testament to their kinship with the writers on the other coast and both Castleman's and Chalfant's presentations. (While these writers had the courtesy to return the book, other books on graffiti tend to be "declared missing" in no time, making research into this topic often frustrating.)

Despite the lack of scholarly attention to Los Angeles, documentary films as well as several journalistic accounts have helped define the city as a major hip-hop center. Ruben

Martinez's (1992) *The Other Side,* for example, boasts one chapter about early tagging crews in Los Angeles. In addition, three outstanding documentary films chart the rise of L.A. hip-hop graffiti's more mature forms of writing: *Bombing L.A.* (1987) and more recently *Graffiti Vérité* (1996) and *GV2* (*Graffiti Vérité 2,* 1998) look to a time already considered "back in the day" in hip-hop circles. Like analogues to the New York–based film *Style Wars* (1983), the L.A. films help spread the hip-hop phenomenon around the country and across national boundaries. *Style Wars* and a similar film, *Wild Style,* were a significant inspiration for L.A. writers across the coast to take on the challenges of this new art form. In addition to the two L.A.-based films, a handful of popular accounts have helped solidify Los Angeles as a particular landscape of production (see, for example, Urban 1993; Party and Higa 1996; Birk 1997). Further, the "Artcrimes" Web site currently houses a plethora of articles that testify to an emerging scholarship on the subject of graffiti in all its aspects and in many places around the globe, including Los Angeles.

Documenting hip-hop graffiti around the city was at different times both the easiest and most difficult fieldwork I did. In the gallery, it felt great to be at ease, to wander among the artists asking questions or photographing their work. Looking around, I could see that these were people who would have been my friends already. The class divisions that separated me from the gang members I worked with seemed erased by the hip-hop form; stark racial boundaries were made equally invisible in an integrated environment. Some of the writers did have "attitude," but I tried not to let it bother me. On the street, my experiences were a little more varied. Just to get pictures I was always forced to do something strange. What a rush it was—getting out of my car, planting my feet on the surreal concrete of the freeway to feel the quakish rumbling of passing trucks; or having to trespass in different places, jumping over fences while all the time dodging the authorities' watchful eyes. Traveling in the hip-hop circles of the street was more crazy, fear-invoking stuff—often total unknowns versus the knowable dangers of gang neighborhoods. These guys went everywhere. They took risks. They did everything. They wrote in the most messed-up places, useless train tracks with dead cats and dogs to step over, resident constituencies of the homeless, feces, and the stench of urine. Other times, some of the yards or the walls of the L.A. River seemed peacefully rural. Hearing the trickle of the water, smelling the mossy green, or feeling the cool of the tunnels on my cheeks, feet squishing in the mud after a rain. Despite these moments of urban sanctity, no matter where I was going I liked to have someone with me; my husband accompanied me on many hip-hop adventures. I generally felt safer in gang neighborhoods, where I always traveled alone. There may have been gang members around (dangerous, you know), but

there were also families and traffic, people selling fruit, kids walking home from school. With hip-hop, I was a big chicken about going into areas where young kids with clinking spraycans would enter without batting an eye.

The three types of hip-hop graffiti—tags, throw-ups, and pieces—can each be distinguished by their complexity and their frequency of production.

### Tagging

The lives of taggers are heart-pounding, two o'clock in the morning affairs. They travel in dangerous circles to create Zen-like repetitions of a name with just the flash of a hand. Over and over again, they write their nametags everywhere, to become known, to earn fame and recognition from the community of their fellow taggers. Taggers are universally credited by other graffiti writers in Los Angeles (including gang members) as taking the most risks for the work that they do. More of them die as a result—hit by a car as they dash across the freeway by night, falling from the heavens to the same fate, or, most memorably, shot by a vigilante ultimately more dangerous than they. However, their status as nongang members protects them from harsh penal sentences if they do get caught in the act.

Tags are single-line writings of an artist's nickname or crew initials. Sometimes the compositions start out small and get bigger, as in figure 5.3, with both Chaka's and Theme's tags. Tags can extend any number of directions and utilize multiple hip-hop styles, a variety of widths (depending on the type of nozzle), and any number of colors. Hip-hop tags are all over the place, both in form and geography. They contrast sharply to the writings of gang members, which are composed in rectangular formats that generally run parallel to the ground.

Tags are not so different from other types of popular graffiti, calling back the insignia of various ages from "Ivan wrote this" to "Kilroy was here." But while writers of those older "I was here" forms directed messages at everyone in a legible style, the hip-hop community primarily directs messages at itself. The cryptic initials and cursive-type style constrain the ability of mainstream audiences to understand either their meaning or purpose. Unusual nicknames coupled with two- or three-letter crew initials make graffiti literacy in this form next to impossible without insider guidance. CBS, for example, instead of representing a television network, can mean Can't Be Stopped, City or California Bomb Squad, Chronic Bud Smokers, and a handful of other definitions. Sometimes tags consist of numbered codes that stand for an individual or that may refer to certain codes, such as the penal code for graffiti (594) or the 911 emergency code. Such practices as initialing, naming, and code use constitute creative (and often humorous) efforts that enhance the cryptic quality of the graffiti.

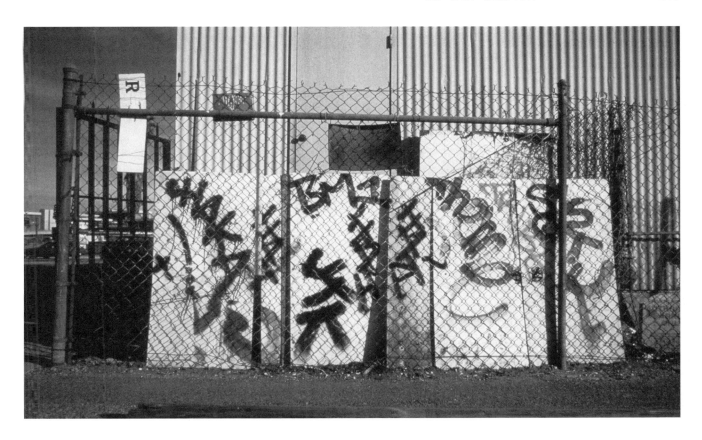

Many hip-hop graffiti writers start off tagging and enter into a course of maturation that develops their style and form. It is a step-and-stairs process. Particularly in the face of such stiff competition, those who lack the talent to produce good quality larger pieces may choose to make tagging their career-long focus. Instead of developing into what they know will be their level of inefficiency, some people remain taggers who produce large numbers of tags over as wide a geography as possible for as long as they write. The main goal of such taggers is simple: fame. Getting their name up and getting known.

One of the most famous taggers Los Angeles has seen was the ubiquitous "Chaka" (seen in figure 5.3). In college, my husband and I used to marvel at his name everywhere, all over the freeways, on the street, downtown, even up on Interstate 5's water towers toward Northern California. We contemplated making "Free Chaka!" T-shirts when he was finally caught in 1990 and jailed for his crimes. New York's first tagger, Taki 183, became a sort of immigrant turned folk hero, and Chaka achieved similar celebrity status in Los

Fig. 5.3. Hip-hop tags (1996). From left to right: "Chaka"; "Hai"; "BM1"; "UTK"; "Hai"; "Hai"; "Theme"; "Tribe"; "STU." Chaka is now an old-timer; Hai's tags can be seen all over town these days.

Angeles—an unbelievable story for a normal kid. We sort of admired him. For others, he represented the worst of our city, out-of-control youth with screwed up values, graffiti the new urban addiction. Accounts of his crimes and imprisonment were broadcast over local news and plastered throughout the papers. When he tagged the elevator as he was leaving the court building, people were astonished at his temerity. Some saw it as a last-ditch gesture at the very institution that meted out the law; else they wished for some sort of twelve-step program, Graffiti Anonymous, perhaps, for people like Chaka, for those who could no longer control their tagging urges. Chaka, like the city, was anything you wanted to make him, Los Angeles at its best or its worst or at least its most quirky.

For the L.A. graffiti community, Chaka represented something different again. He was the guy with whom everyone could relate. He was an everyday kid. Any kid could have done what he did. L.A. graffiti writers credit Chaka (or discredit him) for mainly two things in the graffiti world: opening up the style of the New York–based tags and creating the phenomenon of the individual tagger—not someone who tagged only in the name of a particular crew, but to publicize himself as his own entity. Not striving to become a graffiti artist, but a tagger pure and simple.

The early tags imported to Los Angeles from New York were curlicue affairs, cursive scrawls, and difficult to read. In Los Angeles, gang graffiti had its influence on the tags of people like Chaka. He wrote tags you could read. He wrote in a blockish, more gang-type lettering, as well as in the traditional New York way. When he adopted this more readable format over a wide geography, Chaka made tagging available to more people. For some, this signaled that tagging was "going downhill" and was no longer New York authentic. If it happened anywhere, the crossing over of the gang style to hip-hop was bound to happen in Los Angeles, where graffiti's biggest influence had been that of Chicano gangs.[2] However, the one style didn't replace the other; a variety of tag types continue to coexist in Los Angeles today and none of them are readily confused—by the practiced eye—as gang graffiti proper.

Chaka is someone almost everybody has an opinion about. Many people I talked to, both gang and nongang, would automatically bring him up. He is one of those people everybody knows by their first name, by his tag name. As the common reference point for all L.A. graffiti, Chaka embodies the graffiti problem in all its aspects, from production to consumption, to punishment, to motivation.

Like Taki 183, Chaka demonstrates the ability of an individual to have a massive effect on a city phenomenon. The entire history of hip-hop in Los Angeles is peppered with such individuals: those who innovated new styles or placements of graffiti (Wisk, for example,

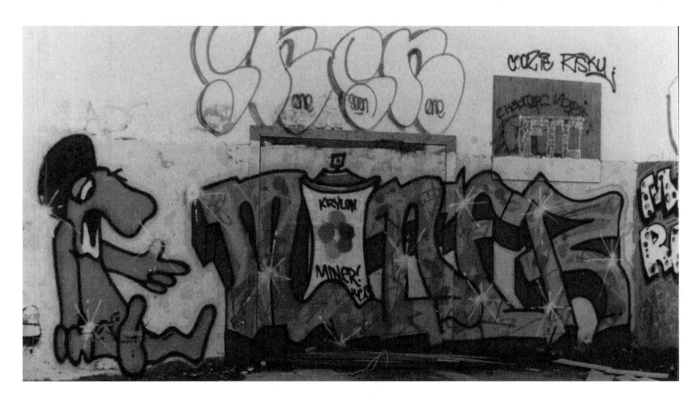

whose tagging of bus doors started that new trend). Those who fought legendary early battles—when Hex battled Slick, it set standards for graffiti battles of the future. But knowledge of such innovations was confined to the hip-hop community. Chaka was exceptional in that he garnered a reputation both inside and outside the graffiti world. He remains Los Angeles's quintessential tagger.

Though others admire the risks they take, taggers are the least liked of all graffiti writers, both inside and outside the graffiti community. But at the bottom of the hip-hop graffiti barrel is the real heart of graffiti. In these taggers are the most daring, committed, ingenious, devoted, and exasperating individuals in the graffiti community. Tagging is as in your face as any form of graffiti today.

## Throw-ups

Taggers manufacture both tags and slightly more involved compositions called "throw-ups": one- or two-color compositions, usually two-dimensional in appearance, that are simply "thrown up" on the wall (see figure 5.4). As with tags, quantity, consistency,

visibility, and risk within an adherence to the hip-hop aesthetic are the criteria that count. The second step up in complexity of the hip-hop art form, the popular "bubble" or other rounded letters are hallmark styles of throw-ups. Because they are less complex, these two forms of hip-hop writing are the most ubiquitous. They reside on freeways and city walls, often in crowded or highly visible areas. Their simplicity of design allows for speedy manufacture. Because participation is widest with these less complex forms, experience with the hip-hop phenomenon varies most greatly for taggers, who are more likely to find themselves constrained within local environments of production.

## Pieces

Driven by competition through style, it is instead the production of quality work that drives "writers"—those people who write "pieces" (they are also called "graffiti artists" or "piecers"). Though their roots are humble in the tag and throw-up, writers mature to working in yards and out-of-the-way tracks where they can accomplish their pieces in (relative) peace. They are dedicated to their art, working to master a style that takes years of practice as well as native talent. Most use sketchbooks to plan out their compositions and practice new lettering styles. The object is always the same: it is the name of the writer. But sometimes names become barely recognizable because they are so wrapped up in decorative letter designs, interwoven within one another, highlighted in a multitude of hues, or surrounded by caricatured, cartoon-like figures.

Writers use different kinds of nozzles (caps, tips) to achieve a variety of effects, from thin lines to "fat caps" in a wide band of paint. Layering defines the production for more complex works. First, writers outline the piece in light colors like pink or yellow. Then they begin to add stronger background colors, then highlights, and finally finishing touches. Depending on the scale and complexity of the composition, writers can manufacture a piece in anywhere from fifteen minutes to several days with any number of spraycans. Sometimes artists work on pieces together, sometimes alone. They practice many years and long hours to perfect their control over the spray-paint medium. These become their skills.

Where the main objective of the tagger is fame, respect is the ultimate goal of serious writers (see figure 5.5). Their production of quality work, innovations of new styles, and continued commitment to the hip-hop form ensure the regard of their fellow producers and drive the maturation of the hip-hop genre.

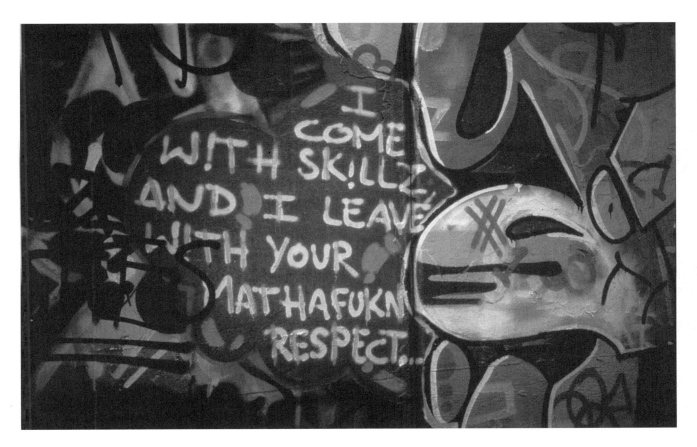

## Spatial Issues

Today, L.A. taggers and hip-hop graffiti writers share the common heritage of the New York hip-hop traditions. But this type of graffiti has now been a part of Los Angeles's history for more than a decade, and the groups, individuals, and experience associated with hip-hop have grown increasingly diverse. Gallery and street traditions of hip-hop are continually divergent, mirroring in some ways the schism that stems from social and productive gaps within the street tradition itself. Writers may now gear their work toward a select portion of the hip-hop world; animosity between taggers and more advanced writers may be marked. Other times, hip-hop crews retain the epitome of New York integration, where a single crew is heavily engaged in the production of all elements of the hip-hop style.

Issues of space and movement abound in the graffiti art form. The boldness of the

Fig. 5.5. Writer demonstrates his motivation—respect—at the Motor Yard (1996). "I come with skillz and I leave with your mathafuckn respect."

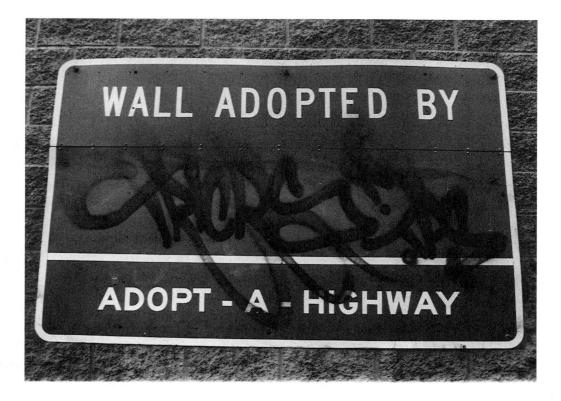

Fig. 5.6. Tricks of the TPS crew (The Private Sector/The Prime Suspects) "adopts" a wall on Interstate 10, just before the Centinela exit (1997). The Adopt-a-Wall, Adopt-a-Highway, and Adopt-a-Spot program was initiated by Caltrans to encourage the public to become involved in the battle on graffiti. This sign is a far cry from the one farther down the freeway that reads "Joe Connely, Graffiti Guerrilla." Connely is the most vociferous, devoted, and successful graffiti fighter in the city.

work on New York City trains spawned an evolution of maturing styles for piecing that set standards for risk as much as aesthetics in the graffiti scene. The movement rested with those trains and the visibility they provided; once the city found a way to protect their facades, the traveling museum stopped traveling. By rail, anyway. By comparison, the L.A. analogue to the train, the freeway, attracts mostly tagging—the simplest form of writing (see figure 5.6). Kids could produce their tags covertly and quickly; unlike work in New York's train yards, tags on freeways must be done on site and in full view of passersby. New York subway "whole car" and "half car" masterpieces, on the other hand, were done mostly in train yards into which the artists would sneak at night. Come morning, trains would leave decorated with new names that would travel the city far and wide (see Cooper and Chalfant 1984; Castleman 1982; and Spitz 1991 for particularly compelling accounts of this). Instead, L.A. kids hoist themselves up to tag in the "heavens" (freeway signs), sometimes writing upside-down or hanging from freeway overpasses.

Where the city of New York saw Oldenberg's "bouquet of flowers"[3] in the colorful and

complex murals, L.A. freeway drivers see only single line tags or throw-ups that frustrate their view of the official signage and that many citizens still believe to be gang related. Now taggers must be even more clever to get at the signage that gives their work greatest visibility, needing to circumvent newly constructed graffiti-proof "hoods" now used by the city in favor of the razor wire wrapping that sometimes makes L.A. freeways look like a Belfast under siege.

In Los Angeles it is generally the people who travel, not the graffiti. There are some exceptions. You do see the occasional truck driving around with throw-ups all over it. Buses became a focal point for taggers early on. It was a prestige symbol to tag the "driver's side" of the bus, as the risk of getting caught was heightened by just a glance into the driver's mirror. Taggers even discovered a way to disable buses by lifting up their back hoods and doing something "magic" to the engine to make it stall. Thus they were able to take a few more seconds and tag to their heart's delight. All this was speedy, daring stuff. Now it seems that tagging is so well accepted, and people so unwilling to get involved, that kids tag the insides of buses all the time without even looking over their shoulders. Despite these few exceptions, the walls are the rule in Los Angeles.

Because of the necessity of on-site, nontraveling production, graffiti art pieces became disassociated from tagging more dramatically in Los Angeles. Most of the world was seeing only the two less complex forms of writing, tagging and throw-ups. Places for graffiti murals, on the other hand, like the Venice Pavilion (the graffiti pit) or the Belmont Tunnel, are sometimes barely visible from the street. Some areas, like the Motor Yard, are even more secluded. Few commuters on Interstate 10 realize that they are driving over a minefield of layer upon layer of spray-painted pieces, explosions of color in the train tunnel beneath them. Instead of placing the tags within the context of those larger mural-like pieces, however, the public instinctively associates them with gangs.

For the most part, piecing takes place in out-of-the-way, tacitly legal, and highly localized areas (see figure 5.7). Usually such places are littered with empty spraycans, and artists have to squeeze through holes or over chain-link fences to get to them. Some yards are actually legal—for example, unused vacant lot space where the owners have given permission for people to write graffiti. Despite the fact that these yards are intended for the more complex pieces, tags tend to follow suit because they are part of the same phenomenon. A vacant lot might be filled with pieces, but the only things to spread out to the surrounding residential areas are tags. These tags are thorns in the sides of both the

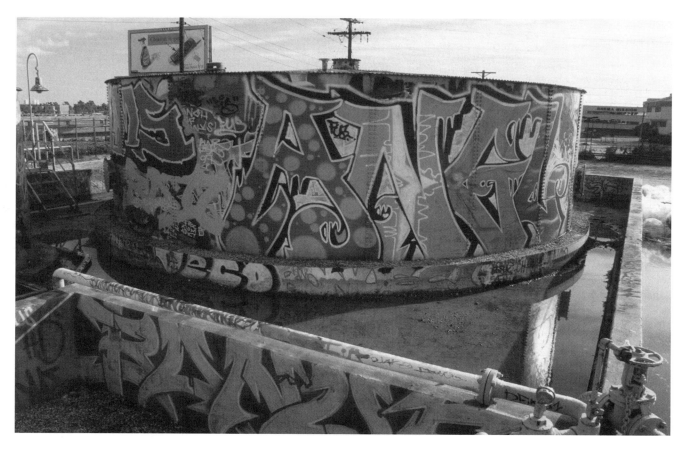

Fig. 5.7. Piece off the Harbor Freeway, 1998.

communities where the legal pieces are situated and the graffiti artists whose writing privileges are revoked when neighborhood residents have had enough. A constant irritation to the graffiti artists themselves, taggers also sometimes write their tags over pieces that writers had just labored over for hours. Such taggers are considered "vandals" by those whose work they invade.

I often think of those tags on large, beautiful pieces as little birds sitting atop the backs of elephants. It is a selfish bird, however, that procures a place for itself among greatness, while the elephant gets nothing out of the relationship except grief. No association here, just the bird using the other for a free ride. Infuriating indeed to those who have worked for years to build up their so-called can control to so masterful a level. Although most hip-hop writers mature along the traditional pathway—from tags, to throw-ups, to pieces—people at varying levels of production may have tense, and even antagonistic, relationships.

## LOS ANGELES'S GRAFFITI ELITE

Inextricably inked with street hip-hop is a strong gallery tradition of L.A. graffiti. As several New York articles praise or lament, graffiti in Los Angeles also has a gallery life. But the transition to the gallery didn't share New York's impact, largely because of the non-traveling aspects of graffiti on the West Coast. In Los Angeles, instead of focusing the movement around a single type of canvas, any out-of-the-way walls are sufficient for piecing. L.A. yards serve as standing galleries of the street for hip-hop work being produced. If writers are penalized or persecuted, or their walls buffed, they can always find other places to work around the city. Partly because of trends established in New York, gallery and street traditions have not been mutually exclusive; they have coexisted fairly peaceably since hip-hop graffiti came of age in the Los Angeles area.

The L.A. hip-hop graffiti gallery scene has developed under the watchful eye of curator Stash Maleski. Like New York's Hugo Martinez, Stash has done more than any other individual to bring the gallery scene in Los Angeles to greater coherency and mainstream visibility. The openings he hosts with his crew, I.C.U. (In Creative Unity), reintegrate the various elements of hip-hop that otherwise tend to seem separate in Los Angeles; DJs and rappers, scratching and break dancing, and general urban fashion merge in these graffiti events that periodically dot the L.A. landscape.

In a city notorious for its lack of a center, its various artistic movements themselves usually decentered, I.C.U. events have in many ways become the hub for the hip-hop art scene. They draw the best writers from all over the city and from all walks of life to work toward improving their common form, to see the work of others, meet the greats, get space to work undisturbed (see figure 5.8), and maybe make a little money on the side. Stash's position as curator of this movement is only possible in a city with as many talented writers as Los Angeles has to offer.

One of the strengths of the hip-hop medium is that it successfully bridges boundaries of legality and illegality. This is not without debate—controversies regarding graffiti and legality and illegality surround the production of legal and commissioned pieces on the street as much as work within actual galleries. Some argue that it can't truly be considered graffiti if it is done legally. However most people believe that if you start out, develop your style, and pay your dues on the street, then you can turn around and get paid back. No one begrudges another the chance to make a little money if the opportunity arises. In

Fig. 5.8. Hip-hop gallery graffiti. A Chicano artist works on a piece in the back lot of a gallery on Melrose at an ICU show. Foreground piece (detail) by Toonz.

this way, someone who has developed talent illegally may "launder" such skills for use in legal realms without committing a crime or bearing the stain of the lawbreaker; in fact, such roots in illegality tend to enhance the legitimacy of pieces for lay and street audiences, as well as would-be buyers.

Stash is the self-made center of the legitimate hip-hop graffiti scene. He has been in charge of gathering together artists for legal work on Rodeo Drive in Beverly Hills and on school campuses as well as organizing conferences to celebrate the hip-hop roots and the global hip-hop phenomenon. Although Stash is himself not a hip-hop writer, during the Los Angeles Uprising in 1992 a billboard in Westwood bore his chalky comment: "L.A. pays for Simi Valley Ways." His politicization and anti-authoritarian stance mirrors that of the broader gallery participants. Usually artists are in and out of the gallery, or may take some time to transition between illegal street work and newly legitimate art production. The taste of being persecuted by authorities even when they have legal permits for commissioned works remains in the mouths of these writers. Many are also suspicious of city attempts to

appropriate the talents of this community for civic endeavors and antigraffiti efforts.

If they are good enough, some graffiti artists wind up in art school in addition to the gallery. Both traditions find support and encouragement from other Los Angeles–based urban artists like Robbie Conal, Judy Baca, and Chaz Bojórquez, as well as established mural conservationists and advocates like those at S.P.A.R.C. in Venice. The gallery scene as well as the art school emphasis (often linked) provide the crossover between otherwise illegal graffiti practices and mainstream endeavors. Illegal city walls, however, remain the primary canvas for production and, for the city of Los Angeles, even in their illegality remain one way out of the harsh atmosphere of the urban environment. And built into more mature work of piecers are strong links to similar traditions in other cities around the world.

## LOCAL TC GLOBAL

Many people debate about how manifestations of American urban experience find themselves in such diverse parts of the globe, as we saw in the previous chapters with gangs popping up in various parts of the United States. Klein (1995) argues that this is due to the preponderance of media such as MTV and movies like *Menace II Society* or *Boyz in the Hood*. But to learn a whole culture, people must be present to transfer the knowledge. Most times when Bloods and Crips appear in other cities, for example, someone from Los Angeles has moved to that place and started a branch of their gang there (Alejandro Alonso, conversation with the author, 1995). Otherwise, gangs disconnected from urban-based gang systems create homegrown groups based on local traditions, if they exist, and the closest imitation they can muster from media sources. Similarly, one wonders how something like hip-hop travels—whether it can journey through media alone or if it needs people to make it happen.

Though magazines, the Internet, and movies like *Wild Style* and *Style Wars* connect hip-hop and globalize its community, people drive the migration by clarifying and enforcing what they consider "authentic" work. Thus the Sardinian (figure 5.9) who wrote "Turk 182" after the movie of the same name is admonished by another writer not to "copy from the movie." *Turk 182,* loosely based on Taki 183, is a rather weak representation of hip-hop and its motives. However, Turk's name seems to have caught on elsewhere as well. Jeff Ferrell, for example, also indicates that he has seen several references to Turk 182

Fig. 5.9. Globalization of hip-hop graffiti (Núoro, Sardinia, September 1994). "Turk 182"; "Non si copia dai film" ("Don't copy from the film").

in Denver and has photographed similar phenomena as far away as Amsterdam, noting that "in graffiti writing as well as other collective activity, the interplay of media imagery and everyday social practices continues" (1993, 96). Despite its inherent lack of authenticity, then, *Turk 182* seems to have made an indelible mark on the hip-hop graffiti community worldwide. (I also saw evidence of the movie's influence on my own sidewalk one day: a tag in bright blue that read "Terk 182.")

Bypassing the many theoretical uses of the word, the concept of authenticity is a core set of realities through which people determine insider- and outsidership. The crux of authenticity for the hip-hop community is adherence to aesthetic criteria; neglect of the hip-hop style fosters harsh judgments of cheap imitators. "Toys" are those who don't quite come up to snuff on the scale of hip-hop authenticity. Even within a city like Los Angeles with its pervasive examples, toys spring up here or there who attempt to write tags without having sought out people to show them the finer points of writing. They are roundly rejected by the real writers who will not tolerate such uninformed imitation.

Despite toys and copycats, like the Sardinian Turk 182, piecing and tagging have spread remarkably successfully. Worldwide, the hip-hop style finds uncanny similarity in both language and style in far-flung corners of the globe. It is now all over North America, throughout Eastern and Western Europe, and is increasingly popular in South America and Asia.[4]

In the United States and beyond, migration from city to city has created local elements of a global phenomenon. At first there were few mechanisms to keep the phenomenon connected other than the people and the practice itself. But as hip-hop expanded to different cities and grew ever more popular, people began to produce magazines that could circulate across city boundaries. The few available films and documentaries had major influences on the spread of knowledge regarding the subject of hip-hop. Together, these media linked the disparate elements of hip-hop into a fair amount of vicarious communication.

Today, national and international links have grown immeasurable, and populations of hip-hop artists are connected through a variety of sources. Many magazines now have an international focus, with pages from Amsterdam, all over Europe, and in many North American cities as well, including Montreal, Los Angeles, and Houston. In addition to movies and magazines, an increased amount of work on nationally traveling freight trains, gallery shows, conventions, and now particularly the Internet have connected hip-hop

graffiti writers and enabled them to view one another's work outside the old city boundaries. And though not necessarily represented in national and international hip-hop magazines, which tend to focus more on pieces, tagging has also readily joined the circumnavigatory hip-hop party. By documenting their own work and submitting themselves to these media, people can make their names today across national boundaries.

This does not mean that the global culture of hip-hop lacks variety. Differences as well as similarities continue to chart local landscapes. In Europe, for example, hip-hop is often interlinked with traditions of left-wing politics and youth activism; in Japan, it is most strongly associated with fashion trends in richer communities. Although the style and general goals remain the same, individuals in Zagreb, Helsinki, and Mexico City are going to have different experiences of hip-hop. Depending on the breadth of the phenomenon, experiences of hip-hop even within single cities can be markedly diverse.

In Los Angeles, hip-hop has been cited as comprising a rainbow of participants, where Los Angeles's desire to be a multicultural paradise has seen a powerful realization in these young writers (see Lipsitz 1993; Martinez 1992). Taken as a totality, the production of hip-hop graffiti is an arena where the boundaries of race and class have not precluded a common embrace of the hip-hop form. Crews can be either integrated or divided across race lines. For example, the NFL crew is one of the oldest in Los Angeles; in figure 5.10, its initials here stand for "*Nuestra Familia Latina*" (our Latino family), demarcating a Latino constituency (the same initials may stand for several different things).

Conversely, George Lipsitz told me in 1991 about his encounter with the crew ALZA, which he at first took to mean the hopeful "Rise Up!" in Spanish. However, he was soon informed that the initials stood for the racial constituency of the crew: Asian, Latino, Zulu, and Anglo. Mixed areas with racially integrated high schools may wind up with racially integrated crews; many times these are in more middle-class parts of town. In the inner city, where racial divisions even within mixed neighborhoods are more marked, crews may continue to be solidly one thing or another. Crews themselves run the gamut of Los Angeles's dreams and realities for multicultural harmony and/or dissonance.

The single phenomenon of hip-hop graffiti involves entirely different groups of people, crosses racial and social boundaries of class, and connects ethnic groups within the city of Los Angeles. In this way are individual experiences of hip-hop within Los Angeles often radically different. For example, I talked to one young man from the Jungles who had been a tagger when hip-hop graffiti was first beginning in Los Angeles. He described

a world almost as fraught with danger as the gang world itself. Later, I asked another friend of mine, a writer from WCA (West Coast Artists, one of the original crews in Los Angeles), to tell me about the dangerous aspects of his experience. Without hesitation he told me that he hadn't particularly associated his involvement in hip-hop with any kind of danger. WCA was primarily a Westside crew comprising mainly white, middle-class kids. Their experience of the identical stylistic phenomenon during a similar time period was certainly less perilous than that of a member of an all-black crew from a Crips neighborhood going undercover from Bloods at Dorsey High School. (He took on the crew affiliation so that he wouldn't be associated with Crips.)

In any given city, working in graffiti circles can present special hazards. For Los Angeles, this comes most obviously with negotiating relationships between hip-hop graffiti

Fig. 5.10. Throw-up from NFL, one of the oldest hip-hop crews in Los Angeles. "Strait [sic] from SC LA [South Central Los Angeles]. Nuestra Latina Familia. Free Axer!" (probably a reference to a jailed comrade).

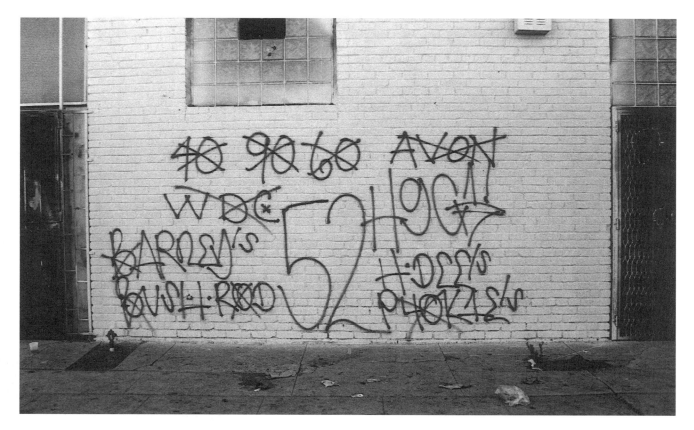

Fig. 5.11. The We
Don't Care Crips
("WDC"), formerly the
We Don't Care tagging
crew, is identified as an
enemy in gang writing
by the Hoover Gang-
ster Criminals ("52
HGC"). Hoover gang
members include "#1/
Barney's"; "BushRod";
"Hdee's"; and
"P40kie's" (Pookie's).
Enemies include "40";
"90"; "60"; "WDC";
and "Avon" (Avalon).

crews and gangs. For example, by writing over gang graffiti or trying to usurp wall space,
sometimes a tagging crew will make itself the enemy of a gang. Some crews in particu-
larly hostile areas have actually become gangs. In South Central Los Angeles, for exam-
ple, Alejandro Alonso told me that the We Don't Care Crew has become the We Don't
Care Crips (March 1996). They now fight within the established Bloods-Crips system and
frequently appear on enemy lists of the Five Duce Hoovers, as shown in figure 5.11.

On a similar note, at one time the Mexican Mafia declared "open season" on taggers
for disrespectfully writing over the graffiti of the Chicano gangs. Many gangs have openly
antagonistic relationships with taggers and graffiti artists. The Diamond Street gang just
north of downtown, for example, has been responsible for several deaths—including that
of a well-respected graffiti artist—at the Belmont Tunnel, a favorite site of L.A. hip-hop
graffiti writers.

The places crew members come from as well as their race impact their view and ex-

perience of this now-global phenomenon; meanings and motivations may remain severely localized even within single cities. With tagging, the scene is rarely connected to common spaces off the street like galleries or the Internet, so that their experience of the phenomenon is more localized in the places where they live. This contrasts with that of established hip-hop writers who participate in the gallery scene and global network. Often these artists really do begin to find themselves part of a phenomenon that bypasses racial categories and local value systems.

It is strange that questions of diffusion that so occupied theorists of the late nineteenth century have found renewed relevance in the analysis of how people are connected transnationally. Hip-hop's spread from New York to a worldwide setting has taken place in the last twenty years. Those who would study global to local similarities will find themselves charting the allure as well as the machinations of this written form both within and across cultural and national boundaries.

## CONCLUSION

Whether or not they achieve any legitimate ends, kids involved with hip-hop graffiti may glean several benefits in addition to those that are mainly antigang. Those youth who join hip-hop circles learn things that schools that are increasingly cutting art programs and extracurricular activities now fail to teach. Perhaps surprisingly, skills utilized toward graffiti production include several basic American values, including a strong work ethic. Their often years-long dedication to this graffiti form teaches kids all kinds of things. They demonstrate commitment and concentration and learn tactical problem solving, time management, cooperation, and creativity. The values they espouse include respecting the work of others and not "biting" from them (stealing their ideas), and constant improvement and development through practice and dedication. Though there are exceptions, most hip-hop taggers and writers adhere to these core values.

In his article on New York hip-hop, "Graffiti as Career and Ideology," Richard Lachmann quotes a high school counselor who says that kids who have entered into hip-hop apprenticeships are more likely to return to school and be promoted to the next grade: "The sort of kid who can be motivated to work for hours each day tagging to become famous can also accept the grind of school in order to get a degree" (1988, 239). In many

ways their experience on the street mirrors this process—kids spend their time planning out actions and making them happen, learning from others, practicing now so that they can be better later. The instant gratification that is so readily associated with graffiti, we find, is not so instant after all.

I am sometimes amused by people as young as twenty who have already realized a full hip-hop career; they seem more like retirees looking back on a lifetime of experience as opposed to young adults just beginning their professional lives (cf. Buford 1993). Whether as tagger or established writer, to survive in the hip-hop world you must be creative. More than anything today, ingenuity and resourcefulness are the skills that people need to look to the future and to represent themselves within the increasingly competitive environment of a shrinking job market. They may be able to take the skills they develop in the hip-hop realm and transfer them to traditional, legitimate work arenas.

Positive aspects of hip-hop graffiti are clearly countered by the fact that people break the law in order to achieve them. They may steal paint by the crateful or simply by racking it one can at a time. They violate all kinds of moral and legal codes with their subsequent writing on private and public property, concerns that they may understand and just ignore, that they may not relate to at all, or that may be blatantly driving them. Their work selfishly prioritizes their own wishes and needs over those outside their system. Despite these drawbacks, the positive points of hip-hop graffiti should not be overlooked. Neither should the problems kids are trying to solve with their endeavors and affiliations. As the silhouette artist Joey indicates in figure 5.12, sometimes art really can save lives.

To date, hip-hop graffiti has inspired the most insightful and theoretically sound body of literature on the graffiti topic. This chapter represents the smallest scratch at the surface of this elephantine phenomenon. I am anxious to see the fruits of the new research being done on this rich medium from the far corners of the globe. For my part here, I have presented some basic ideas regarding hip-hop graffiti in Los Angeles and combined them with the focus on gangs, in hopes that the divisions between the two can be drawn in the popular mind once and for all.

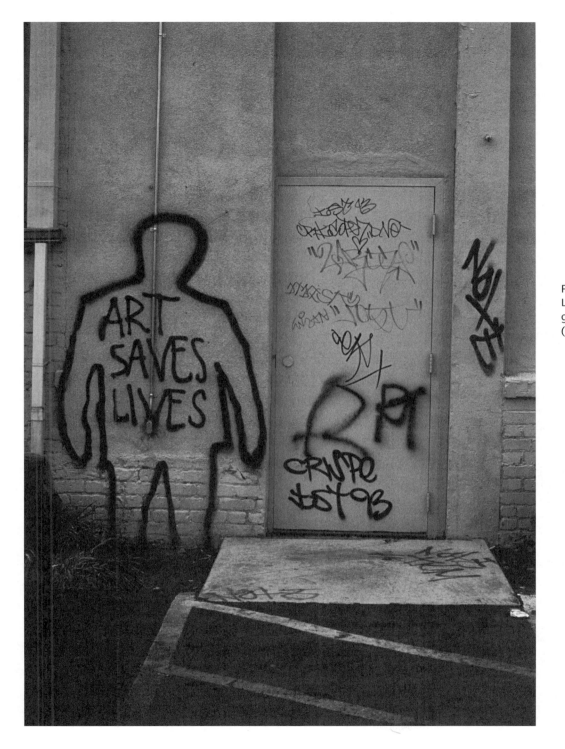

Fig. 5.12. "Art Saves Lives" silhouette by graffiti artist Joey (Santa Monica, 1992)

# 6    CONCLUSION

Graffiti is a cheap medium that allows interchangeability from one moment to the next. Shifting in time and place, through culture and politics, it runs the gamut from the statement "I was here" to proclamations of political affiliation, group relationship, and communal identity. Graffiti developed in urban areas have now taken over as the predominant forms of graffiti in the United States. They are the most visible and carry the widest impact in their interaction with the everyday world. I have shown in previous chapters how gang members use graffiti to close themselves into bounded systems: they cordon off territories, make their place within neighborhoods, define friends and enemies, and in the process negotiate a host of political and cultural concerns. Graffiti takes gang members from ideology to experience in a manner that grounds their thoughts and feelings into concrete, wall-written realities.

In its variability, the gang graffiti of Los Angeles has bridged political and apolitical genres. During the 1970s Chicano movement, claims of "Viva la Raza Cosmica" (long live the cosmic people) concluded typical gang graffiti in the Avenues neighborhood (Cesaretti 1975). At the end of the 1960s, proclamations of "All Power to the People" infused the walls next to where Brims, Pirus, and Crips battled for primacy. During the 1992 Los Angeles Uprising, gang members took the writings of their own gang traditions and combined them with overtly politicized messages that fought injustice and declared race wars. These graffiti helped people to punctuate certain political moments; they were the exclamation points for those events.

These "open windows" represent times of overtly politicized activism. Today in the United States it seems such periods are fewer and fewer. Most groups are not geared toward larger oppressive forces whom they could never chance to confront directly. The inward focus of social entities like gangs points to their exclusion of the larger society, if just through absence of referent. Intriguing in the gang case is that, although gang members have developed specialized language and writing systems, the difference of their practices from those of the larger society has little to do with that entity. Rather, gang members' linguistic and written tactics most powerfully represent plays of respect and disrespect within gang social systems. Instead of indicating overt political action or resistance in the face of oppression, the difference they create represents the daily irrelevance of their opposition to the larger society. The flexibility of both acceptance and opposition is true of many forms of political affiliation; it has constituted the core of the argument that makes my discussion of gang activities political.

Today, people negotiate internalized politics through consumerism and material practice. They know who's who by the type of shoes they wear, by the beer they drink, by the tiny tattoos on their hands or above their eyes. In the process, material forms grow to host the subtleties of identity politics and become imbued with symbolic meaning. Visual cues and material practices become the secret codes that define communities and, through their apolitical aspect, represent the growth of new systems of internalized concerns within existing state boundaries.

## GANGS, HYBRIDITY, AND INSTITUTIONALIZATION

*Pachuco, cholo, pocho.* Africans in America. People stuck in the spots betwixt and between cultures may be part of many things but seem to belong nowhere. Néstor García Canclini has written about forms of hybridity, noting how the model of hybridity creates new social forms within the "layered conception of the modern world," balancing modernity and tradition (1989, 2). In his penultimate chapter "Hybrid Cultures, Oblique Powers," he discusses how U.S. gang graffiti (and graffiti in general), relates to hybridity: "Graffiti is a syncretic and transcultural medium. Some graffiti fuse word and image with a discontinuous style: the crowding together of diverse authors' signs on a single wall is like an artisanal version of the fragmented and incongruent rhythm of the video. . . . It is a

marginal, deinstitutionalized, and ephemeral way of assuming the new relations between the private and public, between daily and political life" (251–52).

Canclini is both right and wrong. By forming gangs, people have made ethnic groups that would otherwise have been construed as "hybrids" into clearly demarcated, racially based forms of culture. Most gang affiliations, customs, and traditions have been part of neighborhood history since before their members' own memories, or sometimes even those of their parents. Though they spring from cholo or pachuco blends of Mexican and American, or mixtures of African, slave, and citizen, gangs are a culture for today, one that transforms its members from marginality into a concrete, pure form of self and group. Chicano and black gangs have themselves become institutions, with institutionalized codes and practices within the city of Los Angeles.

Graffiti testifies to the conservative nature of gang members through the ages. In a way that was even startling to me, the historical photographs of graffiti included in this text attest to the markedly stable focus of gang members through time, even in the face of developments within their own systems. Material culture itself is what allows gang members to connect their groups over larger distances and to systematize their concerns without an overarching state apparatus and without the benefit of traditional mass media (that is, without the institutions of the larger society). Practice through mechanisms of material culture moves gang members from hybridity toward the institutionalization of their own symbols and a new form of culture.

When gang members combine forms of graffiti or begin to cross each other out in ways they didn't used to, they represent moments of change out of which new institutions may eventually emerge. Already, startling combinations of classic L.A. gang forms abound, exhibiting unique qualities based on ethnic group or nationality.

Considerable blending of genres is at work within the boundaries of Los Angeles. Asian street gangs, for example, combine the models of African American and Chicano gangs, superimposing Cambodian, Chinese, Thai, or Vietnamese profiles. Pacific Islander groups do the same—Samoans or Tongans may claim a Bloods or Crips affiliation, write in Old English letters like Chicanos, and add a "100% Samoan" or "100% Tongan" to tattoos they blazon across their backs or on their stomachs in typical L.A. gang style. Area codes and tagbangers in the hip-hop world appear to be a curious blend of local and global perspectives, with writers also throwing up a black gang "187" next to the name of someone

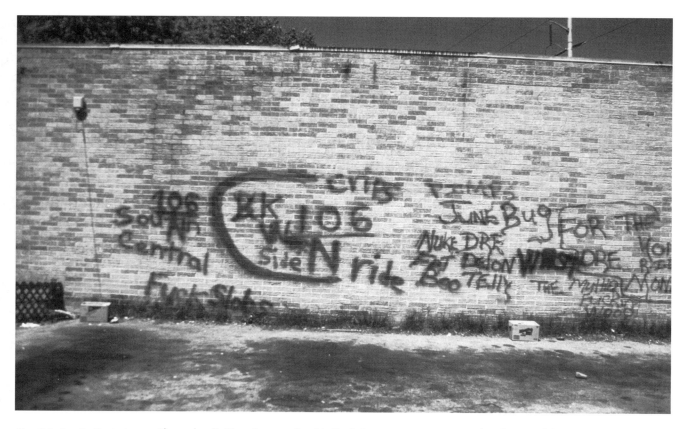

Fig. 6.1. South Central L.A. Crips graffiti in Decatur, Georgia (May 1997). "106 South Central"; "C BK"; "Fuck Slobs"; "Crips 106"; "W side, N Ride" (perhaps signifying "Westside, North Ride").

they don't like. Across the United States, gangs may take the pitchfork of the Folks and combine it with a CK for Crip Killa, mixing gang systems through graffiti that integrate histories and multiple affiliations. This is the sense in which Canclini is right.

Figure 6.1 shows a wall in Atlanta, Georgia, where Crips claim "South Central 106th Street" from two thousand miles away, placing it next to the People and Folks graffiti (not visible here) to merge east and west coast into a southern system of concerns. For now, the Thai Crips are the hybrids. The Chicano and African American gang systems presented in this book have now become the institutions upon which hybrid cultures are based.

In most of this work, I have attempted to show exactly the opposite of what Canclini proposes. I have demonstrated how graffiti is precisely what allows for institutionalization; how modes of writing graffiti and the groups that produce them have themselves become institutionalized. "100% Samoan" in the face of multiple urban realities—the hybrids of today are institution builders at their core. It is precisely the fragmentary nature of moder-

nity, to which Canclini refers, that has created the possibility, if not the abject necessity, for the development of rooted and historic entities like gangs. Gangs and graffiti destroy the hybrid.

## CROSS-ETHNIC GANG RELATIONSHIPS

In the previous ethnographic sections, I have presented the basic groundwork of Los Angeles gangs and have looked to graffiti to uncover several aspects of this system. Gangs fight inwardly, directing warfare toward themselves. It is my hope that in explaining how this system works that I have been able to answer lingering questions regarding the shape of gang violence so alien to national models of warfare with which we're all familiar. This low-level, endemic conflict, as much as the material culture, has thus far been a stable model of gang membership.

Even today, cross-ethnic violence has not been systematized into gang membership. In Los Angeles, particularly as the black community loses demographic standing in neighborhoods traditionally theirs, shared neighborhood spaces can be fraught with cross-ethnic violence that seems to differ from gang norms. Many have predicted that this is indeed the wave of the future for L.A. gangs.

Because Chicano gangs outnumber all other types of gangs in Los Angeles, their cycles of internalized violence will continue to chart the course of battle in Los Angeles for years to come. But the lingering question of black-Chicano relations remains poignant in mixed neighborhoods. During my fieldwork, I encountered several different kinds of gang relationships between African American and Chicano gangs that merit discussion here. They run the gamut from interracial harmony to a loathing that extends from gang to larger racial group and vice versa. This last was true for the Blood Stone Villains. The Villains were enemies with all Mexican and Latino people, who they felt were taking over their neighborhood. At the same time, of course, they were also enemies with the local Mexican gangs, particularly the Playboys. The Villains demonstrated to me how Chicano or black gangs can be markedly at odds with immediate neighbors, enemies not only of other gangs but any black or Mexican person. Gang and racial affiliations get shuffled in the mix to foster neighborhood tensions that are racially based. This is one potential outcome of living in mixed areas of Los Angeles today.

What I believe to be the most common form of cross-ethnic gang relationships is

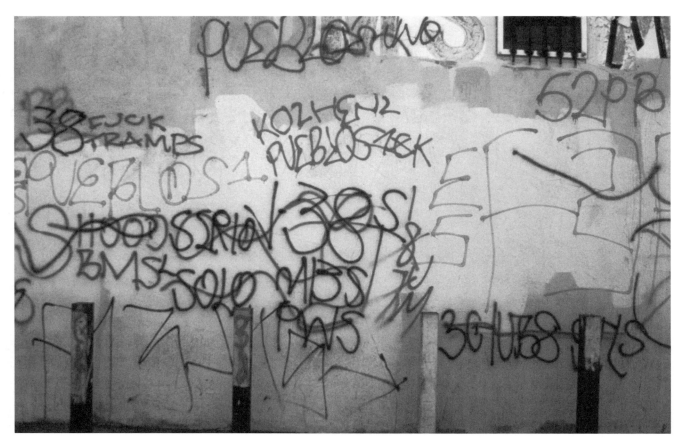

Fig. 6.2. Cross-ethnic gang relations (May 1997). The rivalry between the Pueblo Bishops and 38th Street is evidenced by graffiti cross-outs; the pristine compositions of Florencia 13 and BMS (Barrio Mojados, another Chicano gang neighbor), on the other hand, demonstrate the Pueblos' friendly relationship with these other Chicano gangs.

slightly less bleak. Consider the relations among the African American Pueblo Bishops and their neighboring gangs. The Pueblos get along with Florencia 13 and Barrio Mojados, their Chicano gang neighbors to the south and west. But they don't get along with 38th Street, the Chicano gang that borders them to the north. The reason for the disparity between relationships has to do with past events within the neighborhood. Some members of 38th Street stole one of the Pueblo's cars and then subsequently also shot a Pueblo in the park. Though he lived, the Pueblos were infuriated and launched a series of attacks on the 38th Street neighborhood. After a few nights of retaliatory violence, the 38th Streeters sent representatives over to the Pueblos to negotiate a ceasefire. Though staunch enmity was declared at this meeting, the Pueblos agreed to stop shooting if the car was returned. They also made it clear that members of 38th Street

were no longer welcome in the Pueblos' projects. 38th Street has a chop shop in their neighborhood; they never did return the car and have even stolen another since that time. As evidenced by continual wallbangin' between the two (see figure 6.2), relationships between them are still tense, but for a time actual violence ceased with the formal negotiation between parties. It has since started up again, fomenting a full-blown and continuing rivalry between the two.

The important thing here is that throughout this conflict, the Pueblos continue to maintain friendly relations with Florencia 13 and Barrio Mojados, their other Chicano gang neighbors. They have not extended their hatred of one Mexican gang to all Mexican gangs or all Mexican people. In the Pueblos neighborhood, black and Chicano relationships are driven by specific events and not generalized racial tension; this seems to be a fairly common example of cross-ethnic relationships in the gang world today.

A third possibility for intergang relationships I take from the Foe Duce, Foe Tray Gangster Crip neighborhood, where gang members from the Chicano gang 42nd Place hang out with their African American Gangster Crip friends on a daily basis. The Chicano gang members have written graffiti for their Gangster Crips counterparts on a number of occasions. One man I know from the Foe Duces even had a baby with a girl from the family of one of the 42nd Place boys. When I asked them about it, members of these two gangs scoffed at the interracial tensions that plagued other neighborhoods in the South Central area. They considered it a point of pride to get along so well with each other. They said they had grown up in the same area, gone to school together, and that there was never any reason for them not to get along—they were there to back each other up if it came down to that. Their good relationship hadn't precluded continued references to their racial identities, but both groups found it unnecessary to flaunt them in the face of the other ethnic group.

The last possibility is certainly the rarest, but it may be increasing in frequency. The 81st Street Boyz gang comprise both blacks and Mexicans and do not participate in either the Chicano or the African American gang systems presented in this book. Though they live closest to the neighborhood of the Mad Swan Bloods, the 81st Street Boyz indicate that their loyalty is to the block on which they live. They see no reason to get involved with anyone else's beef. I have heard of several gangs in the L.A. area with such combined constituencies. Only time will tell whether they can last through multiple generations—

whether indeed they may form their own gang system eventually. The challenge of prison for such "unaffiliated" gang members is a critical juncture that may determine their ability to survive inside as well as out.

Many people fear that black versus brown violence may be the future of this city. Multiple interethnic relationships demonstrated in these few cases indicate that a surprising number of people do get along in many gang neighborhoods. They find it beneficial to coexist, trade, do illegal business together, and back each other up if necessary. However, they retain distinct identities as racial groups in part to ally themselves with systems that have stood the test of time and that have aided their members' journeys from the street into prison. On the other hand, sometimes antagonism between gangs or neighbors is great enough to translate into generalized racial hatred. At the core, events, histories, and the question of respect between races are the factors that define multiple cross-ethnic relationships of today's gang neighborhoods.

## PARADOXES OF THE GANG WORLD

Several paradoxes define the gang world. Perhaps the biggest disjuncture is that proximate and ultimate goals of the gang life are mutually exclusive. Methods gang members use to reach proximate (or immediate) goals for power, reputation, and respect do not promote the ultimate goal: racial advancement. Instead, such proximate goals undermine efforts toward ethnic unity. The segmentary and oppositional nature of these gang systems itself constrains gang members in their "real" goals to make their lives better for themselves and for their children.

Researchers Jackson and Rudman have indicated that the numbers and average ages of gang members have increased in recent years because of a lack of economic opportunity and the state's heightened focus on prison punishment. They argue that "locking up gang members may well sever existing ties to the community, accelerate the spread of gang influence, and provide a continuity between socialization in the community and the prison" (1993, 272). It is equally paradoxical, then, that the gang system is only strengthened by harsher sentences meant to destroy that system. Jackson and Rudman further state that "The informed use of least-restrictive alternatives should be combined

with the development of social alternatives that provide avenues of escape from an underclass existence" (272).

The gang system—its graffiti, illicit economics, and communicative media—is currently what provides such "social alternatives." Through these self-made alternatives, gang members effectively subvert mainstream notions of private property by appropriating public or private space for their own purposes. Their warfare makes them seem to have a fundamentally different approach to human life; pervasive robbery shows them to take advantage of people who are weaker than they. A gang's version of respect relies on instilling fear in others, ultimately in order to protect themselves. All of these practices alienate them from the larger society.

Gang members make up groups that are concerned with their own politics, not the politics of the larger society. They direct their communication inward, toward other people in the gang world who already know how to appreciate, understand, and respond to the messages. Gang members rarely write graffiti to "get back" at society or to claim something that is not theirs. They write graffiti to represent themselves and their own political system in the places where they live. One Chicano gang member reiterated this perspective:

> It's just a communication between us. We all communicate with each other. I mean like you wake up in the morning and you go to work: welcome to the neighborhood. That's just us. Not to say that we can't change our program, but that's just us. That's our lifestyle. Change what? This *is* us. What are you going to do, go sit up in a cafe and have cappuccino? The reality is, that's not gonna happen. This is reality here. Everyday no matter what happens we gotta go to work, working with my homeboys. And if I'm not here, the rest of my homeboys might come. All the stuff we been through together. . . . How you gonna change your homeboys for something you got no part in? Why do they want to change us, you know what I mean? Why can't we be ourselves and it be alright?

The "communication between us" and "changing your homeboys for something you got no part in" crystallize the dilemma gang members face. They are constantly exposed to elements of the larger society through television, media, and the police. But the isolation and segregation of Los Angeles combined with the racism that has historically

excluded people of color ultimately disables entire populations. It does this primarily by preventing people from affecting the outcome of their own lives through legitimate means. They "got no part" in what society has to offer.

In response, some elements of a population—such as gangs—choose to empower themselves in the development of local political and economic groups like gangs. Thus in the process of demanding what they believe to be their basic rights as humans—the right to make a living, to self-determination, and so on—gang members violate laws and the civil rights of others. They give those outside their system justification to fear them and to feel threatened by them. No matter how successfully gang members create worlds bounded and closed up by their style, their action, their consensus, and their morality, gang members do not live in a vacuum. Their behaviors do influence the larger society and the state, which does retain the legitimate use of force in the United States, and which often uses it to fight against them.

To understand gangs, we must first understand how they work as bounded systems. Only after grasping the basics of these systems can we begin to tackle the important questions—the ones that consider gang members' encounters with the larger society. Here the viable options become frighteningly clear. Something makes gang members take one road instead of another. As a "choice," gang membership is always at the level of the individual. But that choice is influenced by society's role in the process of creating gangs. We must focus our efforts on identifying the paradoxes of gang life and establishing why even gang members who want to leave remain entrenched within the system.

Gang members feel confined by the prejudices of others, ironically longing to be understood by a society that their entire system of gang membership rejects. As Vigil (1988a,b), Moore (1991), and a variety of others have pointed out, gang members do wish for better living situations for themselves and their families and often seek out regular types of employment. But often, the illegitimate means gangs have found to support themselves undermine opportunities to create shifts in their current economic positions. Even when they attempt to cut their gang ties, their past often influences their experience in a world colored by racial tension and antigang sentiment.

I often found myself in situations during which people would plead with me for the recognition of their humanity. This happened during one day I was spending with some gang members from the 29th Street neighborhood. We were talking about just these is-

sues, and one of the girls in the crowd said, "Yeah, you know, you can't judge a book by its cover." At the same time, I looked around to see the gang cover: the facade of fierceness that is very real, the violence that pervades their lives. These people spend their time creating an image that scares people and separates them from society; in large part they are successful. What I hope I have shown here is that this facade of fierceness ultimately protects them from both racism and the hazards of their daily environment, and that it is just one of many complex aspects of their lives.

Many gang members realize that their goals for power and respect parallel those of the larger society: "It just comes down to the same shit, just at a different level." As one man told me:

> Everybody's corrupt. Everything's corrupted. It just happen to be they got a license to do it, we don't. They got authority, and they got a gun. We got a gun, we got no authority. Our authority is this. The way we see authority is by putting fear into people. To our rivals. Because they'll think twice before they come over here. Because they know, those guys got something over there. So it makes us safer. By us putting fear . . . doing what we have to do, makes our place safer. Cause they're gonna hesitate to come over here if they know what we got. The cops do the same thing, come here all the time and show fear into us, so we won't do nothing wrong now. But what they don't understand is that some of us don't got nothing to lose. And when you got somebody that doesn't have nothing to lose, they got a "fuck it" mentality. They don't give a fuck. They see no future. They look at their older brother, he's busted. They look at somebody else, they see somebody else, he got killed, and he wasn't even a gang member. "What future I got? Fuck it." And when you got a little kid with a gun that has a fuck it attitude, those are the most dangerous ones.

They got the gun, and they got the authority to use it. This mirrors almost exactly Max Weber's definition of the state as the entity that holds the monopoly on the legitimate use of force. Gang members always thoughtfully articulated the reasons for their lot in life to me; they must constantly question the twists and turns of their lives while confronting portrayals of their culture by the dominant system. Why does it have to be that way? The answer to this question boils down to histories, to circumstance, to accidents of birth, and

to the not-so-accidental relations of power that go along with them. From the point of view of those without power, it could very well be different.

Understanding the shifting relevancies of gang relationships has been crucial to our investigation. Efforts to curb gang violence can be based on native models of alliance within that system—proven mechanisms for conflict control and unification. I have demonstrated how gang members form alliances on a daily basis and negotiate peace between parties through methods ranging from neighborhood cease-fires to full-blown gang truce treaties (see Perry 1995).

Particularly as they get older, gang members may turn to nationalism as the native solution to the gang problem. But nationalism brings its own problems to the front; it is a harmful model that engenders precisely the kind of racialized hatred that has periodically burned down this city. Nationalism pits ethnic groups against one another in a manner that has torn Europe apart; it has incited ethnic cleansing and fomented religious battles worldwide. For gangs, however, espousing nationalist ideals helps them to address their problems of perpetual infighting. Further, these ideals also imply assimilation—gang members have taken the model of the nation and of advancement *within* society as their ultimate goal.

It sometimes scares me to think of the bright-eyed kids I know in the projects growing up in an entirely different world than mine. These are kids who know they are Bloods by the time they are three years old. They live in a world where gangs are the norm. I have given just the smallest glimmer of information here regarding gangs, which I hope combines insight with a sobering understanding that if we don't want gangs in our lives, we must get to work quickly.

If we are going to fight gangs, we need to do so in a way that will be effective in the long run. Passing laws that violate the civil rights of gang members, as certain cities have done in recent years, is another shut-out mechanism. This legislation engenders hatred for the system and, by specifically targeting certain elements of the population, further alienates and excludes people. Under such laws, gang members are prohibited from congregating in groups of three or more either on the street or in the home of another gang member, from standing on rooftops, from carrying beepers, from being on the street after eight o'clock at night, and from frequenting certain parts of the city, particularly public places—including sometimes even their own front lawns. The list goes on. These tactics,

which may seem to alleviate tension for a time, will only entrench the gang system further by separating and antagonizing the two worlds even more. Ultimately, I believe such legislation will worsen our situation.

We may never be able to get rid of gangs—ever. No one can remember a time when there weren't gangs somewhere on the American landscape. But people can remember a time when gangs were limited to teenagers, when they weren't fraught with uncontrollable violence, and when they didn't grow to become lifelong support networks. In fighting gangs, we can do two things: We can limit the duration of gang membership by helping kids make the transition out of gangs and by nurturing internal peace efforts. We can also stop other groups like tagging or party crews from becoming gangs, and prevent gangs in suburban or rural areas from becoming permanently entrenched within those environments. In working to help our next generation, these are the areas where we need to focus effort—on prevention and occupation outside the gang realm, certainly; on transition and guidance beyond it, definitely.

These ideas are more beginnings than ends. In that sense, I wish this book could be more like graffiti—complete, enumerated, specific, and to the point. But gangs and graffiti are open topics. As time passes, new shifts within gang communities and new layers of research will change the meaning of this book, just as I have tried to change the process of interpreting gangs and graffiti for today.

Graffiti has provided me a special window into people's lives. This window has allowed me to see the positive in what is usually viewed as negative, to find morality in what is often considered depravity, and to discover a creativity and depth of history that makes me grateful to live in the time and place that I do. This work has so changed my relationship to the city where I live that the discovery of an older piece of graffiti, in figure 6.3, gave me a feeling of connectedness to Los Angeles that surpassed anything I had felt before.

It is 1947—the year before the spraycan makes its first appearance in Los Angeles, just two years after the end of World War II, and four years after riots ripped through downtown. Two Mexican boys named Cobra and Bingo go to the river. Maybe they laugh and joke around a bit, or maybe they toss a few stones from the railroad tracks at each other. They come here often with their friends, to hang out, sometimes to drink, or to smoke a little tea. This day, they collect black tar drippings, vestiges of the train's passage, and move toward the bridge overlooking the river. While Bingo looks on, Cobra edges over

Fig. 6.3. "El Cobra de los MNRs Flats, 3/29/47"

the concrete side wall. He climbs up underneath the first archway support of the bridge. Never looking down, he takes a deep breath, and slowly moves up to the second. Hundreds of feet above the poor trickle of L.A. water, he precariously nestles into the cranny with his tar and stick for writing. Pressing black ooze onto the concrete surface, he writes "= Cobra = =Bingo= MNR 7/2/47" in the squared lettering typical of his day.

In my day, in 1998, I sit staring above me. I see the black words, protected by the bridge. They have survived, the names of Cobra and Bingo. Soon I see another list of names—this one much longer. It is produced in the same manner, with tar letters, a darker black than I've ever seen. My camera lens is too weak to catch them. They are hidden in shadow, and I will not fight my vertigo to follow in Cobra's footsteps. Suddenly, I look down and see that Cobra has been here another time, sitting right next to where I am sitting, his legs hugging the concrete side wall just as mine are now. Three months earlier,

he had written his name along with the name of his neighborhood. He could not have known that, after all the years of sun, the tar he used would bake onto the surface and etch the letters indelibly into the concrete beam of the bridge. I reach over and my fingers trace the words next to me. Most of the tar has fallen off, but here and there little black bits cling to the edges. For all the hazards of a lonely composition on the wall, the words still shine through.

# NOTES

## INTRODUCTION

1. In 1943, during the highly publicized "Sleepy Lagoon" case, nine members of the 38th Street gang were convicted of second-degree murder for the death of a single man (McWilliams 1948). Today, during what Joan Moore has called our society's second gang-related "moral panic," this practice rages ever stronger (see Moore 1991). I personally know of several cases in which more than one gang member has been charged with first-degree murder for the death of one person. See, for example, the highly publicized case of a stabbing by one man in a white "gang" from the San Fernando Valley. Though only one person actually committed the crime, it led to four convictions of first-degree murder; two of those convicted were juveniles at the time the crime took place. Three are serving life sentences and the youngest is currently serving a term of twenty-five years to life (Sullivan 1997).

2. See Theodor Adorno's *Minima Moralia: Reflections from Damaged Life* (1974). I would like to thank David James for pointing out the implications of this passage, and also for introducing me to the material by Walter Benjamin.

## CHAPTER 1

1. Graffiti from Nizhny Novgorod, Russia, 1998. Thanks to Jeffrey and Liesl Miller for sending it my way.

2. I am grateful to Dana Cuff for directing me to this collection, and also to Evelyn De Wolfe Nadel for generously sharing Leonard's work with me.

3. In the 1980s and 1990s, as homeless populations have increased, some new cultural elements have begun to emerge that use graffiti. Homeless young people (like the so-called gutter punks of Hollywood) may mark out spaces to "squat" using the traditional European insignia of a circle with a broken arrow through the middle to designate it. The members of a loose association called the "Freight Train Riders of America" (FTRA), started by Vietnam veterans in the early 1980s, also write graffiti to represent their group. The Southern Poverty Law Center describes the FTRA as "gangs of railriding hobo killers with a penchant for white supremacy," adding that "they may be responsible for hundreds of deaths, beatings and thefts along railroads in the past 15 years" ("Hobo Killings" 1998, 4). Subdivisions of the group supposedly communicate through graffiti that include swastikas and the double lightning bolts of the Aryan Brotherhood (originally the symbol of the Nazi SS).

4. Erik Christiansen and Louise Tallen first took me to see this type of graffiti in their Sea Tow boat; I thank them for their generous trip and for the information Erik provided me about the context of this type of graffiti production. I was amazed by the amount and duration of this graffiti in the L.A.

harbor, where harbor officials retain a policy not to erase the writing of the sailors. We saw images dating as far back as 1971, from too many countries to count.

5. I follow John Breuilly's (1994) idea of the meaning of nationalism—Breuilly believes that forms of nationalism are inherently against the state *as it exists* because nationalists wish either to create a new state in its place, or to change certain things about the current system. This is not blind support but rather the active designation of wishes and dreams for a new reality. Freemen in the United States are a case in point. Though they seem ultraconservative and patriotic, their politics separate them from the established state-level system of democracy in this country. They wish to change the state and they shun participation in the current system.

## CHAPTER 2

1. I use South Central Los Angeles as an example because it has been my major field site, and it has one of the highest gang densities in the city. It has also been one of the most studied areas from an economic perspective—this precisely because of its historically poor living conditions and the two riots that have occurred in its vicinity. South Central Los Angeles has a long history of both black and Latino populations and their gangs.

2. This may seem to mirror Althusser's (1971) view, duly noted by Hebdige (1979), that nearly autonomous subcultural elements are part of the same larger entity. I take a slightly more separatist stance regarding the L.A. gangs , viewing them as mature cultures that exist relative to the apparatus of the state while retaining distinct cultural and political identities.

3. The concept of segmentation originated with Durkheim in his *Division of Labor in Society* (see Kuper 1982 for a historical review of this concept). I am well aware of the debates surrounding segmentary lineage theory. Kuper, in fact, states that the concept is completely useless, in part because no society characterizes its own identity this way. However, the information from graffiti as well as that garnered through interviews in both ethnographic chapters demonstrates that both black and Chicano gangs conceive of their systems in just such a manner, writing on the wall and on their bodies each element of the segmentation as it becomes more and more broad. Other recent work has tended to uphold the theory as well. As Paul Dresh (1986) points out, the basic concept apart from its kin implications is still inherently useful in charting nomadic alliance and animosity among the Bedouin he studies. Losing the "lineage" part of the segmentary lineage opposition make sense when dealing with gangs that can link people together whether or not they are blood relatives. Although I have not done comprehensive kinship analyses among the gangs with whom I have worked, the importance of this system is that it offers mutual protection whether its members are kin or not.

4. Gangs and the Mafia do share some similarities, including ideals of retribution, an honor code of silence, and an internal pattern of violence. But the economic immersion of the Mafia in nondrug industries and in higher-level political systems, as well as their weblike, almost pyramidal structure, distinguishes them from street-level L.A. gangs. Higher-level prison gangs among both blacks and Chicanos in California's prison system intentionally mimic Mafia-like structures, but although their control over street-level entities has shown some success, it is often short-lived. What has been successful is an ideology of unity that originates in jailhouse practices.

5. *Acephalous* comes from the Greek word *akephalos,* meaning "without a head," and refers to a characteristic lack of overarching leadership in certain populations. In these ground-level systems, organization comes primarily through kinship by defining relationships to a common (and often mythic) founder.

6. The segmentary systems anthropologists have described were often based on deterritorialized, kin relationships that connected people over large distances. Theorists have wondered why such designations were based on kinship instead of on something simpler, like locality (Vincent 1990). Lately,

Simons has offered that formerly nomadic peoples, who no longer have to follow their herds, may eventually link kin affiliations with locality during processes of settlement.

7. Minimizing a focus on territory in warfare might seem to be the wrong tack for the analysis of gangs in light of how tied they are to the neighborhoods they inhabit—gang members are willing to die and kill for those places that house so many emotional, familial, and economic concerns. But black and Chicano gang neighborhoods are mostly well established; the land itself is not what is at stake. As I demonstrate in the ethnographic chapters, at stake is a gang's ability to represent itself within a specific locality, and, from there, to negotiate their position and reputation within a community of similar gangs.

8. Work that focuses on ethnic violence comes close: Appadurai's notion of "implosion" outlined in *Modernity at Large* (1996) is just one semantic step away from explaining violence within relatively homogeneous populations. His theory eloquently sets the stage but still relies too heavily on cross-ethnic battles and national positioning to apply to conflict within ethnicities.

9. In terms of the Chicano literature, Los Angeles is often considered a colonial city—part of the mythical nation of Aztlan. It retains seemingly separate spheres of language and culture (Spanish and English) that are not merely ethnic enclaves in a sea of white culture—they now constitute over half the Los Angeles population. It is not only the remnants of Los Angeles's colonial past but also the continual racism of whites toward minority populations that drives the growth of gangs in our society. Further, Los Angeles's stark divisions between English-speaking and Spanish-speaking populations sometimes make it seem more like a Johannesburg, with dual linguistic and cultural systems that often provide similar services and means—a deinstitutionalized separate but unequal practice.

## CHAPTER 3

1. The story of Chavez Ravine as well as recent moves to raze housing projects exemplify how the designation of areas as "slums" many times provided an excuse to get rid of "questionable" (i.e., poor, often minority) neighborhoods while ultimately failing to provide new housing for their residents. In the Chavez Ravine case, an entire Mexican neighborhood was destroyed in order to build what were supposed to have been new low-income housing projects. After several turns of political events, the low-income housing was never built, and the land was usurped for the construction of Dodger Stadium (see Hines 1982).

2. Pachucos shared the zoot suit with other urban youth of their time, both in Los Angeles and across the United States. The zoot suit was, in fact, linked to jitterbug music and dance styles (the tight cuffs so they wouldn't trip on the dance floor)—I like to think of it as a 1940s version of what hip-hop is for urban youth today. The dissent by both pachucos and hip-hop kids is embedded in the clothing and in the style, which is experienced in a variety of ways by a variety of populations.

3. William Fulton (1997) has noted how in cities with Chicano majorities, like Bell, Bell Gardens, and Huntington Park, a revolution has taken place almost overnight. White city councils have been replaced by Latino majorities. The California state legislature is also experiencing a gentle Latino revolution, in which Chicanos from Southern California are gathering considerable political weight. (*Mexicans* are people from Mexico and their descendants; *Chicano* is another term for Americans of Mexican descent (also Mexican Americans); and *Latinos* are people from Latin America.)

4. Johnson and Earle (1987) also discuss how ideas of family and cross-marriage heighten security for a variety local group–level societies, whether or not they have strong clan systems in place.

5. The disproportionate prosecution (and punishment) of minorities and the poor for crimes involving drugs like crack rather than the white upper classes for powder cocaine offenses is a prime example of the skewed power relations within the court system. California's "three strikes" law only seems to make matters worse. For example, two former gang members I know who were on their

third strike got eight years each for minor drug possession charges, although each had been working hard to straighten themselves out. One had stayed out of trouble for five years; one for ten years. Because the "strikes" include crimes committed even before the law was passed, this leaves no room for rehabilitation. It effectively eliminates the possibility for many men to stay with their families and help raise their children.

6. On a questionnaire developed by French geographer Jerome Monnet in Los Angeles and distributed among seventh-grade students at a Boyle Heights school, many students listed "graffiti" and "gang members" as basic neighborhood landmarks.

7. The work of anthropologist Henry Field (1950), which I cited in the introduction, is relevant to discussions of gang migration. The tribal marks used by Bedouin nomads in the Middle East resemble the way modern gangs use their gang insignias: mainly to designate ownership among similar groups. Anything from camels and chicken's feet to wives and water wells bear designatory tribal markers. In a note toward the back of Field's publication, Hans A. Winkler discusses the content of these markers as they relate to nomadic migrations: "If a tribe becomes too large and division results, there must be a differentiation of their tribal brands. This may be done by slight changes in the common ancestral signs. It is obvious, however, that repeated divisions must lead to more serious differentiation of the old signs and that new signs must eventually be chosen" (1950, 30). The Clanton 14 gang demonstrates such "slight changes" by adding differentiating elements ("SC"; "31") while retaining the original "ancestral sign" ("C14"). As Winkler discusses, these modifications can help researchers chart movements of populations from specific areas.

8. This is what African American gangs and Chicano gangs native to the area consider the Eastside of South Central Los Angeles. City Hall (1st Street) and Main Street leading up to it become the points through which east, west, north, and south are officially reckoned in Los Angeles. But many communities have their own "east" and "west" sides: the Eastside of South Central is the Westside to people from east of the L.A. River. The Crenshaw district is the Westside for the black community, as is anything west of Main Street. But this is a different Westside from the Santa Monica, West Los Angeles, Culver City, and Venice foursome—what most whites consider the Westside. Gang names are some of the most accurate reflectors of both local and official east-west designations.

9. Transporting names across traditional boundaries is common in a variety settings. For instance, in 1994 the Milan police forced the closure of a famous left-wing autonomist social center called Leoncavallo, named for the street on which its building stood, Via Leoncavallo. But when its former residents attempted to establish new centers elsewhere, they did not change the name completely: they simply added on the new street name—for example, Leoncavallo at Via Watteau. Though these new names were recognized formally, people continued to write graffiti invoking the traditional Leoncavallo name, as the name itself had become a symbolic center for the movement.

10. African American gangs also use the term "roll call" to describe their membership lists.

11. Dunston (1992) indicates that, in addition to gangs, many underground and cult groups use similar number and letter systems to represent group concepts and practices (see especially pages 16–19).

12. See articles by Romotsky and Romotsky in *Arts in Society* (1977) and *Human Behavior* (1974).

13. This piece in particular is in reference to the draft and war in Vietnam. Ultimately, these types of sentiments culminated in a street riot in East Los Angeles on the day of the Chicano Moratorium on the Vietnam war (August 29, 1970). Famous L.A. Chicano journalist Ruben Salazar was killed in what must be the saddest note to these events; see Armando Morales's *Ando Sagrando* (1972) for a compelling and thorough account of the events surrounding the riot.

CHAPTER 4

1. From Geertz (1973). His "Notes on the Balinese Cockfight" is the textbook example of "thick description," which involves the analysis of a single event or cultural practice, examining in detail the connections and social and economic relationships that transpire. In 1940, Max Gluckman used a similar technique, which he termed a "situational analysis" (see his "Analysis of a Social Situation in Zululand"). In Geertz's account, as he demonstrates his own position and relationship to the Balinese, he also draws for us a Balinese picture, a scene in which the Balinese were real people and in which abstract social processes came to life. Geertz's article has never been accepted as what anthropology is or even wants to be. But for my purposes it demonstrates what the word "ethnography" means—the portrait of a people. His goal was to give people an idea as well as ideals, facts as well as impressions, which enrich our understanding of cultural phenomena at a multiplicity of levels.

2. Reginald Denny was the white truck driver who was filmed being beaten nearly to death by four African American men. He became one of the symbols of the 1992 events and represented a symbolic reversal of the Rodney King beating: four black males beating a white man, instead of four white males beating a black man.

3. Most people agree that South Central Los Angeles is constrained by Interstate 10 to the north and Alameda to the east. However, the western boundary of South Central Los Angeles is continually debated: some people don't include the Crenshaw District; some people stop at Leimert Park or they count anything east of Ladera Heights (Leimert Park and Ladera Heights are both strongly middle-class black neighborhoods). Some people only include those places east of Western Avenue. In this sense, the term "South Central" is a stereotype of sorts. It continues to designate the working- or underclass black neighborhoods of Los Angeles that are roughly limited to this geographical and historical region, originally based and named for (South) Central Avenue. Because of deserved criticism for their indiscriminating use of this term as a generic label to mean "poor and black," much of the media has begun to use "South Los Angeles." I find this solution to be more like a Band-Aid rather than the development of any kind of sensitivity about why they were criticized in the first place.

4. The practice of percentages in tattoos is shared among several subcultural groups—someone from the Aryan Brotherhood, for example, might have a tattoo that says "100% Honky." What concerns me here is how the addition of specific numbers—for example, "52" if you're from 52nd Street or "83" if you're from 83rd Street—fit into a host of similar African American gang numerological practices.

5. I have only rarely heard *seece* for "six" in the gang community, but I have always wondered whether the usage might derive from a French origin because it sounds exactly like the French word for "six." The fact that *seece* is not a common term in gambling makes the interconnection through language to the French Creole South potentially even more compelling.

6. In his Balinese example, Geertz (1973) also indicated that status rarely permanently changes through gambling.

7. "The Jungles" are a complex of apartments on the L.A. Westside, just bordering La Brea and the wealthy black population of Baldwin Hills. This complex is one of the earliest housing developments built in the United States. It is not called "the Jungles" from some ironic sense of their own urbanity, as I had originally imagined, but because the architects that designed the complex in the 1940s imported exotic plants with which to landscape the environment. Today, there may not be a single living plant in the Jungles. But the moniker itself is indicative of the city-planned architectural innovation, plants included, as well as of the quirky decisions of those up-and-coming young architects. Many gang names, black and Chicano alike, hearken back to lost elements of neighborhood areas and origins. With a little digging, they provide a unique and accessible record of our "city without history."

8. Five Line is one specific set of Bounty Hunters, who also comprise Ace Line, Duse Line, Foe Line, Bell Havens, and others. Ace Line is at 101st Street; Duse Line, 102nd Street; Foe Line, 104th; Five Line, 105th; and Bell Havens, Bell Haven Street. Together these sets form one of the largest gangs within a single area; the nontraditional names make the Bounty Hunters seem more like an army than a street-based gang structure. My guess is that "Bounty Hunters" is a derivative of the Bell Haven street name—because of the B and the H—but I have not yet been able to examine this possibility. In Watts, the Bounty Hunters were instrumental in negotiating peace among the housing projects (Nickerson Gardens, Hacienda Village, Imperial Courts, and Jordan Downs). Theirs is one of the more politicized neighborhoods in the city.

9. This is one of those moments when the parallels with Middle Eastern and African tribal structures are startling. My colleague Conerly Casey had witnessed violent rioting between the Hausa and Yoruba in Nigeria, where a popular bumper sticker, "My friend is my enemy," referred to the circumstances whereby friendships could be ended because of tribal or religious affiliations. This is precisely the same phenomenon that brings Bloods and Crips together in prison or separates them on the street. Each segment and the oppositions that go along with them can be called into play at different times. Depending on the circumstances, different forms of association are acceptable where they hadn't been before.

## CHAPTER 5

1. Crew members sometimes claim regional affiliation in their work ("South Central") or use area codes to represent themselves and their crews ("213"). Different crews may be associated with different yards around the city, and their groups may be somewhat racially divided depending on the constituency of the crew.

2. Perhaps predictably, the exact opposite seems to be the case in New York City, where gang graffiti—even the graffiti of Bloods and Crips in New York (themselves imports from Los Angeles)—tends to look more like tagging. Considering the fact that hip-hop graffiti has been the most influential form of writing in that city, this is not surprising.

3. Castleman quotes artist Claes Oldenburg in *Getting Up: Subway Graffiti in New York*: "You're standing there in the station, everything is gray and gloomy, and all of a sudden one of those graffiti trains slides in and brightens up the place like a big bouquet from Latin America" (1982, 142). Cresswell (1992) and Mailer (1974) also refer to this quote.

4. The only unaffected places may be parts of Latin America, Africa, and perhaps the Middle East, but even these may already have their own hip-hop traditions.

# R E F E R E N C E S

Abel, Ernest L., and Barbara E. Buckley. 1977. *The Handwriting on the Wall: Toward a Sociology and Psychology of Graffiti.* Westport, Conn.: Greenwood Press.

Abrahams, Roger D. 1964. *Deep Down in the Jungle: Negro Narrative Folklore from the Streets of Philadelphia.* Hatboro, Pa.: Folklore Associates.

Abu-Lughod, Lila. 1986. *Veiled Sentiments: Honor and Poetry in a Bedouin Society.* Berkeley and Los Angeles: University of California Press.

Adorno, Theodor. 1974. *Minima Moralia: Relections from Damaged Life.* London: Verso.

Ahearn, Charlie (director). 1983. *Wild Style.* First Run Features. Film.

Alder, Bill. 1967. *Graffiti.* New York: Pyramid Books.

Alonso, Alejandro. 1998. "Territoriality among Los Angeles Bloods and Crips." Master's thesis, University of Southern California, Department of Geography.

Alsaybar, B. 1999. Constructing Deviance: A Study of Filipino Youth Subculture. Ph.D. diss., University of California, Los Angeles, Department of Anthropology.

Althusser, Louis. 1971. "Ideology and Ideological State Apparatuses." In *"Lenin and Philosophy" and Other Essays,* trans. Ben Brewster. New York: Monthly Review Press.

Anderson, Benedict R. 1983. *Imagined Communities: Reflections on the Origin and Spread of* Nationalism. London: Verso.

Anderson, Elijah. 1978. *A Place on the Corner.* Chicago: University of Chicago Press.

Appadurai, Arjun. 1986. *The Social Life of Things: Commodities in Cultural Perspective.* Cambridge: Cambridge University Press.

———. 1996. *Modernity at Large: Cultural Dimensions of Globalization.* Minneapolis: University of Minnesota Press.

Belcher, Wendy Laura. 1993. *South Central Los Angeles: An Annotated Bibliography with Accompanying Statistics on Inner City Underdevelopment and Minority Business.* Los Angeles: Dist. by the City of Los Angeles Human Relations Commission and Kaiser Permanente.

Benjamin, Walter. 1979. "The Author as Producer." In *Reflections: Essays, Aphorisms, Autobiographical Writings,* ed. Peter Demetz. New York: Harcourt Brace Jovanovich.

Bing, Léon. 1991. *Do or Die.* New York: HarperCollins Publishers.

Birk, Sandow. 1997. "Graffiti: Street Justice." *Juxtapose* 3, no. 2 (spring).

Bloch, Ernst, ed. 1977. *Aesthetics and Politics.* London: New Left Books.

Bloch, Herbert A., and Arthur Niederhoffer. 1958. *The Gang: A Study of Adolescent Behavior.* Westport, Conn.: Greenwood Press.

Bourdieu, Pierre. 1990. *The Logic of Practice,* trans. Richard Nice. Stanford, Calif.: Stanford University Press. Original edition, Paris: Éditions de Minuit, 1980.

Bourgois, Philippe. 1996. *In Search of Respect: Selling Crack in el Barrio.* Cambridge: Cambridge University Press.

Bowman, Alan K., and Greg Woolf, eds. 1994. *Literacy and Power in the Ancient World.* Cambridge: Cambridge University Press.

Breuilly, John. 1994. *Nationalism and the State.* Chicago: University of Chicago Press.

Bright, Brenda Jo. 1995. "Remappings: Los Angeles Low Riders." Pp. 89–123 in *Looking High and Low: Art and Cultural Identity,* ed. Brenda Jo Bright and Elizabeth Bakewell. Tucson: University of Arizona Press.

Bright, Brenda Jo, and Elizabeth Bakewell. 1995. *Looking High and Low: Art and Cultural Identity.* Tucson: University of Arizona Press.

Bruner, Edward M. 1972. "Batak Ethnic Associations in Three Indonesian Cities." *Southwestern Journal of Anthropology* 28, no. 3: 207–29.

Bryan, Bob. 1995. *Graffiti Vérité: Read the Writing on the Wall.* Los Angeles: Bryan World Productions. Video.

_____. 1998. *GV2 (Graffiti Vérité 2).* Los Angeles: Bryan World Productions. Video.

Bryant, Clora, Buddy Collette, William Green, Steve Isoardi, Jack Kelson, Horace Tapscott, Gerald Wilson, and Marl Young, eds. 1998. *Central Avenue Sounds : Jazz in Los Angeles.* Berkeley and Los Angeles: University of California Press.

Buford, Bill. 1993. *Among the Thugs.* New York: Vintage Departures.

Bushnell, John. 1990. *Moscow Graffiti: Language and Subculture.* Boston: Unwin Hyman.

Campbell, Anne. 1991. *The Girls in the Gang.* Cambridge: Basil Blackwell.

Canclini, Néstor García. 1989. *Hybrid Cultures: Strategies for Entering and Leaving Modernity,* trans. Christopher L. Chiappari and Silvia L. López. Minneapolis: University of Minnesota Press.

Castleman, Craig. 1982. *Getting Up: Subway Graffiti in New York.* Cambridge, Mass.: MIT Press.

Cesaretti, Gusmano. 1975. *Street Writers: A Guided Tour of Chicano Graffiti.* Los Angeles: Acrobat Books.

Chaffee, Lyman. 1989. "Political Graffiti and Wall Painting in Greater Buenos Aires: An Alternative Communication System." *Studies in Latin American Popular Culture* 8: 37–60.

Chagnon, Napoleon A. 1992. *The Yanomamo.* Fort Worth: Harcourt Brace Jovanovich College Publishers.

Chalfant, Henry, and Tony Silver, producers. 1985. *Style Wars!* Film.

Chin, Ko-Lin. 1990. *Chinese Subculture and Criminality: Non-Traditional Crime Groups in America.* Westport, Conn: Greenwood Press.

Clark, Bob, director. *Turk 182!* Twentieth Century Fox. Film.

Cockcroft, Eva Sperling, and Holly Barnet-Sanchez. 1990. *Signs from the Heart: California Chicano Murals.* Venice, Calif.: Social and Public Art Resource Center.

Comaroff, John, and Jean Comaroff. 1992. *Ethnography and the Historical Imagination.* Boulder: Westview Press.

Conquergood, Dwight. 1993. *Homeboys and Hoods: Gang Communication and Cultural Space.* Evanston, Ill.: Center for Urban Affairs and Policy Research, Northwestern University.

Cooper, Martha, and Henry Chalfant. 1984. *Subway Art.* New York: Holt, Reinhart and Winston.

Cresswell, Timothy. 1992. "The Crucial 'Where' of Graffiti: A Geographical Analysis of Reactions to Graffiti in New York." *Environment and Planning D: Society and Space* 10: 329–44.

Cummings, Scott, and Daniel J. Monti. 1993. *Gangs: The Origins and Impact of Contemporary Youth Gangs in the United States.* Albany: State University of New York Press.

Currie, Elliot. 1998. *Crime and Punishment in America: Why the Solutions to America's Most Stubborn Social Crisis Have Not Worked—and What Will.* New York: Metropolitan Books.

Davis, Mike. 1990. *City of Quartz: Excavating the Future in Los Angeles.* London: Verso.

Dawley, David. 1992. *A Nation of Lords: The Autobiography of the Vice Lords.* Prospect Heights, Ill.: Waveland Press, Inc.

DeMarrais, Elizabeth, Luis Jaime Castillo, and Timothy Earle. 1996. "Ideology, Materialization, and Power Strategies." *Current Anthropology* 37, no. 1 (February): 15–31.

Dematte, Paola. 1996. "The Origins of Chinese Writing: Archaeological and Textual Analysis of the Pre-dynastic Evidence." Ph.D. diss., University of California, Los Angeles.

Deverell, William. 1997. Los Angeles and the Mexican or, What's Typical in Los Angeles History? Unpublished manuscript.

Dirks, Nicholas B. 1993. *The Hollow Crown: Ethnohistory of an Indian Kingdom.* Ann Arbor: University of Michigan Press.

Drake, St. Clair, and Horace R. Cayton. 1946. *Black Metropolis : A Study of Negro Life in a Northern City.* London: J. Cape.

Dresch, Paul. 1986. "The Significance of the Course Events Take in Segmentary Systems." *American Ethnologist* 13, no. 2: 309–24.

Du Bois, W. E. B. 1967. Reprint. *The Philadelphia Negro: A Social Study.* New York: B. Blom. Original edition, Philadelphia: University of Pennsylvania Press.

Dundes, Alan. 1966. "Here I Sit: A Study of American Latrinalia." *The Kroeber Anthropological Society Papers* (February).

Dunston, Mark S. 1992. *Street Signs: An Identification Guide of Symbols of Crime and Violence.* Powers Lake, Wis.: Performance Dimensions Publishers.

Duranti, Alessandro, and Charles Goodwin. 1992. *Rethinking Context: Language as an Interactive Phenomenon.* Cambridge: Cambridge University Press.

Durkheim, Emile. 1964. *The Division of Labor in Society.* New York: Free Press of Glencoe.

Ekeh, Peter P. 1990. "Social Anthropology and Two Contrasting Uses of Tribalism in Africa." *Comparative Studies in Society and History* 32, no. 4 (October): 660–700.

Evans-Pritchard, E. E. 1940. *The Nuer: A Description of the Modes of Livelihood and Political Institutions of a Nilotic People.* Oxford: Clarendon Press.

Farrell, Susan, and Brett Webb. 1994–98. *Art Crimes: The Writing on the Wall* (Web site). <http://www.graffiti.org>.

Ferguson, R. Brian. 1995. *Yanomami Warfare: A Political History.* Santa Fe, N.Mex.: School of American Research Press. Distributed by the University of Washington Press, Seattle.

Ferguson, R. Brian, and Neil L. Whitehead. 1992. "War in the Tribal Zone: Expanding States and Indigenous Warfare." Santa Fe, N.Mex.: School of American Research Press.

Ferrell, Jeff. 1996. Reprint. *Crimes of Style: Urban Graffiti and the Politics of Criminality.* Boston: Northeastern University Press. Original edition, New York: Garland, 1993.

Field, Henry. 1952. *Camel Brands and Graffiti from Iraq, Syria, Jordan, Iran, and Arabia.* Baltimore: American Oriental Society.

Fortes, Meyer, and E. E. Evans-Pritchard, eds. 1940. *African Political Systems.* London: Oxford.

Fremon, Celeste. 1995. *Father Greg and the Homeboys: The Extraordinary Journey of Father Greg Boyle and His Work with the Latino Gangs of East L.A.* New York: Hyperion.

Fried, Morton H. 1967. *The Evolution of Political Society: An Essay in Political Anthropology.* New York: Random House.

————. 1975. *The Notion of Tribe.* Menlo Park, Calif.: Cummings Publishing Co.

Fulton, William. 1997. *The Reluctant Metropolis: The Politics of Urban Growth in Los Angeles.* Point Arena, Calif.: Solano Press Books.

Gadpaille, W. J. 1971. "Graffiti: Its Psychodynamic Significance." *Sexual Behavior* 2 (November): 45–51.

Garcia Canclini, Nestor. 1989. *Hybrid Cultures: Strategies for Entering and Leaving Modernity.* Minneapolis: University of Minnesota Press.

Garstang, John, Percy E. Newberry, and J. G. Milne. 1989. *El Arabah: A Cemetery of the Middle Kingdom; Survey of the Old Kingdom Temenos; Graffiti from the Temple of Sety.* London: Histories & Mysteries of Man.

Geertz, Clifford. 1973. "Deep Play: Notes on the Balinese Cockfight." *The Interpretation of Cultures: Selected Essays.* New York: Basic Books.

————. 1983. "Art as a Cultural System." *Local Knowledge: Further Essays in Interpretive Anthropology.* New York: Basic Books.

Giddens, Anthony. 1979. *Central Problems in Social Theory: Action, Structure, and Contradiction in Social Analysis.* Berkeley and Los Angeles: University of California Press.

Gluckman, Max. 1940. "Analysis of a Social Situation in Zululand." *Bantu Studies* 14: 1–30.

Goldschmidt, Walter. 1990. *The Human Career: The Self in the Symbolic World.* Cambridge, Mass.: Basil Blackwell.

Goody, Jack. 1977. *The Domestication of the Savage Mind.* Cambridge: Cambridge University Press.

————. 1986. *The Logic of Writing and the Organization of Society.* Cambridge: Cambridge University Press.

Govenar, Alan. 1988. "The Variable Contexts of Chicano Tattooing." *Marks of Civilization: Artistic Transformations of the Human Body,* ed. Arnold Rubin. Los Angeles: Museum of Cultural History.

Graff, Harvey J. 1987. *The Legacies of Literacy: Continuities and Contradictions in Western Culture and Society.* Bloomington: Indiana University Press.

Griffith, Beatrice. 1948. *American Me.* Boston: Houghton Mifflin.

Griswold del Castillo, Richard. 1979. *The Los Angeles Barrio, 1850–1890: A Social History.* Berkeley and Los Angeles: University of California Press.

Hagedorn, John, and Perry Macon. 1988. *People and Folks: Gangs, Crime, and the Underclass in a Rust-belt City.* Chicago: Lake View Press.

Hager, Steven. 1984. *Hip-hop: The Illustrated History of Break Dancing, Rap Music, and Graffiti.* New York: St. Martin's Press.

Harris, Mary G. 1988. *Cholas: Latino Girls and Gangs.* New York: AMS Press.

Heath, Shirley Brice, and Milbrey Wallin McLaughlin. 1993. Pp. vi, 250 in *Identity and Inner-city Youth : Beyond Ethnicity and Gender.* New York: Teachers College Press.

Hebdige, Dick. 1979. *Subculture: The Meaning of Style.* London: Methuen.

Hines, Thomas S. 1982. "Housing, Baseball, and Creeping Socialism: The Battle of Chavez Ravine, Los Angeles, 1949–1959." *Journal of Urban History* 8 (February): 123–44.

"Hobo Killings Probed." 1998. *Intelligence Report,* issue 89 (winter), 4. Published by the Southern Poverty Law Center, P.O. Box 548, Montgomery, AL 36104-0548.

Hobsbawm, E. J., and T. O. Ranger. 1983. *The Invention of Tradition.* Cambridge: Cambridge University Press.

Horowitz, Ruth. 1983. *Honor and the American Dream : Culture and Identity in a Chicano Community.* New Brunswick, N.J.: Rutgers University Press.

————. 1990. "Sociological Perspectives on Gangs: Conflicting Definitions and Concepts." In *Gangs in America,* ed. C. Ronald Huff. Newbury Park, Calif.: Sage Publications.

Huff, C. Ronald, ed. 1990. *Gangs in America.* Newbury Park, Calif.: Sage Publications.

Hutson, H. Range, Deirdre Anglin, Demetrios N. Kyriacou, Joel Hart, and Kevin Spears. 1995. "The Epidemic of Gang-Related Homicides in Los Angeles County from 1979 through 1994." *Journal of the American Medical Association* 274: 1031–36.

Jackson, Kenneth T. 1980. "Race, Ethnicity, and Real Estate Appraisal: The Home Owners Loan Corporation and the Federal Housing Administration." *Journal of Urban History* 6, no. 4: 419–52.

Jackson, Pat, and Cary Rudman. 1993. "Moral Panic and the Response to Gangs in California." Pp. 257–76 in *Gangs: The Origins and Impact of Contemporary Youth Gangs in the United States,* eds. Scott Cummings and Daniel J. Monti. Albany: State University of New York Press.

Jah, Yusuf, and Shah'Keyah Jah. 1995. *Uprising: Crips and Bloods Tell the Story of America's Youth in the Crossfire.* New York: Scribner.

Jameson, Fredric. 1991. *Postmodernism; or, The Cultural Logic of Late Capitalism.* Durham, N.C.: Duke University Press.

Jankowski, Martin Sanchez. 1991. *Islands in the Street: Gangs and American Urban Society.* Berkeley and Los Angeles: University of California Press.

Johnson, Allen W., and Timothy Earle. Forthcoming. *The Evolution of Human Societies: From Foraging Group to Agrarian State.* 2d ed. Stanford: Stanford University Press.

Keiser, R. Lincoln. 1969. *The Vice Lords: Warriors of the Streets.* New York: Holt, Rinehart and Winston.

Kim, Sojin. 1997. "Vital Signs: Signage, Graffiti, Murals, and 'Sense of Place' in Los Angeles." Ph.D. diss., University of California, Los Angeles.

Kim, Sojin, and Peter Quezada. 1995. *Chicano Graffiti and Murals: The Neighborhood Art of Peter Quezada.* Jackson: University Press of Mississippi.

Klein, Malcolm W. 1995. *The American Street Gang: Its Nature, Prevalence, and Control.* Oxford: Oxford University Press.

Kohl, Herbert R. 1972. "Golden Boy as Anthony Cool." In *Golden Boy as Anthony Cool: A Photo Essay on Naming and Graffiti,* ed. Herbert R. Kohl and James Hinton. New York: Dial Press.

Kohl, Herbert R., and James Hinton, eds. 1972. *Golden Boy as Anthony Cool: A Photo Essay on Naming and Graffiti.* New York: Dial Press.

Korem, Dan. 1994. *Suburban Gangs: The Affluent Rebels.* Richardson, Tex.: International Focus Press.

Kuper, Adam. 1982. "Lineage Theory: A Critical Retrospective." *Annual Review of Anthropology* 11: 71–95.

Kurlansky, Mervyn, Norman Mailer, and Jon Naar. 1974. *The Faith of Graffiti.* New York: Praeger.

Lachmann, Richard. 1988. "Graffiti as Career and Ideology." *American Journal of Sociology* 94 (September): 229–50.

Landre, Rick, Mike Miller, and Dee Porter. 1997. *Gangs: A Handbook for Community Awareness.* New York: Facts on File.

Leach, Edmund. 1990. *Political Systems of Highland Burma: A Study of Kachin Social Structure.* London: Athlone Press.

Ley, David, and Roman Cybriwsky. 1974. "Urban Graffiti as Territorial Markers." *Annals of the Association of American Geographers* 64: 491–505.

Liebow, Elliott. 1967. *Tally's Corner: A Study of Negro Streetcorner Men.* Boston: Little, Brown.

Lindsay, Jack. 1960. *The Writing on the Wall: An Account of Pompeii in Its Last Days.* London: F. Muller.

Lipsitz, George. 1993. "Knowing Their Place: Street Artists, Communities, and the Politics of Space." *Shared Spaces: Collaboration in Contemporary Public Art in the United States, 1975–1990,* ed. Donna Graves. Minneapolis: University of Minnesota Press.

Lomas, Ben [Harvey D.]. 1973. "Graffiti: Some Observations and Speculations." *Psychoanalytic Review* 60 (March): 71–89.

Mailer, Norman. 1974. "The Faith of Graffiti." In *The Faith of Graffiti,* ed. Mervyn Kurlansky, Norman Mailer, and Jon Naar. New York: Praeger.

Malcom X, with Alex Haley. 1965. *The Autobiography of Malcom X.* New York: Ballantine Books.

Martinez, Ruben. 1992. "Going Up in L.A." In *The Other Side: Notes from the New L.A., Mexico City, and Beyond,* ed. Ruben Martinez. New York: Vintage Books.

Massey, Douglas S., and Nancy A. Denton. 1994. *American Apartheid: Segregation and the Making of the Underclass.* Cambridge: Harvard University Press.

Mazon, Mauricio. 1984. *The Zoot-Suit Riots: The Psychology of Symbolic Annihilation.* Austin: University of Texas Press.

McCrum, Robert, William Cran, and Robert MacNeil. 1986. *The Story of English.* New York: Viking.

McWilliams, Carey. 1948. *North from Mexico: the Spanish-Speaking People of the United States.* New York: Greenwood Press.

Mendoza-Denton, Norma. 1996. "*'Muy macha'*: Gender and Ideology in Gang Girls' Discourse about Makeup." *Ethos* 24.

Miller, Daniel. 1987. *Material Culture and Mass Consumption.* New York: Basil Blackwell.

Miller, Walter P. 1990. "Why the United States Has Failed to Solve Its Youth Gang Problem." In *Gangs in America,* ed. C. Ronald Huff. Newbury Park, Calif.: Sage Publications.

Miranda, Gloria E. 1990. "The Mexican Immigrant Family: Economic and Cultural Survival in Los Angeles, 1900–1945." Pp. 39–60 in *Twentieth-Century Los Angeles: Power, Promotion, and Social Conflict,* eds. Norman M. Klein and Martin J. Schiesl. Claremont, Calif.: Regina Books.

Mishan, Ahrin, and Rick Rothenberg. 1994. *Bui doi: Life like dust.* Urban Nomad Productions. San Francisco: Cross-Current Media; National Asian American Telecommunications Association. Film.

Mitchell, J. Clyde. 1970. "Tribe and Social Change in South Central Africa: A Situational Approach." *Journal of Asian and African Studies* 5, nos. 1–2: 83–101.

Moonwoman, Birch. 1992. "Rape, Race, and Responsibility: A Graffiti-Text Political Discourse." Vol. 2, pp. 420–29 in *Locating Power: Proceedings of the Second Women and Language Conference* (Berkeley, April 4 and 5), eds. Kira Hall, Mary Bucholtz, and Birch Moonwoman.

Moore, Joan W. 1991. *Going Down to the Barrio: Homeboys and Homegirls in Change.* Philadelphia: Temple University Press.

Moore, Joan W. 1978. *Homeboys: Gangs, Drugs, and Prison in the Barrios of Los Angeles.* Philadelphia: Temple University Press.

Morales, Armando. 1972. *Ando Sangrando (I Am Bleeding): A Study of Mexican American Police Conflict.* La Puente, Calif.: Perspectiva Publications.

Murray, Yxta Maya. 1997. *Locas.* New York: Grove Press.

Navarro, Carlos, and Rodolfo Acuña. 1990. "In Search of Community: A Comparative Essay on Mexicans in Los Angeles and San Antonio." Pp. 195–226 in *Twentieth-Century Los Angeles: Power, Promotion, and Social Conflict,* ed. Norman M. Klein and Martin J. Schiesl. Claremont, Calif.: Regina Books.

Newton, Jim. 1996. "Crackdown on Street Gang Leads to Twenty-one Arrests." *Los Angeles Times,* 4 July, sec. B1, Metro edition.

Oliver, Melvin L., James H. Johnson, and Walter C. Farrell Jr. 1993. "Anatomy of a Rebellion: A Political-Economic Analysis." Pp. 117–41 in *Reading Rodney King: Reading Urban Uprising,* ed. Robert Gooding-Williams. New York: Routledge.

Party, Rock A., and Ben Higa, eds. 1996. *Rap Pages* 5, no. 1 (February, special graffiti issue).

Perry, Anthony. 1995. *Black Leadership, Black Gangs: Will They Unite to Rebuild Black America?* Beverly Hills, Calif.: Ant Valley Book Productions.

Pritchard, Violet. 1967. *English Medieval Graffiti.* Cambridge: Cambridge University Press.

Ranger, Terence O. 1983. "Invention of Tradition in Colonial Africa." Pp. 211–62 in *The Invention of Tradition,* ed. Eric Hobsbawm and Terence Ranger. Cambridge: Cambridge University Press.

Read, Allen Walker. 1935. *Lexical Evidence from Folk Epigraphy in Western North America: A Glossarial Study of the Low Element in the English Vocabulary.* Paris: privately printed.

Read, Allen Walker. 1977. *Classic American Graffiti: Lexical Evidence from Folk Epigraphy in Western North America.* Waukesha, Wis.: Maledicta Press.

Reisner, Robert George. 1971. *Graffiti: Two Thousand Years of Wall Writing.* New York: Cowles Book Co.

Robarchek, Clayton. 1998. *Waorani: The Contexts of Violence and War.* Fort Worth: Harcourt Brace College Publishers.

Rodriguez, Luis J. 1993. *Always Running: La vida loca—Gang Days in L.A.* Willimantic, Conn.: Curbstone Press.

Rodriguez, Luis, Cle Sloan, and Kershawn Scott. 1992. "Gangs: The New Political Force in Los Angeles." *Los Angeles Times,* 13 September, M1.

Romo, Ricardo. 1983. *East Los Angeles: History of a Barrio.* Austin: University of Texas Press.

Romotsky, Jerry, and Sally Romotsky. 1974. "Plaqueasos on the Wall." *Human Behavior* 4 (May): 64–70.

———. 1976. *Los Angeles Barrio Calligraphy.* Los Angeles: Dawson's Book Shop.

———. 1977. "Placas and Murals." *Arts in Society* 11: 288–89.

Rosaldo, Renato. 1980. *Ilongot Headhunting, 1883–1974: A Study in Society and History.* Stanford, Calif.: Stanford University Press.

———. 1995. Foreword to *Hybrid Cultures: Strategies for Entering and Leaving Modernity,* ed. Néstor García Canclini. Minneapolis: University of Minnesota Press.

Sackett, James R. 1977. "The Meaning of Style in Archaeology: A General Model." *American Antiquity* 42, no. 3: 369–80.

Sale, Richard T. 1972. *The Blackstone Rangers: A Reporter's Account of Time Spent with the Street Gang on Chicago's South Side.* New York: Random House.

Salinger, J. D. [1951] 1986. *The Catcher in the Rye.* Reprint, New York: Bantam Books.

Sanchez-Tranquilino, Marcos. 1991. "*Mi casa no es su casa:* Chicano Murals and Barrio Calligraphy as Systems of Signification at Estrada Courts, 1972–1978." M.A. thesis, University of California, Los Angeles.

———. 1995. "Space, Power, and Youth Culture: Mexican American Graffiti and Chicano Murals in East Los Angeles, 1972–1978." Pp. 55–88 in *Looking High and Low: Art and Cultural Identity,* eds. Brenda Jo Bright and Liza Bakewell. Tucson: University of Arizona Press.

Schieffelin, Bambi B., Kathryn A. Woolard, and Paul V. Kroskrity, eds. 1998. *Language Ideologies: Practice and Theory.* New York: Oxford University Press.

Scott, James C. 1985. *Weapons of the Weak: Everyday Forms of Peasant Resistance.* New Haven, Conn.: Yale University Press.

———. 1990. *Domination and the Arts of Resistance: Hidden Transcripts.* New Haven, Conn.: Yale University Press.

Shakur, Sanyika [Monster Kody]. 1993. *Monster: The Autobiography of an L.A. Gang Member.* New York: Atlantic Monthly Press.

Sikes, Gini. 1997. *Eight-ball Chicks: A Year in the Violent World of Girl Gangsters.* New York: Anchor Books.

Silva Tellez, Armando. 1986. *Una ciudad imaginada.* Bogota: Universidad Nacional de Colombia.

———. 1987. *Punto de vista ciudadano: Focalizacion visual y puesta en escena del graffiti.* (From the city's point of view). Bogota: Instituto Caro y Cuervo.

Silver, Tony. 1983. *Style Wars.* New York: Public Art Films, Inc.

Simons, Anna. 1995. *Networks of Dissolution : Somalia Undone.* Boulder, Colo.: Westview Press.

———. 1997. "Democratisation and Ethnic Conflict: The Kin Connection." *Nations and Nationalism* 3, no. 2: 273–89.

Sipchen, Bob. 1993. *Baby Insane and the Buddha: How a Crip and a Cop Joined Forces to Shut Down a Street Gang.* New York: Doubleday.

Southall, Aiden. 1970. "The Illusion of Tribe." *Journal of Asian and African Studies* 5, nos. 1–2: 28–50.

Spitz, Ellen Handler. 1991. "An Insubstantial Pageant Faded: A Psychoanalytic Epitaph for New York Subway Car Graffiti." Pp. 30–56 in *Image and Insight: Essays in Psychoanalysis and the Arts,* ed. Ellen Handler Spitz. New York: Columbia University Press.

Stack, Carol B. 1974. *All Our Kin: Strategies for Survival in a Black Community.* New York: Harper & Row.

Stewart, Susan. 1987. "*Cei tuera cela:* Graffiti as Crime and Art." Pp. 161–80 in *Life after Postmodernism: Essays on Value and Culture,* ed. John Fekete. New York: St. Martin's Press.

Sullivan, Randall. 1997. "Lynching in Malibu." *Rolling Stone,* Sept. 4.

Tanzer, Helen. 1939. *The Common People of Pompeii: A Study of the Graffiti.* Baltimore: Johns Hopkins University Press.

Taussig, Michael T. 1992. *The Nervous System.* New York: Routledge.

Thames, Kelly. 1995. Unpublished video. Georgia State University, School of Art and Design.

Thomas, Nicholas. 1995. *Oceanic Art.* New York, N.Y.: Thames and Hudson.

Thrasher, Frederic M. 1927. *The Gang: A Study of 1,313 Gangs in Chicago.* Chicago: University of Chicago Press.

Torrey, Charles C. 1937. *Aramaic Graffiti on Coins of Demanhur.* New York: American Numismatic Society.

Trik, Helen, and M. E. Kampen. 1983. *The Graffiti of Tikal.* Philadelphia: University Museum, University of Pennsylvania.

Turner, Victor. 1967. *The Forest of Symbols: Aspects of Ndembu Ritual.* Ithaca, N.Y.: Cornell University Press.

———. 1969. *The Ritual Process: Structure and Anti-structure.* Chicago: Aldine Pub. Co.

Urban, Hope. 1993. "Bombs Away! Graffiti: Art or Terrorism?" *Los Angeles Reader* 15, no. 44 (Aug. 13).

Vail, Leroy. 1989. *The Creation of Tribalism in Southern Africa.* Berkeley and Los Angeles: University of California Press.

Vigil, James Diego. 1983. "Chicano Gangs: One Response to Mexican Urban Adaptation in the Los Angeles Area." *Urban Anthropology* 12, no. 1: 45–75.

———. 1988a. *Barrio Gangs: Street Life and Identity in Southern California.* Austin: University of Texas Press.

———. 1988b. "Group Processes and Street Identity: Adolescent Chicano Gang Members. *Ethos* 16, no. 4: 421–45.

Vigil, James Diego, and John M. Long. 1990. Emic and Etic Perspectives on Gang Culture: The Chicano Case. Pp. 55–70 in *Gangs in America,* ed. C. Ronald Huff. Newbury Park, Calif.: Sage Publications.

Vigil, James Diego, and Steve Chong Yun. 1990. "Vietnamese Youth Gangs in Southern California." Pp. 146-162 in *Gangs in America*, ed. C. Ronald Huff. Newbury Park, Calif.: Sage Publications.

Vincent, Joan. 1990. *Anthropology and Politics: Visions, Traditions, and Trends.* Tucson: University of Arizona Press.

Wallerstein, Immanuel. 1974. *The Modern World-System: Capitalist Agriculture and the Origins of the European World-Economy in the Sixteenth Century.* New York: Academic Press.

Weber, Max. 1991. *The Protestant Ethic and the Spirit of Capitalism,* trans. Talcot Parsons. London: HarperCollins Academic.

Whyte, William. 1943. *Street Corner Society: The Social Structure of an Italian Slum.* Chicago: University of Chicago Press.

Wimsatt, William Upski. 1994. *Bomb the Suburbs.* 2d ed. rev. Chicago: The Subway and Elevated Press Company. Left Bank Distribution, Seattle, Wash.

Wobst, Martin. 1977. "Stylistic Behaviors and Information Exchange." *Museum of Anthropology, University of Michigan, Ann Arbor, Anthropological Papers* 61: 317–42.

Wolf, Eric. 1957. "Closed Corporate Communities in Mesoamerica and Java." *Southwestern Journal of Anthropology* 13: 1–18.

———. 1982. *Europe and the People without History.* Berkeley and Los Angeles: University of California Press.

———. 1986. "The Vicissitudes of the Closed Corporate Peasant Community." *American Ethnologist* 13, no. 2: 325–29.

Yablonsky, Lewis. 1997. *Gangsters: Fifty Years of Madness, Drugs, and Death on the Streets of America.* New York: New York University Press.

Zane, Wally. 1997. Surfers and Sex on the Beach: Southern California Surf Culture and Its Impact on the World. Unpublished manuscript.

# INDEX

›